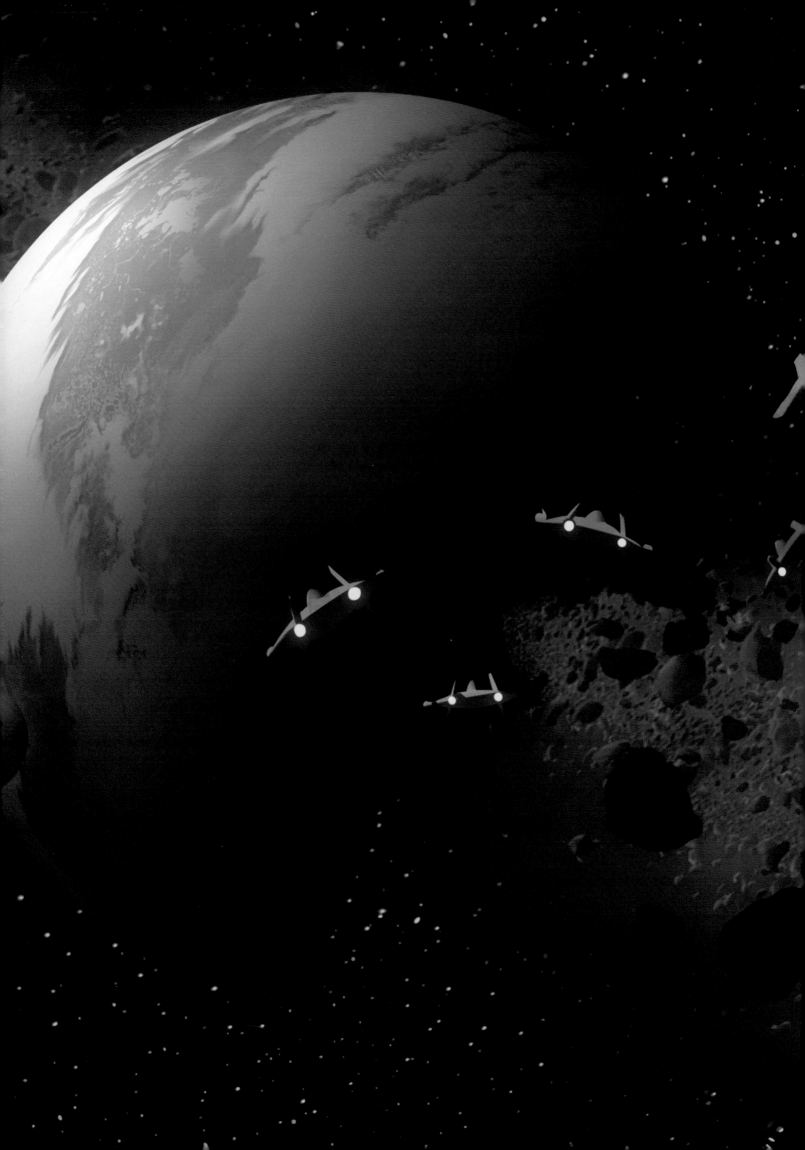

THE ART OF

STAR WARS™

REBELS

Foreword by
DAVE FILONI

Written by
DANIEL WALLACE

DARK HORSE BOOKS

PUBLISHER Mike Richardson

EDITOR Megan Walker

ASSISTANT EDITOR Joshua Engledow

DESIGNERS Sarah Terry and Cindy Cacerez-Sprague

DIGITAL ART TECHNICIAN Ann Gray

Special thanks to Dave Filoni and Kilian Plunkett; Eugene Paraszczuk and Christopher Troise at Disney; Michael Siglain and Robert Simpson at Lucasfilm; and Nick McWhorter and Ian Tucker at Dark Horse Comics.

FOR LUCASFILM LTD.

SENIOR EDITOR: Robert Simpson

CREATIVE DIRECTOR: Michael Siglain

ART DIRECTOR: Troy Alders

ASSET GROUP: Nicole LaCoursiere, Gabrielle Levenson, Tim Mapp, Bryce Pinkos, and Erik Sanchez

STORY GROUP: Pablo Hidalgo, Leland Chee, Matt Martin, and Emily Shkoukani

LUCASFILM ART DEPARTMENT: Phil Szostak

THE ART OF STAR WARS REBELS™

Published by Dark Horse Books
A division of Dark Horse Comics LLC
10956 SE Main Street
Milwaukie, OR 97222

DarkHorse.com
StarWars.com

Facebook.com/DarkHorseComics
Twitter.com/DarkHorseComics

Advertising Sales: (503) 905-2315

To find a comics shop in your area, visit comicshoplocator.com

First Edition: April 2020
ISBN 978-1-50671-091-4
Limited Edition ISBN 978-1-50671-485-1

1 3 5 7 9 10 8 6 4 2
Printed in China

TABLE OF CONTENTS

⟁⟊⟟⟊⟊⟊ ⟊⟟ ⟊⟊⟊⟊⟊⟊⟊⟊

FOREWORD

006

EARLY DEVELOPMENT

008

CHAPTER ONE

SEASON ONE: SPARK OF REBELLION

011

CHAPTER TWO

SEASON TWO: FUTURE OF THE FORCE

061

CHAPTER THREE

SEASON THREE: THE FATE OF THE ALLIANCE

109

CHAPTER FOUR

SEASON FOUR: ONE GIANT STEP AHEAD

159

FOREWORD

Star Wars is fundamentally a story about family. When Simon Kinberg and I would get together to talk about *Star Wars Rebels*, we would always come back to that touchstone. *Rebels* would be a story about a group of individuals who came together to form a new family while helping each other understand their roots and overcome the tragedies they had endured once the Galactic Empire took over.

Star Wars Rebels would act as a bridge between the first Lucasfilm animated series, *Star Wars: The Clone Wars*, and the first standalone *Star Wars* film, *Rogue One: A Star Wars Story*. To accomplish a cohesive look for the series, my art director Kilian Plunkett and I went back to many of the original inspirational images for *Star Wars*, especially those by Ralph McQuarrie. As the series developed we were able to collaborate with the live-action productions and include a stylistic bridge for characters like Saw Gerrera,

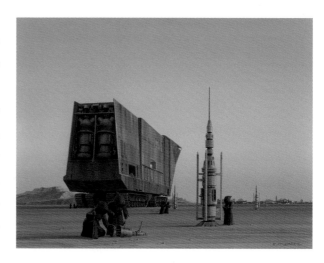

who appeared in both *Rebels* and *Rogue One*. The style of *Rebels* was a bit lighter than *Clone Wars*, but we were able to mature the look of the series as our characters came of age and faced more challenging obstacles.

Most importantly we wanted to maintain the legacy of the *Star Wars* saga and that of its creator, George Lucas. Beginning in 2005, my team and I would spend the better part of a decade learning our craft under the direct guidance of George Lucas while making the animated series *Star Wars: The Clone Wars*. Every day we were in film school, and our classes were steeped in not just *Star Wars*, but George's vast knowledge of filmmaking and film history. We all did our best to make sure that the lessons he taught us were ever-present in how *Rebels* was crafted.

I'm very proud of the work, and the people who came together to make this series. While this book may be about design and artwork, it also represents many, many individuals around the globe who formed their own family through hard work, dedication, and love of *Star Wars*. My hope is that when you turn these pages you will see more than just sketches, lighting concepts, and maquettes, but the legacy that is *Star Wars*. As powerful as the Force itself, this legacy represents all of us here at Lucasfilm, where our knowledge is passed from generation to generation, and now, thanks to this book, on to you. Use it wisely, and remember . . . the Force will be with you . . . always.

—Dave Filoni

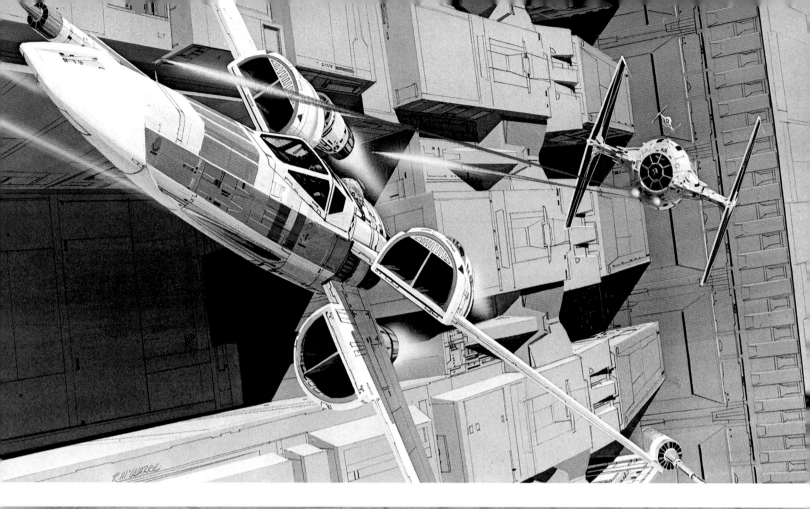

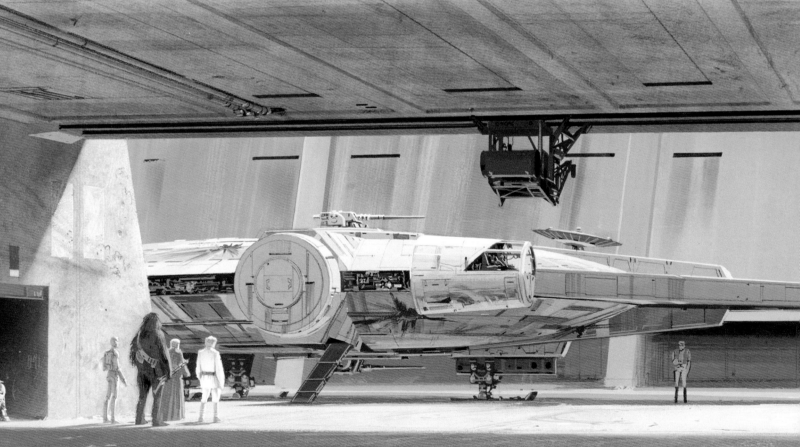

Art this spread: RMcQ

ARTIST CREDIT KEY:

RMcQ - Ralph McQuarrie	DM - Darren Marshall	WN - Will Nichols	LH - Luke Harrington
DF - Dave Filoni	PP - Pat Presley	JP - Jason Pichon	GJ - Goran Josic
KP - Kilian Plunkett	AK - Andre Kirk	ZP - Zak Plucinski	EM - Eli Maffei
ABC - Amy Beth Christenson	CV - Chris Voy	MD - Molly Denmark	TV - Tuan Vo
CG - Chris Glenn	JPB - John Paul Balmet	SB - Sean Burke	DJW - DJ Welch

Maquette photography by Joel Aron

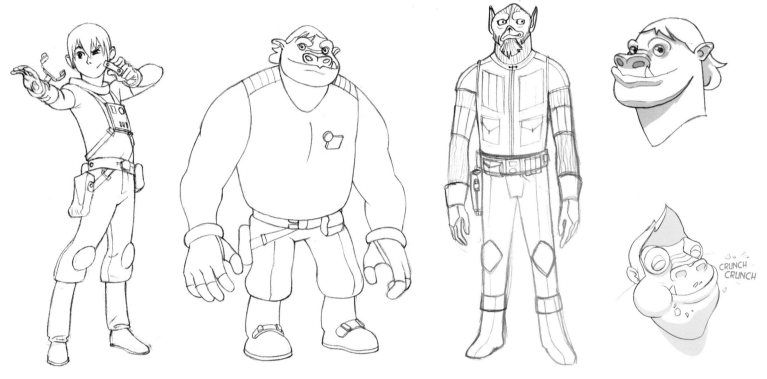

In order of appearance: KP, KP, DF, KP, ABC
Bottom half: CG

Star Wars Rebels started development in early 2013 with a planned release of late 2014. This accelerated schedule meant that the visuals for the series were created while the details of the story and characters were still being developed. From the outset, the crew's family dynamic was the cornerstone of the show. The design team started by exploring ideas for a mother, father, siblings, and a family pet before the characters had final names and backstories. Some of the explorations are presented here.

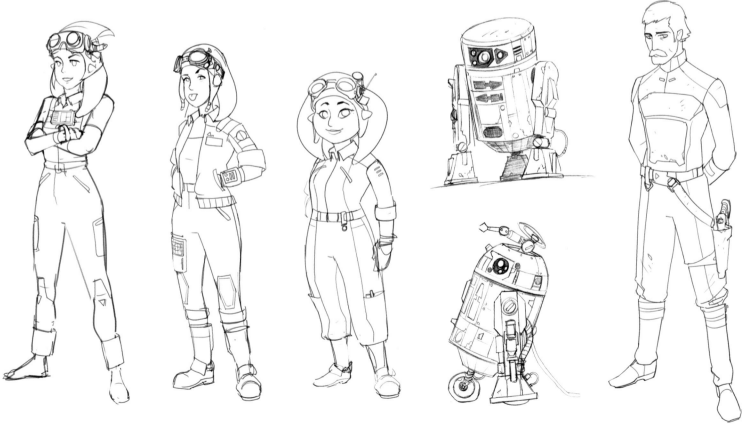

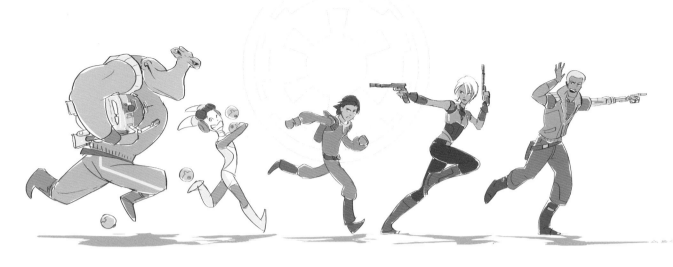

Top: ABC; bottom: PP

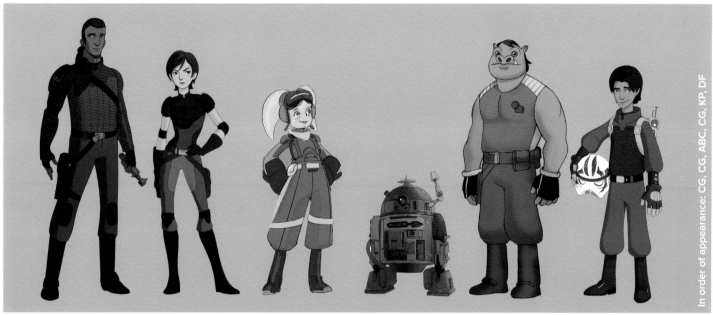

In order of appearance: CG, CG, ABC, CG, KP, DF

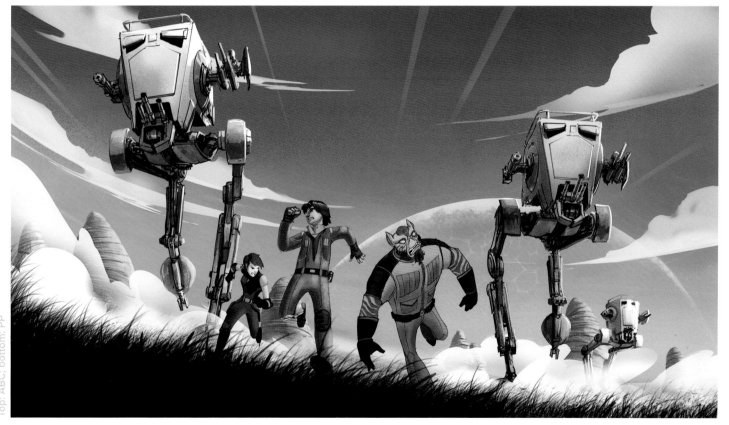

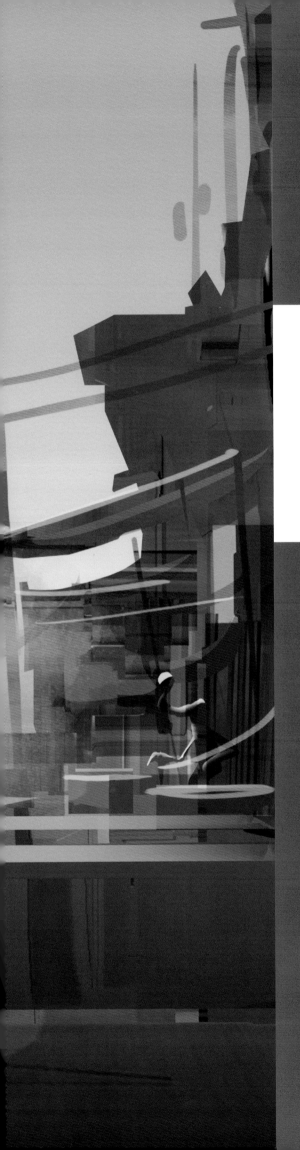

SEASON ONE
SPARK OF REBELLION
ꓥꓴꓘ7ꓷ ꓓ� ꓒꓶꓥꓳꓥꓥ1ꓳꓥ

Though the Galactic Empire seems unbeatable, a few trouble-makers are willing to lose everything if it means igniting the spark of rebellion. That's the premise of the animated series *Star Wars Rebels*, created by Dave Filoni, Simon Kinberg, and Carrie Beck, which aired seventy-five episodes from 2014–2018. Filoni and other creatives, including art director Kilian Plunkett, were veterans of the animated series *Star Wars: The Clone Wars* but sought to tell a more intimate story with *Rebels*. The new series would focus on a tight cast operating on a local scale yet still deal with stakes of life and death. Setting *Rebels* several years before the events of 1977's *A New Hope* inspired the crew to emulate the saga's earliest inspirations by studying the paintings of *Star Wars* artist Ralph McQuarrie. Throughout season one, Plunkett and senior concept designer Amy Beth Christenson established a distinctive look as the "found family" of *Rebels* heroes pushed to free their corner of the galaxy.

Familial relationships energize the core of *Star Wars Rebels* while fueling its narrative. The series kicks off with Ezra Bridger, a raw rookie, joining the guerrilla team and immediately finding his place within their ranks. The bonds he discovers in the squad only deepen throughout the series, giving them enough strength to face the gravest of threats. They learn to work together not only as a team but as a family, and begin caring for each other more strongly than they ever imagined possible.

HERA SYNDULLA

Hera is the ace Twi'lek pilot of the star freighter *Ghost*. She is also the daughter of Ryloth freedom fighter Cham Syndulla, a character from *Star Wars: The Clone Wars*. Hera's bond with Kanan isn't obvious during season one, but in time their mutual love becomes more text than subtext.

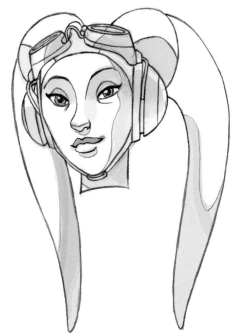

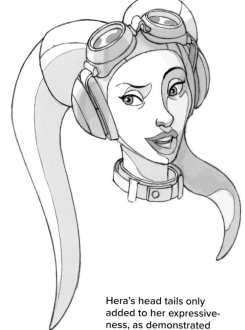

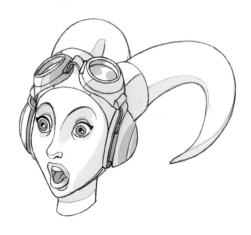

Hera's head tails only added to her expressiveness, as demonstrated by these facial studies.

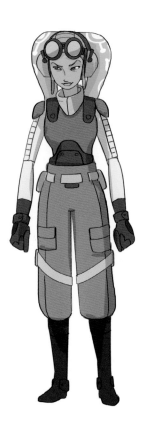

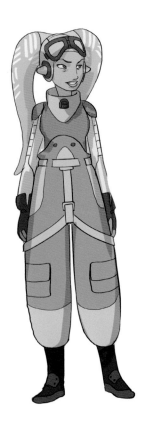

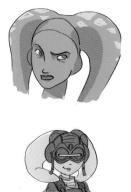

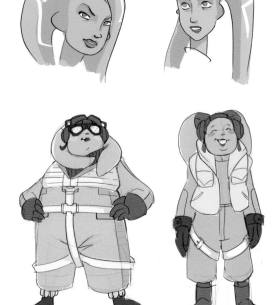

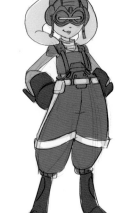

Hera's pilot jumpsuit—a constant throughout her designs—indicates her readiness to leap into action.

Top row: KP
Bottom row: ABC
Previous page: CV

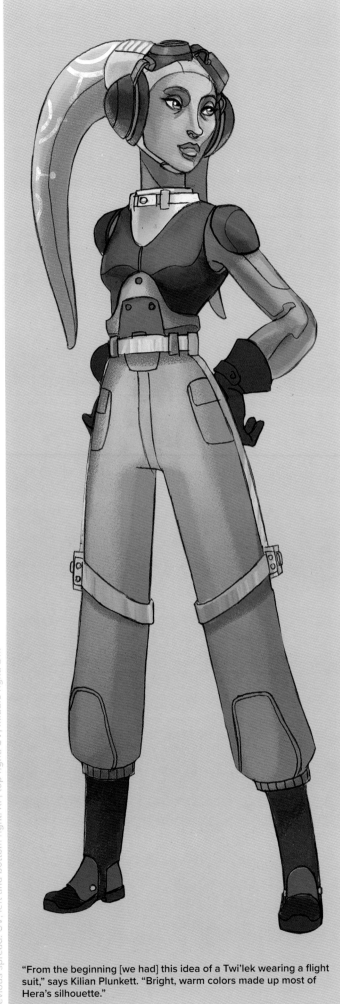

Previous spread: CV; left and bottom right: KP; top right: CV; middle right: DM

"From the beginning [we had] this idea of a Twi'lek wearing a flight suit," says Kilian Plunkett. "Bright, warm colors made up most of Hera's silhouette."

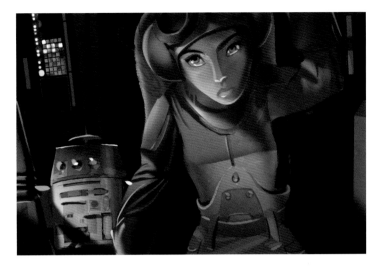

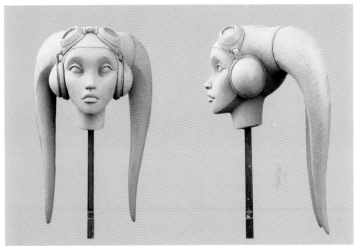

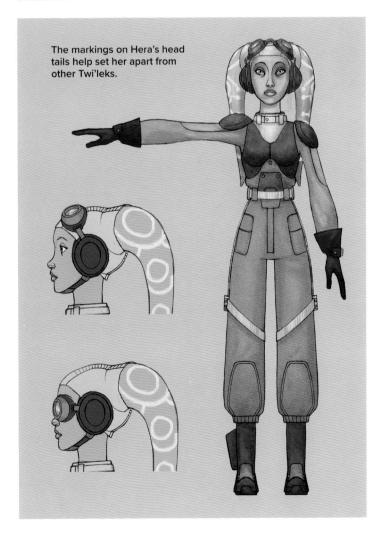

The markings on Hera's head tails help set her apart from other Twi'leks.

EZRA BRIDGER

Teenaged street thief Ezra Bridger joins the rebels in the first adventure of the series, acting as a guide for the audience in contextualizing the galactic clashes between the Rebellion and the Empire. Ezra, the son of political dissidents, has a strong, but raw and untapped, sensitivity with the Force that desperately needs guidance and focus.

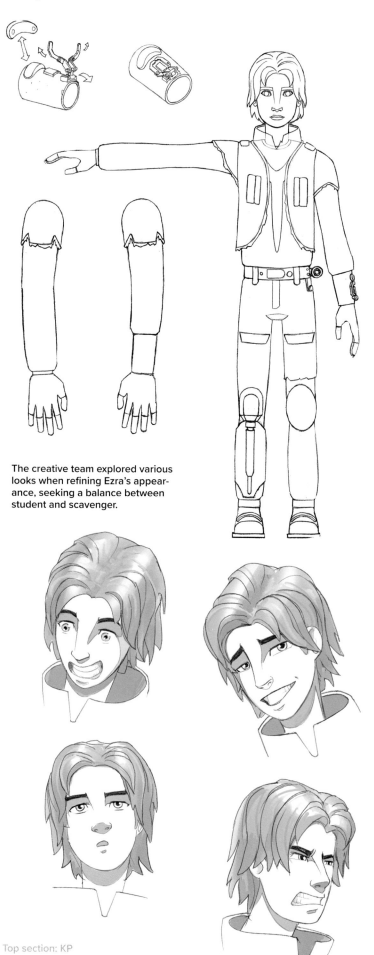

The creative team explored various looks when refining Ezra's appearance, seeking a balance between student and scavenger.

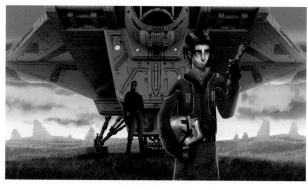

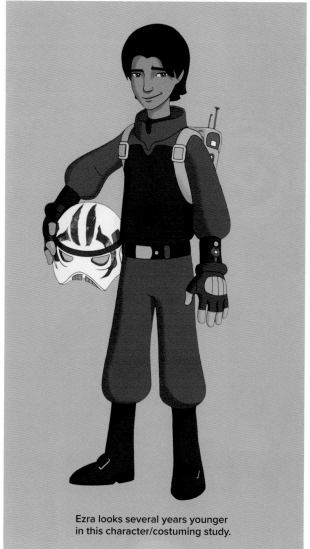

Ezra looks several years younger in this character/costuming study.

Top section: KP
Bottom section: DF

Top right: CV; middle right: PP; bottom right: DF

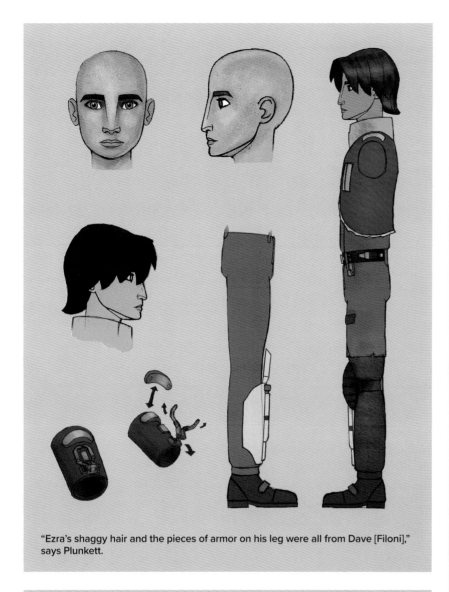

"Ezra's shaggy hair and the pieces of armor on his leg were all from Dave [Filoni]," says Plunkett.

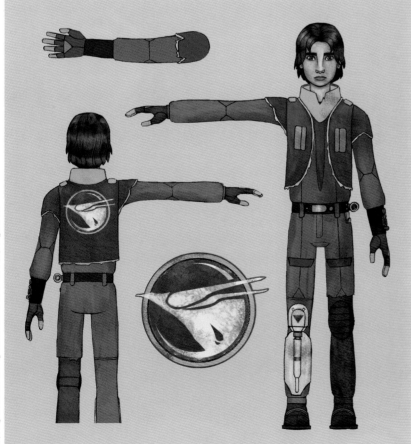

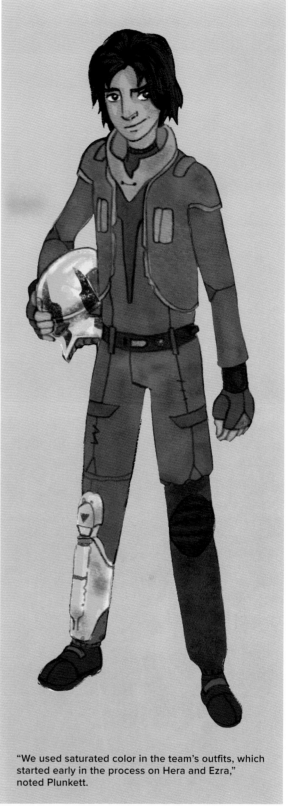

"We used saturated color in the team's outfits, which started early in the process on Hera and Ezra," noted Plunkett.

KANAN JARRUS

One of the few Jedi to escape the extermination of Order 66, Caleb Dume assumed the identity of "Kanan Jarrus" to hide from the Empire's Inquisitors. While serving with the Rebellion, Kanan finds love with Hera Syndulla wand lands a Padawan apprentice in Ezra Bridger.

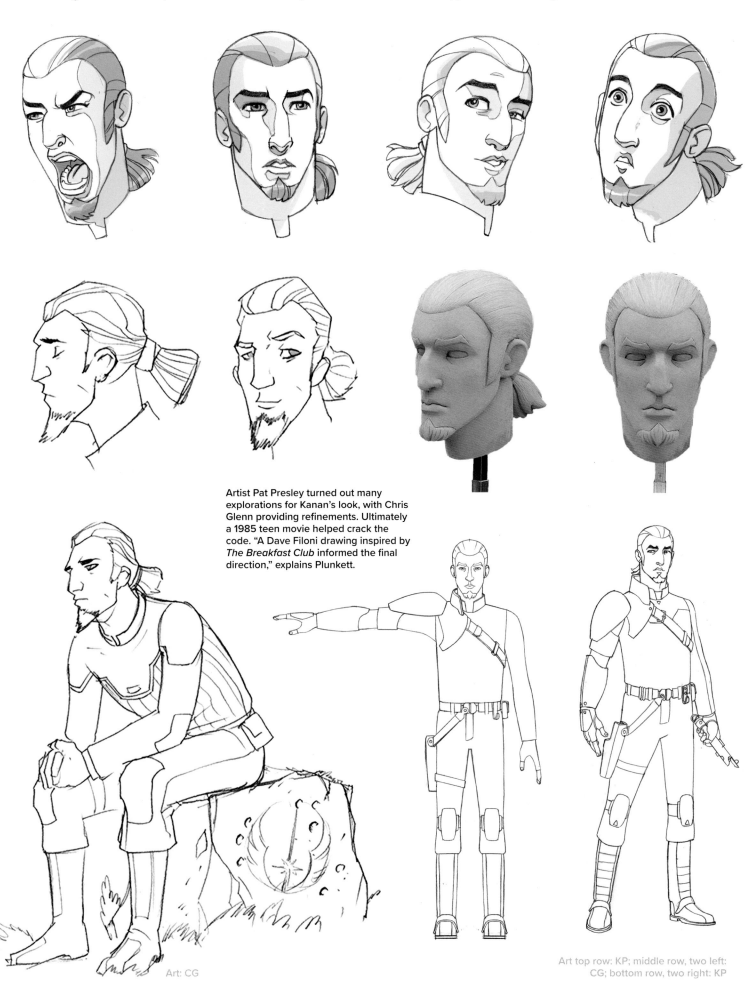

Artist Pat Presley turned out many explorations for Kanan's look, with Chris Glenn providing refinements. Ultimately a 1985 teen movie helped crack the code. "A Dave Filoni drawing inspired by *The Breakfast Club* informed the final direction," explains Plunkett.

Art: CG

Art top row: KP; middle row, two left: CG; bottom row, two right: KP

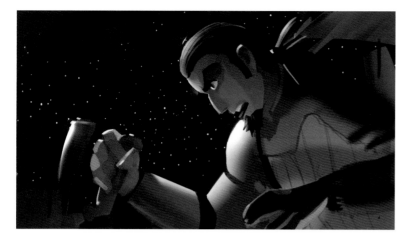

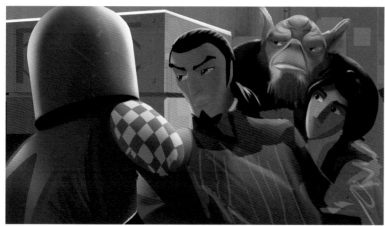

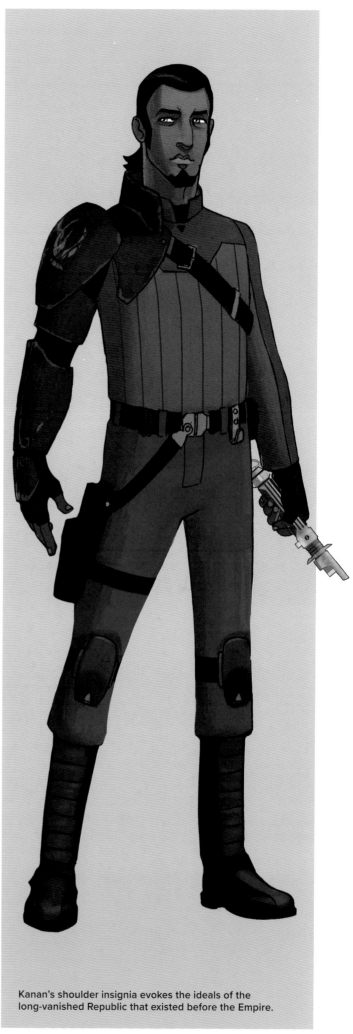

Kanan's shoulder insignia evokes the ideals of the long-vanished Republic that existed before the Empire.

SABINE WREN

Just sixteen years old at the start of *Star Wars Rebels*, Sabine is a renegade Mandalorian with a talent for demolitions and a flair for the artistic. Over the course of the series, Sabine's ties to the warrior clans of Mandalore force her to confront her past.

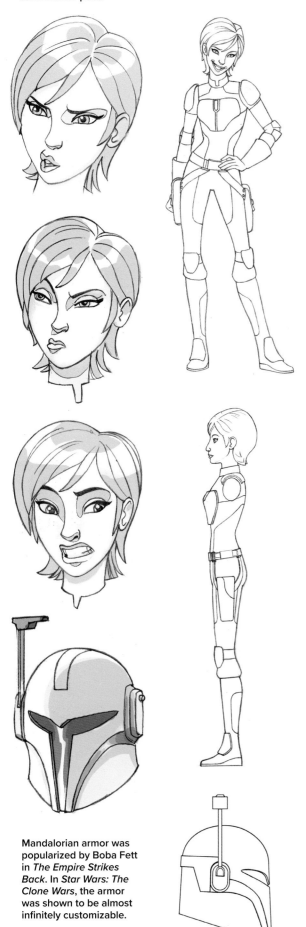

Mandalorian armor was popularized by Boba Fett in *The Empire Strikes Back*. In *Star Wars: The Clone Wars*, the armor was shown to be almost infinitely customizable.

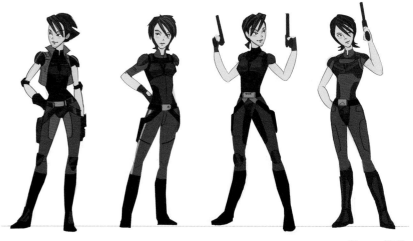

Above: ABC

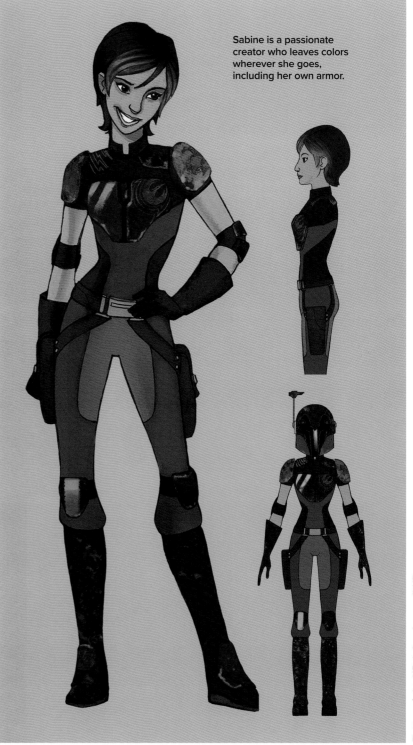

Sabine is a passionate creator who leaves colors wherever she goes, including her own armor.

Bottom right: KP; left column: all KP

ZEB ORRELIOS

A Lasat, Garazeb Orrelios is one of the last survivors of the Imperial-led Lasan genocide. Zeb is the team's heavy-hitting cynic and carries a ceremonial bo-rifle.

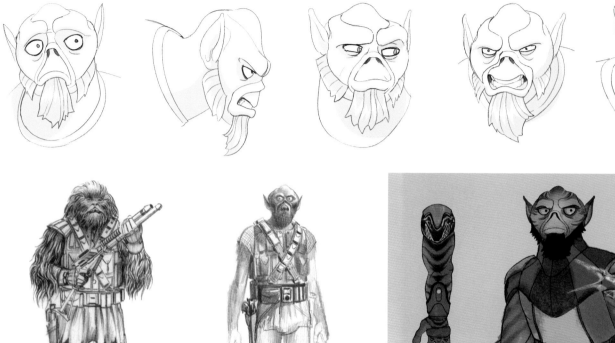

Top row: ABC; left three: RMcQ; right: KP; bottom right heads: DM

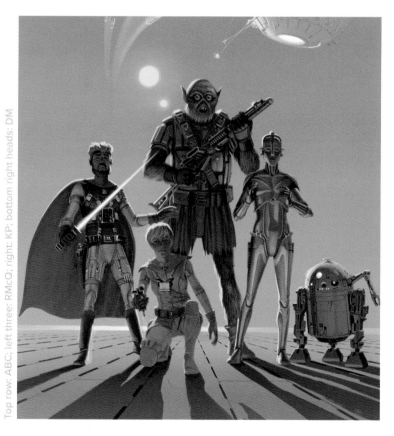

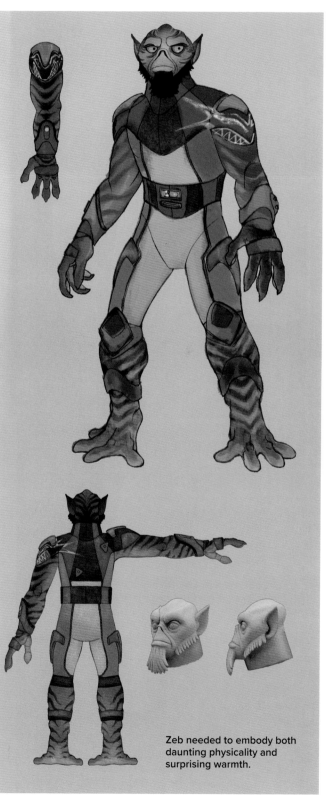

Zeb needed to embody both daunting physicality and surprising warmth.

"Zeb was the trickiest of the crew to settle on a look for," admits Plunkett. "For a long time he was a blue Snivvian [aliens who are sometimes called 'Snaggletooths']. Our final Zeb is a cross between McQuarrie's original concept for Chewbacca and Dave Filoni's cat."

GRAND MOFF TARKIN

As the governor of an entire Galactic Oversector, Grand Moff Tarkin appears to hold even more power than Darth Vader during his scenes in *A New Hope*.

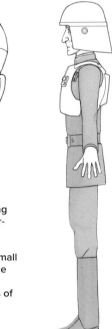

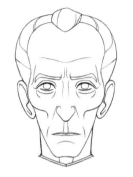

Says Plunkett, "Returning movie characters [underwent the same design process] as new ones: simplified shapes and small areas of detail, with large areas of flat color that featured one or two hits of high-contrast graphics."

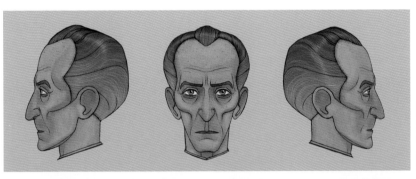

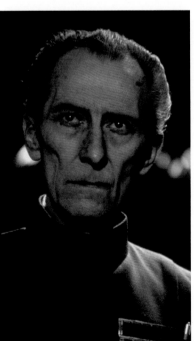

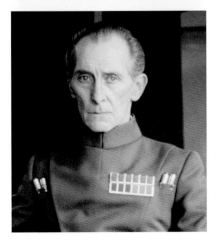

When Tarkin arrives at the end of season one, it's a clear sign that the series has raised the stakes.

This page: KP

CHOPPER

Astromech droid C1-series astromech droid C1-10P ("Chopper") is the squad's ill-tempered mechanic. Artists including Chris Glenn sought inspiration from Ralph McQuarrie's early R2-D2 designs, which featured arms extended from the droid's head. Adds Plunkett, "Chopper had an R2 dome originally. During development this changed to a bucket head to make him more distinct."

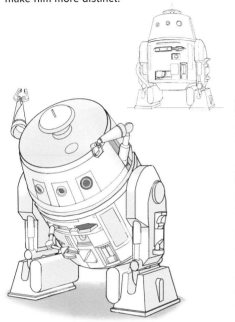

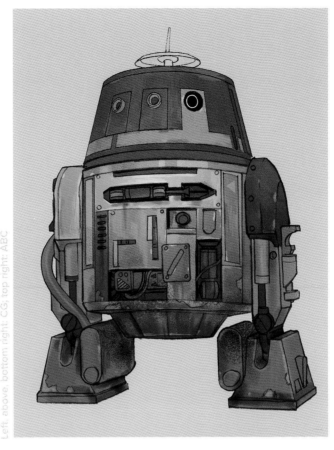

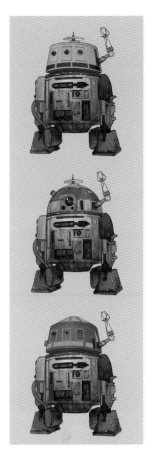

Left, above, bottom right: CG; top right: ABC

LUMINARA UNDULI

Might Jedi Master Luminara Unduli have survived the Jedi purge? When Kanan hears the rumors he allows himself to believe, only to lead his team into a trap on Stygeon Prime which culminates in a confrontation with the Imperial Grand Inquisitor.

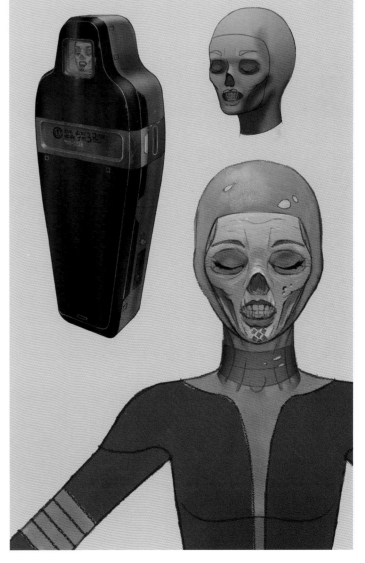

CIKATRO VIZAGO

This devil-horned Devaronian heads up the Broken Horn criminal syndicate on Lothal. Though Vizago isn't exactly trustworthy, his black-market connections prove vital to the operations of Lothal's Rebel cell.

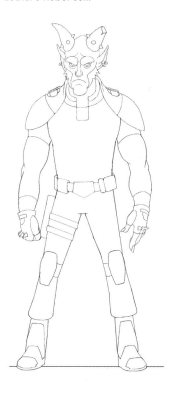

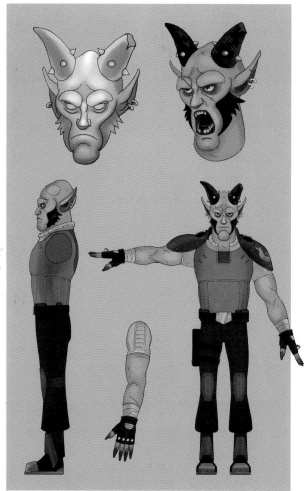

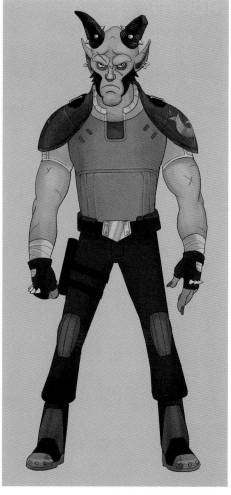

ALEXSANDR KALLUS

Alexsandr Kallus is an agent of the Imperial Security Bureau with one set of orders: to stamp out Lothal's Rebel cell. Kallus's history as a participant in the genocide of Lasan automatically makes him a mortal enemy of Zeb Orrelios. Though by the end of the series, Kallus proves to be more friend than foe to our group of Rebels.

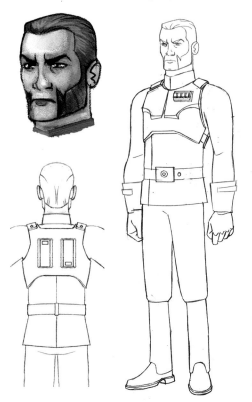

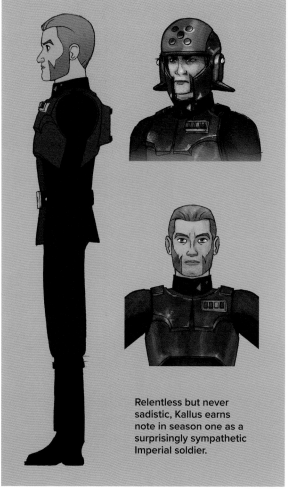

Relentless but never sadistic, Kallus earns note in season one as a surprisingly sympathetic Imperial soldier.

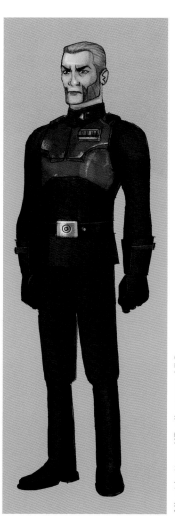

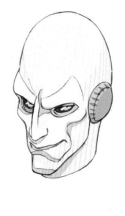

GRAND INQUISITOR

This chalk-skinned Pau'an led the Empire's Inquisitors in their hunt for Jedi survivors. "He was a Chagrian in early designs," reveals Plunkett, describing a species of horned alien. "We tried using a dark red outfit once it was decided to make him Utapaun. In the end Chris Glenn hit the right note with a militaristic, black-and-gray outfit, tailored like an Imperial officer but augmented with armor."

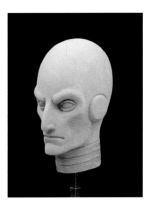

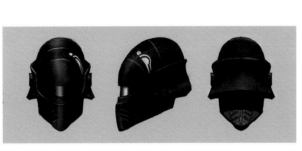

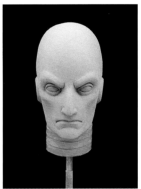

Left: CG: heads on top: KP; helmets: KP; heads right side: DM

MAKETH TUA

A native-born Lothal bureaucrat, Minister Tua oversaw the planet's industrial output on behalf of her Imperial overseers. When Lothal's growing rebellion prompted a visit from Grand Moff Tarkin, Minister Tua anxiously evaluated her options.

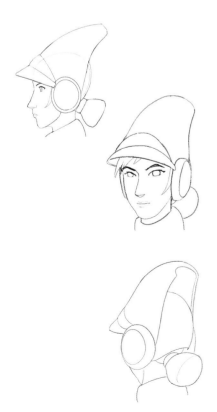

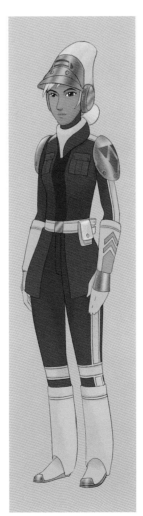

GALL TRAYVIS

Considered one of the "good ones" in the Imperial Senate, Gall Trayvis resigned from that body to spread an anti-Imperial message through underground channels. During the run of the series, Trayvis would be revealed as a double agent still loyal to the Empire.

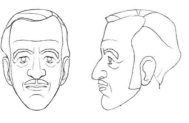

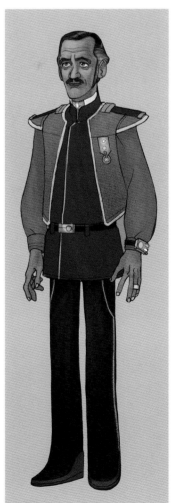

All Maketh art: CG; all Gall art: KP

C-3PO

Protocol droid C-3PO and his astromech counterpart R2-D2 have appeared in nearly every installment of the *Star Wars* film saga. The droids first underwent *Star Wars Rebels*' animated redesign for the season one episode "Droids in Distress."

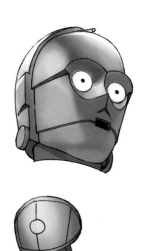

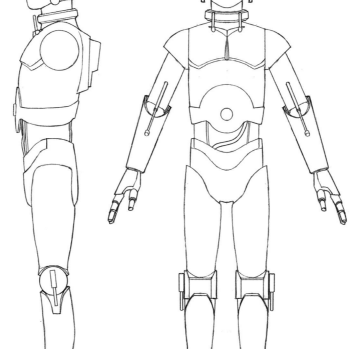

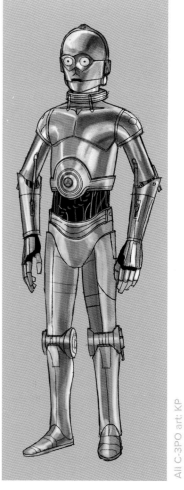

All C-3PO art: KP

WOOKIEE

Not all Wookiees are as fierce as Chewbacca, but their long limbs and strong backs make them optimal laborers for Imperial work crews. During one outing, the Lothal Rebels rescue Wookiee slaves from the spice mines of Kessel.

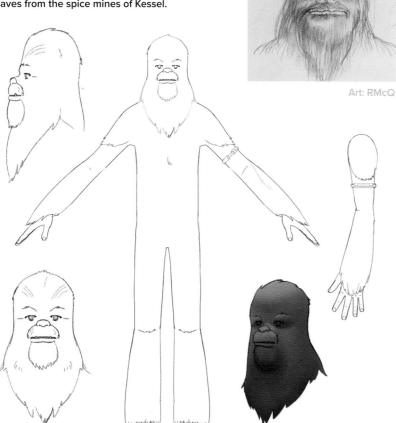

Art: RMcQ

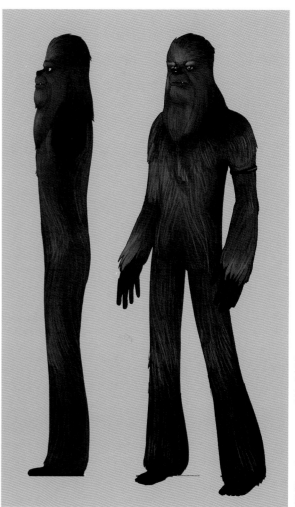

All Chewie art except RMcQ: CG

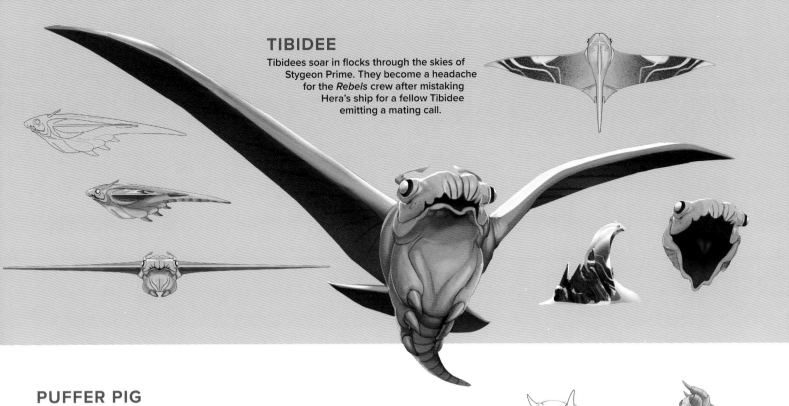

TIBIDEE

Tibidees soar in flocks through the skies of Stygeon Prime. They become a headache for the *Rebels* crew after mistaking Hera's ship for a fellow Tibidee emitting a mating call.

PUFFER PIG

Puffer pigs can sniff out rare minerals which makes them valuable cargo for freelance entrepreneurs like Lando Calrissian. When threatened, the pigs can inflate to comical proportions.

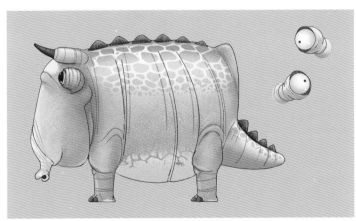

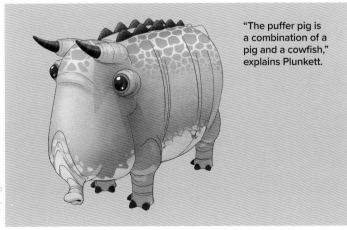

"The puffer pig is a combination of a pig and a cowfish," explains Plunkett.

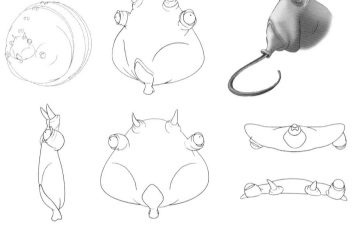

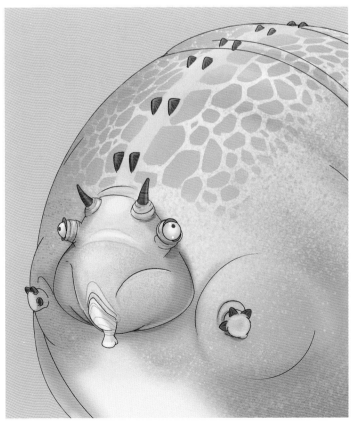

This page: ABC

⟁ ENVIRONMENTS
ᐯᴊᐯ ᐃᑎ ᐃ7 ᗐ ᐯᑎ ᒪᐯᐃ ᐃ ᒐᐱ

Ezra's homeworld of Lothal acts as the base for the *Rebels* crew throughout season one and eventually becomes a critical location in the Galactic Civil War. Largely undeveloped, Lothal is reminiscent of Ralph McQuarrie's early concept art for Alderaan.

"Both Lothal's capital and its rolling grasslands are based directly on specific McQuarrie art," says Kilian Plunkett. "In the north, Lothal's frozen tundra incorporates McQuarrie's 'termite mound' shape around our hidden Jedi Temple."

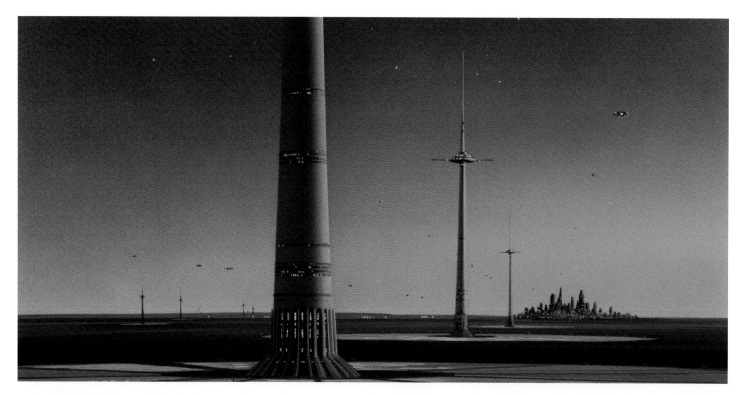

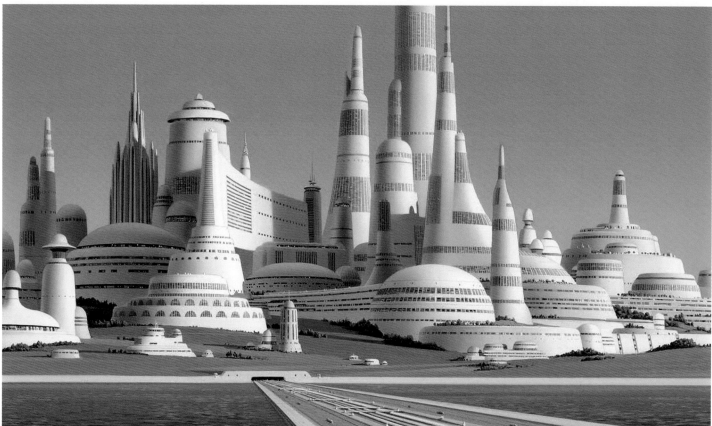

The soft contours of Lothal's milky spires echo McQuarrie's designs for Alderaan and Cloud City.

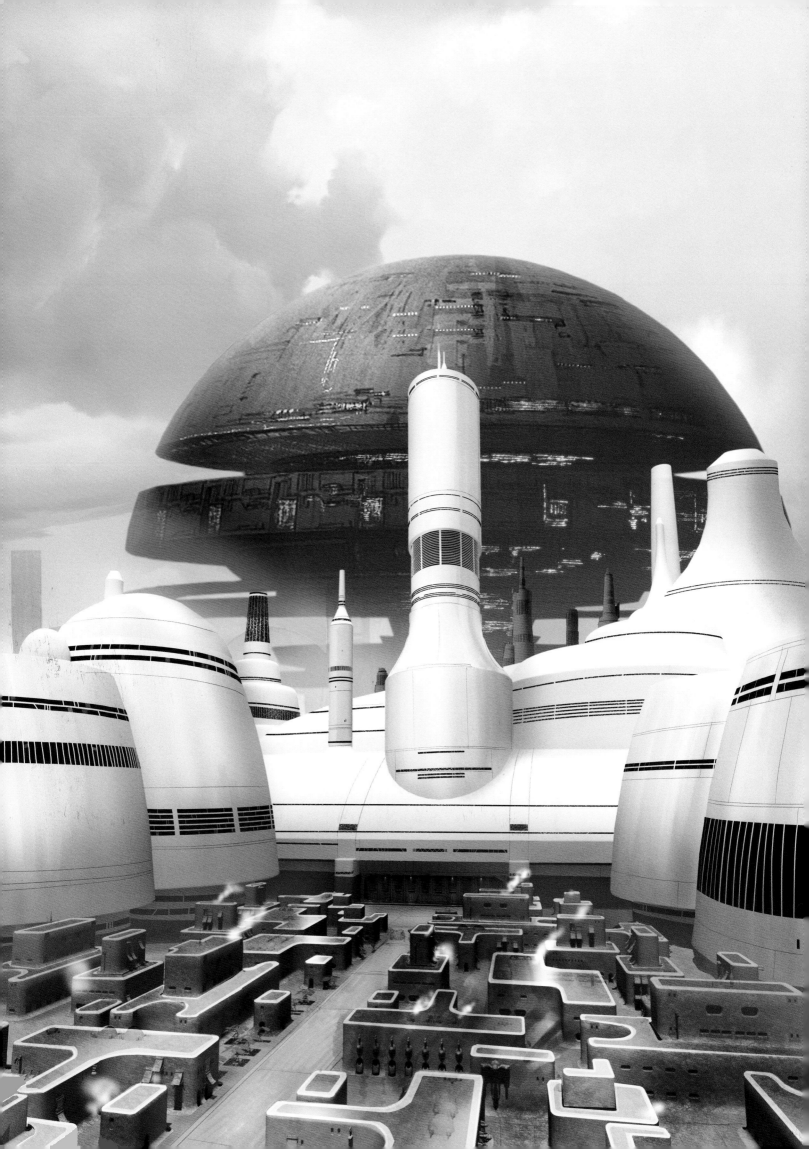

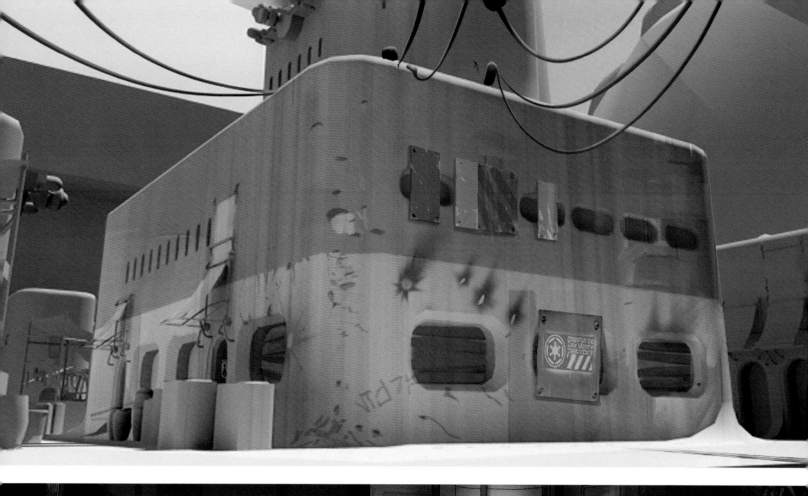

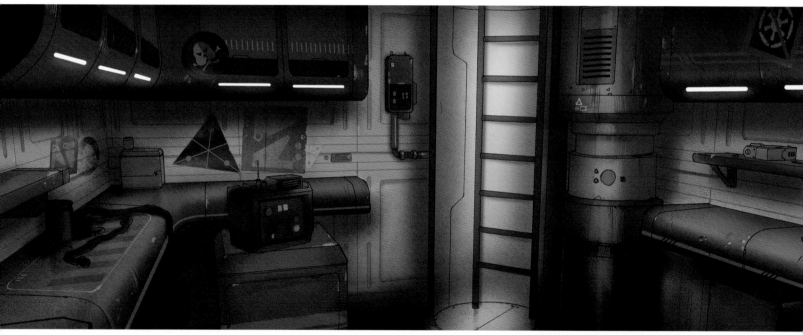

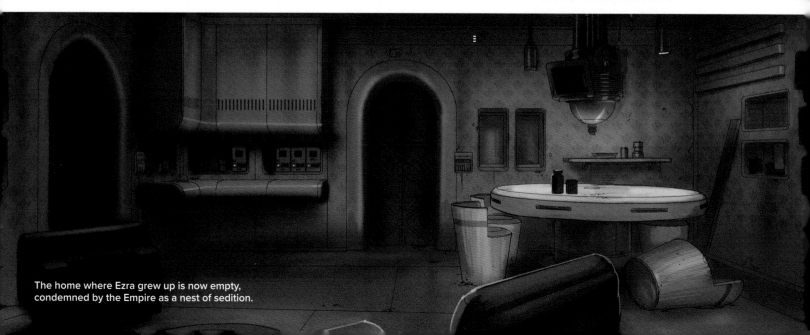

The home where Ezra grew up is now empty, condemned by the Empire as a nest of sedition.

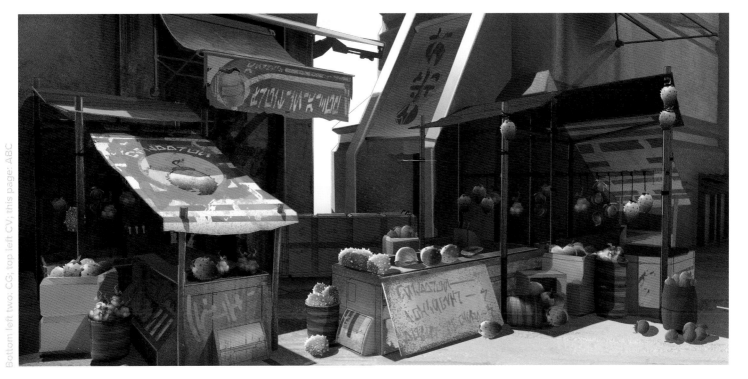

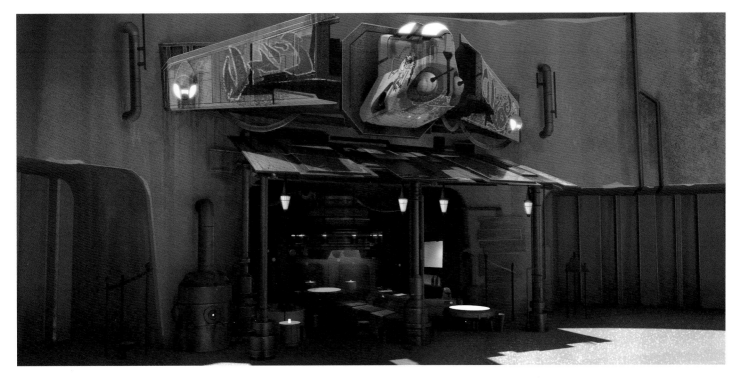

Lothal's street markets sell imported meiloorun fruit.

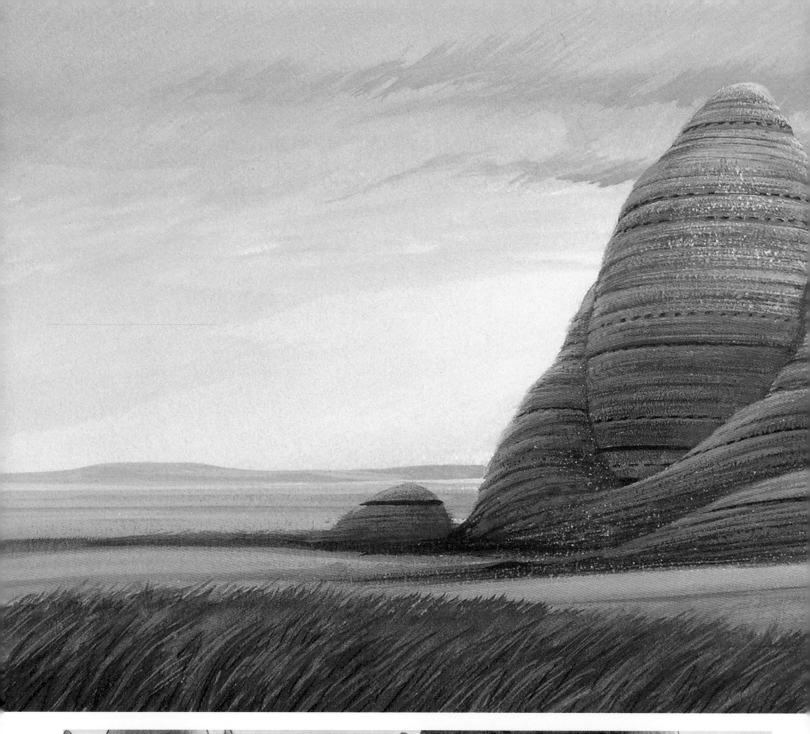

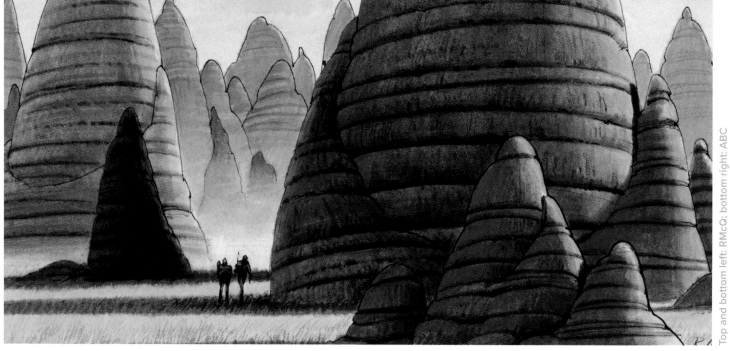

Top and bottom left: RMcQ; bottom right: ABC

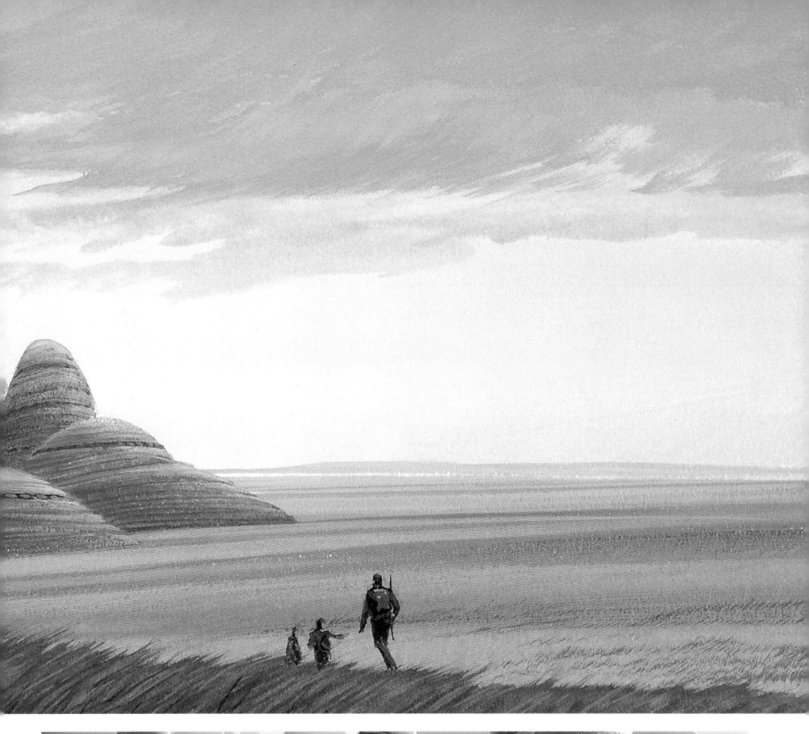

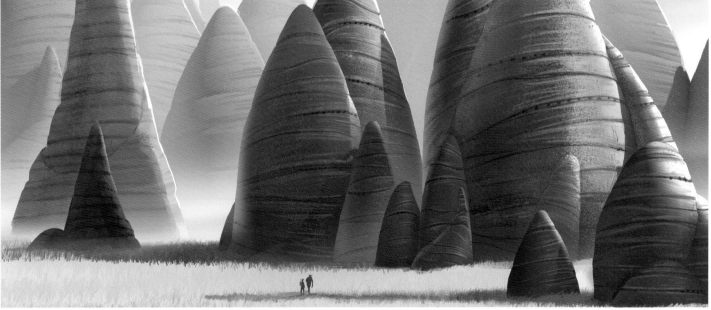

The sweep of Lothal's sweeping rural environs stress the dignity of open, undeveloped space. Ralph McQuarrie's inspiration shines through in these striated rock formations.

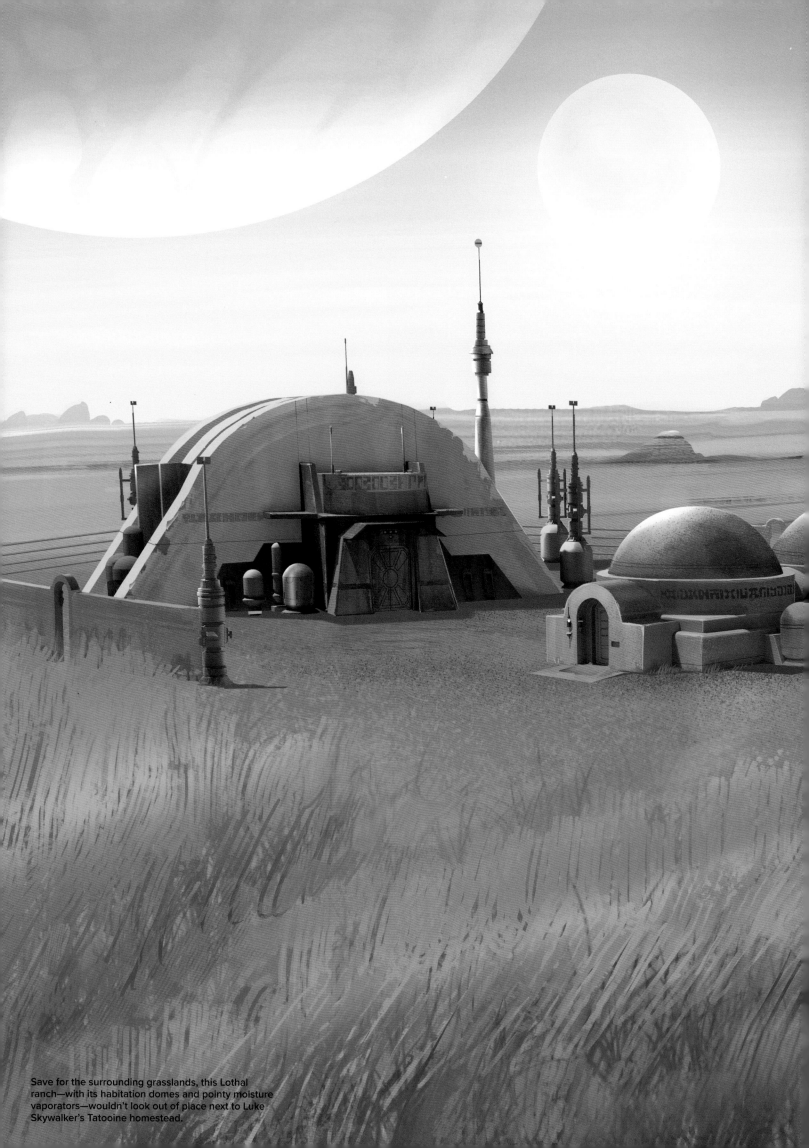

Save for the surrounding grasslands, this Lothal ranch—with its habitation domes and pointy moisture vaporators—wouldn't look out of place next to Luke Skywalker's Tatooine homestead.

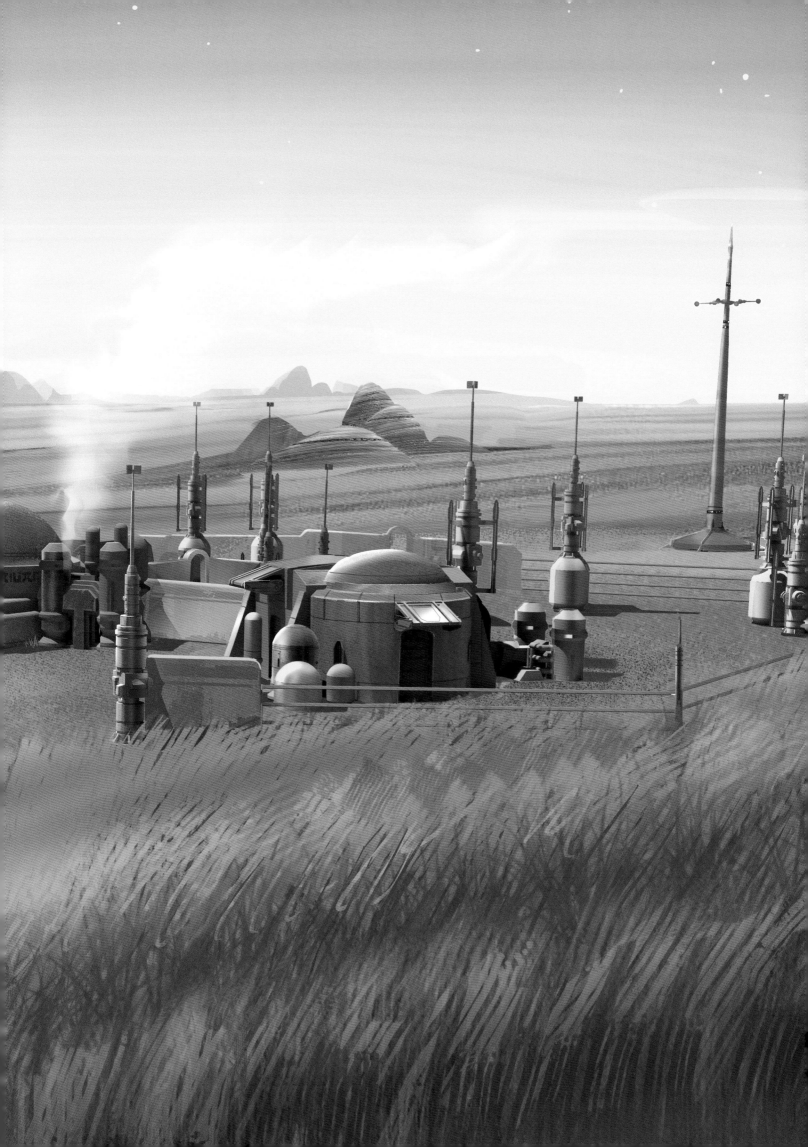

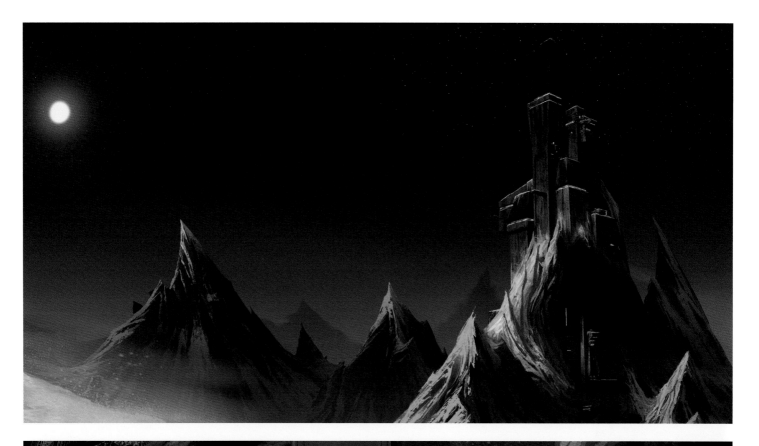

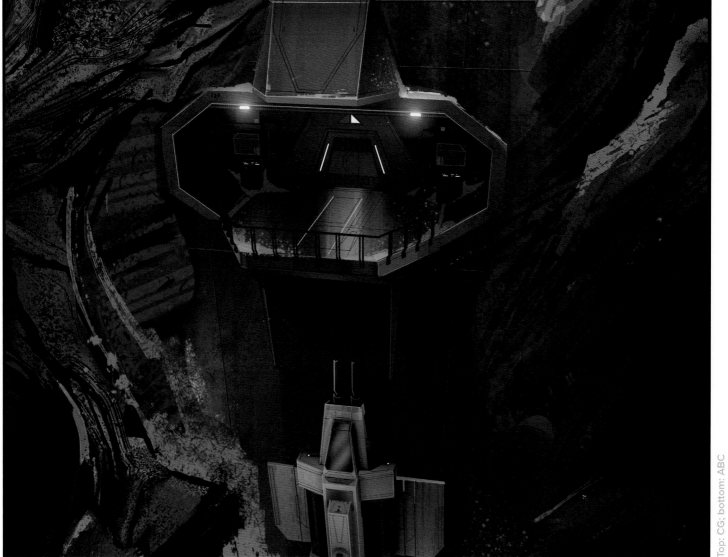

The Spire on Stygeon Prime is an unadorned and unforgiving Imperial prison. Says Plunkett, "The Spire was inspired by McQuarrie's designs for Darth Vader's castle developed for, but unused in, *Return of the Jedi*."

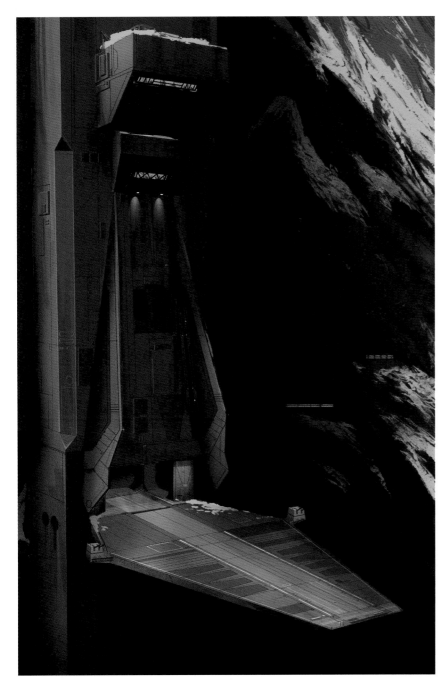

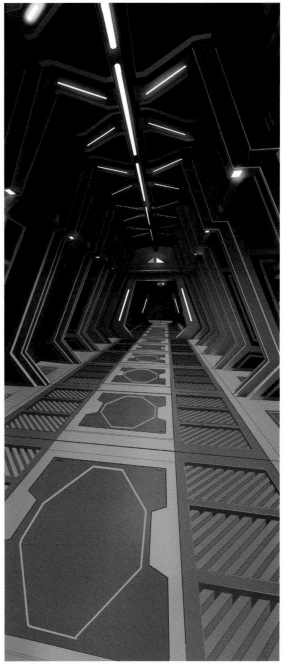

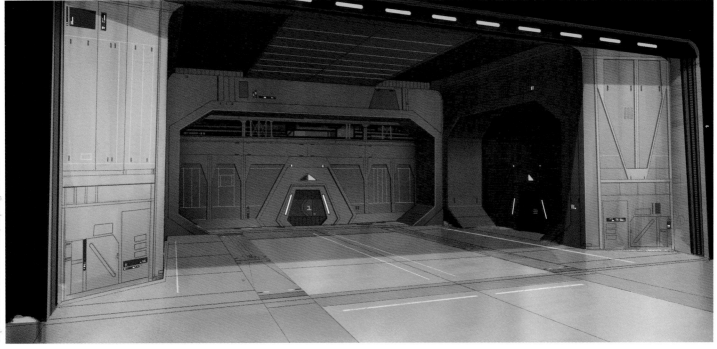

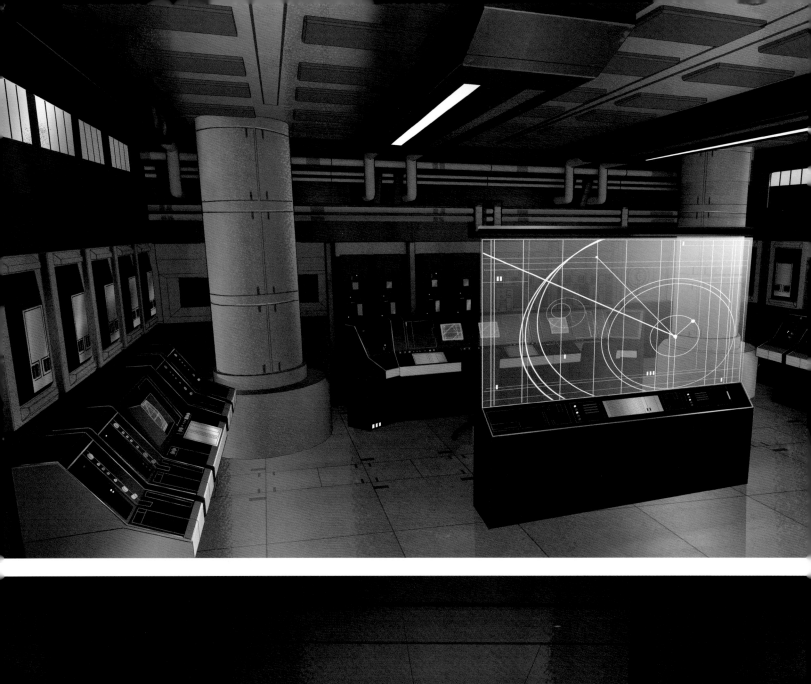
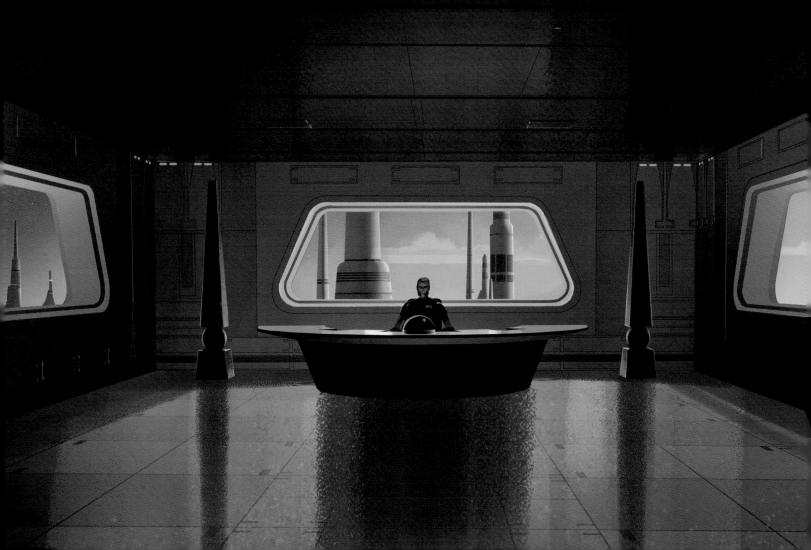

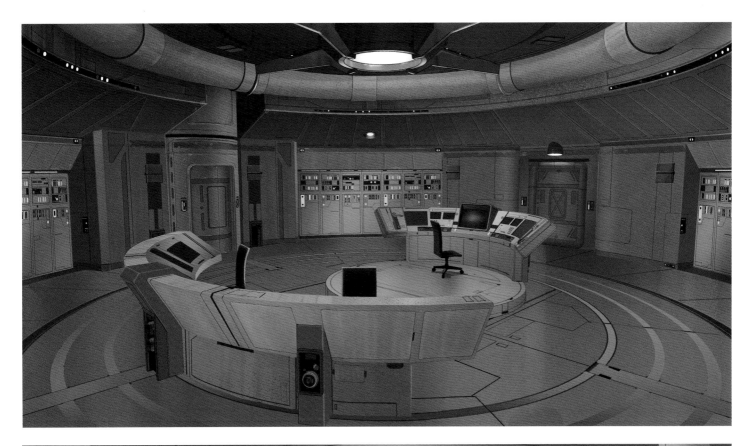

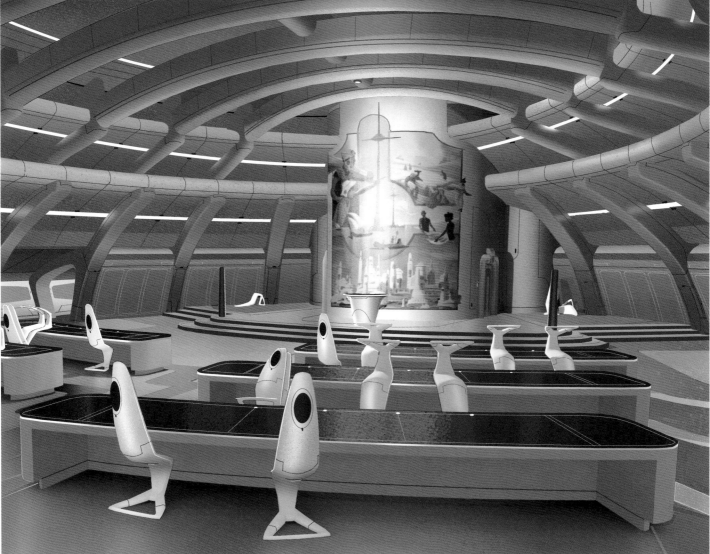

These interiors of Lothal's Imperial HQ depict a control room and Agent Kallus's office. At right are the Lothal Senate Chambers, an environment redressed from a different set created for use on *Star Wars: The Clone Wars*.

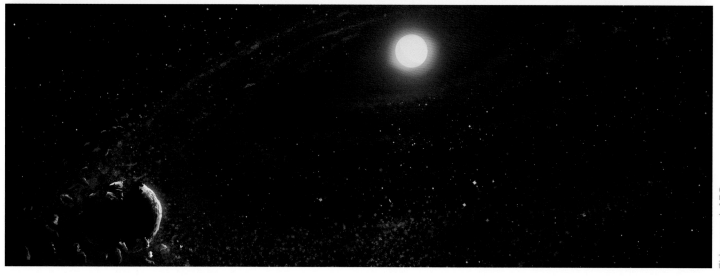

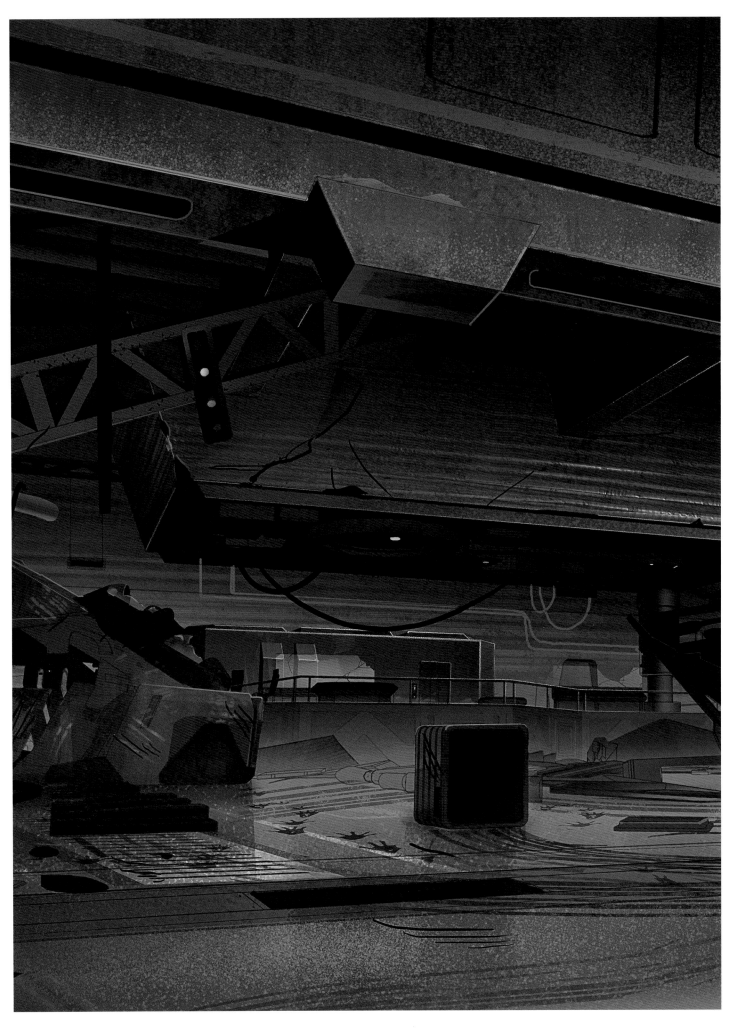

The original environment was ultimately used in the season of *The Clone Wars* that aired on Disney+ in 2020.

PROPS
꒤ㄷ꒛ㄷㄷ꒤

"In season one, time was of the essence," says Kilian Plunkett, addressing the crew's decision to repaint existing prop assets from *Star Wars: The Clone Wars*. "To mimic the hallmarks of Ralph McQuarrie's painting style, Andre Kirk created a set of digital paintbrushes including chalk, a pencil line, an airbrush spatter, and a soft watercolor wash. This way, crates and blasters could literally be given a fresh coat of paint before they reappeared on screen."

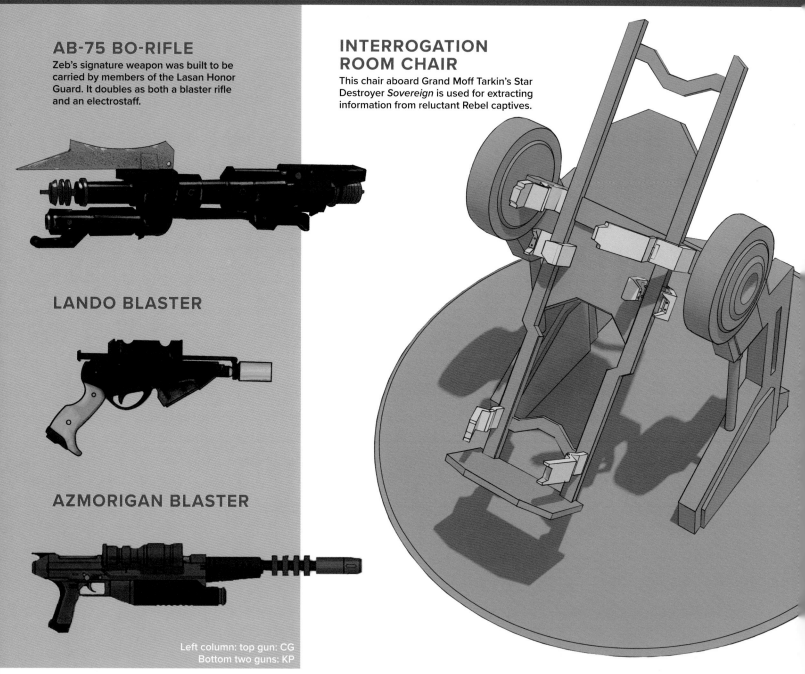

AB-75 BO-RIFLE
Zeb's signature weapon was built to be carried by members of the Lasan Honor Guard. It doubles as both a blaster rifle and an electrostaff.

LANDO BLASTER

AZMORIGAN BLASTER

Left column: top gun: CG
Bottom two guns: KP

INTERROGATION ROOM CHAIR
This chair aboard Grand Moff Tarkin's Star Destroyer *Sovereign* is used for extracting information from reluctant Rebel captives.

Above: GJ; bottom: ABC

BO-RIFLE

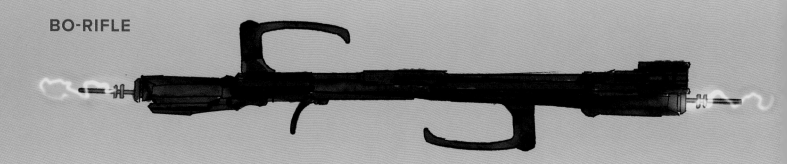

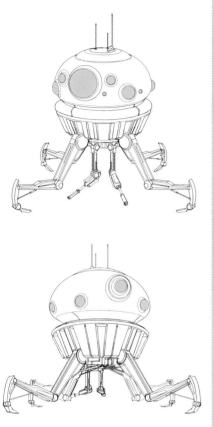

IMPERIAL PROBE DROID

Thanks to their eavesdropping hardware, the Empire's Arakyd Viper probe droids are cunning spies.

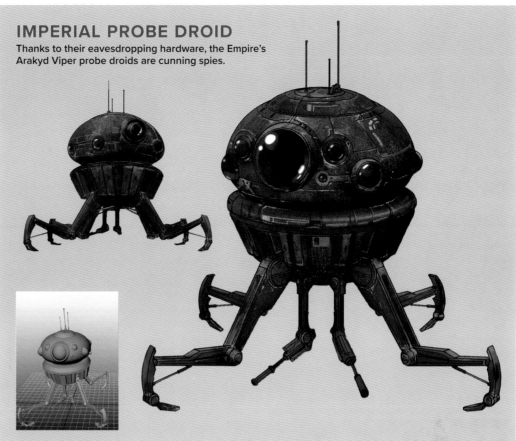

IT-0 INTERROGATION DROID

First seen in *A New Hope*, the Imperial interrogation droid hovers on antigravity repulsorlifts and brandishes a sharp syringe.

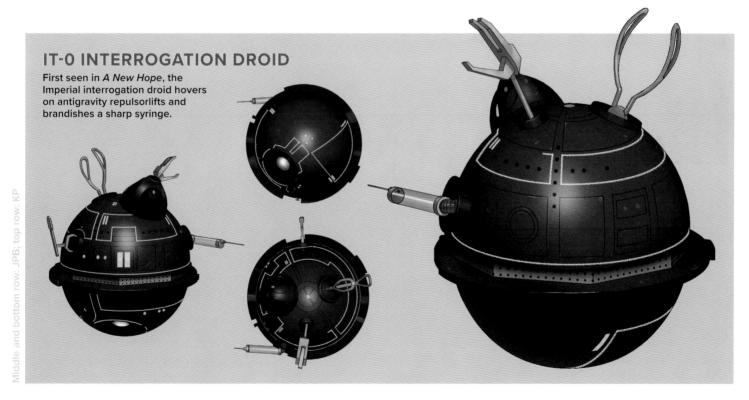

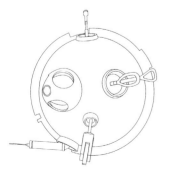
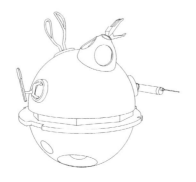
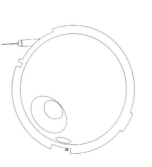
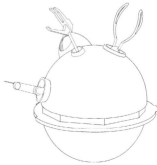

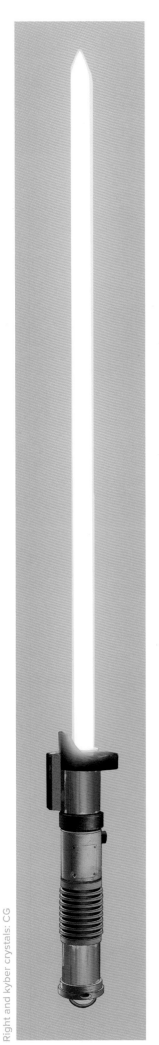

LIGHTSABERS

In this era, the Jedi are all but extinct. Nevertheless, Kanan and Ezra do their part to stoke the fire. Ezra's hybrid saber (*at bottom left*) combines the functions of a lightsaber and a blaster.

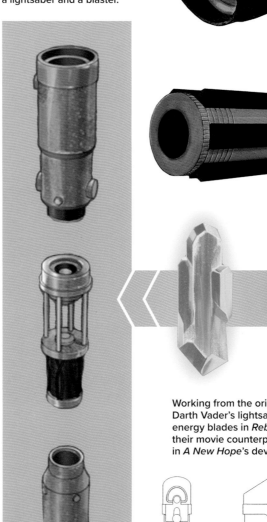

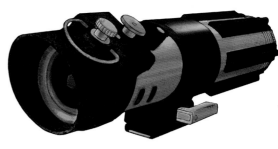

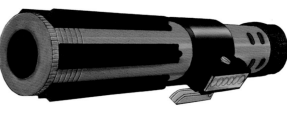

Working from the original prop, *Rebels* artists redesigned Darth Vader's lightsaber for animation. The lightsaber energy blades in *Rebels* appear thinner and sharper than their movie counterparts, reflecting a concept from early in *A New Hope*'s development.

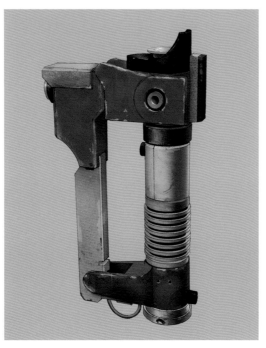

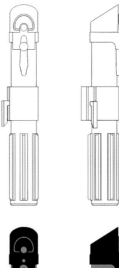

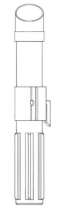

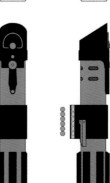

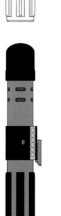

Above: KP

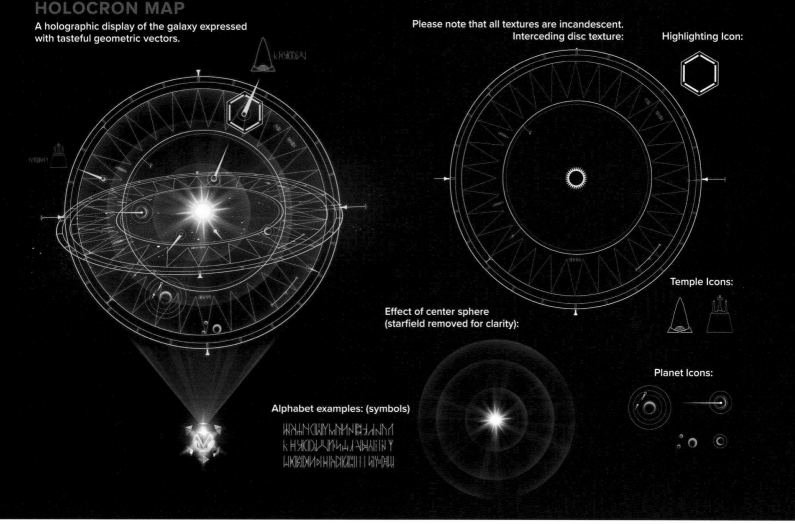

HOLOCRON MAP

A holographic display of the galaxy expressed with tasteful geometric vectors.

Please note that all textures are incandescent.

Interceding disc texture:

Highlighting Icon:

Effect of center sphere (starfield removed for clarity):

Temple Icons:

Planet Icons:

Alphabet examples: (symbols)

Top: CG; bottom: ABC

DATA SPIKE

These circuit-packed shortcuts allow users (and droids) to bypass computer security safeguards. A data spike similar to these can also be seen in season one of *The Mandalorian*.

AHSOKA'S LIGHTSABERS

In this era, Clone Wars survivor Ahsoka Tano carries twin white-bladed lightsabers with gently curving hilts.

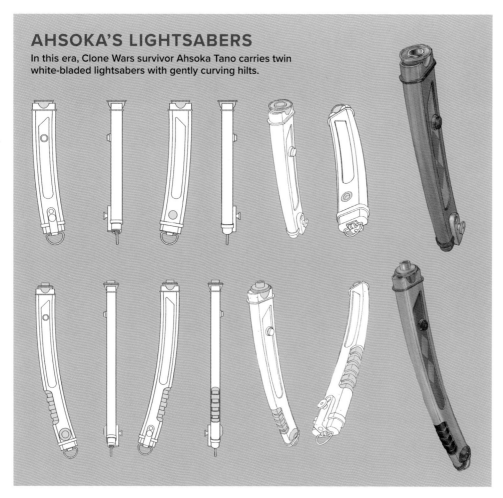

RHYDONIUM CANISTER

A highly explosive starship fuel, rhydonium was stored by the barrel inside the abandoned Fort Anaxes.

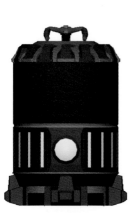

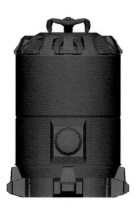

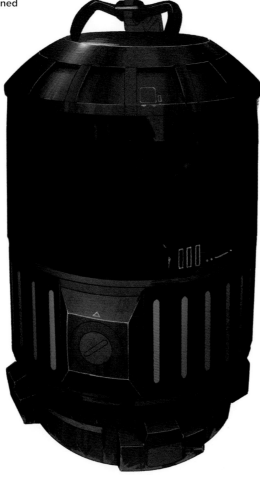

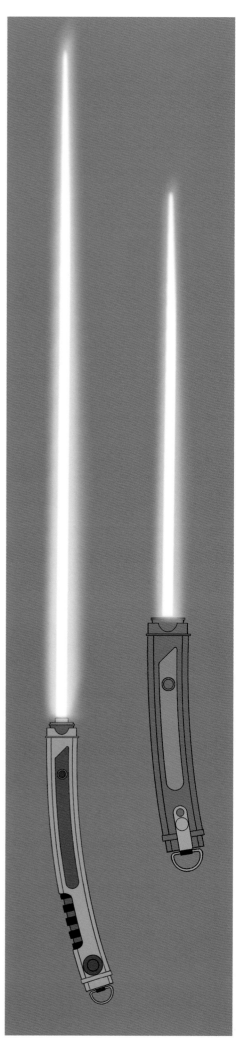

Top left, right column: KP; left bottom: AK

HELMETS

Sabine's helmet is painted in purple and pink, and bears "eye" markings common to the elite Nite Owls of the Mandalorian Death Watch.

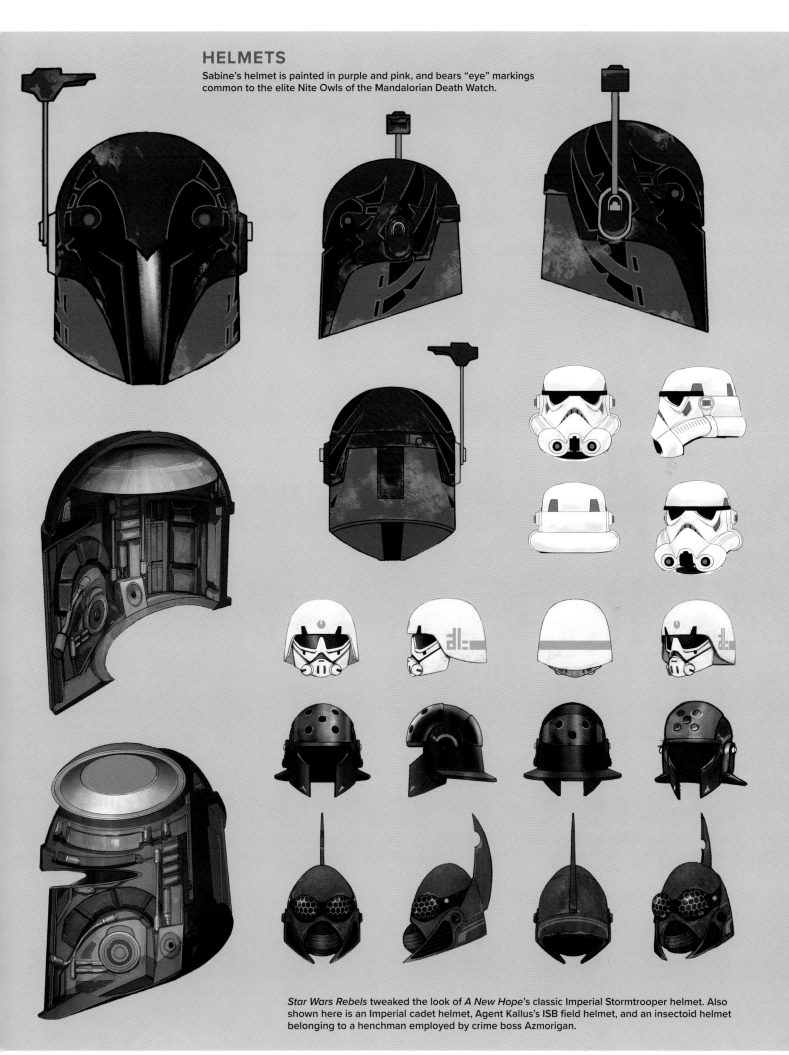

Star Wars Rebels tweaked the look of *A New Hope*'s classic Imperial Stormtrooper helmet. Also shown here is an Imperial cadet helmet, Agent Kallus's ISB field helmet, and an insectoid helmet belonging to a henchman employed by crime boss Azmorigan.

Second to last row of helmets: ABC; all other art this page: KP

This environmental study establishes the entrance hallway of the Lothal Jedi temple. The monks seen below are long dead, but that won't deter the Lothal Rebels from continuing their training.

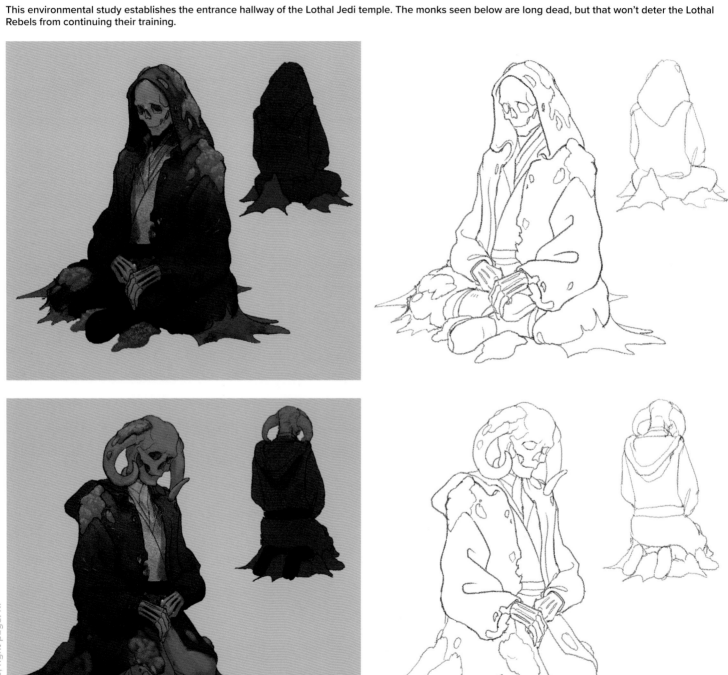

This page: CG; right page: KP

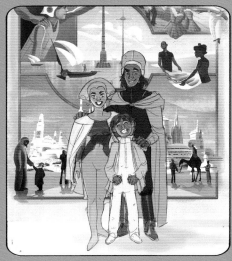
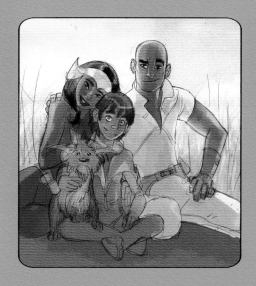
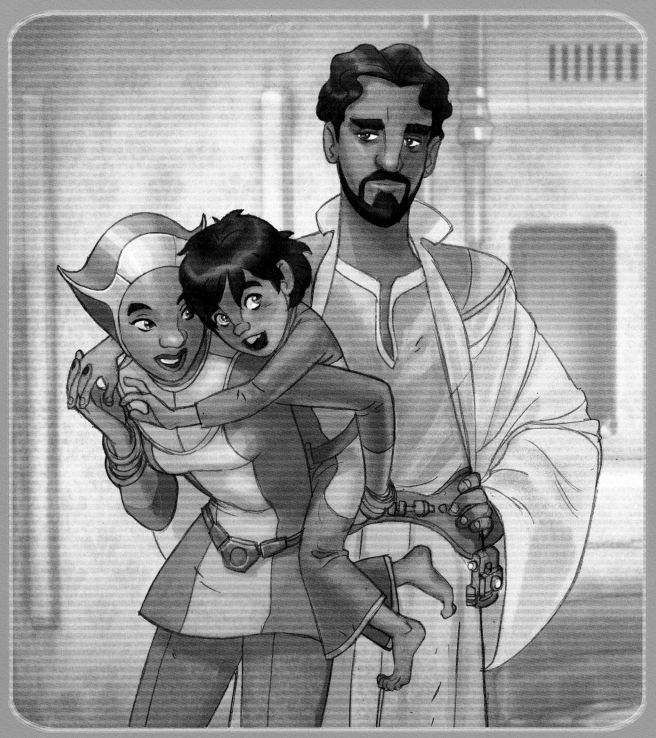

Ezra is seen here as a boy, accompanied by his parents Ephraim and Mira. These images were composed as if they represented family snapshots.

"Ships from the original film trilogy often used one or two simple geometric shapes for their overall form," art director Kilian Plunkett points out. The vehicles in *Rebels* followed similarly straightforward rules.

GHOST

The *Ghost* isn't just a ship, it's also a home. Serving as the Lothal Rebels' mobile HQ, the *Ghost* evokes the *Millennium Falcon* while presenting several design innovations. "Our direction was that the *Ghost* feels like a B-17 bomber, with its cockpit set above the nose gun," explains Plunkett. "When we combined that with a simple diamond shape, it led to the final design."

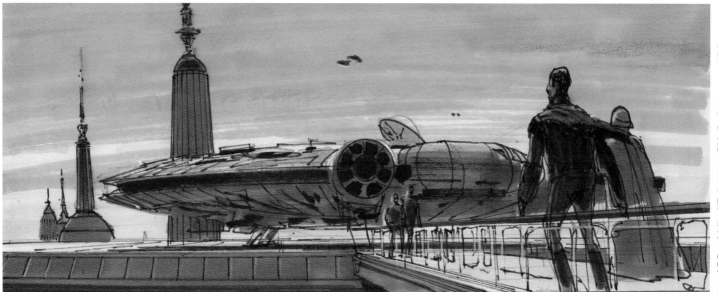

The exterior hallmarks of the *Ghost*, in particular its paneled cockpit screens and battleship hull plating, echo Ralph McQuarrie's depictions of the *Millennium Falcon* for the classic trilogy.

Top: ABC; middle: KP; bottom: RMcQ; right page: ABC

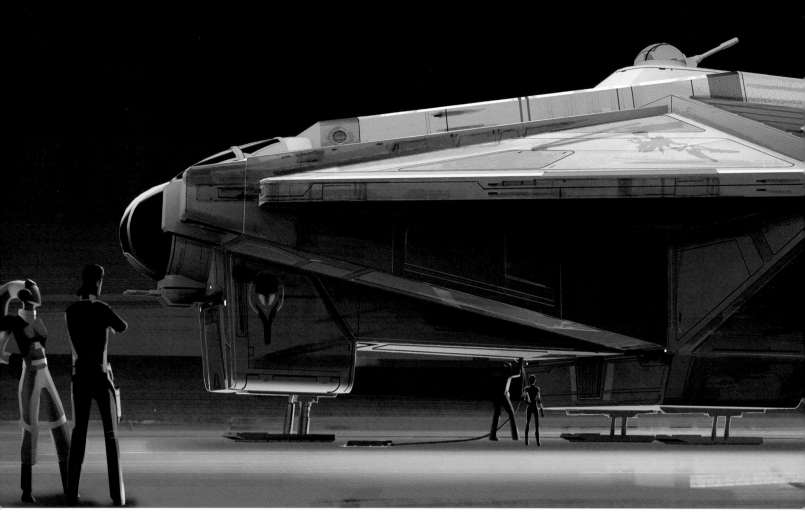

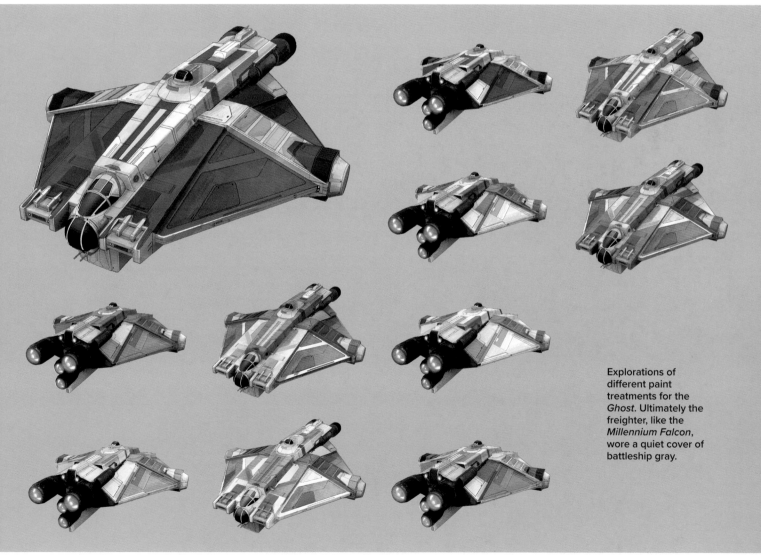

Explorations of different paint treatments for the *Ghost*. Ultimately the freighter, like the *Millennium Falcon*, wore a quiet cover of battleship gray.

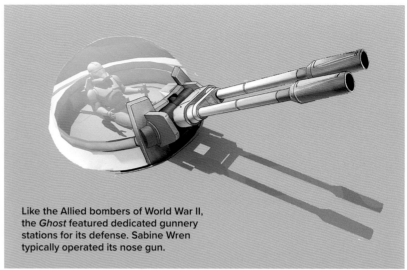

Like the Allied bombers of World War II, the *Ghost* featured dedicated gunnery stations for its defense. Sabine Wren typically operated its nose gun.

Top left: KP
All other art this spread: ABC

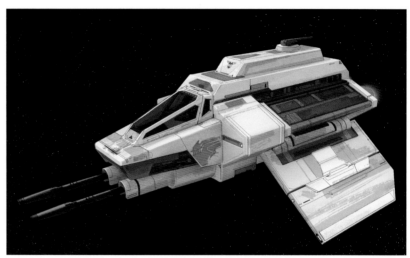

The *Phantom* is the *Ghost*'s clip-on starfighter and shuttlecraft. Says Plunkett, "We hadn't really seen a ship in *Star Wars* with a detachable fighter, so the idea of a smaller ship was there from very early on."

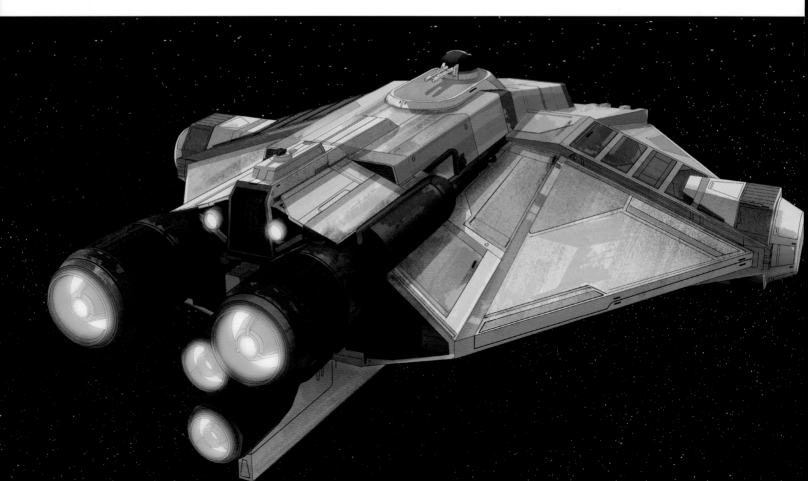

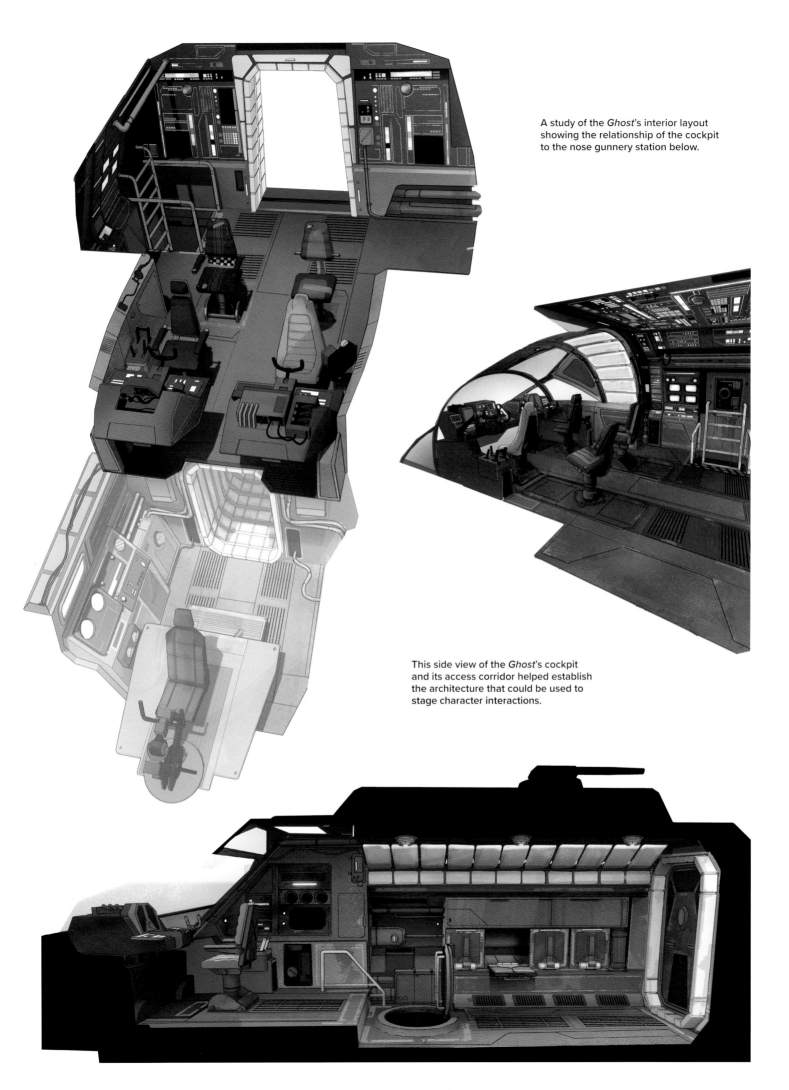

A study of the *Ghost*'s interior layout showing the relationship of the cockpit to the nose gunnery station below.

This side view of the *Ghost*'s cockpit and its access corridor helped establish the architecture that could be used to stage character interactions.

IMPERIAL STAR DESTROYER

The Imperial Navy's wedge-shaped Star Destroyer, one of the most famous starships in science fiction, is a powerhouse combining lethal turbolaser batteries and speedy sublight engines.

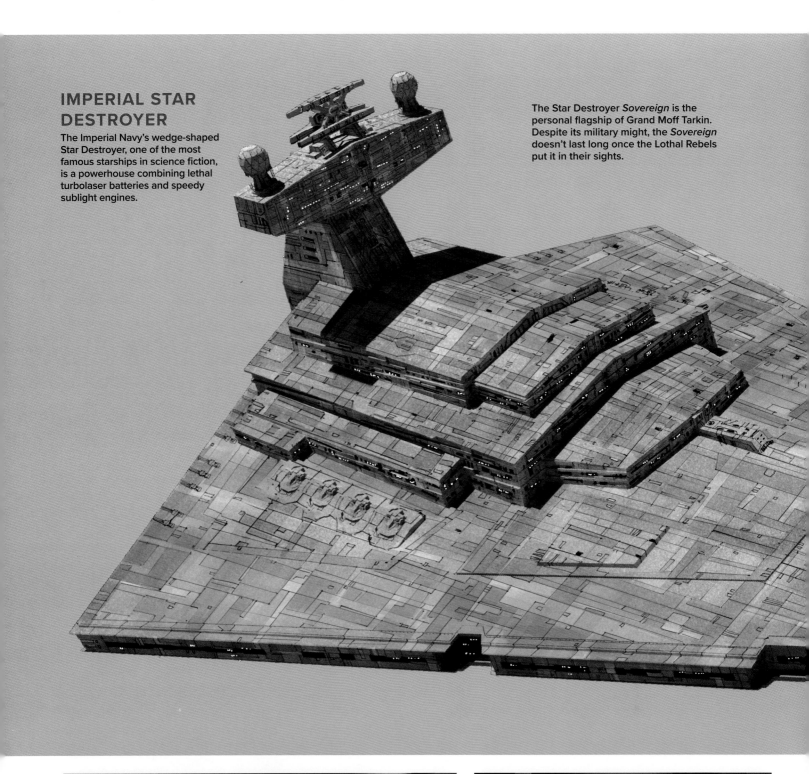

The Star Destroyer *Sovereign* is the personal flagship of Grand Moff Tarkin. Despite its military might, the *Sovereign* doesn't last long once the Lothal Rebels put it in their sights.

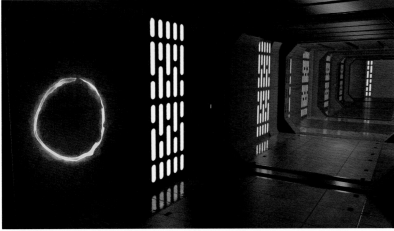

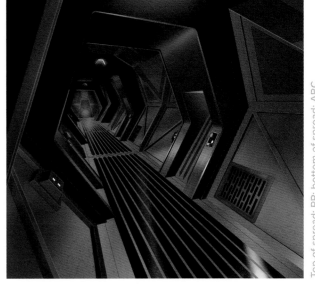

These views (*above and right*) depict a Star Destroyer corridor, a brig, and an interrogation chamber. The glowing ring (*above*) is a result of Ezra cutting through the wall with his lightsaber, as seen in the season one finale.

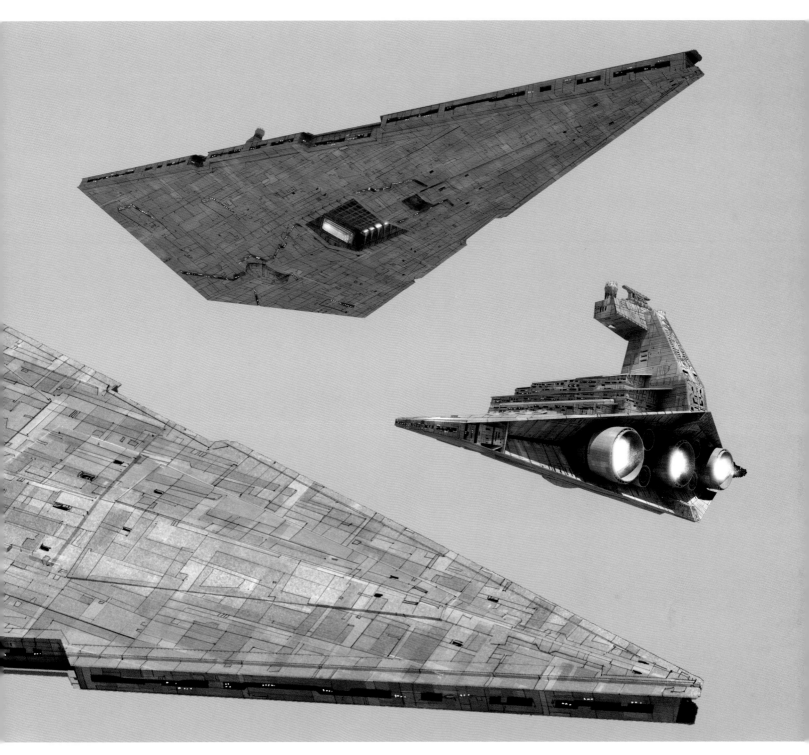

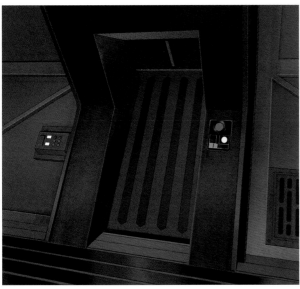

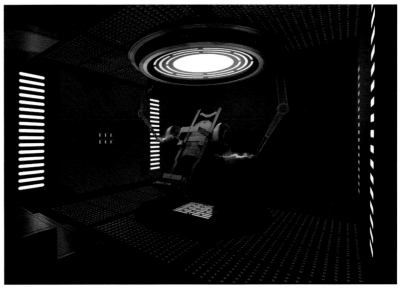

IMPERIAL SHUTTLE

The *Sentinel*-class landing craft shares the same folding-wing design as the Imperial shuttle and can carry dozens of Stormtroopers into battle. The craft is heavily shielded and can retaliate against attackers with laser cannons, ion turrets, and concussion missiles.

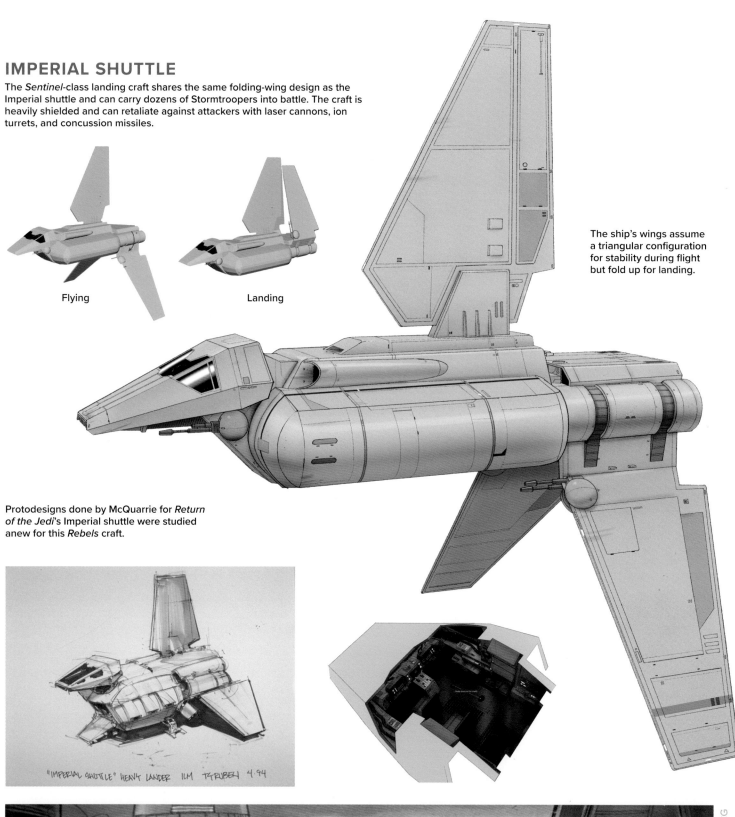

Flying

Landing

The ship's wings assume a triangular configuration for stability during flight but fold up for landing.

Protodesigns done by McQuarrie for *Return of the Jedi*'s Imperial shuttle were studied anew for this *Rebels* craft.

"IMPERIAL SHUTTLE" HEAVY LANDER ILM TJ RUBEN 4.94

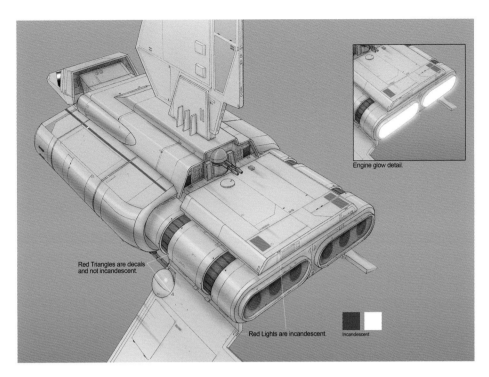

Red Triangles are decals
and not incandescent.

Red Lights are incandescent.

Incandescent

Engine glow detail.

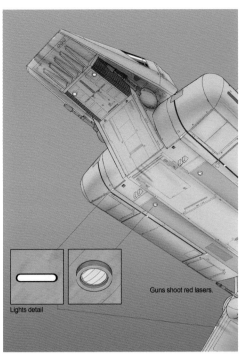

Lights detail

Guns shoot red lasers.

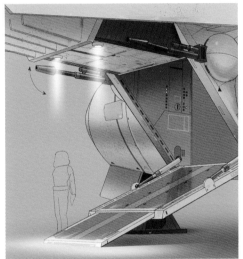

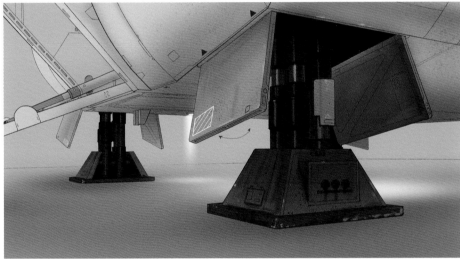

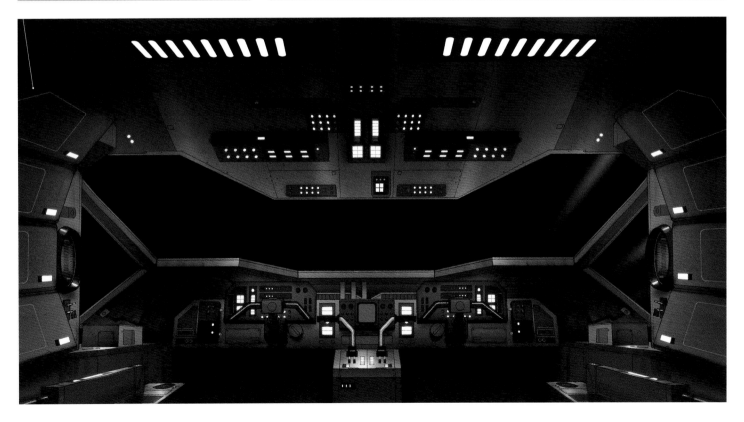

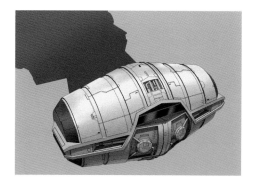

TANTIVE IV

As a CR90 Corellian corvette, the *Tantive IV* isn't too different from other ships of its class —but pop culture will never forget the first *Star Wars* ship to zoom across theater screens in *A New Hope*. The *Tantive IV* is owned by Alderaan's royal family and counts C-3PO and R2-D2 among its passengers.

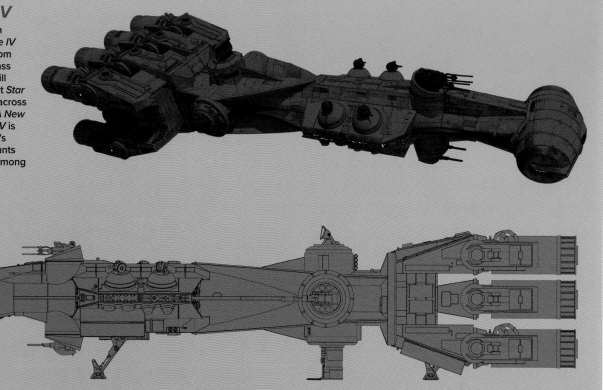

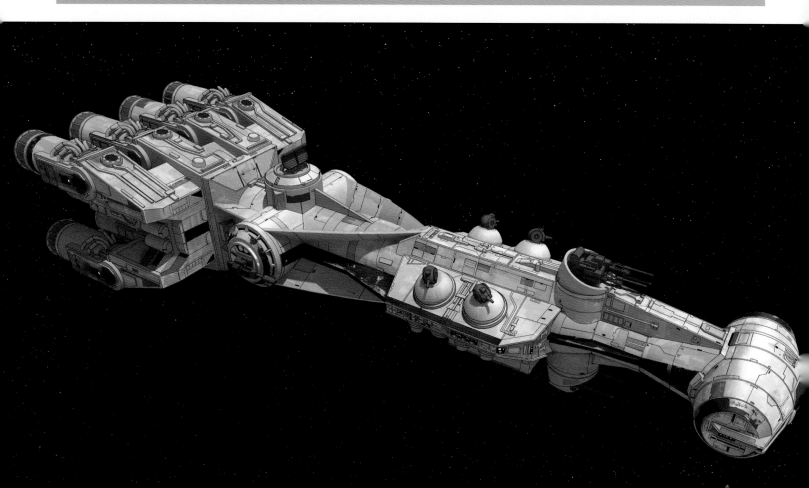

TIE FIGHTER

The TIE fighters in *Star Wars Rebels* possess stubbier wings and simpler exteriors. "By drawing on retro influences, we arrived at a 'shape language' that fit our simpler, smoother take [for the series]," explains Plunkett.

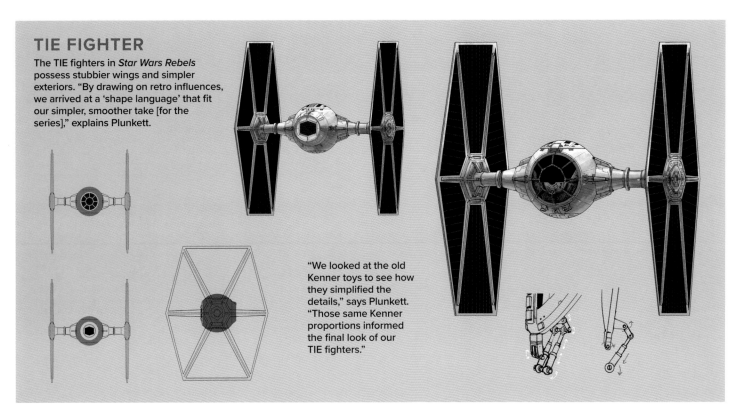

"We looked at the old Kenner toys to see how they simplified the details," says Plunkett. "Those same Kenner proportions informed the final look of our TIE fighters."

PAINTED TIE FIGHTER

Sabine leaves her mark on every monochrome Imperial installation she passes, and this TIE was no exception. The bright gradations on each wing panel and the checkerboard pattern on both struts make this TIE truly one of a kind.

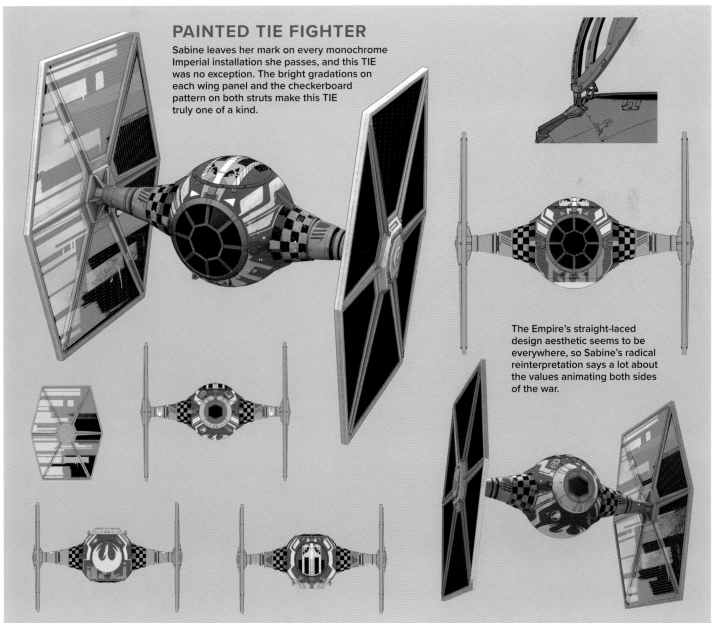

The Empire's straight-laced design aesthetic seems to be everywhere, so Sabine's radical reinterpretation says a lot about the values animating both sides of the war.

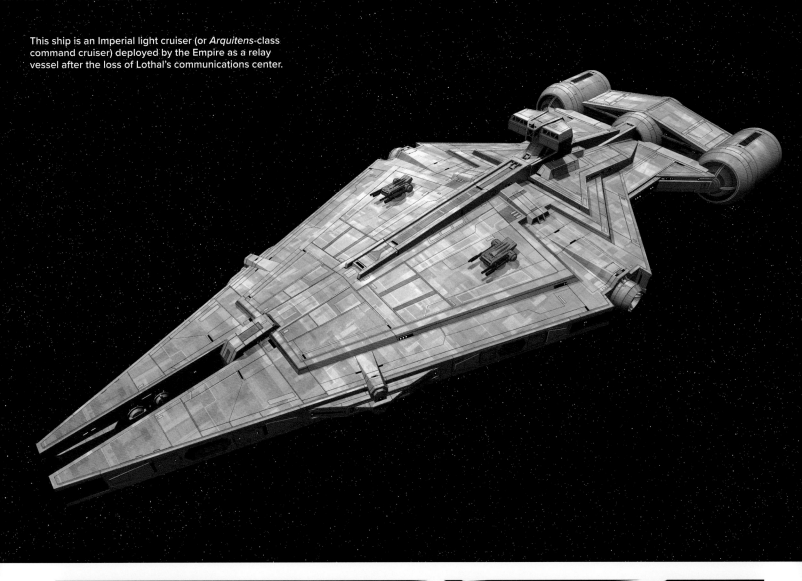

This ship is an Imperial light cruiser (or *Arquitens*-class command cruiser) deployed by the Empire as a relay vessel after the loss of Lothal's communications center.

Various views of the command cruiser's bridge, including its control stations (*above*).

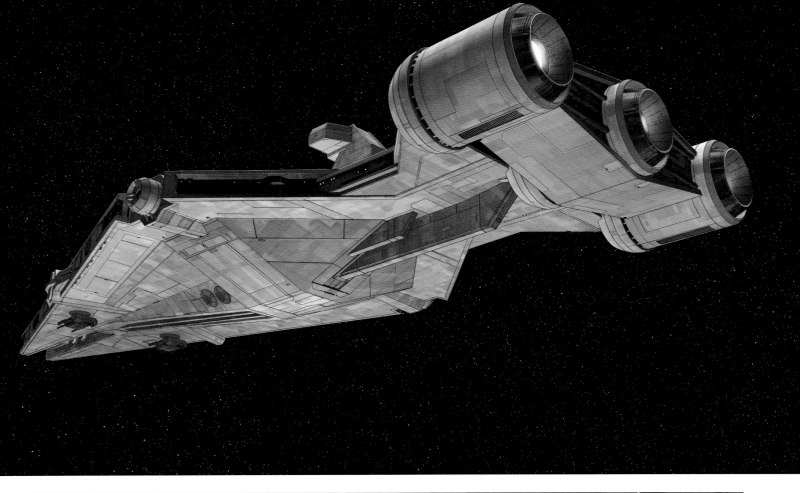

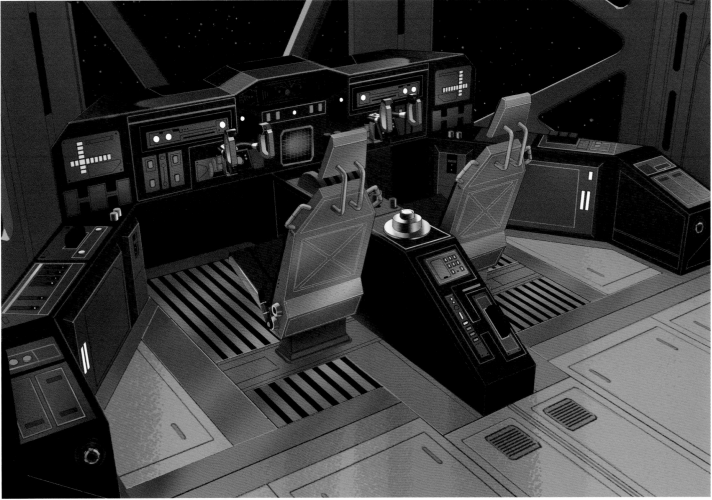

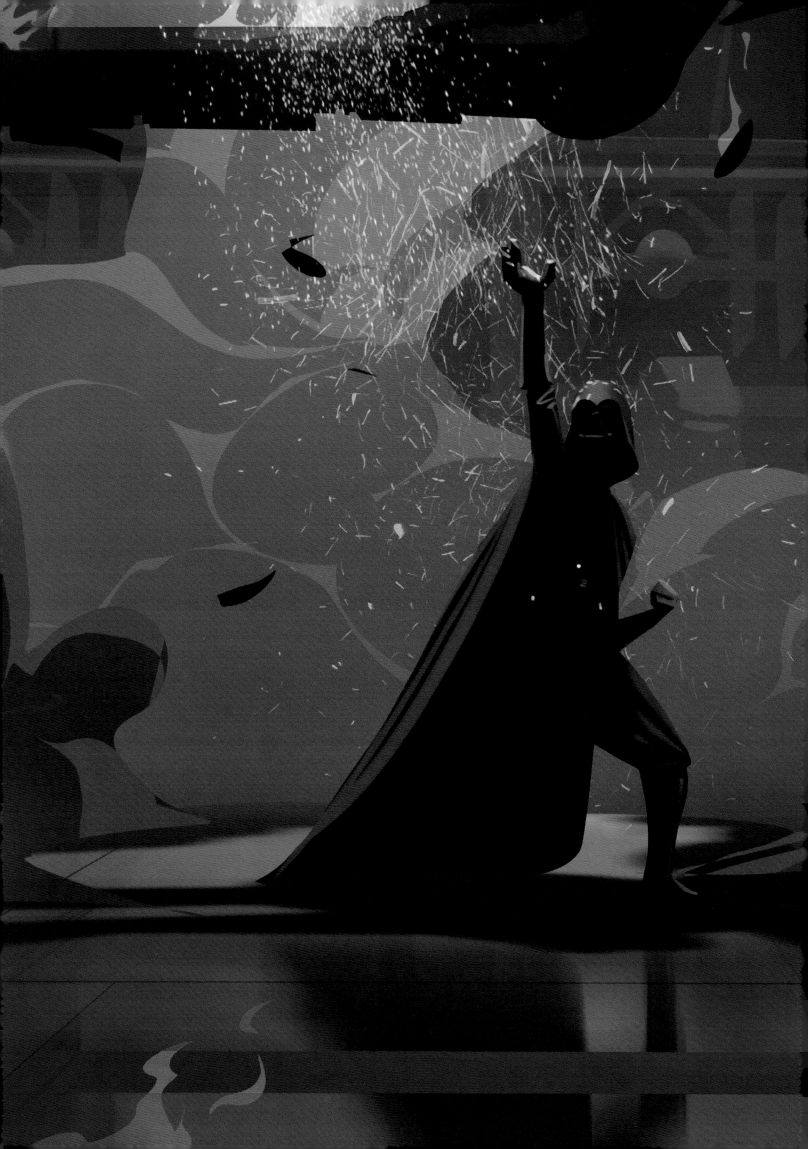

SEASON TWO

FUTURE OF
THE FORCE

꒯ꆆ꒦ꄱ꒦ꆆ꒦ꄱꑒ ꆆꄱ ꒦ꑭꑒꄱ ꒯ꆆ꒦ꑭꆆꄱ

The *Star Wars* films took on a foreboding edge when *A New Hope*'s triumph transitioned into the murkier events of *The Empire Strikes Back*. The second season of *Star Wars Rebels* achieved a similar effect, forcing its core cast members to abandon familiar Lothal in search of new shelter. Darth Vader reclaimed his mantle as the saga's most-feared villain while figures from *Star Wars: The Clone Wars* popped up as older, wiser versions of themselves. Season two brings the Lothal Rebels into a vast galactic movement, which only causes their antagonists to sharpen their knives and their focus.

The heroes of *Star Wars Rebels* have to improvise in season two as as they flee from Lothal while chased by merciless new pursuers. Fortunately, the Rebellion has taken notice of their local resistance cell. Old warriors like Ahsoka Tano and Captain Rex, aged up to reflect the time that has passed since *Star Wars: The Clone Wars*, join the cast and turn in star performances.

DARTH VADER

Black-armored Vader is a clear example of how *Star Wars Rebels* intentionally reworked the primordial designs of *Star Wars* artist Ralph McQuarrie. "Vader is a direct homage to the more insectoid look of McQuarrie's concept art, right down to the colors of the buttons on his chest," says Plunkett.

Previous spread: CV; left column: KP; right column: RMcQ

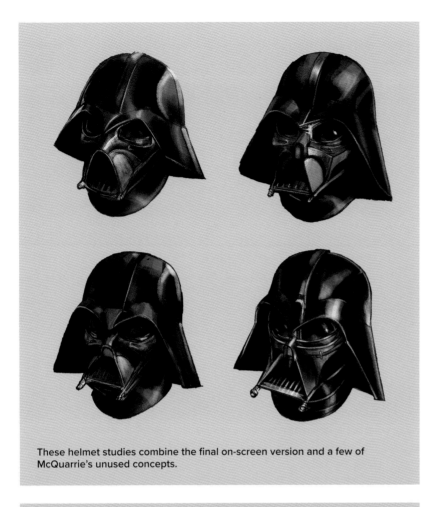

These helmet studies combine the final on-screen version and a few of McQuarrie's unused concepts.

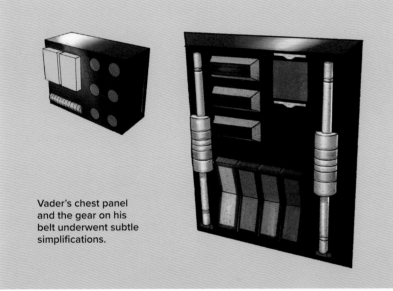

Vader's chest panel and the gear on his belt underwent subtle simplifications.

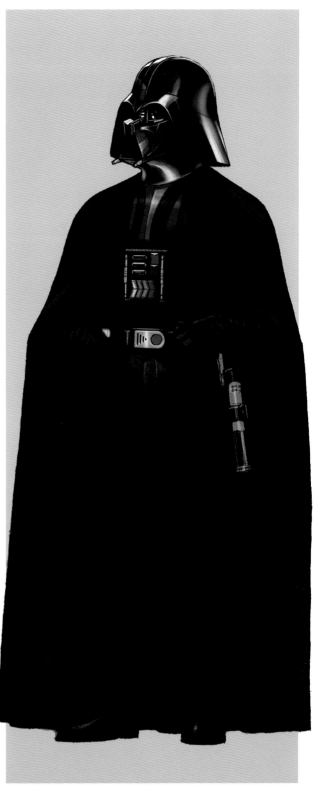

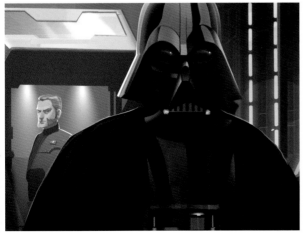

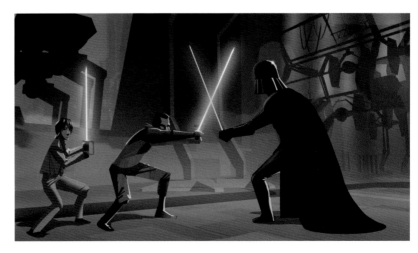

YODA

In this era, Yoda is sequestered on Dagobah, waiting for a new ally who can overthrow the Emperor. But the character plays a key role in *Star Wars Rebels* just the same, as he manifests in Force visions and guides Ezra along his spiritual path.

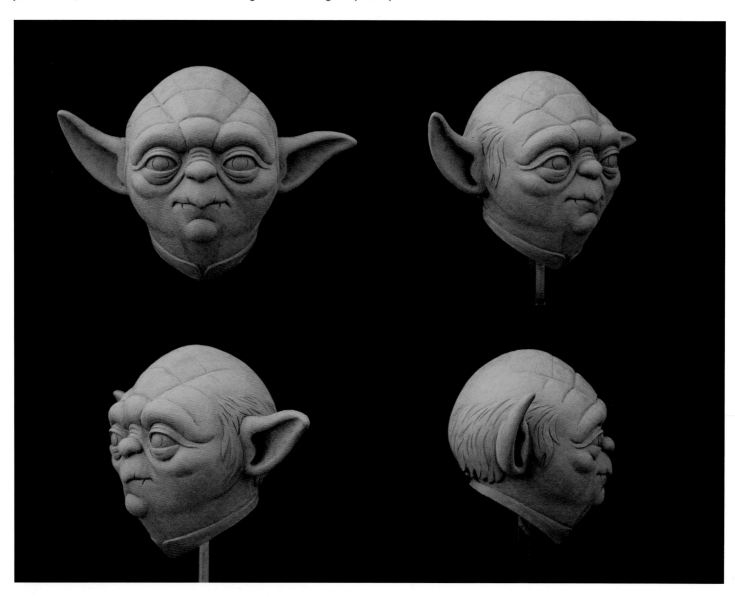

Yoda is one of very few characters in *Rebels* that wears loose, flowing clothing. Only characters that had appeared wearing capes or robes in the live-action *Star Wars* films were allocated time in the production schedule to animate their cloth. Unlike Obi-Wan or Darth Vader, however, Yoda's limited screen time called for a way to eliminate this step.

The solution was to have Yoda wear his robe but pose him seated on a log and keep his lower body static, so that the lower part of his robe would not move during his brief on-screen scenes. The drawing for this pose is seen here.

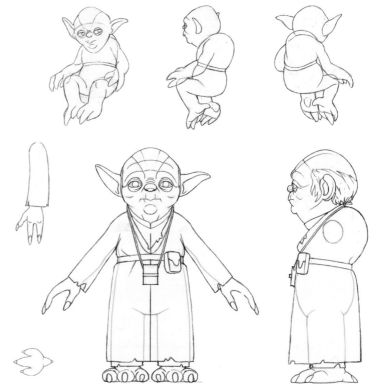

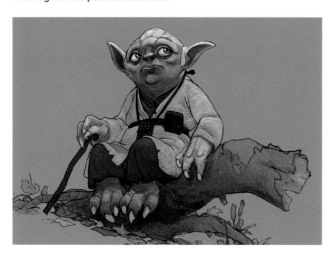

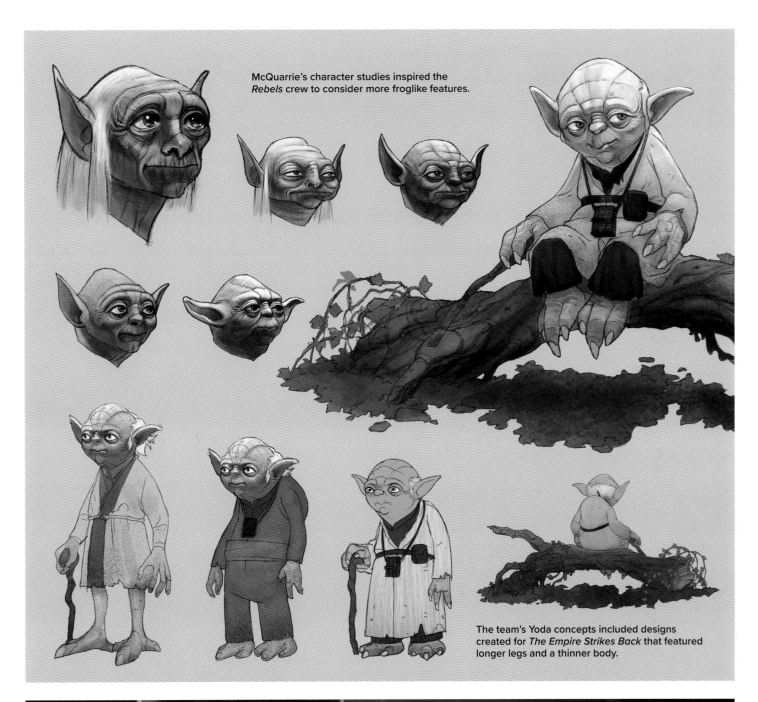

McQuarrie's character studies inspired the *Rebels* crew to consider more froglike features.

The team's Yoda concepts included designs created for *The Empire Strikes Back* that featured longer legs and a thinner body.

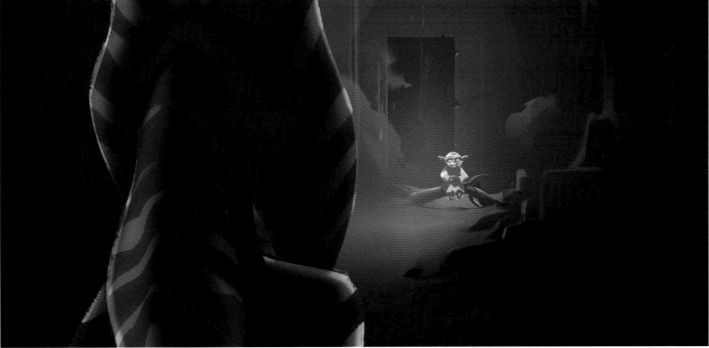

CAPTAIN REX

As one of the only clone troopers who disobeyed Order 66 and refused to turn against the Jedi, Captain Rex had had to go into exile for his own safety. When the *Rebels* heroes encounter the ex-officer on Seelos, Rex and his clone comrades Wolffe and Gregor are living aboard a six-legged walker.

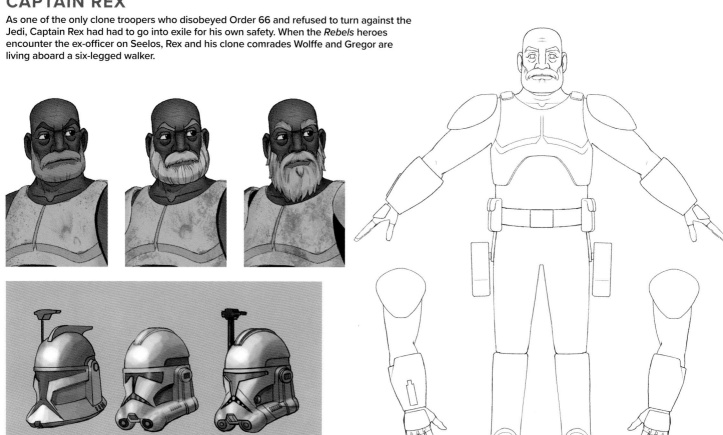

Above: Wayne Lo

Above: JPB

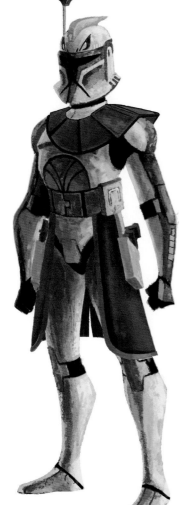

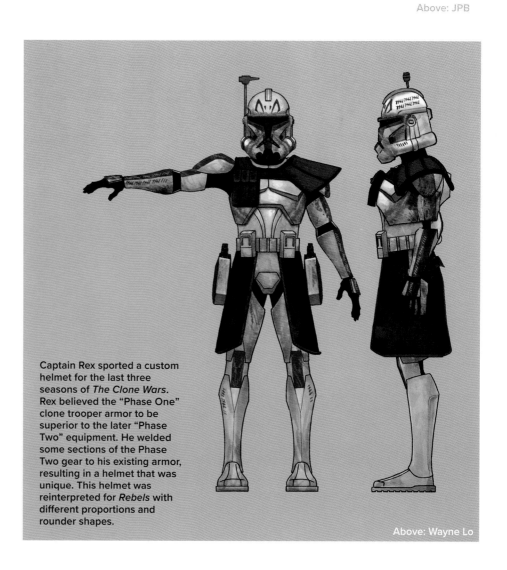

Captain Rex sported a custom helmet for the last three seasons of *The Clone Wars*. Rex believed the "Phase One" clone trooper armor to be superior to the later "Phase Two" equipment. He welded some sections of the Phase Two gear to his existing armor, resulting in a helmet that was unique. This helmet was reinterpreted for *Rebels* with different proportions and rounder shapes.

Above: Wayne Lo

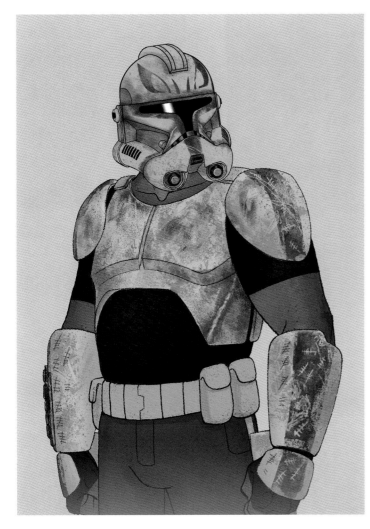

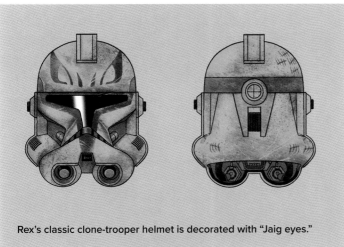

Rex's classic clone-trooper helmet is decorated with "Jaig eyes."

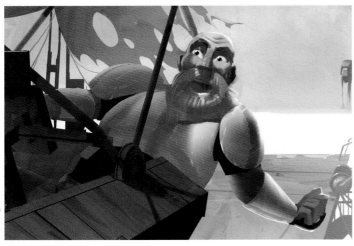

Top, right column: JPB; middle left: KP

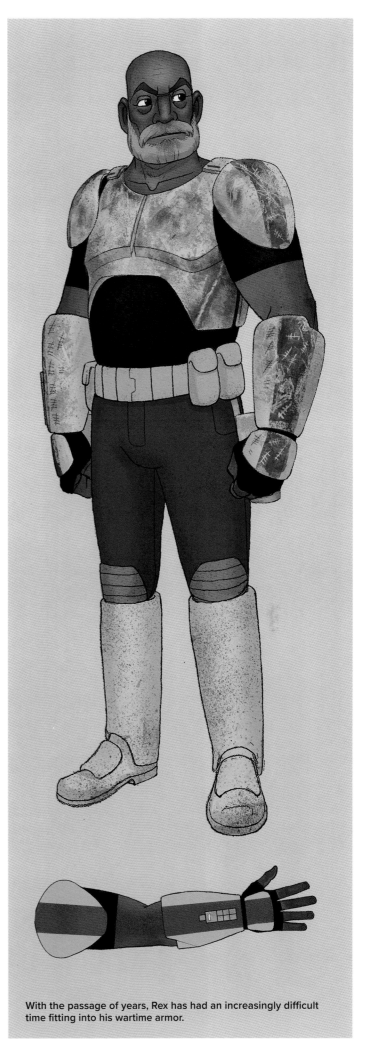

With the passage of years, Rex has had an increasingly difficult time fitting into his wartime armor.

AHSOKA TANO

Ahsoka is Anakin Skywalker's Jedi apprentice during *Star Wars: The Clone Wars*, but by the time of *Star Wars Rebels* she has truly come into her own. The character was slyly introduced via the mysterious "Fulcrum" persona before inviting the Lothal Rebels to join the galactic resistance against Imperial rule.

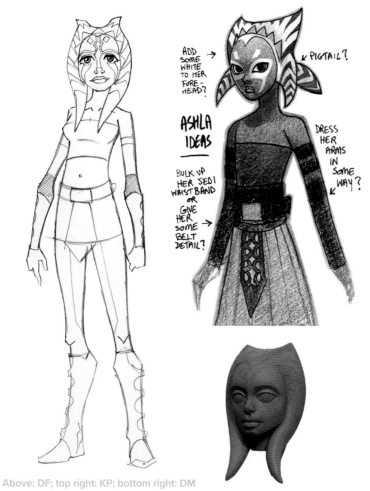

ADD SOME WHITE TO HER FOREHEAD? →

← PIGTAIL?

ASHLA IDEAS

BULK UP HER JEDI WAISTBAND OR GIVE HER SOME BELT DETAIL? →

DRESS HER ARMS IN SOME WAY?

Above: DF; top right: KP; bottom right: DM

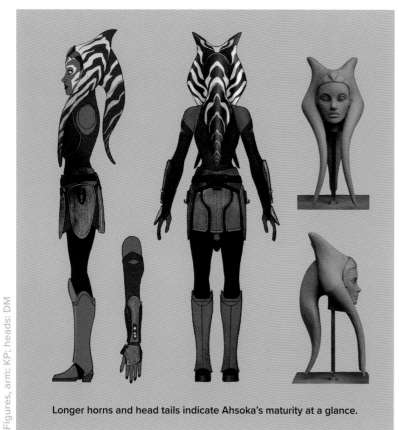

Longer horns and head tails indicate Ahsoka's maturity at a glance.

Figures, arm: KP; heads: DM

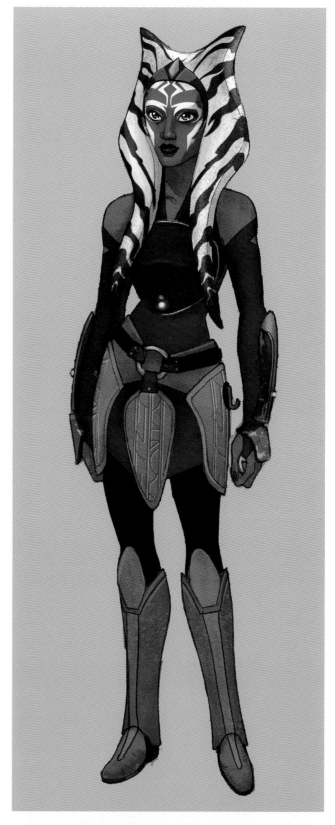

Top left: KP; bottom left: CV

EZRA BRIDGER

Ezra becomes increasingly confident in his Jedi abilities during season two, setting up problems when Darth Maul emerges as a sinister mentor who promises results that Kanan can't deliver.

Ezra wearing an Imperial cadet disguise (with a cadet helmet based on an unused Ralph McQuarrie stormtrooper concept), an identity he first assumed in the season one episode "Breaking Ranks."

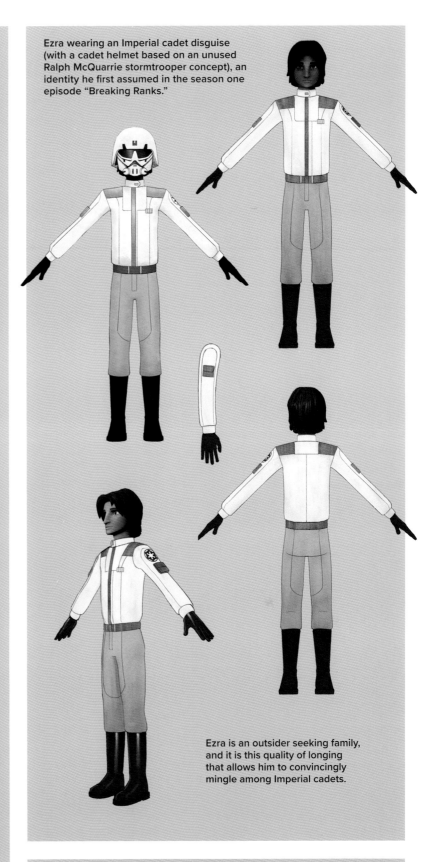

Ezra is an outsider seeking family, and it is this quality of longing that allows him to convincingly mingle among Imperial cadets.

Left column and top right column: WN

HONDO OHNAKA

One of the breakout characters of *Star Wars: The Clone Wars*, Hondo Ohnaka is a Weequay pirate who will do anything to earn a quick credit.

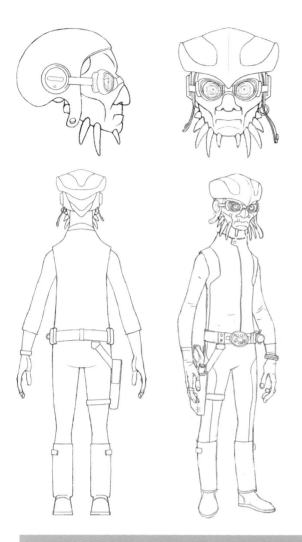

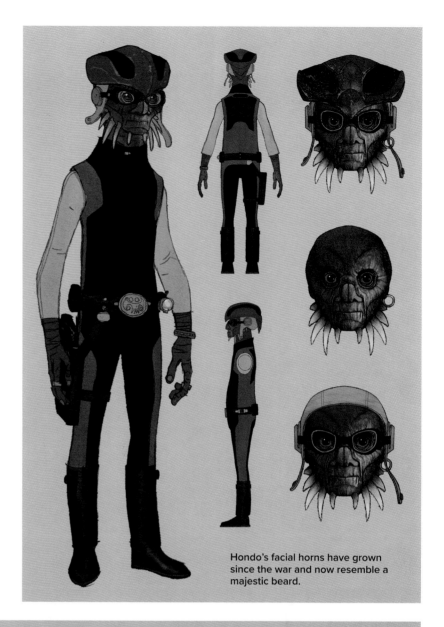

Hondo's facial horns have grown since the war and now resemble a majestic beard.

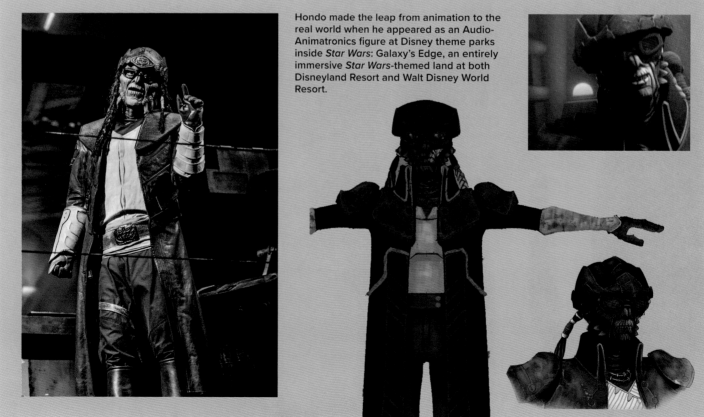

Hondo made the leap from animation to the real world when he appeared as an Audio-Animatronics figure at Disney theme parks inside *Star Wars*: Galaxy's Edge, an entirely immersive *Star Wars*-themed land at both Disneyland Resort and Walt Disney World Resort.

KETSU

A no-nonsense bounty hunter with ties to Sabine Wren, Ketsu Onyo injected some more ambiguity into *Star Wars Rebels'* second season. "Ketsu was based on a design from *The Force Awakens* that we got from ILM, and Amy Beth Christenson completed the rest of her look," explains Plunkett.

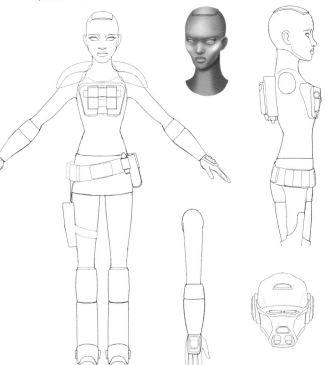

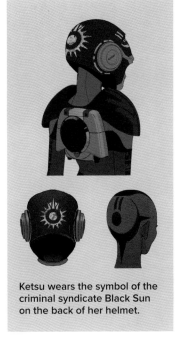

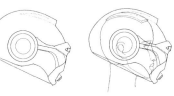

Ketsu wears the symbol of the criminal syndicate Black Sun on the back of her helmet.

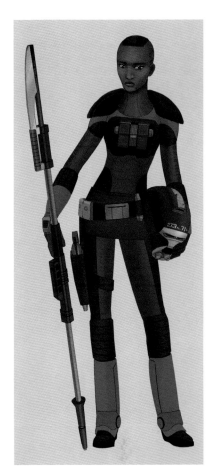

CHAM SYNDULLA

A freedom fighter and folk hero on the Twi'lek world of Ryloth, Cham Syndulla makes a reappearance from *Star Wars: The Clone Wars* to help the Rebels seize an Imperial starship carrier.

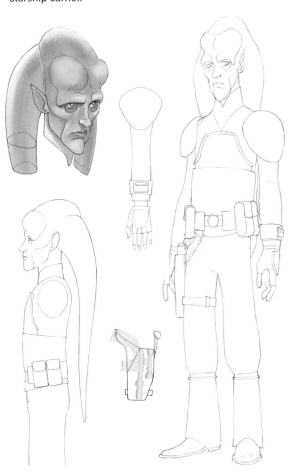

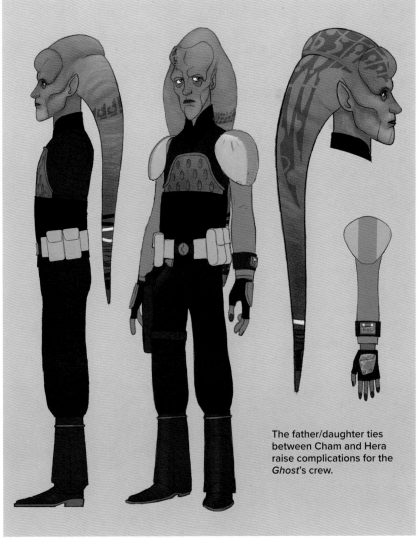

The father/daughter ties between Cham and Hera raise complications for the *Ghost*'s crew.

INQUISITOR SECOND SISTER

A high-ranking member of the Imperial Inquisitorius, the Second Sister took up the slack after the death of the Grand Inquisitor by stepping up the Empire's pursuit of the Lothal Rebels.

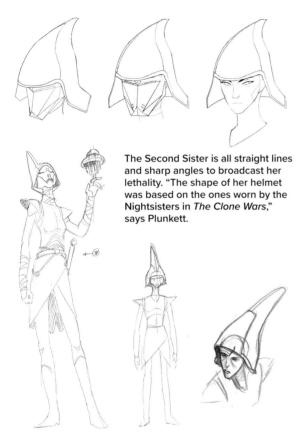

The Second Sister is all straight lines and sharp angles to broadcast her lethality. "The shape of her helmet was based on the ones worn by the Nightsisters in *The Clone Wars*," says Plunkett.

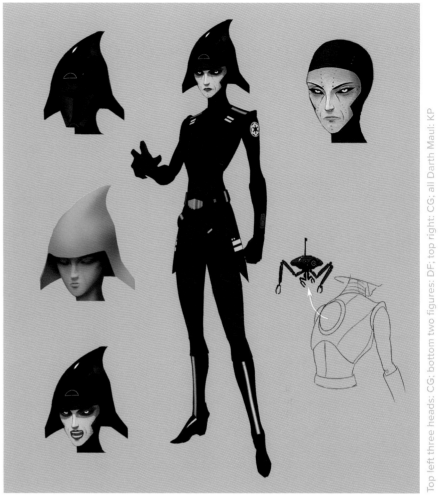

DARTH MAUL

Bisected by a lightsaber in *The Phantom Menace*, Darth Maul returned with mechanical legs in *Star Wars: The Clone Wars* to head a shadowy cabal. Now he seeks revenge against Obi-Wan Kenobi, the Jedi responsible for his maiming.

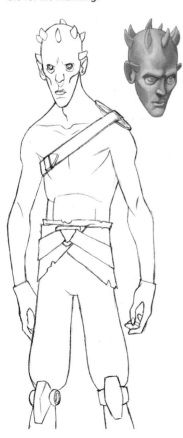

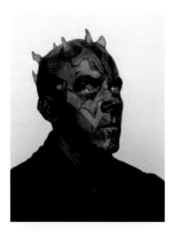

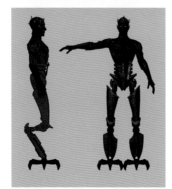

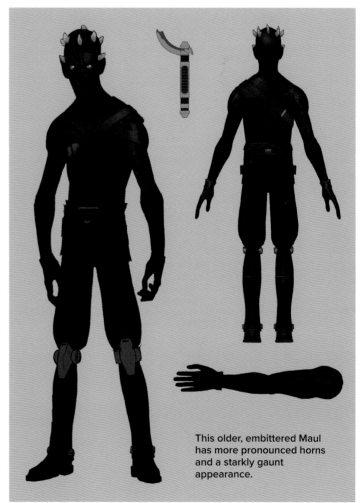

This older, embittered Maul has more pronounced horns and a starkly gaunt appearance.

Top left three heads: CG; bottom two figures: DF; top right: CG; all Darth Maul: KP

INQUISITOR FIFTH BROTHER

This Imperial Inquisitor is a brutal enforcer allied with the dark side of the Force. Says Plunkett, "The Fifth Brother's helmet was a concept created for Kylo Ren in *The Force Awakens* that didn't make it into the film."

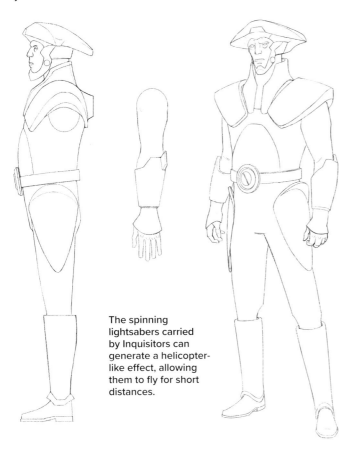

The spinning lightsabers carried by Inquisitors can generate a helicopter-like effect, allowing them to fly for short distances.

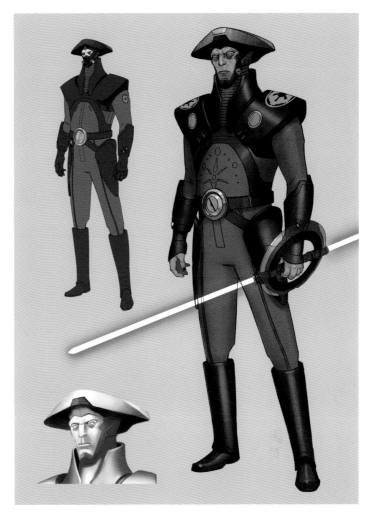

INQUISITOR EIGHTH BROTHER

Lithe and angular, the Eighth Brother hides his appearance beneath a slotted faceplate. Says Plunkett, "His outfit was inspired by medieval plate armor."

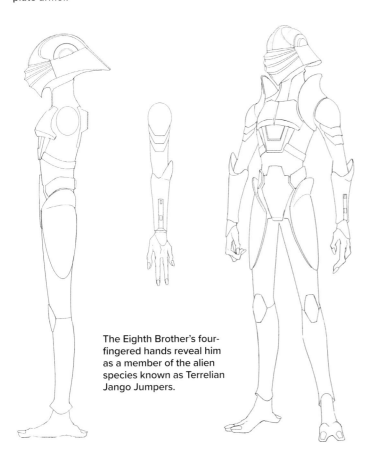

The Eighth Brother's four-fingered hands reveal him as a member of the alien species known as Terrelian Jango Jumpers.

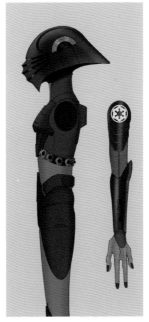

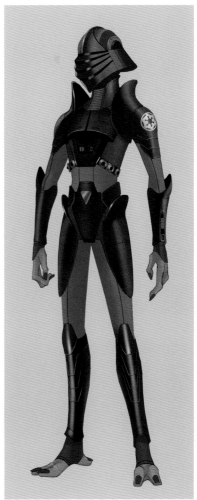

All fifth brother art: JPB; all eighth brother art: ABC

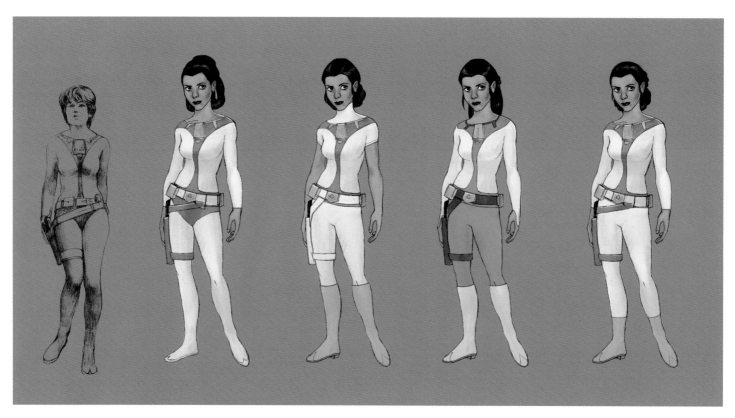

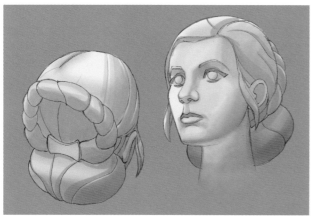

 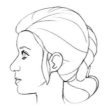 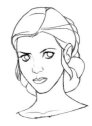

PRINCESS LEIA ORGANA

Leia, still a teenager during the timeframe of *Rebels*, is actively opposing the Empire through "mercy missions" to subjugated worlds. Her youth and steeliness are captured in these designs, with an early McQuarrie concept for *A New Hope* at far left, which served as the inspiration for her outfit.

MIRA BRIDGER

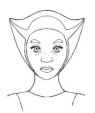 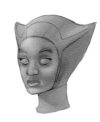

EPHRAIM BRIDGER

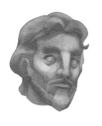 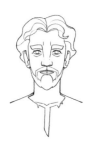

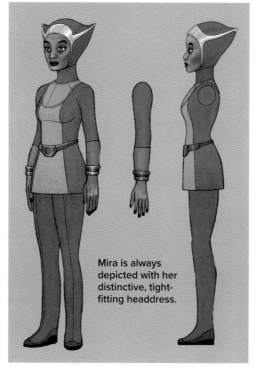

Mira is always depicted with her distinctive, tight-fitting headdress.

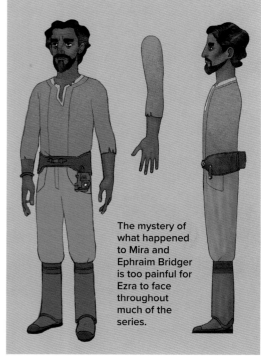

The mystery of what happened to Mira and Ephraim Bridger is too painful for Ezra to face throughout much of the series.

PURRGIL

Looking like the biological splice of a whale and a squid, the purrgil possesses some remarkable evolutionary adaptations. Not only can it swim lazily through the vacuum of space, it can even leap into hyperspace and cross light years in a blink.

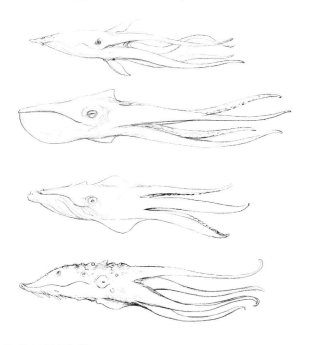

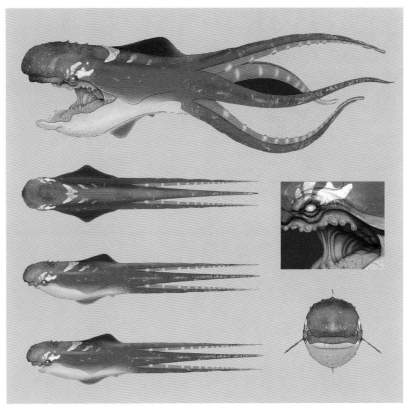

BONZAMI

Native to an icy moon of Geonosis, the bonzami is a behemoth that is nearly impervious to blaster fire. "When creating new creatures, what works best is keeping it simple," explains Plunkett. "It should be easy to understand the analogous animal, which helped when designing the rhino-like bonzami."

Food is scarce on subzero Bahryn, so the bonzami views humanoid visitors as tasty and nutritious snacks.

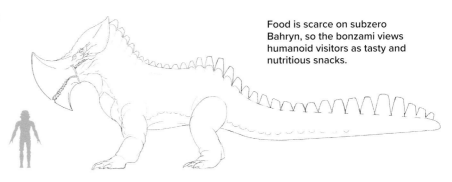

When the bonzami's jaws are closed, they form the shape of an executioner's axe.

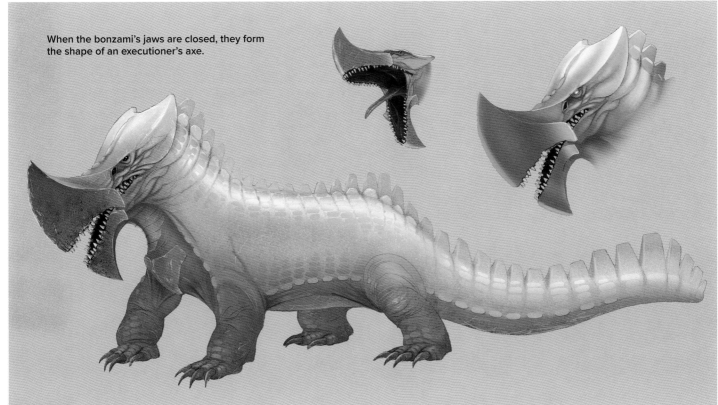

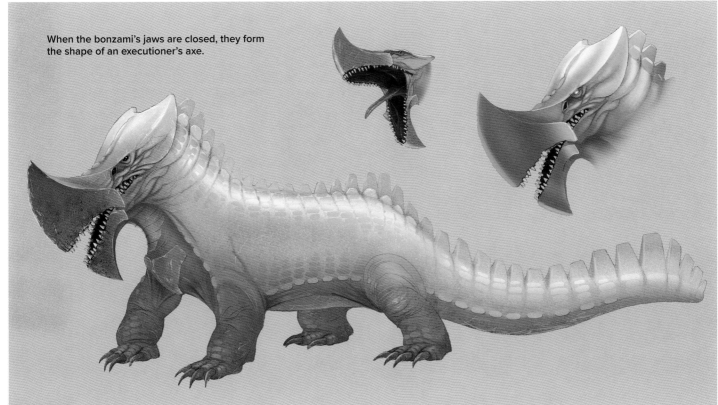

⊘ ENVIRONMENTS
ᐯᓯᐱY17ᗡᐱᒪᐯᓯᐱↆᓀ

The familiar surroundings of Lothal get tragically left behind in season two as our heroes are forced to seek the help of new allies across the galaxy—all while staying one jump ahead of the Empire at all times. Their foes, however, prove to be more cunning and deadlier than ever, resulting in some harrowing close encounters before the Rebels find a new home on Atollon. "The idea [for Atollon] was a coral reef drained of seawater," says art director Kilian Plunkett.

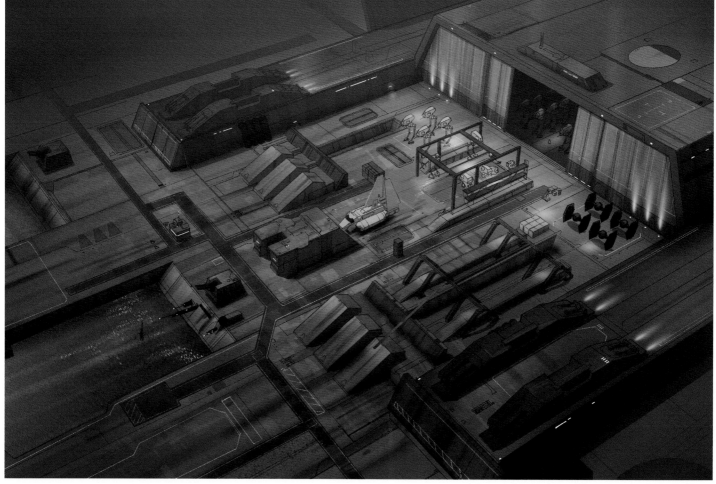

This page: CG

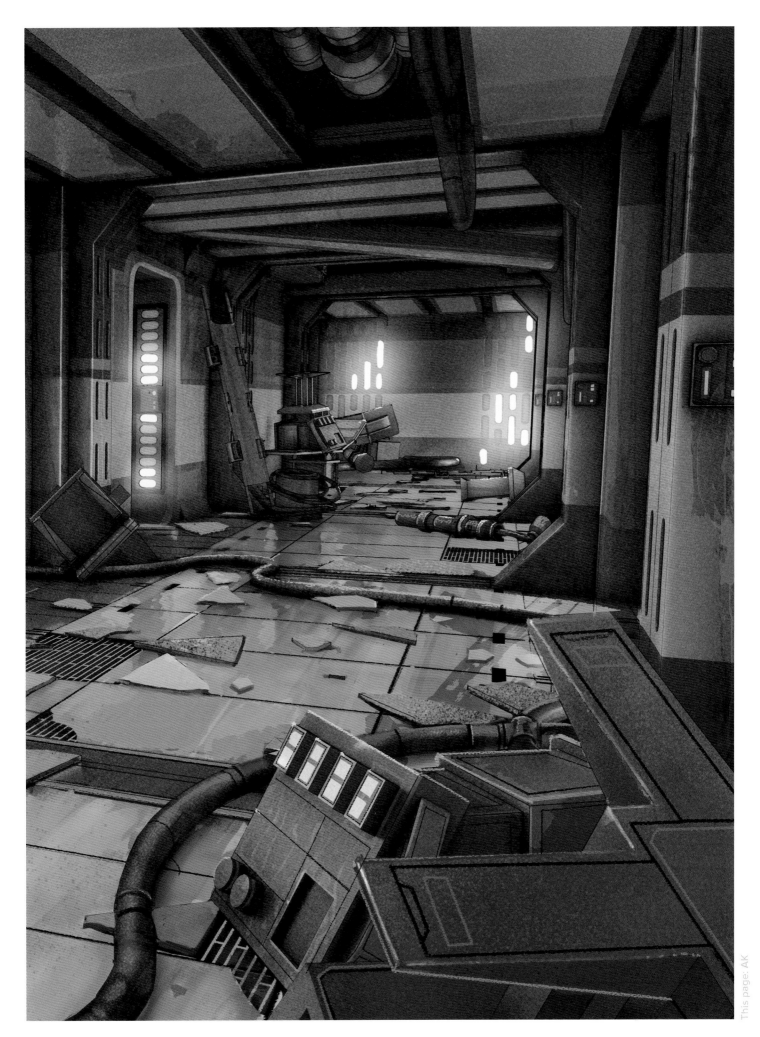

The Imperial Armory in Lothal City (*left*), and a derelict space station (*above*).

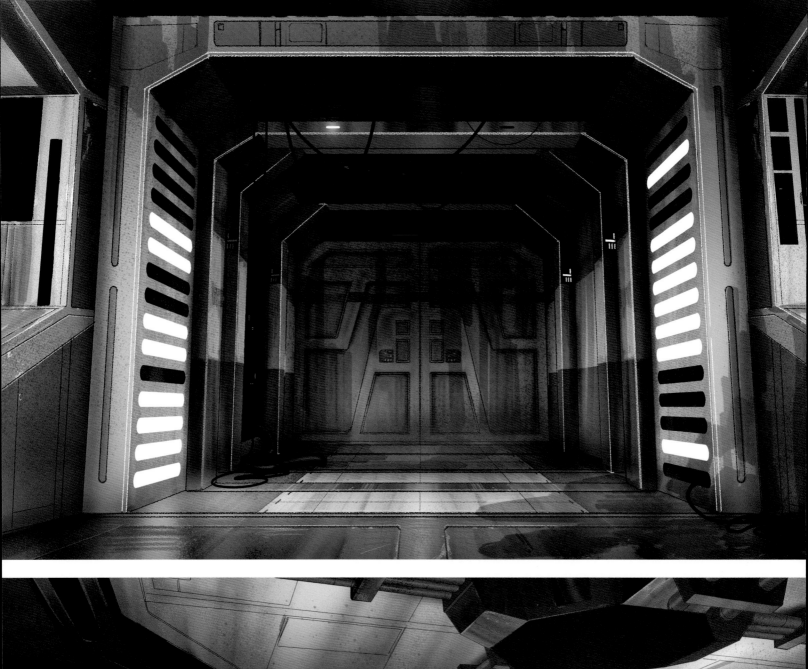
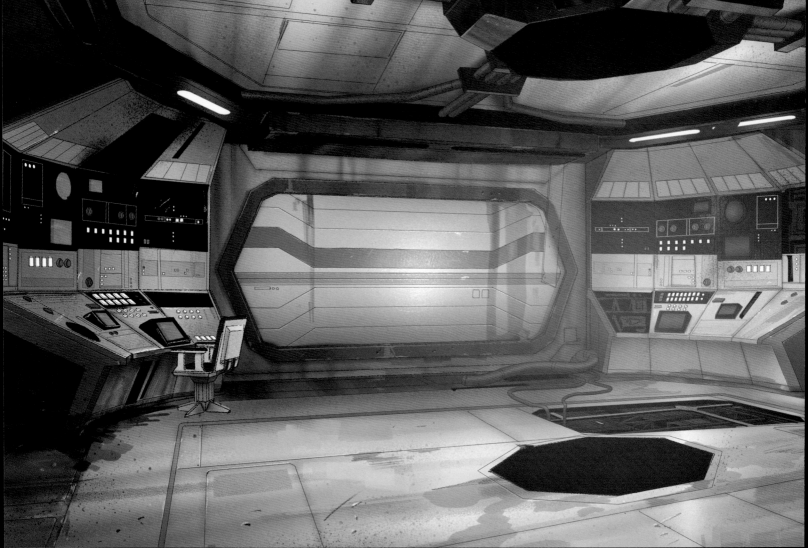

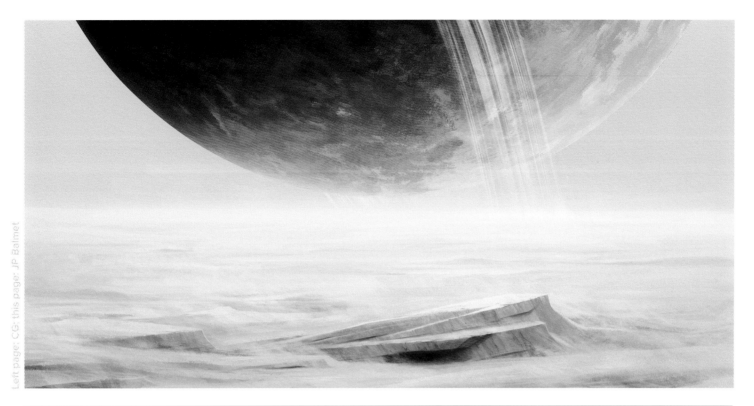

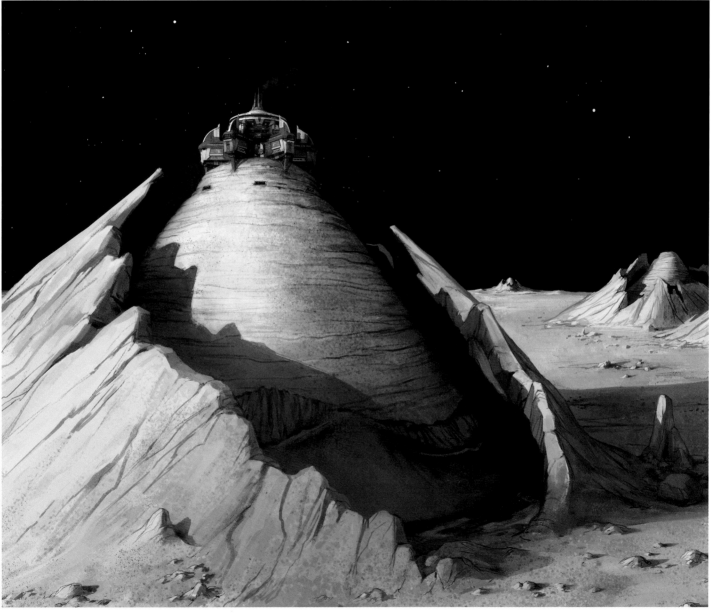

Season two saw a greater number of locations as the scope of the show widened.

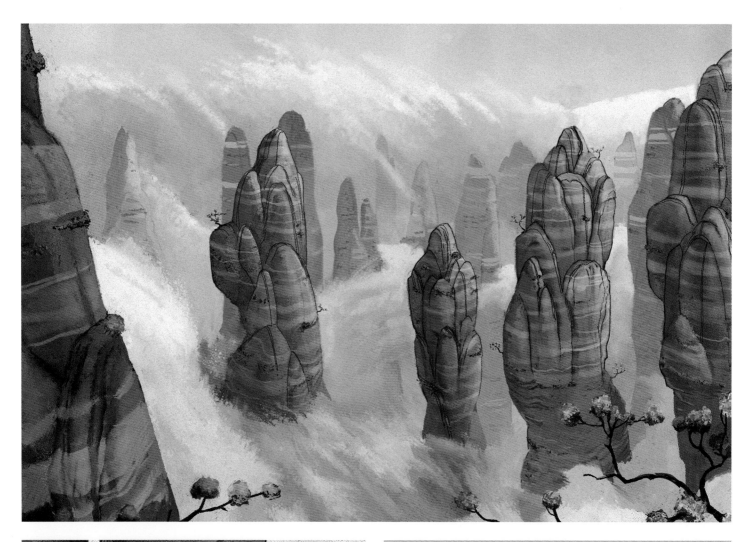

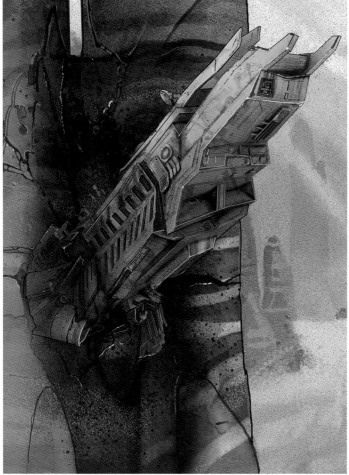

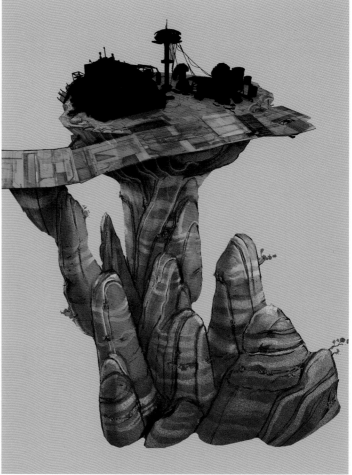

The surface of Shantipole is a mist-wrapped forest of stone pillars. A starship hangar has been built atop one rock formation.

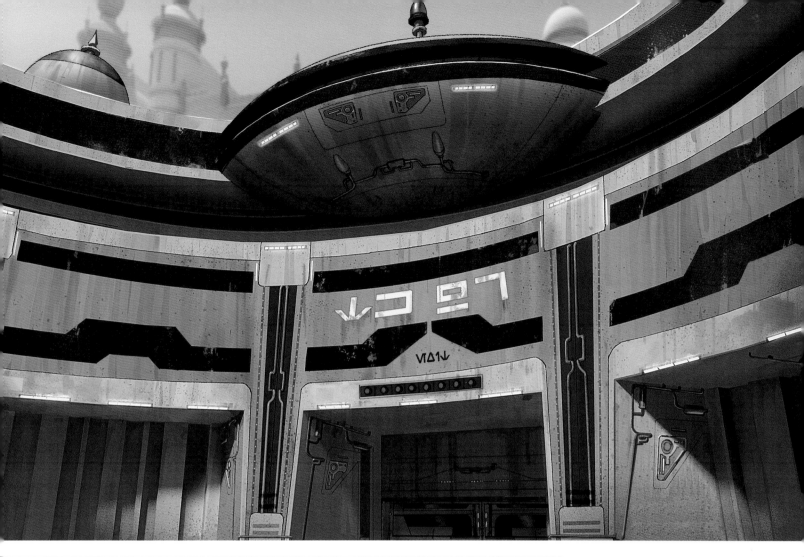

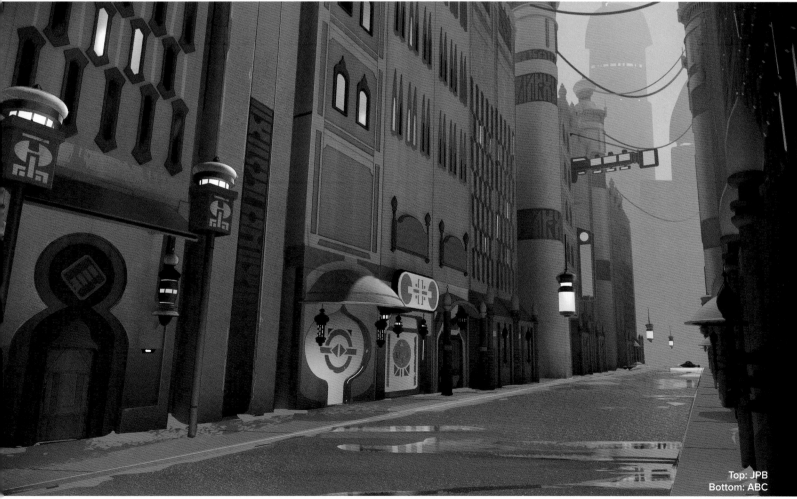

The streets of capital city Takobo City.

This image was originally a view of the planet Pantora for Episode 225 of *The Clone Wars*, "Sphere of Influence." It was created by Chris Voy. In *The Clone Wars* episode as it aired, the action was moved from the surface of Pantora to the interior of a Separatist Battle Sphere so this painting wasn't used until we went to Takobo in *Rebels*. Most of the Takobo sets are based on the unused Pantoran ones.

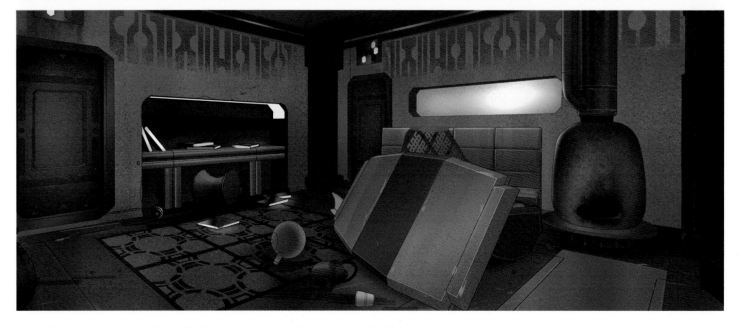

The onion-shaped domes of Takobo City (*at top*), and the interiors of a ransacked Takobo City apartment (*above and right*).

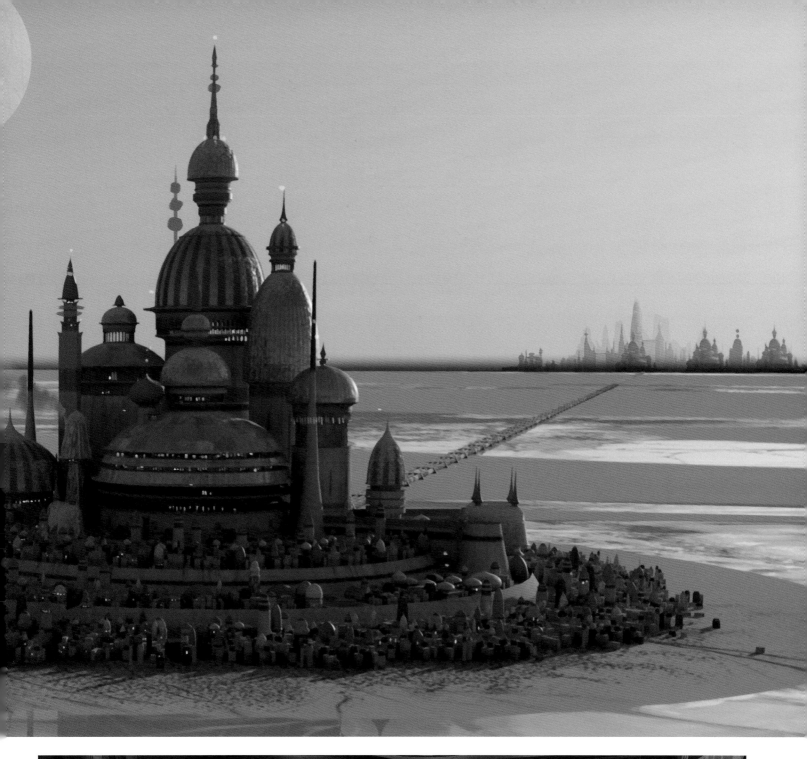

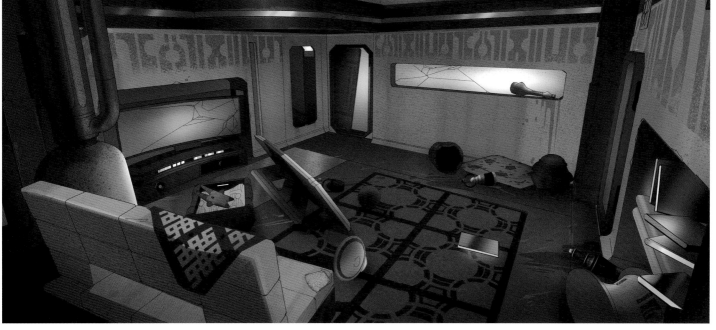

Top: CV; bottom left and right: ABC

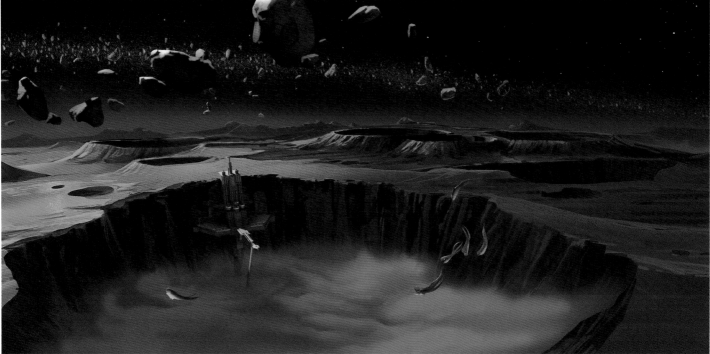

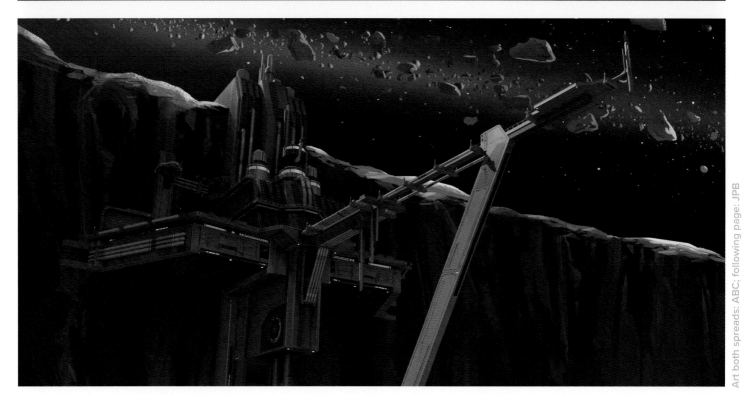

Under the direction of the wealthy Mining Guild, an asteroid has been reshaped into a gas refinery (*above*).

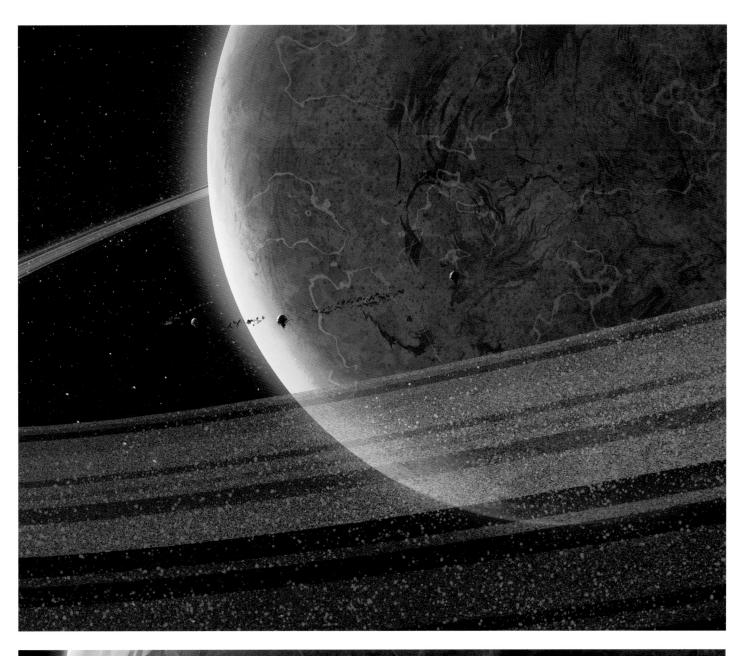

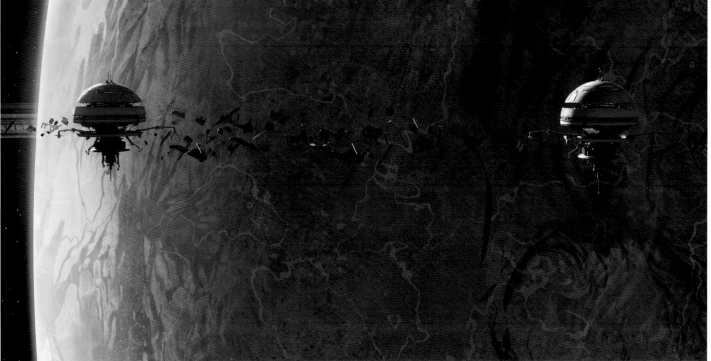

The ringed planet of Geonosis and the Imperial orbital construction spheres staged in its orbit (*above*).

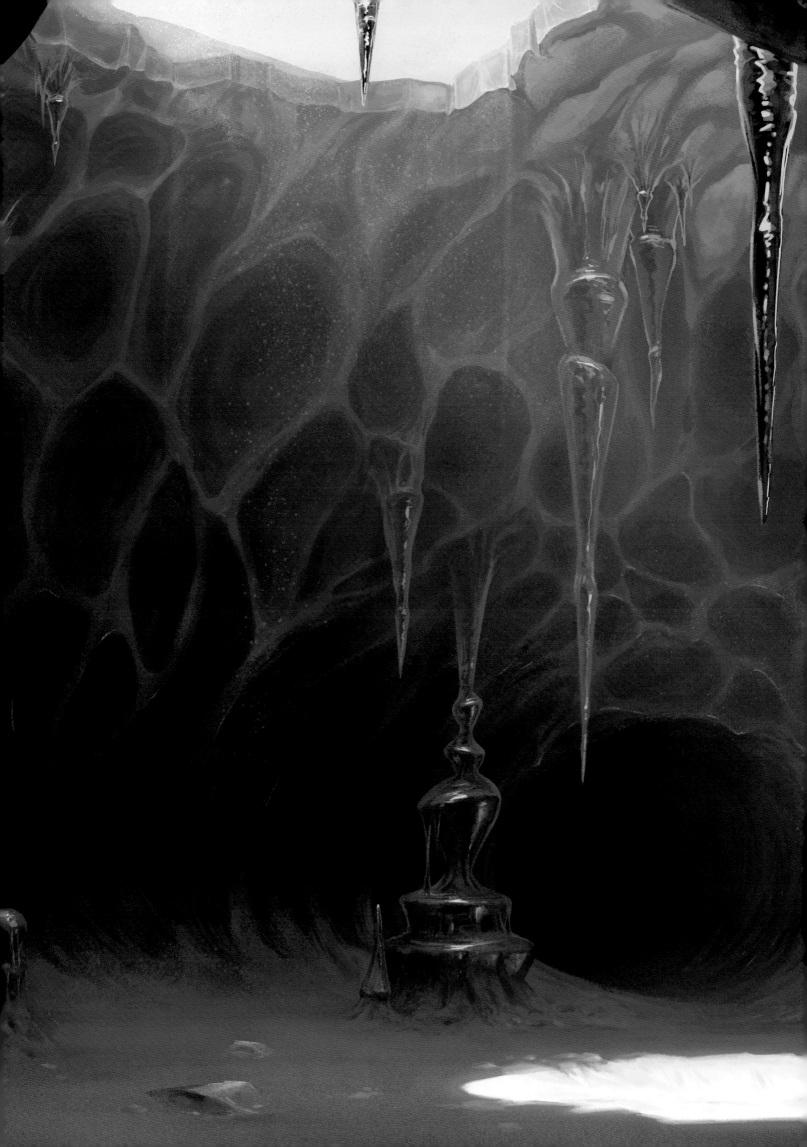

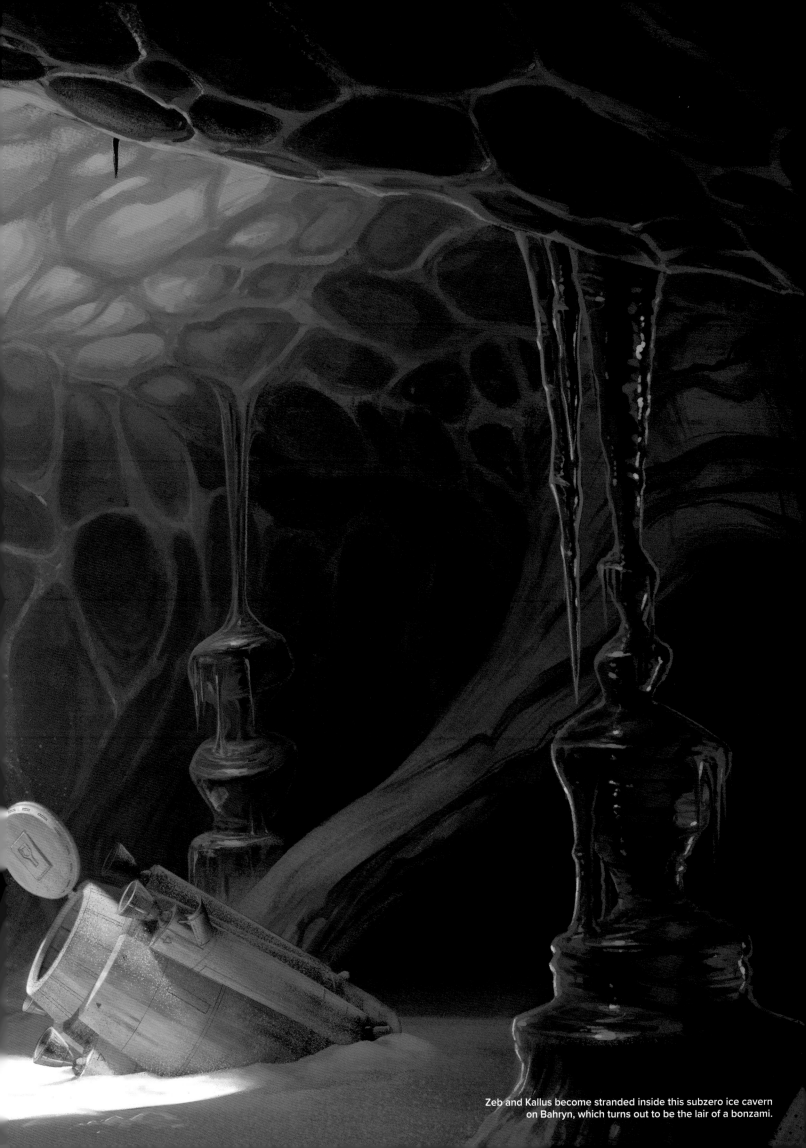

Zeb and Kallus become stranded inside this subzero ice cavern on Bahryn, which turns out to be the lair of a bonzami.

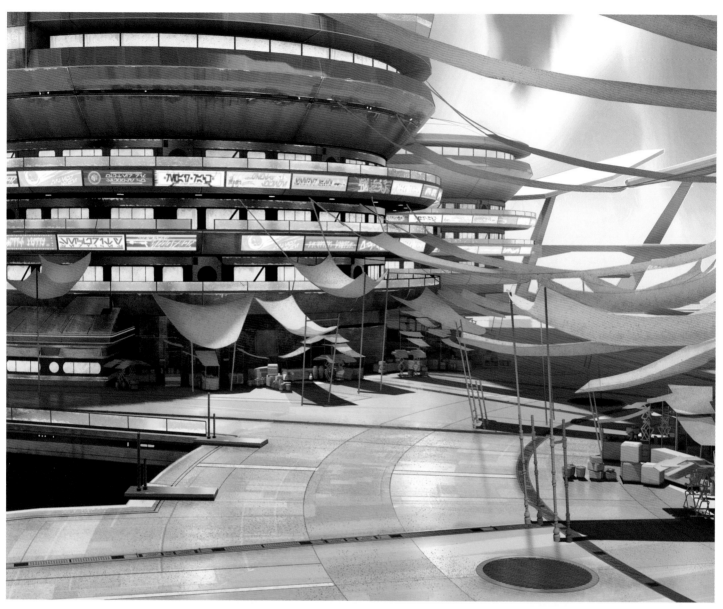

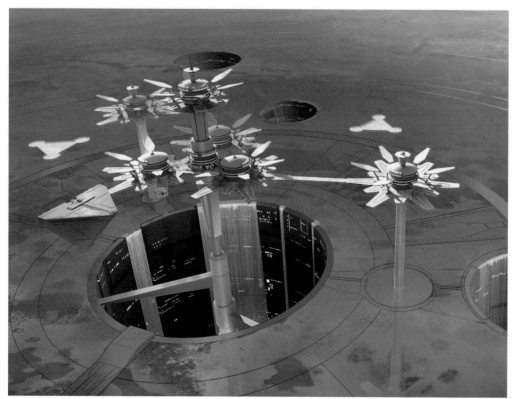

The exterior of this Imperial refueling outpost features a street market marked with colorful fabric awnings.

This page: ABC; right page top: CG; bottom: AK

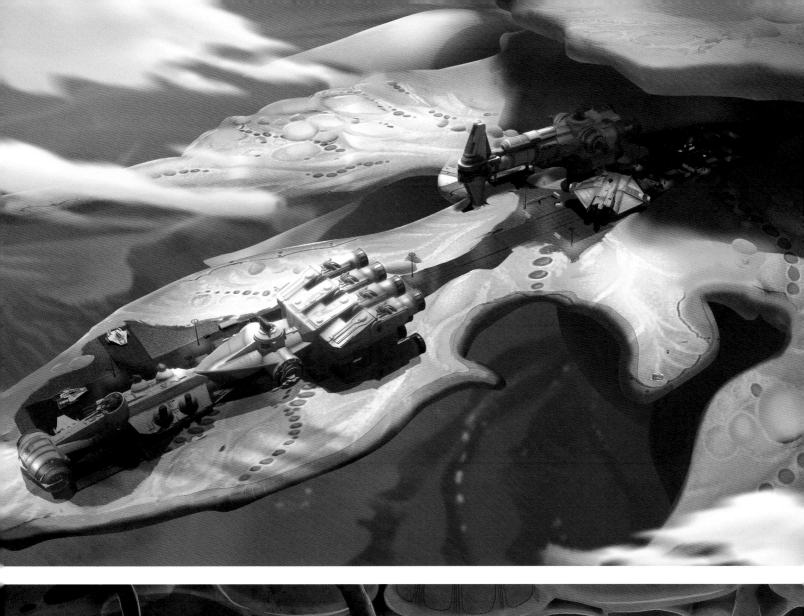

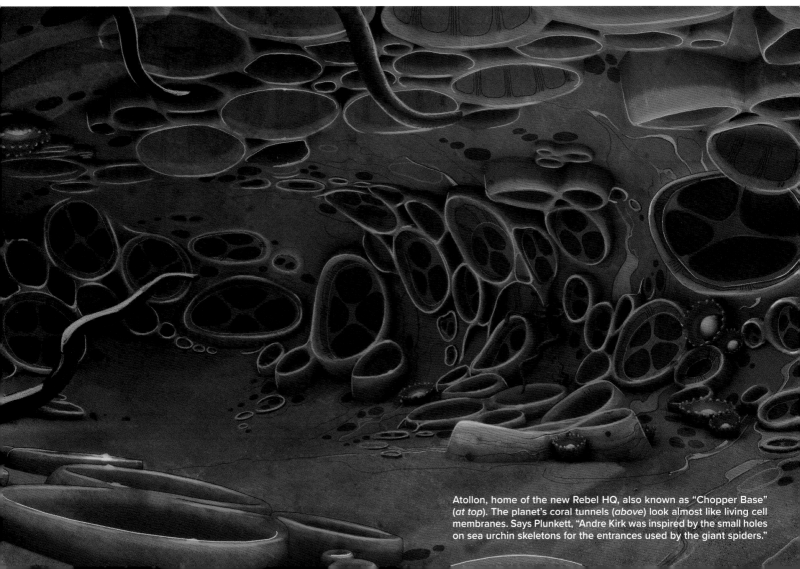

Atollon, home of the new Rebel HQ, also known as "Chopper Base" (*at top*). The planet's coral tunnels (*above*) look almost like living cell membranes. Says Plunkett, "Andre Kirk was inspired by the small holes on sea urchin skeletons for the entrances used by the giant spiders."

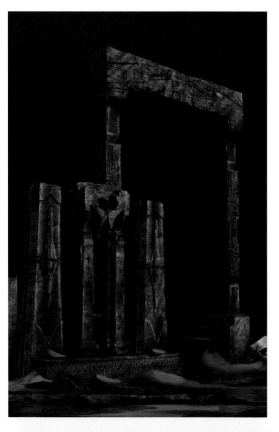
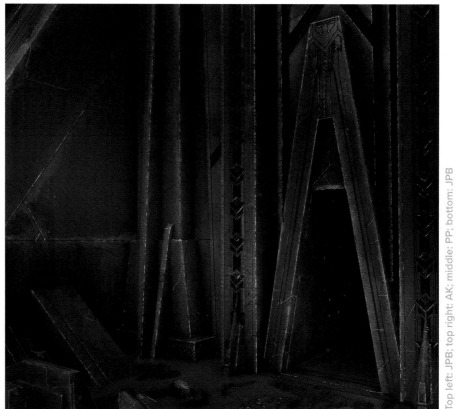
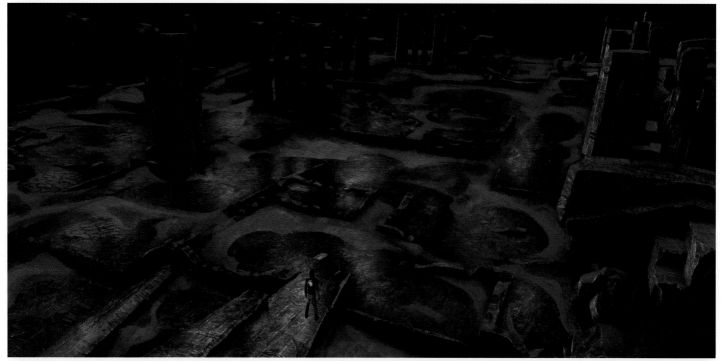
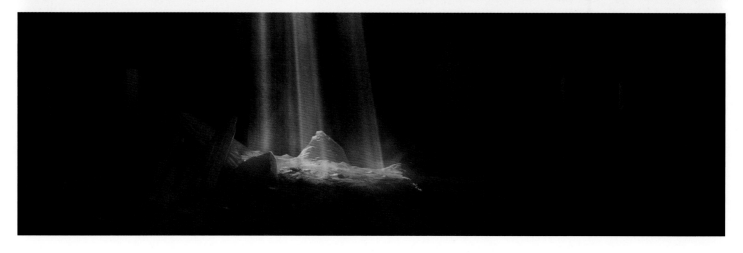

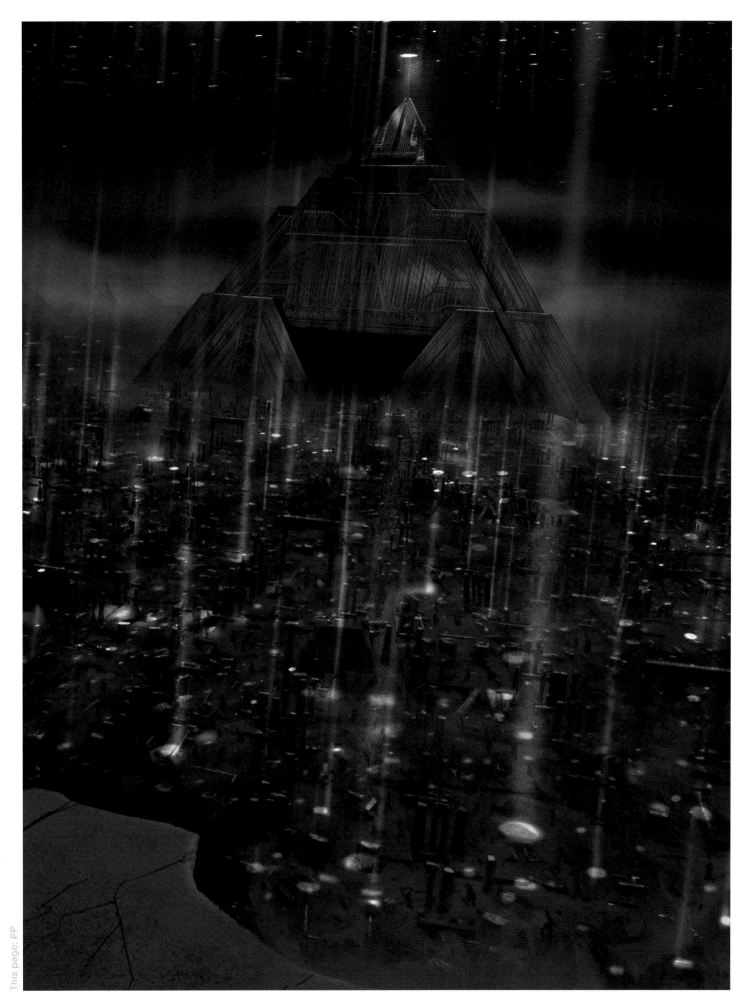

Various views of the Sith Temple on Malachor demonstrate its straight-edged, sharp-angled architecture. "Everything from Malachor's surface to the scale of the Sith pyramid had been sketched out by Dave Filoni," says Plunkett. "Chris Glenn created the final look of the chamber and Pat Presley painted wide views of the dead city surrounding it."

PROPS

In season two, *Star Wars Rebels* greatly escalated the threats our heroes faced every episode. Not only were Imperial agents and bounty hunters tracking down and leveling their weapons at the Rebels at every turn, but a whole cabal of dark-side Force users emerged, providing Kanan and Ezra an entirely new type of threat to deal with. As our two Force-sensitive heroes, the duo were tasked with dealing with these villains and their nefarious ways.

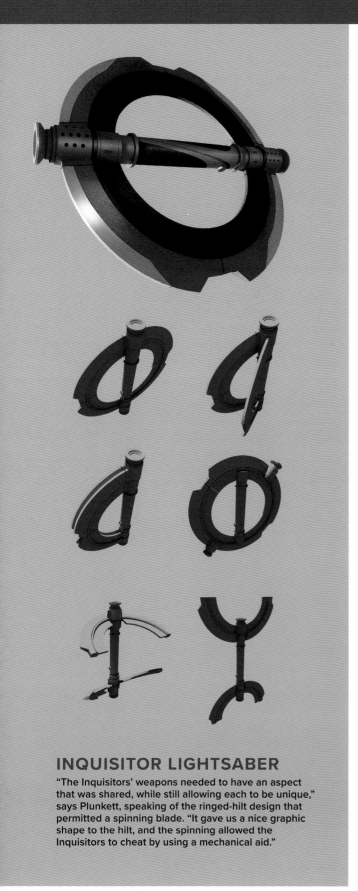

INQUISITOR LIGHTSABER

"The Inquisitors' weapons needed to have an aspect that was shared, while still allowing each to be unique," says Plunkett, speaking of the ringed-hilt design that permitted a spinning blade. "It gave us a nice graphic shape to the hilt, and the spinning allowed the Inquisitors to cheat by using a mechanical aid."

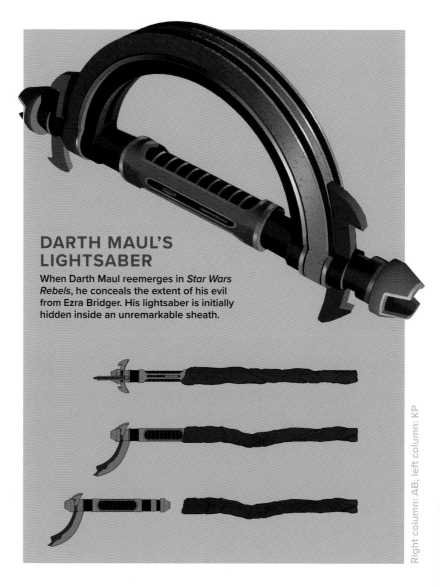

DARTH MAUL'S LIGHTSABER

When Darth Maul reemerges in *Star Wars Rebels*, he conceals the extent of his evil from Ezra Bridger. His lightsaber is initially hidden inside an unremarkable sheath.

Maul's new saber replicates the double-bladed functionality of his weapon from *The Phantom Menace*.

Right column: AB; left column: KP

E-WEB TRIPOD

First seen in *The Empire Strikes Back*, the E-Web is what the Empire rolls out when a situation needs some extra punch. A generator feeds the cannon with hull-punching power.

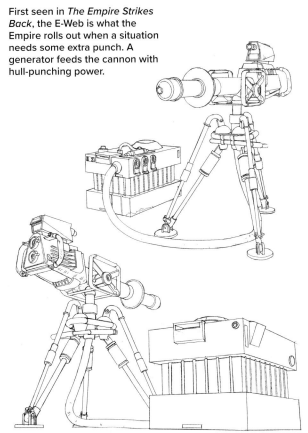

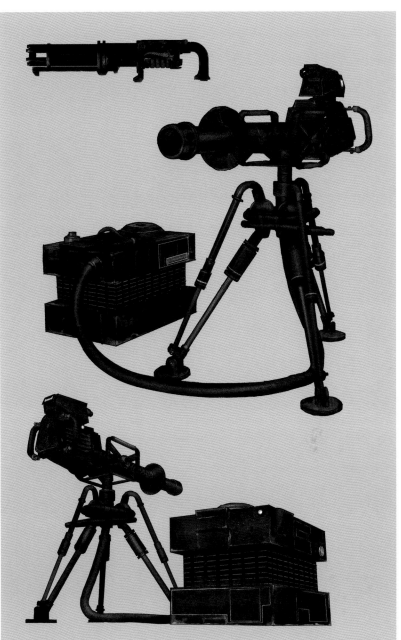

Top section: KP; bottom section: ABC

KETSU ONYO'S STAFF

As a bounty hunter, Ketsu Onyo needs a weapon for close-quarters combat. Her staff can also fire long-range blaster bolts.

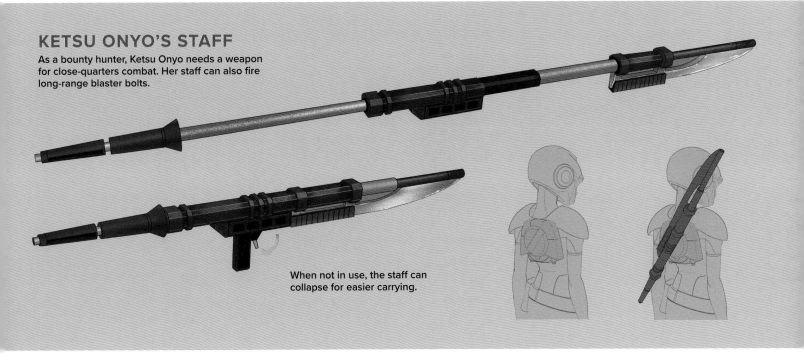

When not in use, the staff can collapse for easier carrying.

SHIELD GENERATOR

The Rebels steal these generators to help fund their war effort. Each Colicoid 49-V99 Deflector can project a robust defensive energy screen.

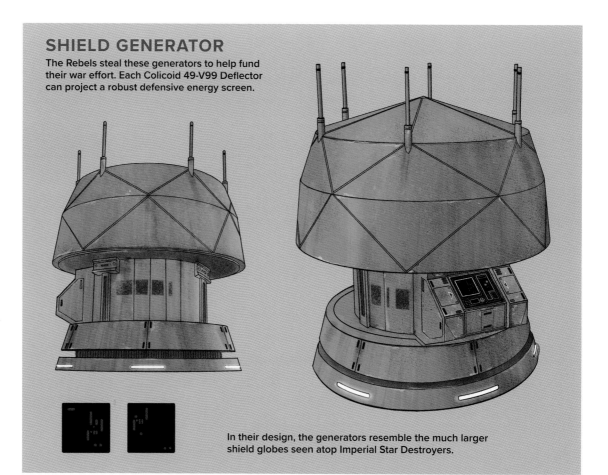

In their design, the generators resemble the much larger shield globes seen atop Imperial Star Destroyers.

MASKING TRANSPONDER

Lando Calrissian provides several of these devices to the Rebels to help them make their escape from Lothal. Masking transponders work by overwhelming sensors with duplicate starship signals.

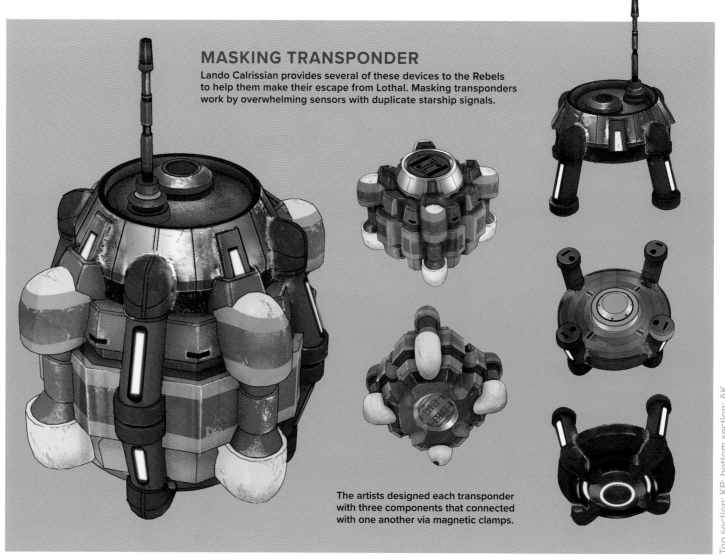

The artists designed each transponder with three components that connected with one another via magnetic clamps.

Top section: KP; bottom section: AK

JOOPA FISHING POLE HARNESS

Zeb wears this contraption to attract joopa worms in the deserts of Seelos, but isn't particularly enthusiastic about becoming live bait.

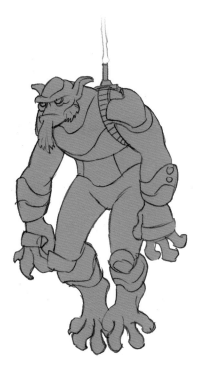

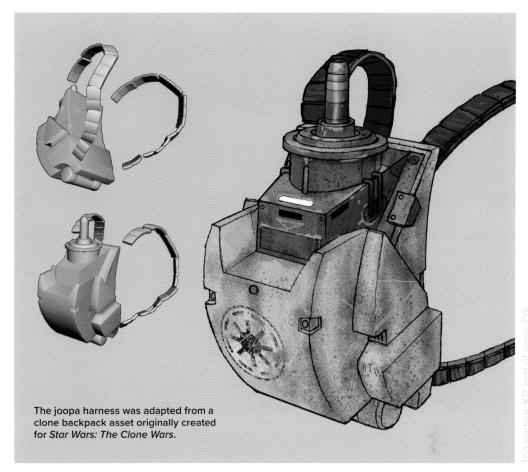

The joopa harness was adapted from a clone backpack asset originally created for *Star Wars: The Clone Wars*.

Top section: KP, rest of page: CG

Macrobinoculars like these provide data readouts on distant targets.

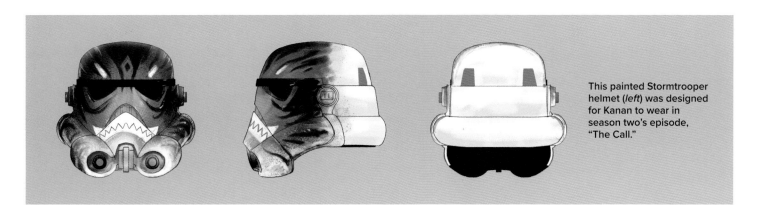

This painted Stormtrooper helmet (*left*) was designed for Kanan to wear in season two's episode, "The Call."

GRAFFITI

This tag of Kanan and Rex was created for application to the hull of an Imperial shuttle.

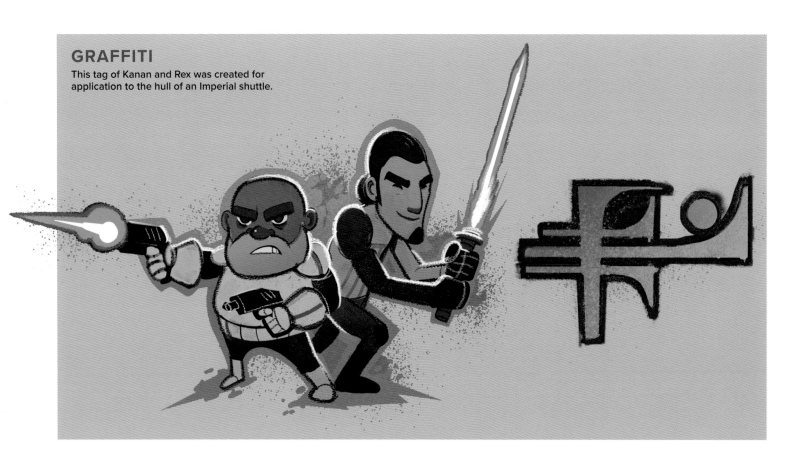

LOTHAL ROCK ART

When Ezra and Kanan return to Lothal's Jedi Temple, this native artwork is seen in the Temple's atrium.

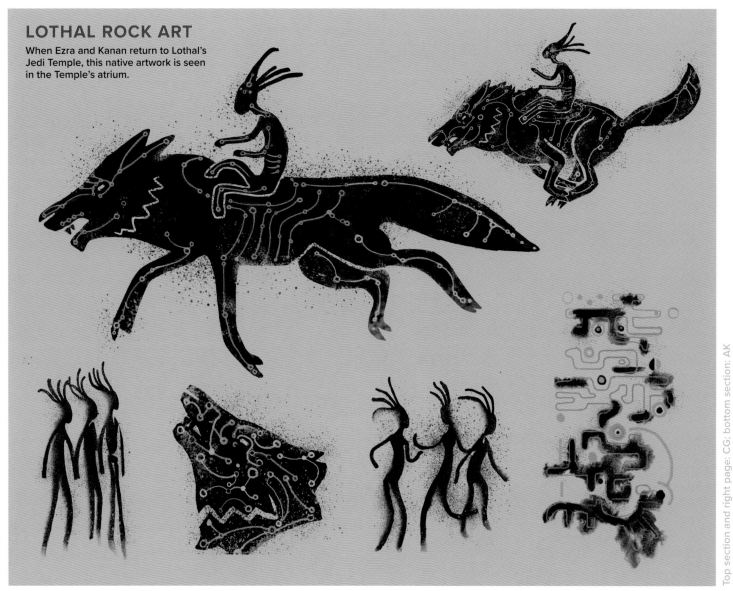

Top section and right page: CG; bottom section: AK

An array of advertising shingles created for the episode "Stealth Strike." Translations include
Hutt's Grotto, Meteor Café, Orondia Tours, Repair Rack, and Eat at Koe's.

Some of the *Star Wars* saga's most beloved hardware is reintroduced during season two, including A- and B-wings, AT-AT walkers, and Darth Vader's TIE fighter. Each returning design underwent simplification to mesh with the show's streamlined aesthetic.

A-WING

The A-wing is the Rebellion's interceptor, capable of running rings around TIE fighters while punching back with its laser cannons and concussion missiles. Commander Jun Sato's Phoenix Squadron relied heavily on A-wings at the start of *Star Wars Rebels* season two.

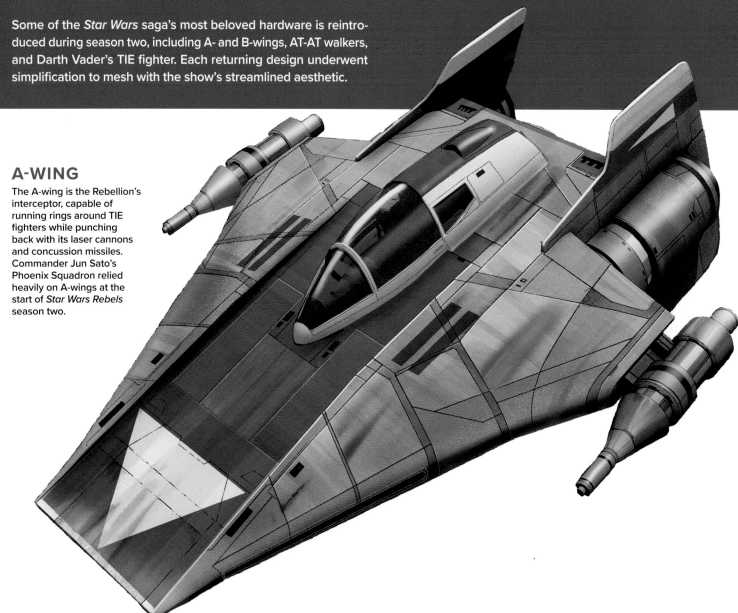

A-wings perform excellently against enemy starfighters, but Darth Vader still decimated Phoenix Squadron in a single engagement. Original McQuarrie painting was the inspiration for the paint job. This paint scheme also appears in *The Last Jedi*.

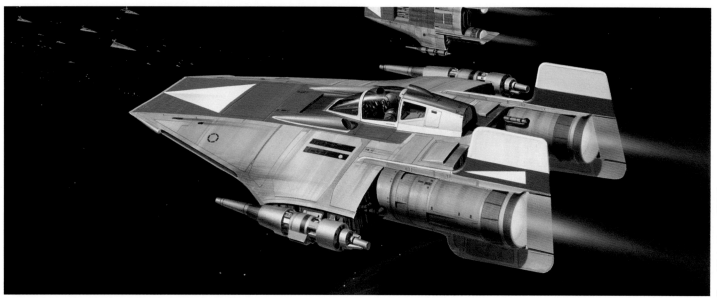

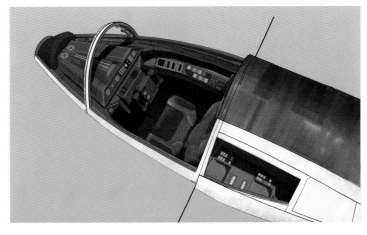

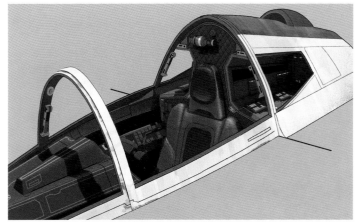

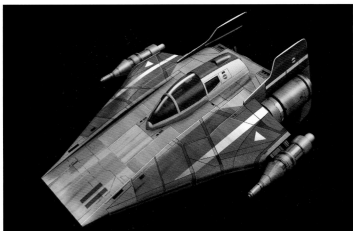

HERA'S A-WING

Hera's personal craft is emblazoned with an image of Kanan, designed and applied by Sabine Wren.

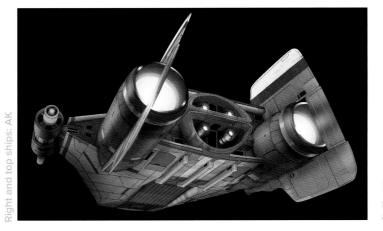

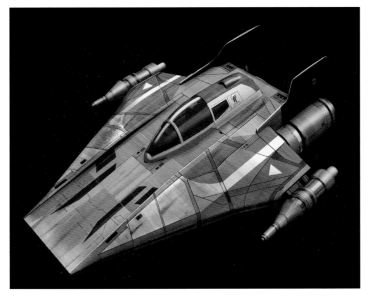

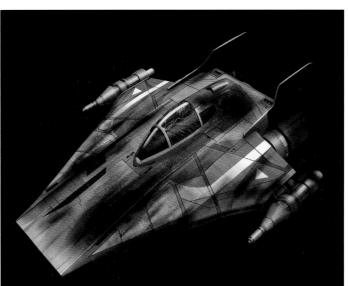

This rendering depicts Hera's A-wing with battle damage and a carbon-scored hull.

MODIFIED AT-TE

Ever since the end of the Clone Wars, Rex and his fellow clones Wolffe and Gregor have lived inside an AT-TE walker endlessly marching across the wastelands of Seelos. Its exterior rigging and hanging ornamentation help convey the changes it has undergone over time.

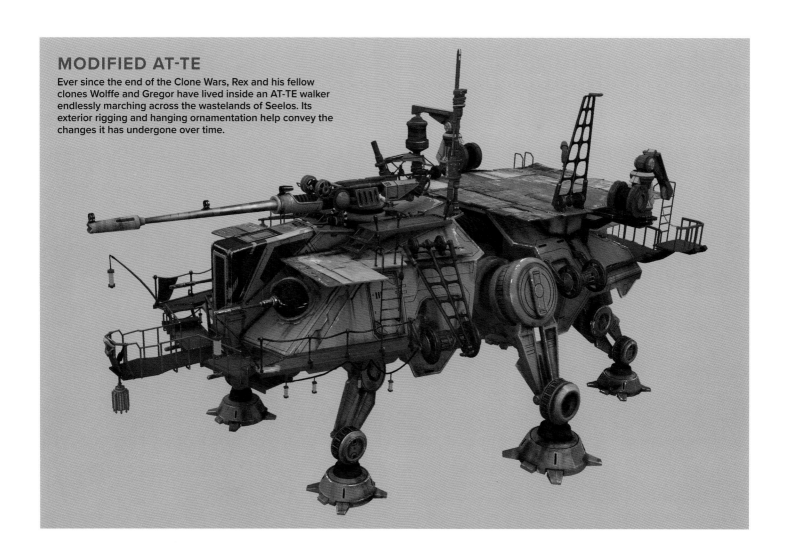

B-WING

The B-wing is the Rebellion's premier heavy bomber, and *Star Wars Rebels* shows how the craft entered military service. "We tweaked its proportions to evoke the Kenner toys, with a stubbier cockpit and smaller wings," says Plunkett.

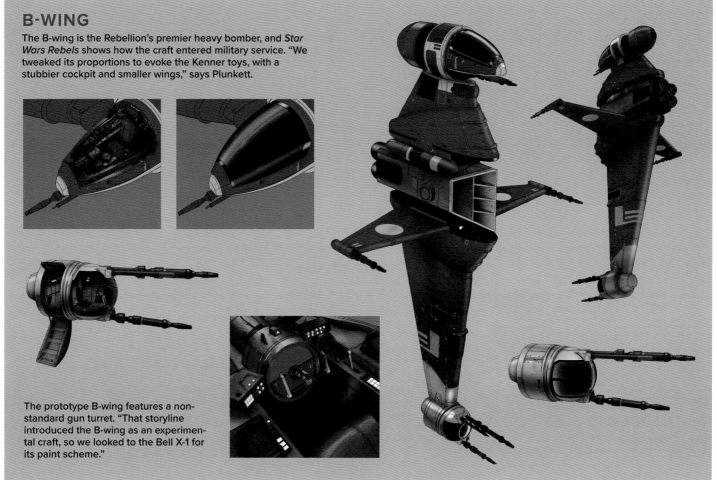

The prototype B-wing features a non-standard gun turret. "That storyline introduced the B-wing as an experimental craft, so we looked to the Bell X-1 for its paint scheme."

Top section: AK; bottom section: CG

DARTH VADER'S TIE FIGHTER

Darth Vader is one of the galaxy's best pilots, and fittingly he flies a TIE Advanced starfighter which is equipped with deflector shields and a fast-travel hyperdrive engine.

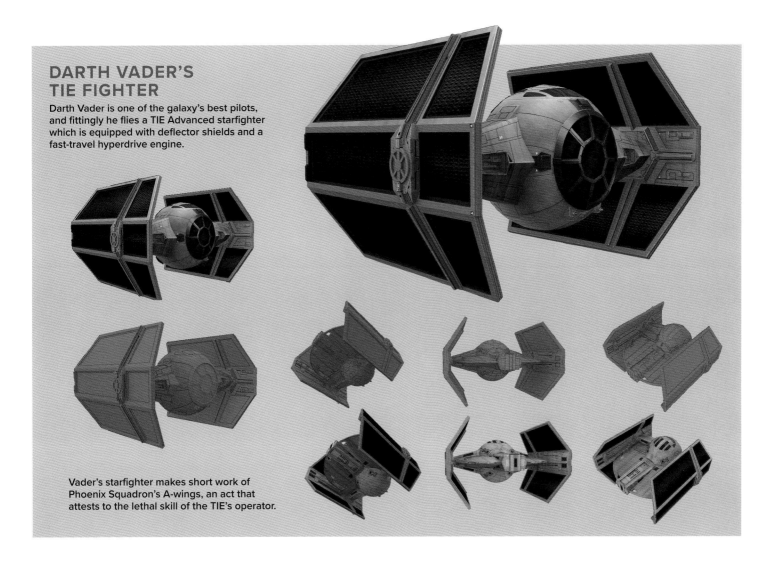

Vader's starfighter makes short work of Phoenix Squadron's A-wings, an act that attests to the lethal skill of the TIE's operator.

SPEEDER BIKE

This single-pilot speeder soars on an antigravity updraft and has enough room to carry a rear passenger.

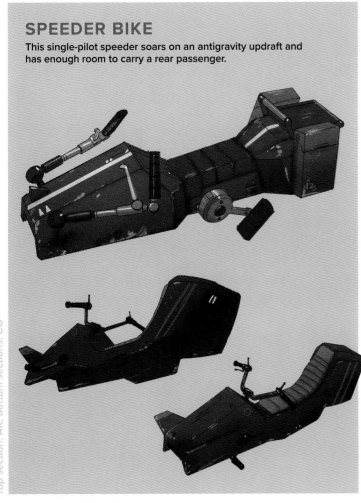

PHOENIX HOME

During their downtime, the Rebel pilots of Phoenix Squadron lived aboard the *Phoenix Home*. This *Pelta*-class frigate, commanded by Jun Sato, served the Rebellion until it disintegrated under the guns of Darth Vader.

Top section: AK; bottom sections: CG

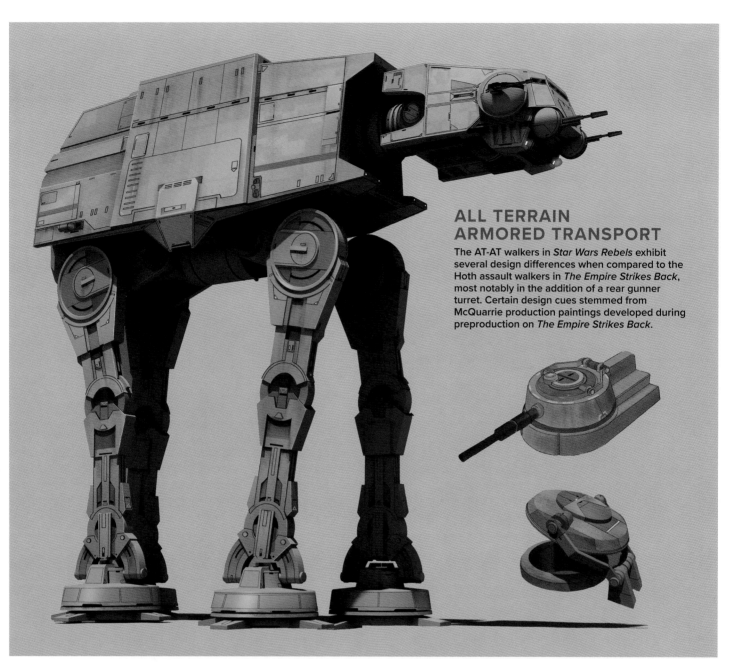

ALL TERRAIN ARMORED TRANSPORT

The AT-AT walkers in *Star Wars Rebels* exhibit several design differences when compared to the Hoth assault walkers in *The Empire Strikes Back*, most notably in the addition of a rear gunner turret. Certain design cues stemmed from McQuarrie production paintings developed during preproduction on *The Empire Strikes Back*.

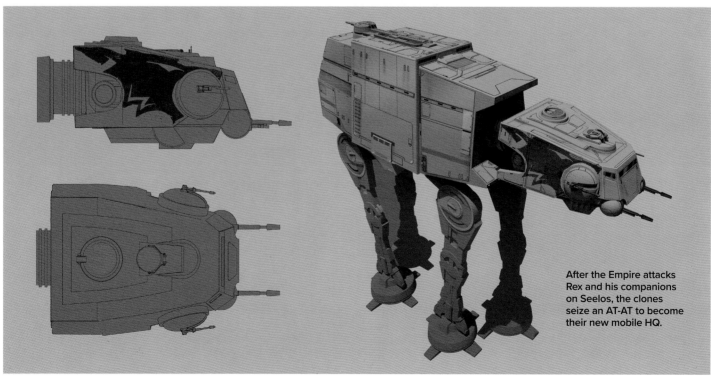

After the Empire attacks Rex and his companions on Seelos, the clones seize an AT-AT to become their new mobile HQ.

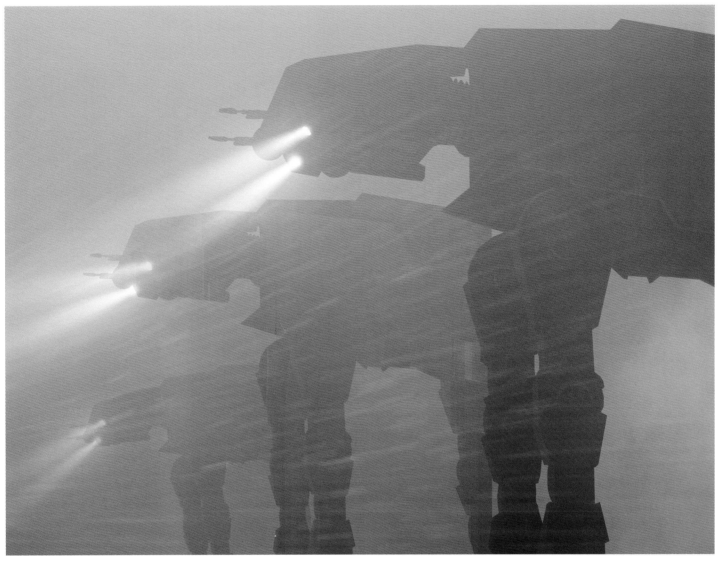

The interior of this version of the AT-AT is modeled closely on the one seen in *The Empire Strikes Back* with adjustments for the slightly different windshield.

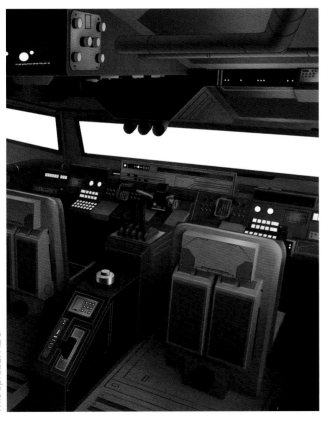

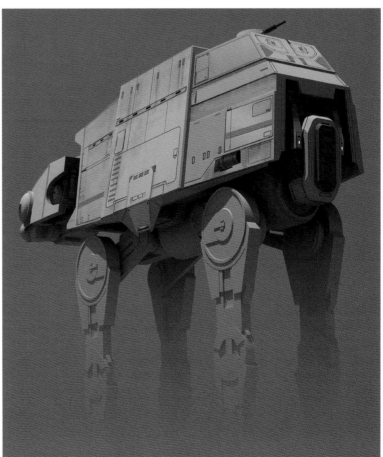

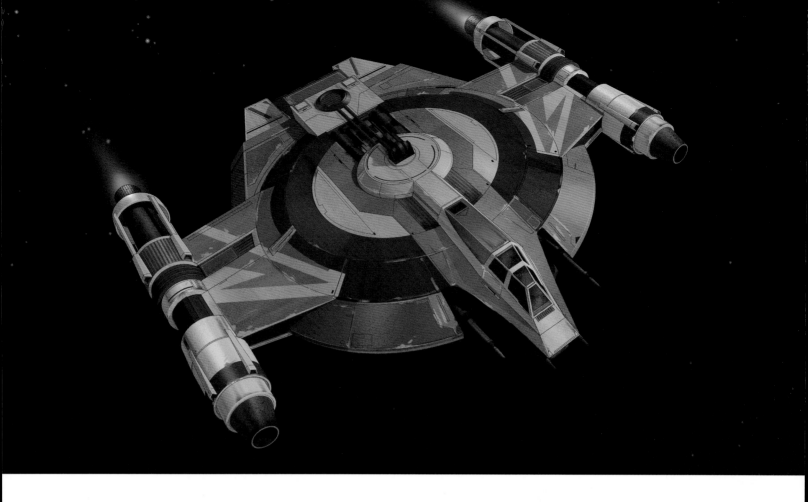

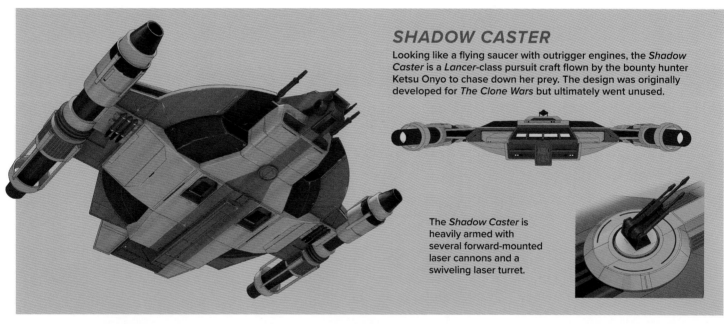

SHADOW CASTER

Looking like a flying saucer with outrigger engines, the *Shadow Caster* is a *Lancer*-class pursuit craft flown by the bounty hunter Ketsu Onyo to chase down her prey. The design was originally developed for *The Clone Wars* but ultimately went unused.

The *Shadow Caster* is heavily armed with several forward-mounted laser cannons and a swiveling laser turret.

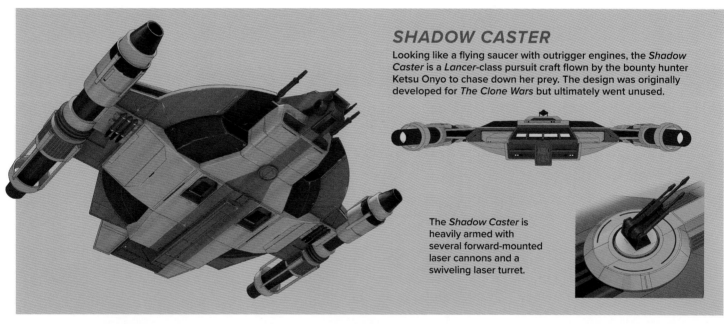This spread: ABC

HAMMERHEAD CORVETTE

The Hammerhead played a notable live-action role in *Rogue One*, pushing a Star Destroyer into a fatal collision with a neighboring warship.

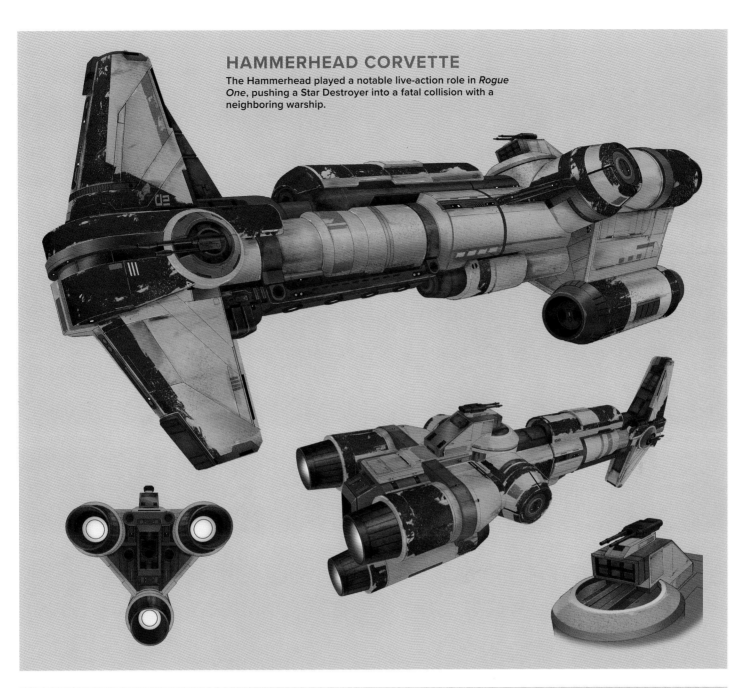

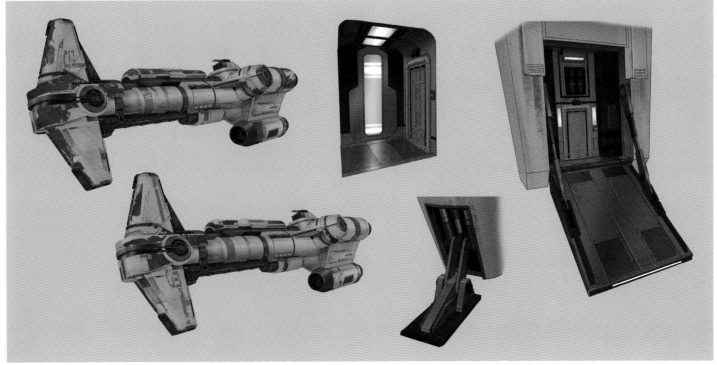

FANG FIGHTER

The primary starfighter of the Mandalorian clans, the Fang fighter is notable for its swivel-mounted wings that lend it remarkable agility during combat. During season two, the Rebels encounter a squadron of Fang fighters that are allied with Fenn Rau's Mandalorian Protectors.

Says Plunkett, "The design for the Fang fighter echoed the Gauntlet troop transport from *The Clone Wars*, while also taking cues from Saab fighter jets."

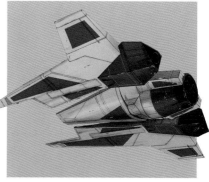

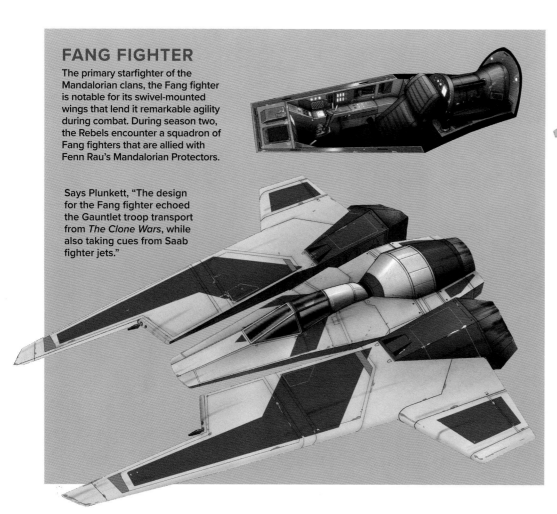

TIE BOMBER

Slow but powerful, TIE bombers carry explosive warheads inside their secondary fuselages and can breach the hull of any battleship.

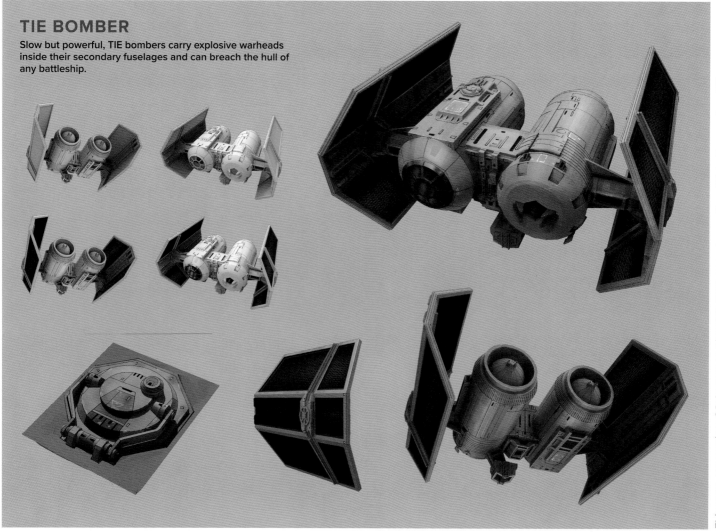

IMPERIAL INTERDICTOR

This experimental Star Destroyer can yank ships from hyperspace by deploying its four gravity-well projectors, visible from the outside as symmetrical hull bumps. The *Rebels* artists found inspiration in a book featuring the work of *Star Wars* designer Doug Chiang. "We did a pretty literal translation of Doug Chiang's Interdictor from *The Essential Guide to Vehicles and Vessels*," says Plunkett. "The bridge layout on the inside evokes the targeting stations on the Death Star."

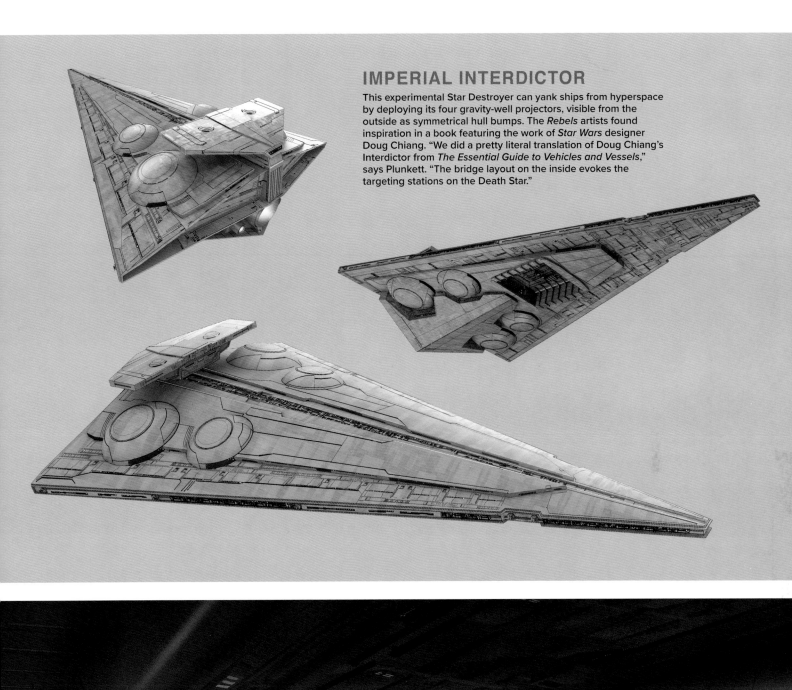

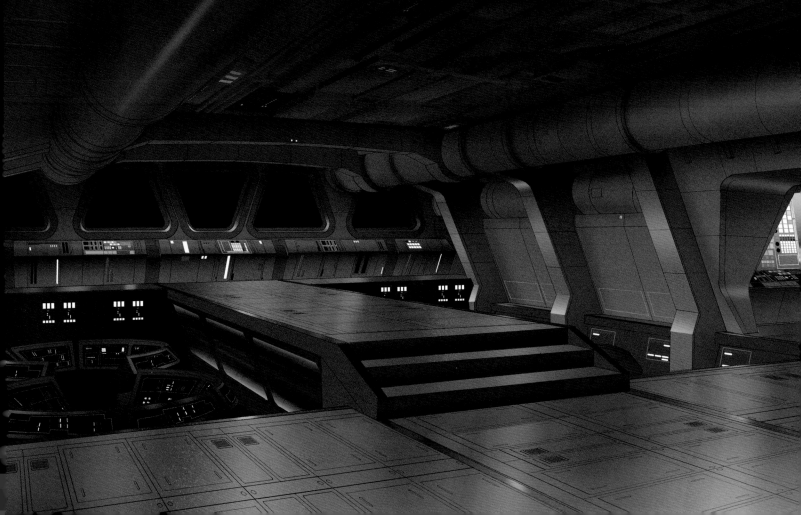

SEASON THREE
THE FATE OF
THE ALLIANCE

The introduction of Grand Admiral Thrawn in season three of *Star Wars Rebels* lands the heroes in more peril than ever before. Thrawn is a rare and deadly thing among the Imperial ranks—a bona fide genius uninterested in vendettas or vague prophecies. But while Thrawn closes in, the Force makes its presence felt in cryptic and terrifying ways. An ancient being known as the Bendu surfaces on Atollon, who could become a mentor for Ezra, if Darth Maul's corruptions don't upset the natural balance first. Other season-defining storylines see Sabine wrestling with the responsibility of wielding the Darksaber and commanding her people, and the appearance of Saw Gerrera and other elements from the feature film *Rogue One: A Star Wars Story*. Season three takes full advantage of *Star Wars Rebels'* backstory to date and the audience's familiarity with its core cast, dispatching its characters on self-contained narratives before bringing them back for satisfying payoffs.

⟟ CHARACTERS
ᒣᒲᛕ7ᛕᚨᚺᛗ7ᚢ

A charismatic Imperial commander draws the Emperor's formidable military forces into position and ready to strike against the hidden Rebel heroes in season three, which is also notable for the roles that are played by the mysterious agents of the Force. Sabine's personal history resurfaces in drama with the clans of Mandalore who seem determined and poised to pull her away from her Rebel family forever, putting stress on the ties that bind our heroes together.

EZRA BRIDGER

Ezra's redesign for season three stands out, particularly for the character's closely cropped hairstyle. A sign of Ezra's growing maturity, it indicates that he has become willing to make dramatic breaks from his past self.

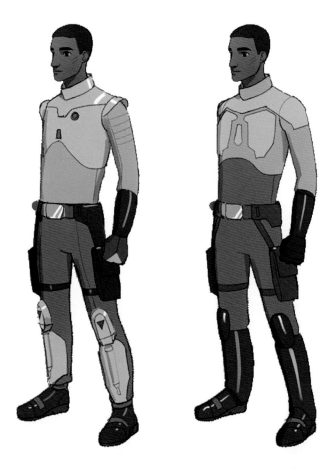

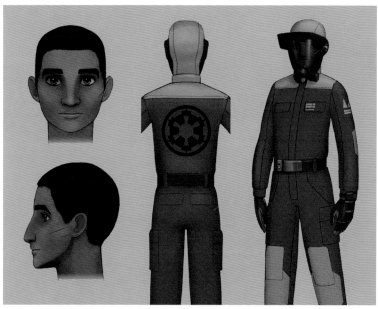

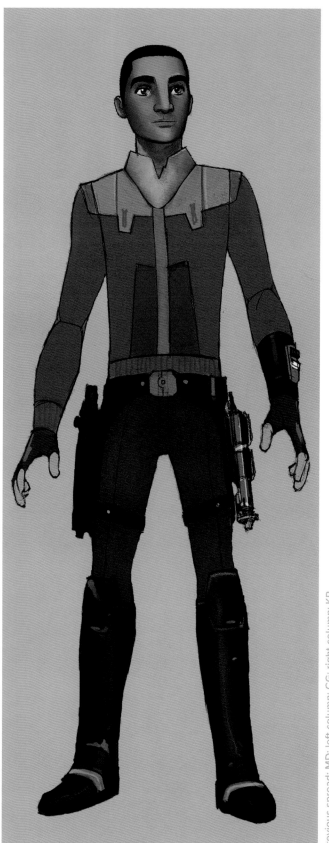

Previous spread: MD; left column: CG; right column: KP

Season three contains a critical arc for Ezra as he drifts ever closer to the dark side of the Force.

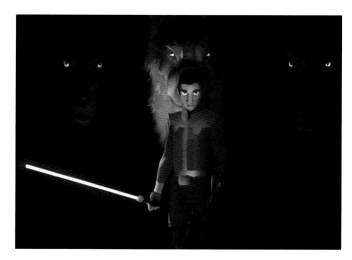

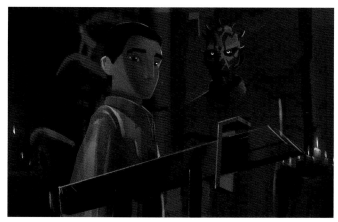

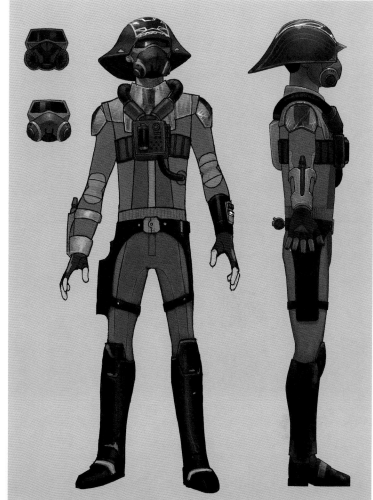

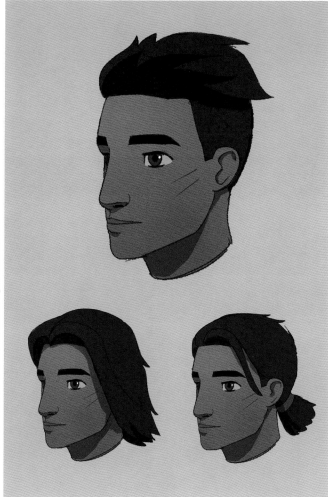

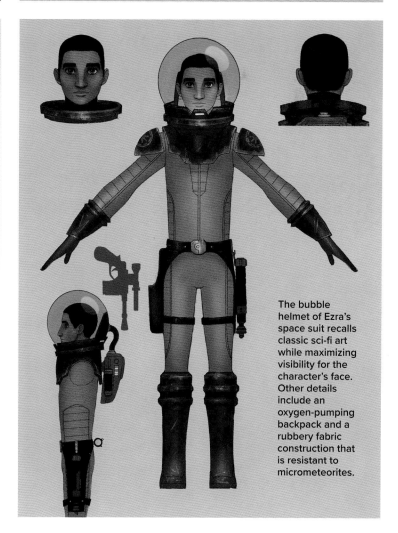

The bubble helmet of Ezra's space suit recalls classic sci-fi art while maximizing visibility for the character's face. Other details include an oxygen-pumping backpack and a rubbery fabric construction that is resistant to micrometeorites.

Left middle and bottom: CG; top left: MD; right column: LH

OBI-WAN KENOBI

Though Obi-Wan was a core protagonist in *Star Wars: The Clone Wars*, the time-jump of *Star Wars Rebels* required a redesign of the character that more closely resembled Alec Guinness's take on the character in *A New Hope*, rather than Ewan McGregor's portrayals in the prequel films. Obi-Wan's ultimate showdown with Darth Maul in season three's "Twin Suns" became a highlight of the series' run.

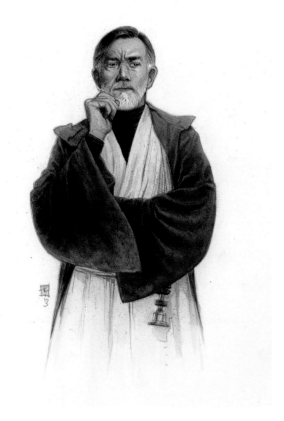

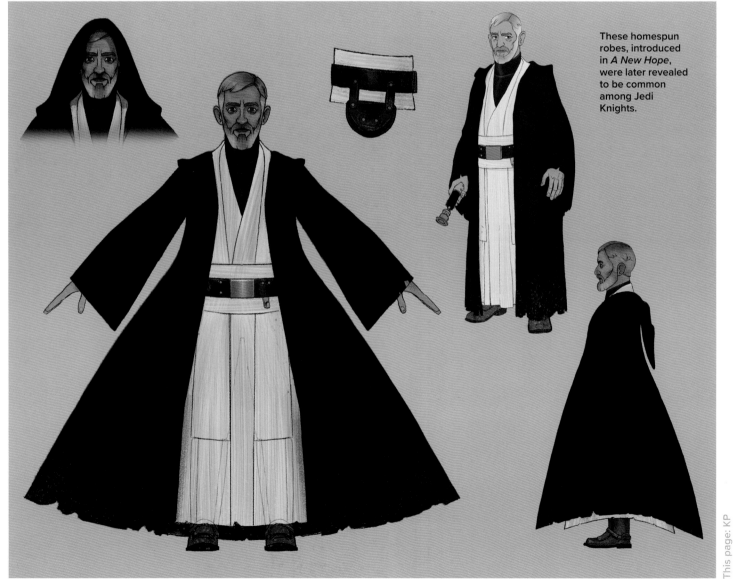

These homespun robes, introduced in *A New Hope*, were later revealed to be common among Jedi Knights.

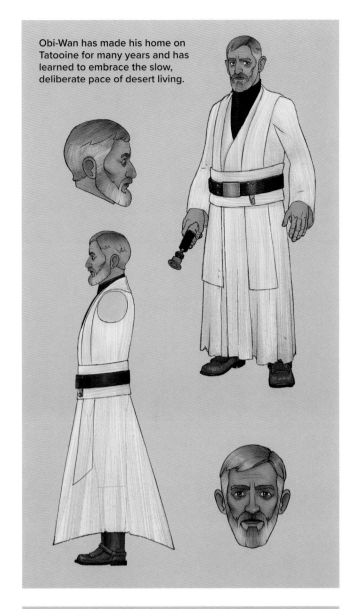

Obi-Wan has made his home on Tatooine for many years and has learned to embrace the slow, deliberate pace of desert living.

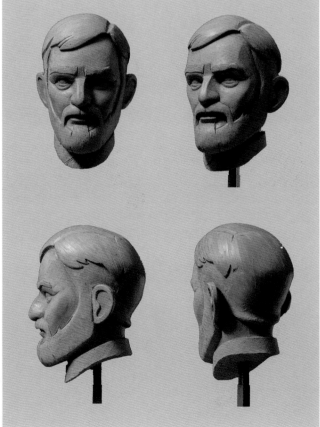

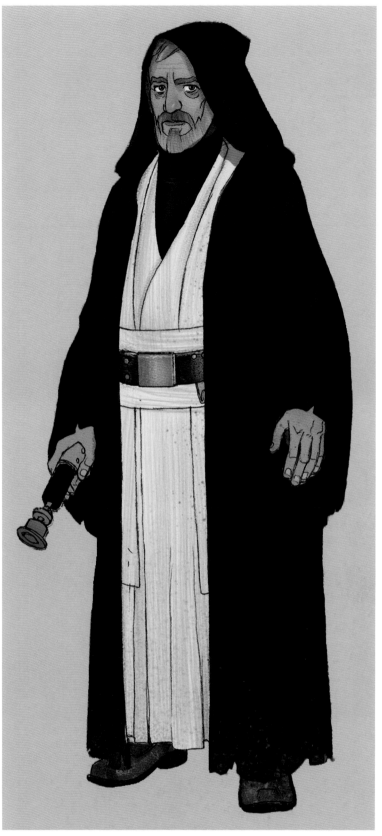

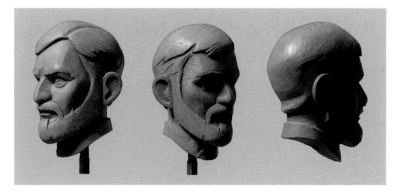

GRAND ADMIRAL THRAWN

Grand Admiral Thrawn debuted in a 1990s novel, but the character's Moriarity-like, sinister genius has made him a fan favorite with roles in many forms of *Star Wars* media. "It was important that our Thrawn be visibly alien, not simply a human with blue skin," explains Plunkett. "Amy Beth Christenson added his inhumanly high forehead and subtle brow bulges."

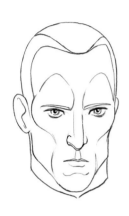

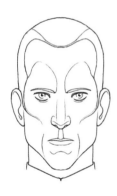

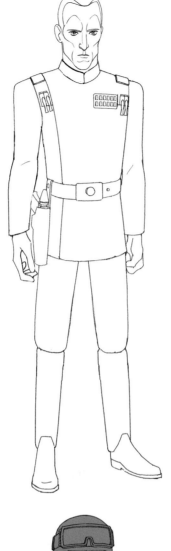

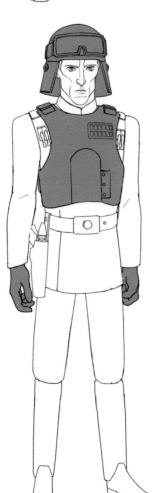

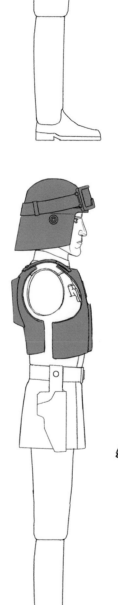

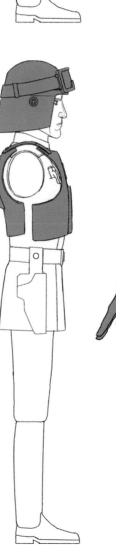

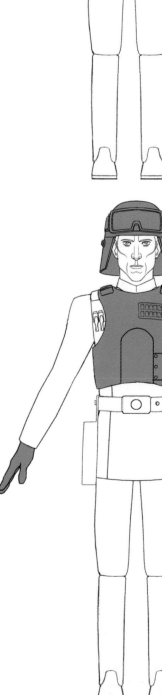

Thrawn is seen here wearing field armor, protected by a breastplate and a flared helmet. This style of armor originated in *The Empire Strikes Back*, worn by General Veers during the Battle of Hoth.

Uncolored line art: ABC; bottom three figures: EM

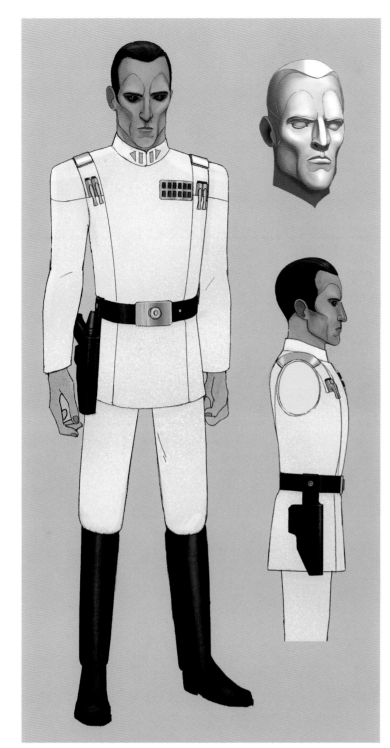
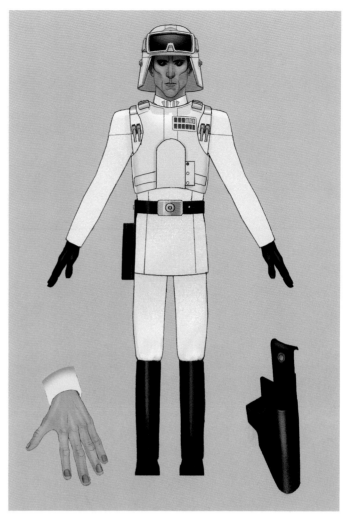
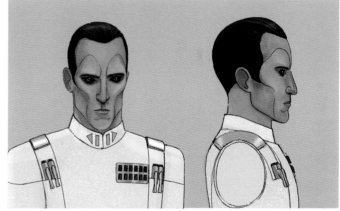

KANAN JARRUS

At the end of the previous season, Kanan was blinded with a slash from Darth Maul's lightsaber. To prep for the character's return, the *Star Wars Rebels* artists explored designs that would both conceal Kanan's injury while suggesting the reality of his ongoing condition.

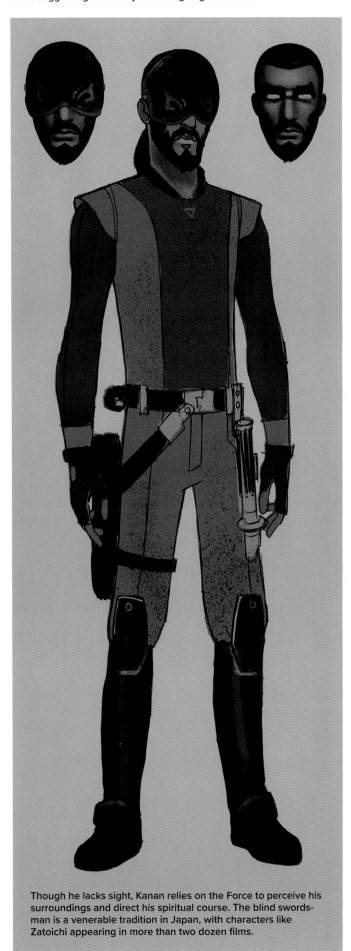

Though he lacks sight, Kanan relies on the Force to perceive his surroundings and direct his spiritual course. The blind swordsman is a venerable tradition in Japan, with characters like Zatoichi appearing in more than two dozen films.

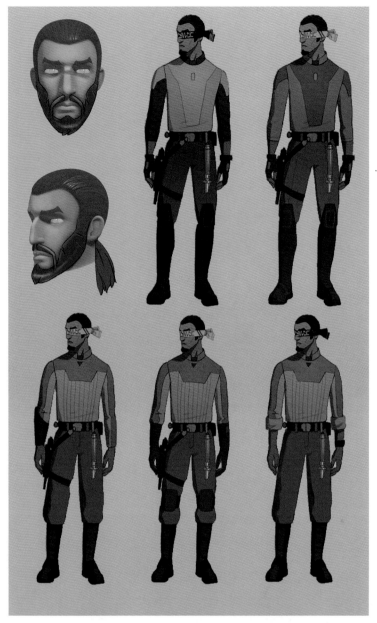

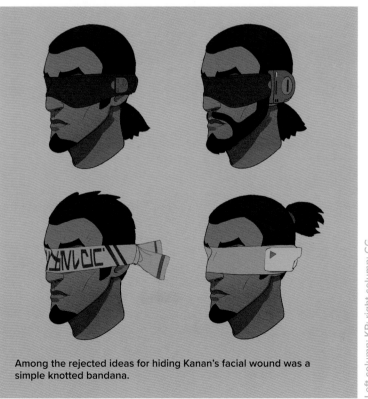

Among the rejected ideas for hiding Kanan's facial wound was a simple knotted bandana.

Left column: KP; right column: CG

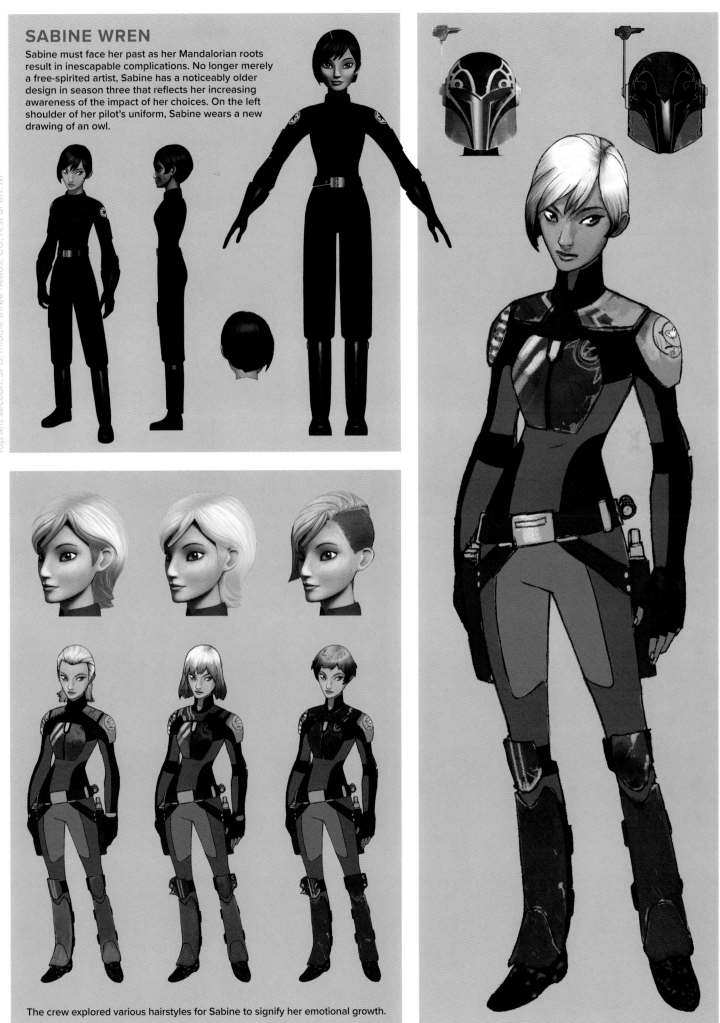

SABINE WREN

Sabine must face her past as her Mandalorian roots result in inescapable complications. No longer merely a free-spirited artist, Sabine has a noticeably older design in season three that reflects her increasing awareness of the impact of her choices. On the left shoulder of her pilot's uniform, Sabine wears a new drawing of an owl.

The crew explored various hairstyles for Sabine to signify her emotional growth.

Top left section: JPB; middle three heads: CG; rest of art: KP

MON MOTHMA

No one in the Rebellion holds a higher rank than Mon Mothma, and the character's introduction in season three provides critical backstory behind the founding of the Rebel Alliance.

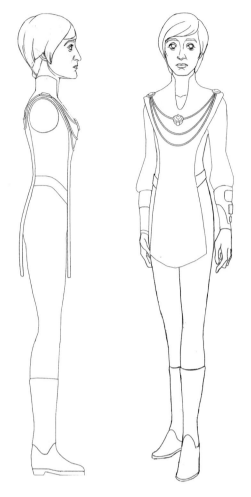

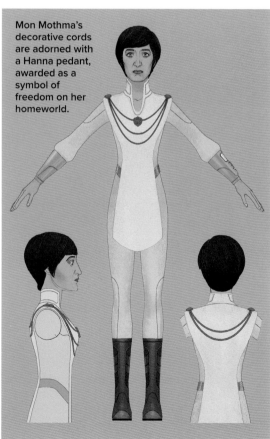

Mon Mothma's decorative cords are adorned with a Hanna pedant, awarded as a symbol of freedom on her homeworld.

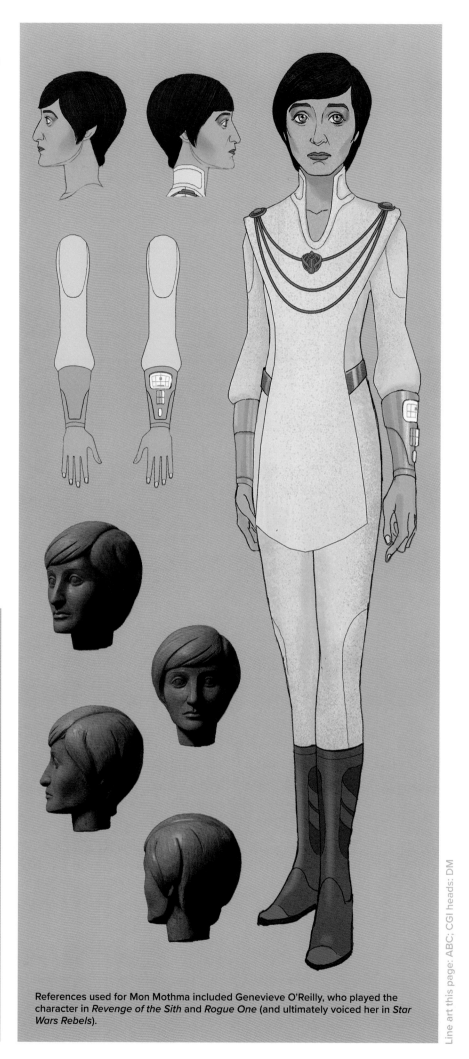

References used for Mon Mothma included Genevieve O'Reilly, who played the character in *Revenge of the Sith* and *Rogue One* (and ultimately voiced her in *Star Wars Rebels*).

Line art this page: ABC; CGI heads: DM

DARTH MAUL

Consumed by hate for nearly three decades, a haggard Darth Maul finally faces his nemesis in season three of *Star Wars Rebels*. Maul's showdown with Obi-Wan is ultimately more about moral consequences than fight choreography.

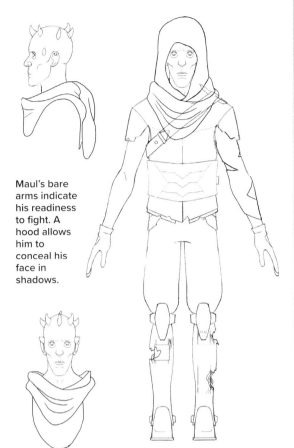

Maul's bare arms indicate his readiness to fight. A hood allows him to conceal his face in shadows.

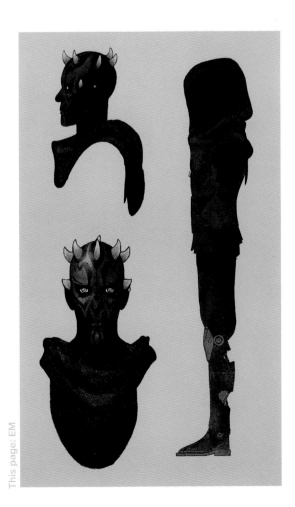

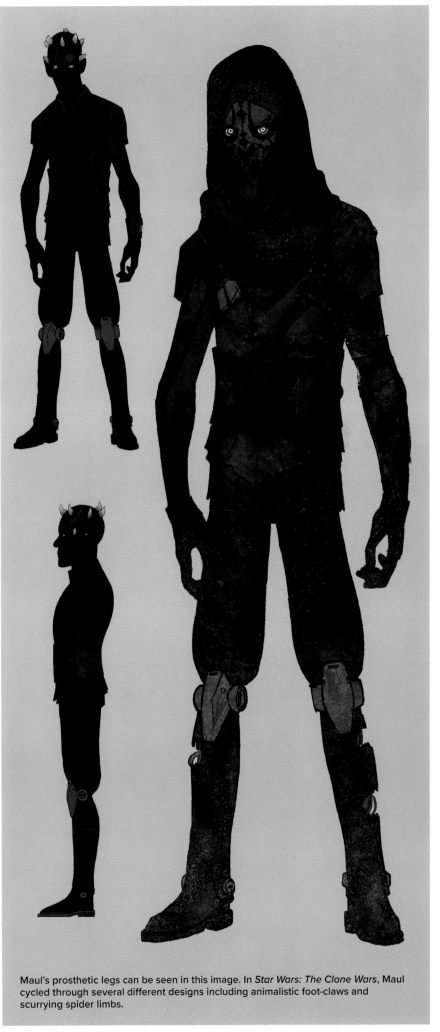

Maul's prosthetic legs can be seen in this image. In *Star Wars: The Clone Wars*, Maul cycled through several different designs including animalistic foot-claws and scurrying spider limbs.

This page: EM

BENDU

The enigmatic creature known as Bendu embodies the balance of the Force between its light side and dark side (or its "ashla" and "bogan"). On Atollon, Kanan receives wisdom from Bendu that helps him deal with his blindness.

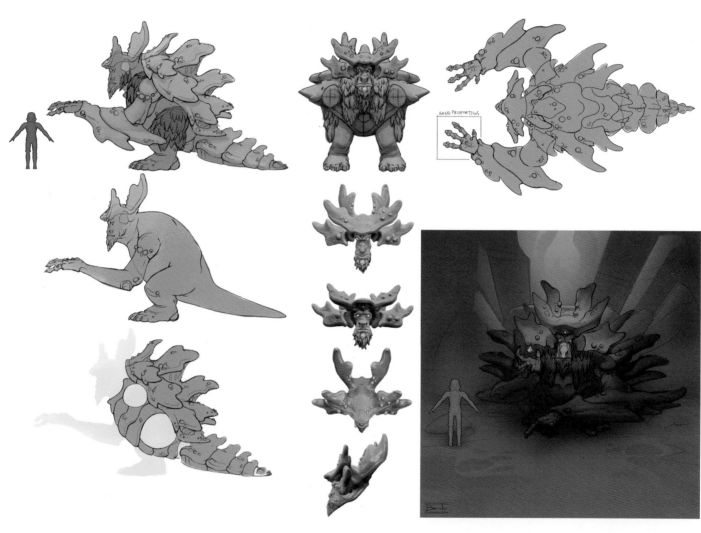

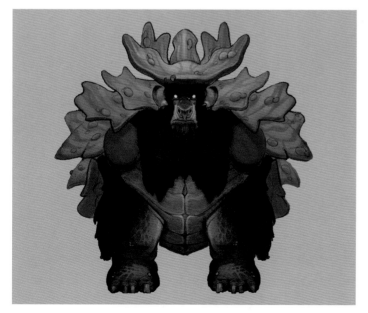

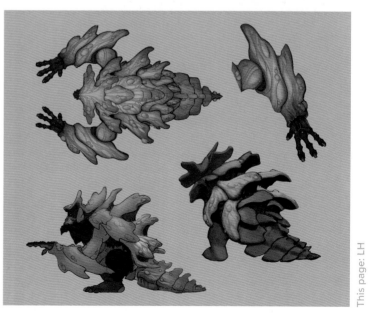

"Bendu was inspired by the large-scale puppets in movies like *The Neverending Story*," explains Plunkett. "Luke Harrington worked on the design as we broke down Bendu's layers—his body, coral carapace, and fur. The plating on the body works like camouflage."

URSA WREN

Sabine's mother leads Clan Wren, belonging to the Mandalorian House of Vizsla. After Sabine denounced the Empire for its plans to test weapons against the Mandalorian people, a staunchly loyal Ursa turned her back on her own daughter.

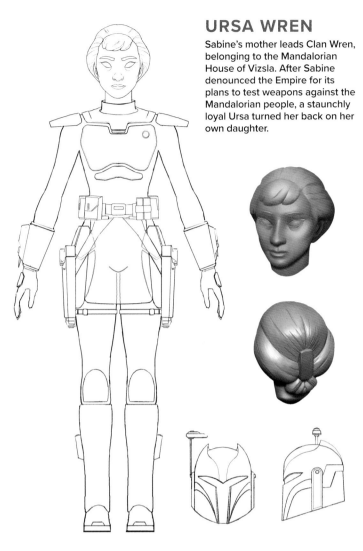

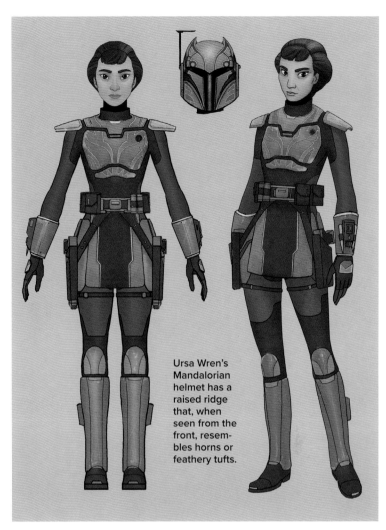

Ursa Wren's Mandalorian helmet has a raised ridge that, when seen from the front, resembles horns or feathery tufts.

TRISTAN WREN

Tristan is Sabine's brother, who joined Gar Saxon's Imperial Super Commandos in a bid to restore his family's honor following his sister's disgrace.

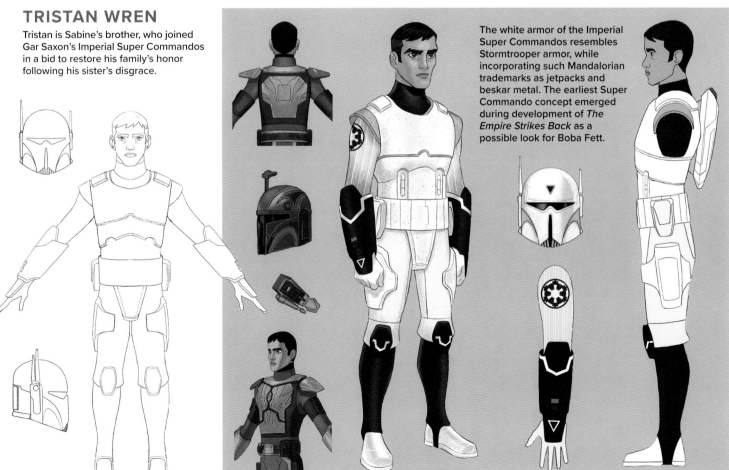

The white armor of the Imperial Super Commandos resembles Stormtrooper armor, while incorporating such Mandalorian trademarks as jetpacks and beskar metal. The earliest Super Commando concept emerged during development of *The Empire Strikes Back* as a possible look for Boba Fett.

Top section: LH; bottom section: ZP

WEDGE ANTILLES

This unpretentious Rebel pilot appeared in all three films of the classic *Star Wars* trilogy and makes his *Rebels* debut in season three's "The Antilles Extraction," defecting to the Rebellion alongside his fellow Imperial cadet, Hobbie.

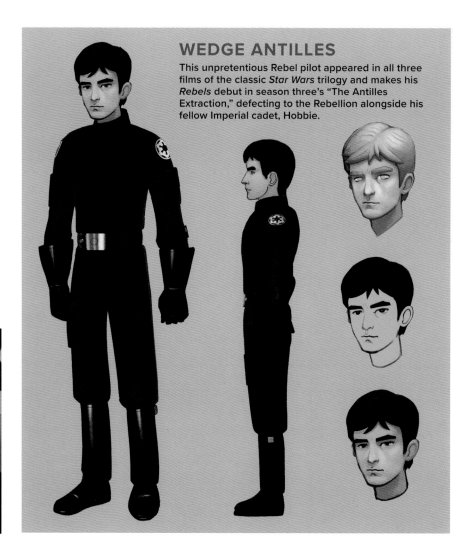

AGENT KALLUS

In season two, Agent Kallus survived a night of polar exposure inside an ice cave with Zeb Orrelios. The experience forced him to find common ground with his ostensible enemy, and by season three, Kallus has secretly switched allegiances. Still a highly placed Imperial agent, Kallus is now a deep-cover Rebel spy.

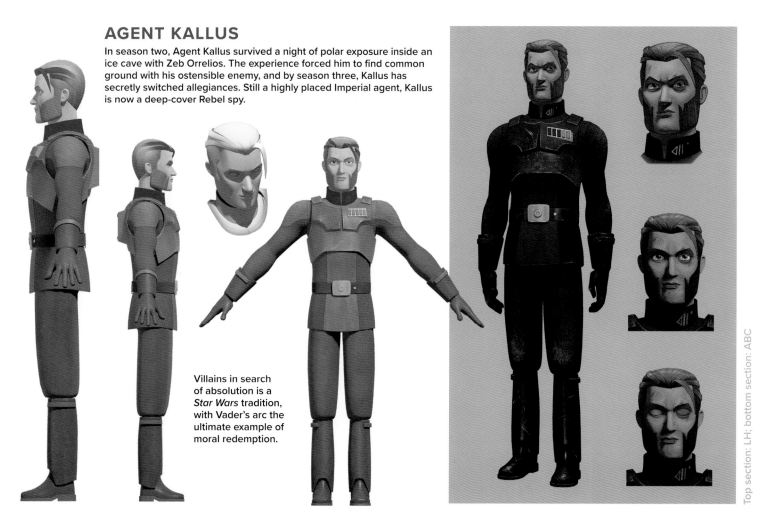

Villains in search of absolution is a *Star Wars* tradition, with Vader's arc the ultimate example of moral redemption.

Top section: LH; bottom section: ABC

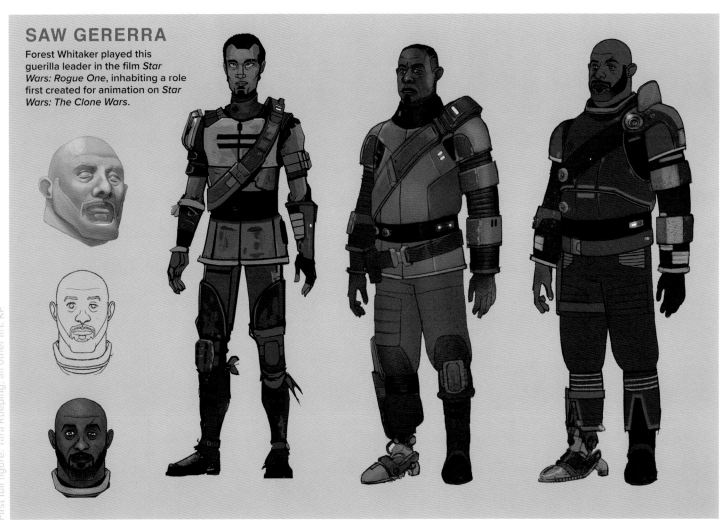

SAW GERERRA

Forest Whitaker played this guerilla leader in the film *Star Wars: Rogue One*, inhabiting a role first created for animation on *Star Wars: The Clone Wars*.

"Updating the character design meant finding a middle ground," explains Plunkett. "We had Forest Whittaker and we had *The Clone Wars*, so we had to pick a version from somewhere in between in finalizing our design."

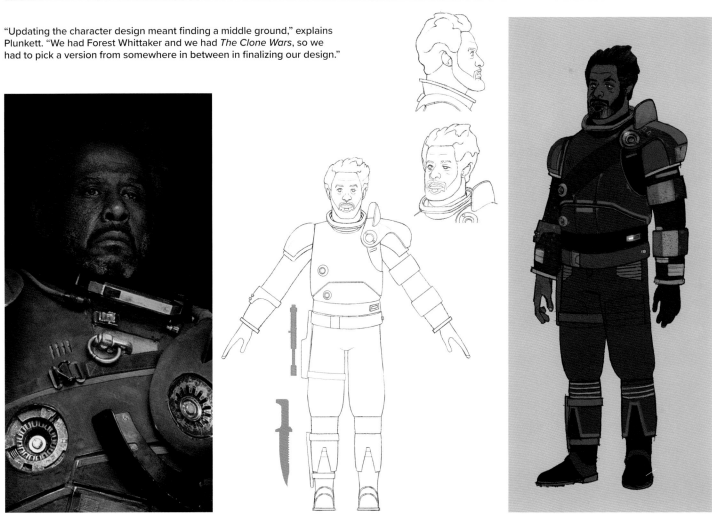

⟨logo⟩ ENVIRONMENTS
ᏙᏁᏗᏴᏆᏁᎧᏗᏔᏝᏙᏁᏗᏝᏋᏔ

Just as the Rebels are ready to settle into their new HQ on Atollon, danger arrives from every vector. Not only is the Empire determined to expose their Outer Rim refuge at any cost, but Grand Admiral Thrawn seems able to anticipate every move that our heroes make. Meanwhile, Darth Maul continues to seek out a showdown on Tatooine, and Sabine returns to her home and her biological family in Mandalorian space, ready to face her past head-on.

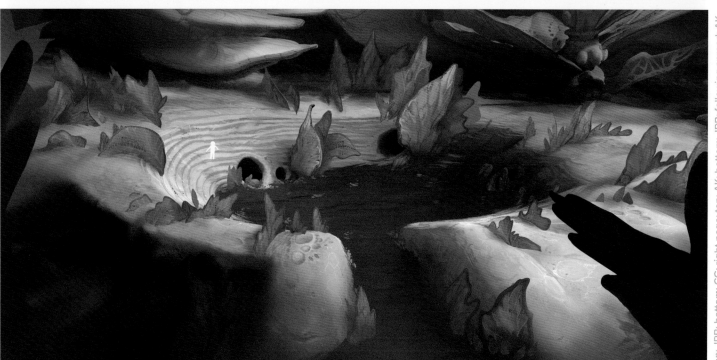

Atollon (*above*) won't remain a Rebel safe haven for long. Reklam Station (*right*), an Imperial salvage facility, hovers amid the thick clouds of the planet Yarma. The station's design is partially based on a McQuarrie concept for *Return of the Jedi*'s second Death Star.

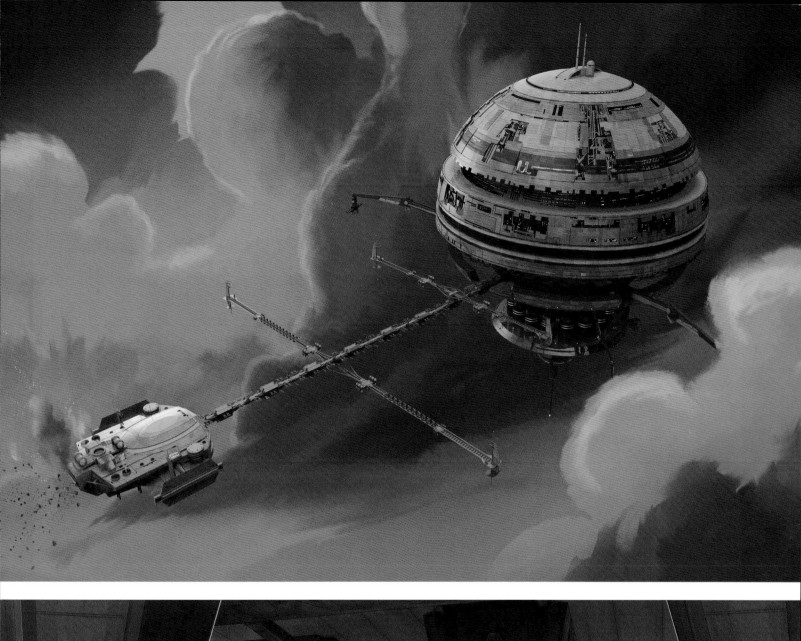

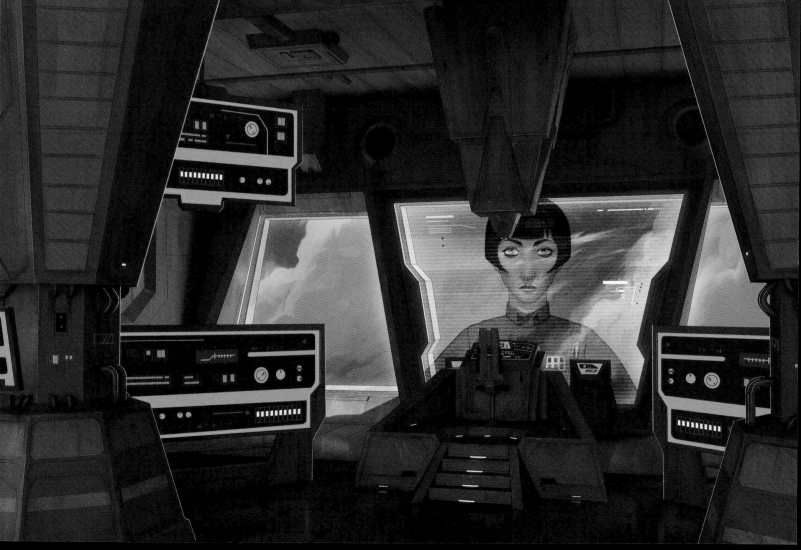

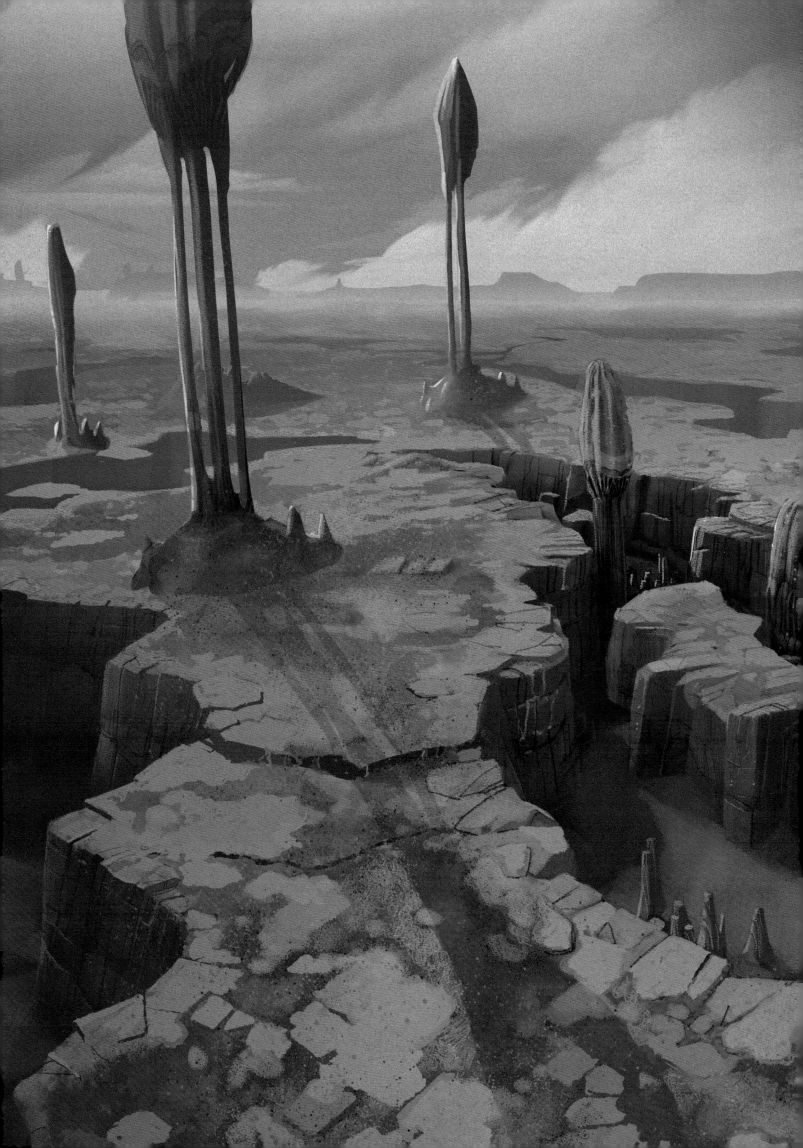

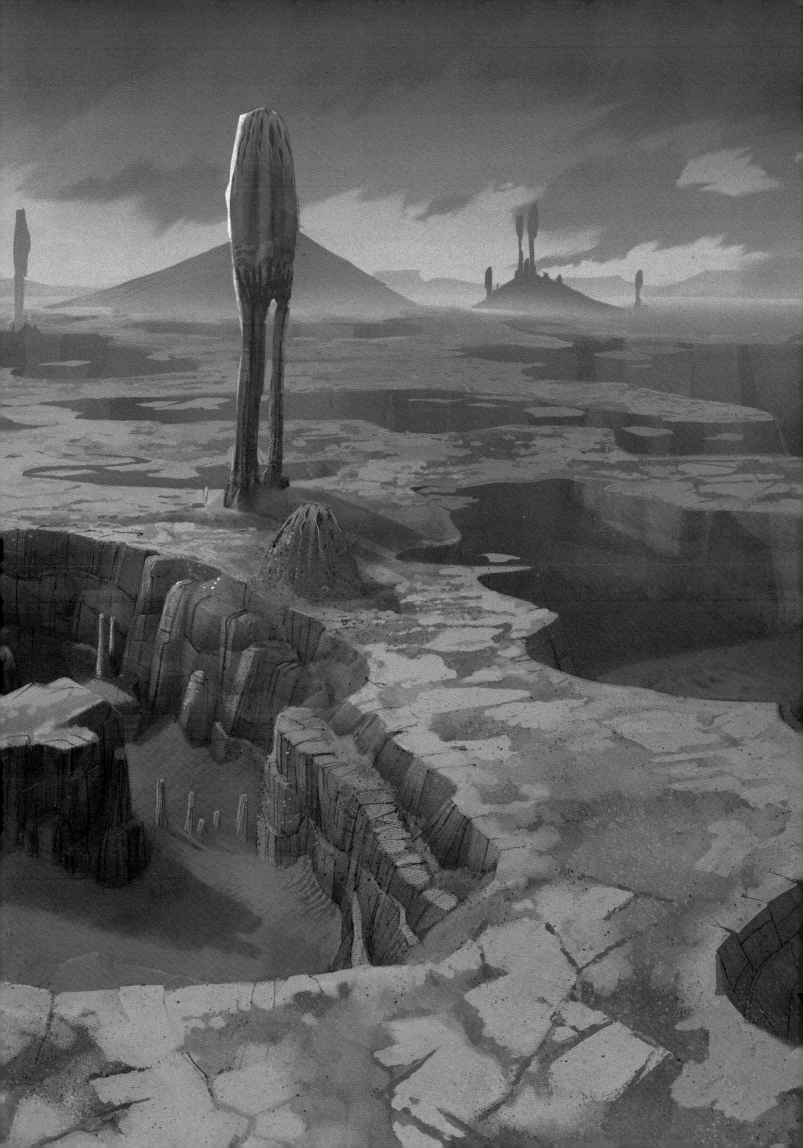

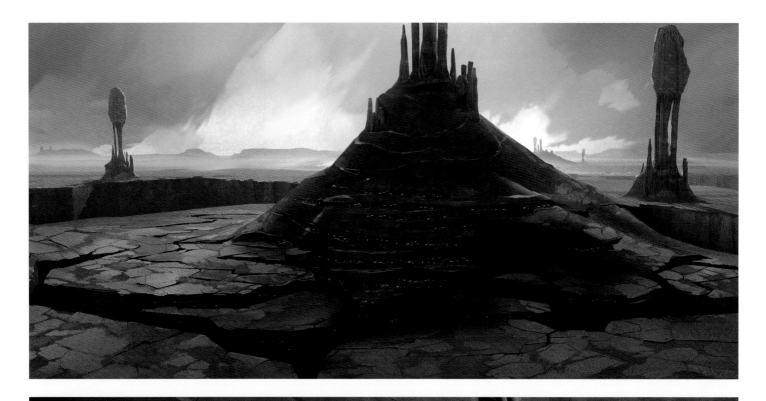

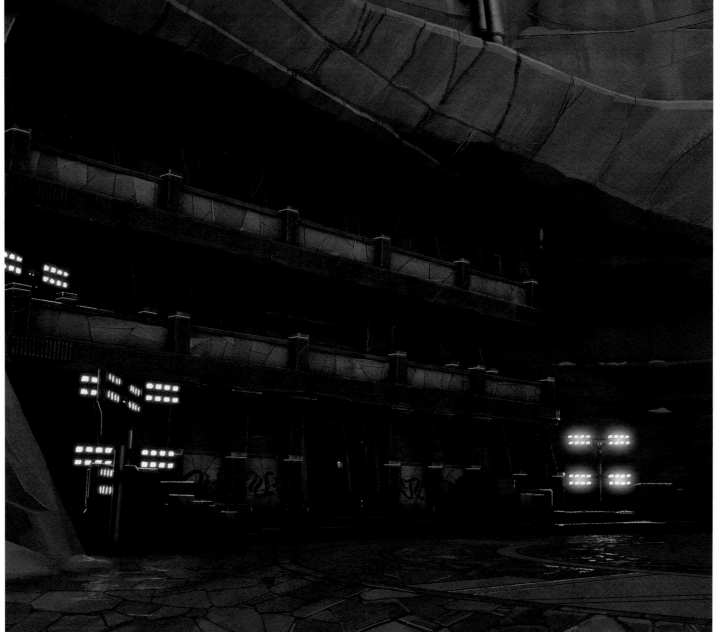

Bottom left: AK; rest of spread: ABC

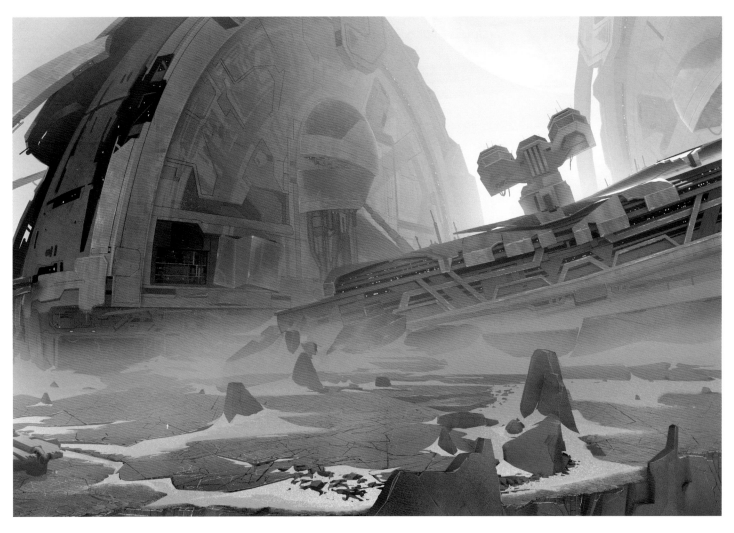

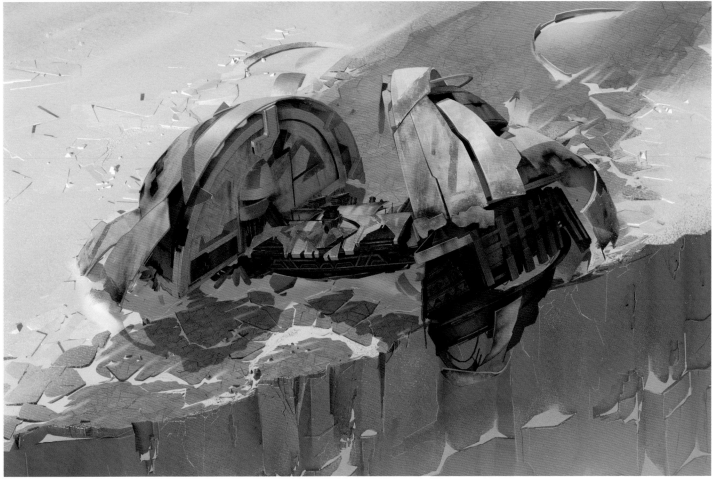

A ruined Separatist Core Sphere (*above*) still lies on a long-ago Agamar battlefield.

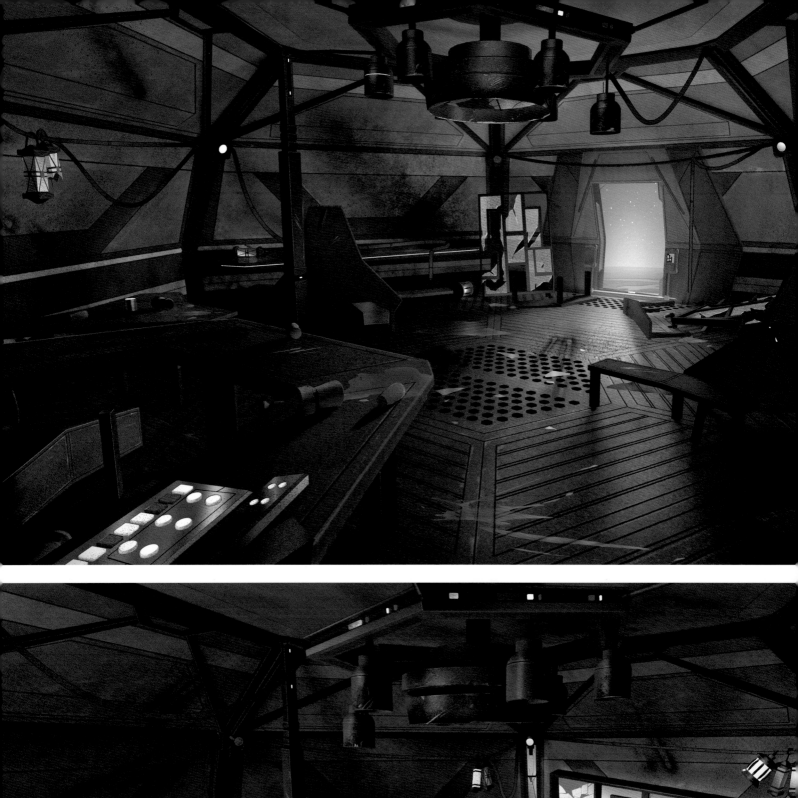
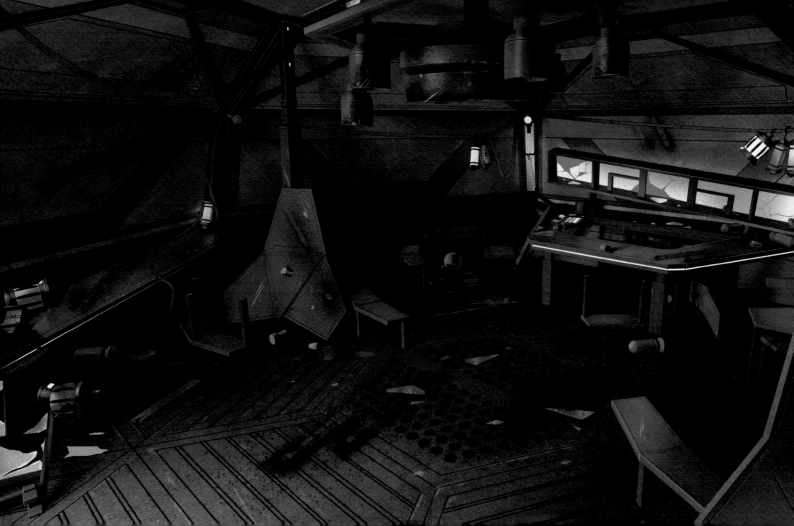

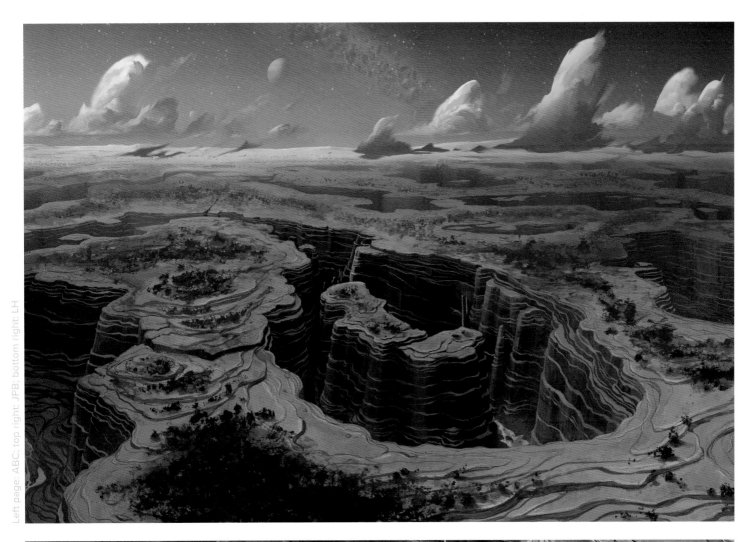

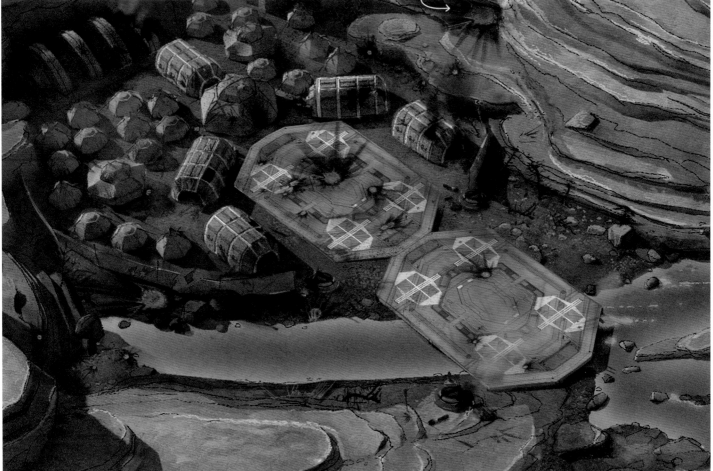

Both of these pieces are of Concord Dawn from the episode "Imperial Supercommandos."

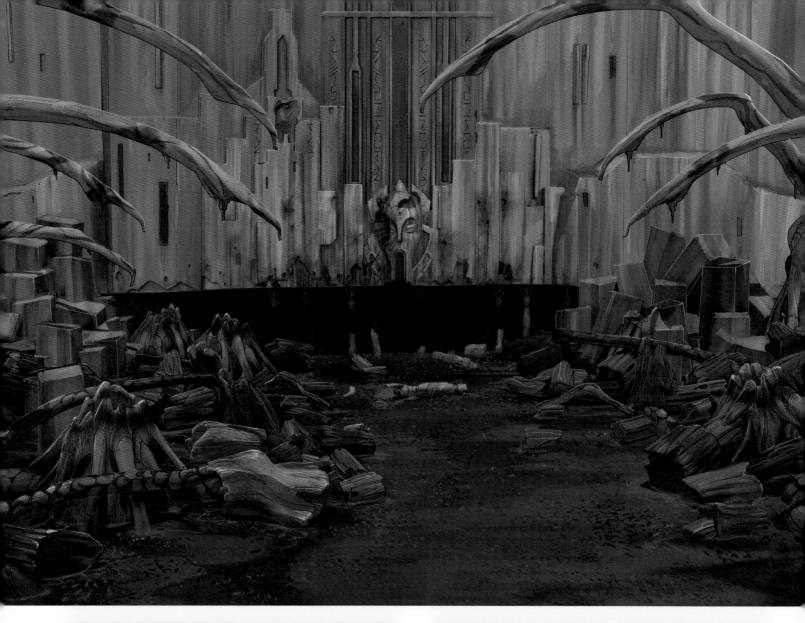

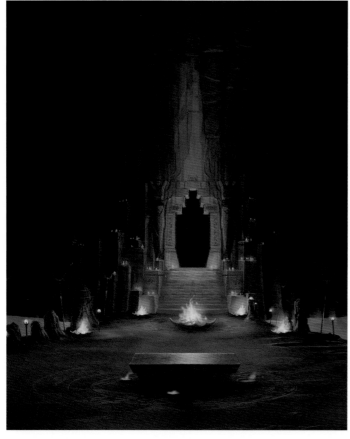

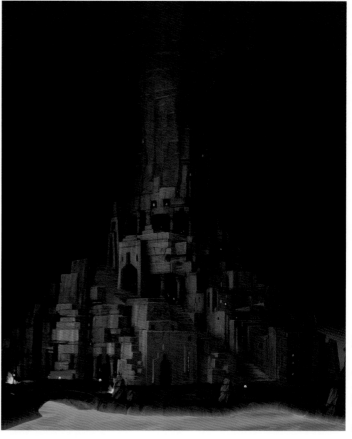

Dathomir is a sinister world of sacrificial magic. The lit flames in this cavern illuminate a ritual altar.

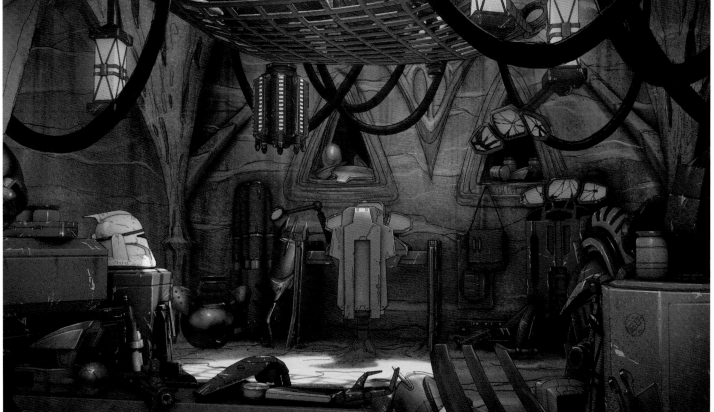

Top: JP; bottom: EM; following page: LH

At the top is the central tunnel shaft on Geonosis from "Ghosts of Geonosis Part 1." The bottom is an image of Klik Klak's nest on Geonosis from the episode "Ghosts of Geonosis Part 2." Following spread: The Mandalorian asteroid base from "The Holocrons of Fate."

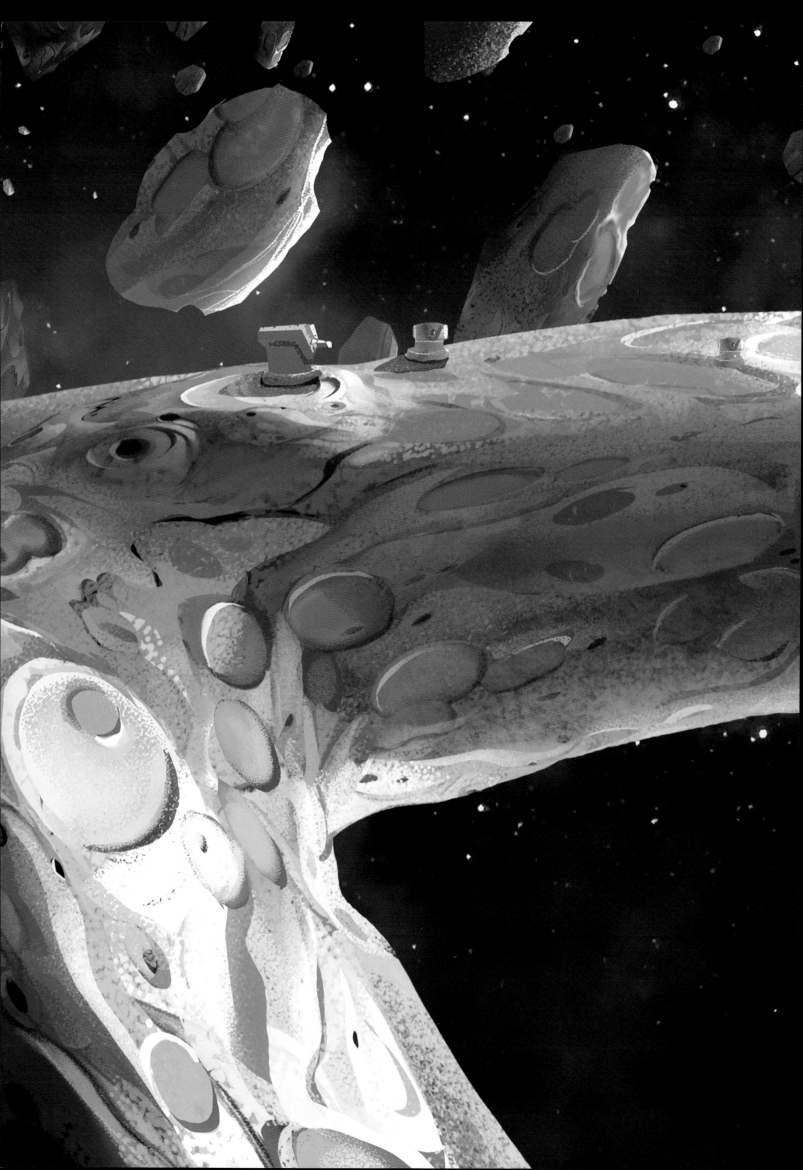

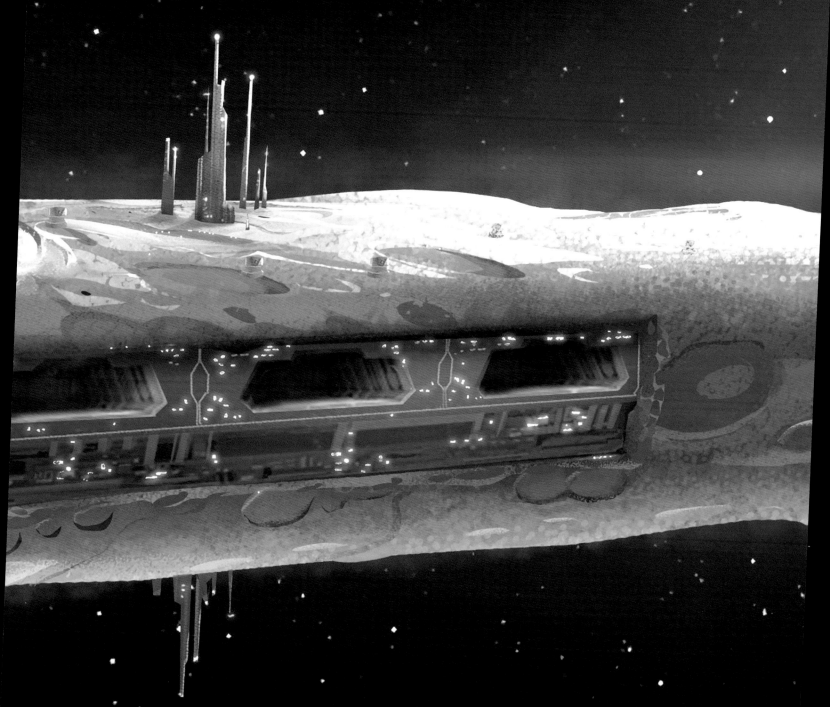

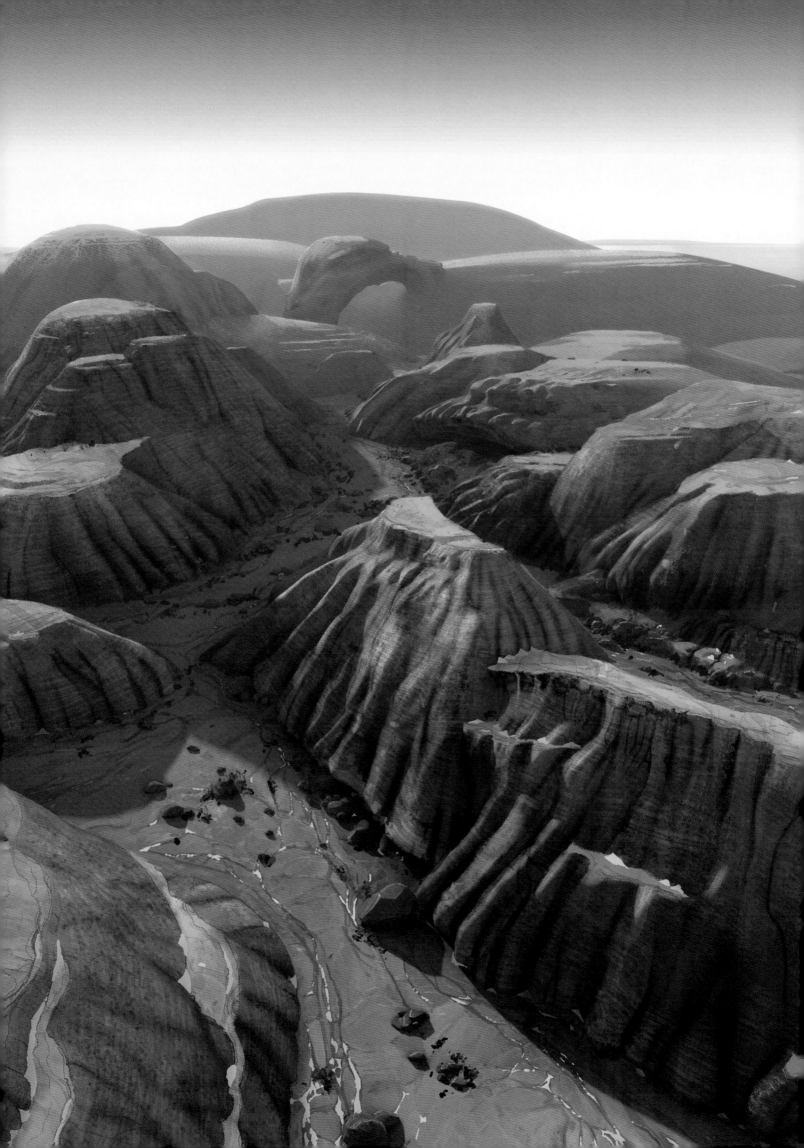

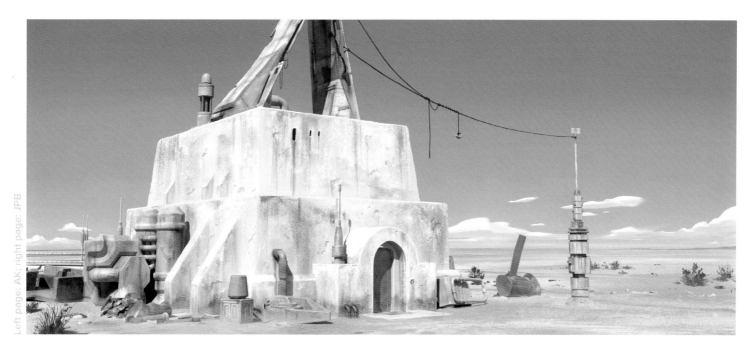

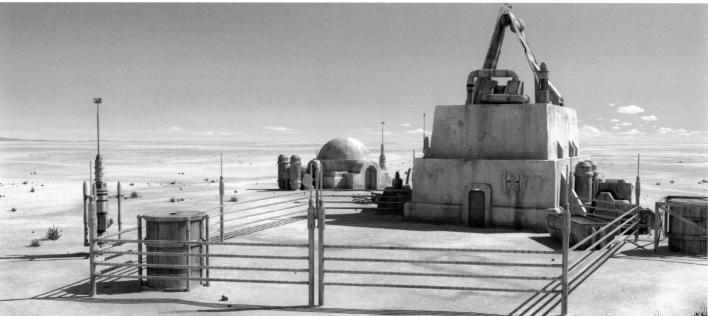

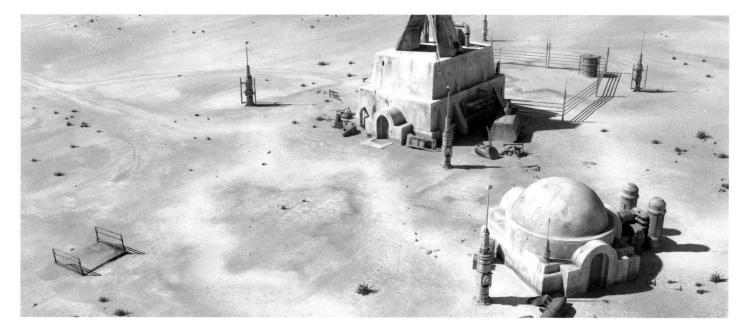

Tatooine's Jundland Wastes (*left*) are the hunting grounds of the native Tusken Raiders. The homesteads of Tatooine settlers are modest constructions that use moisture vaporators to condense water from the air. These specific environments were created for a scene that was cut from the final version of the episode.

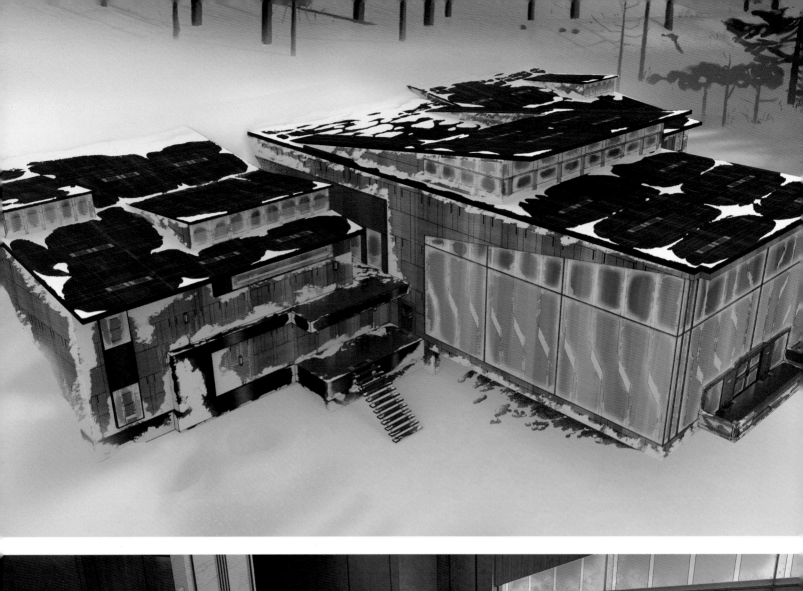

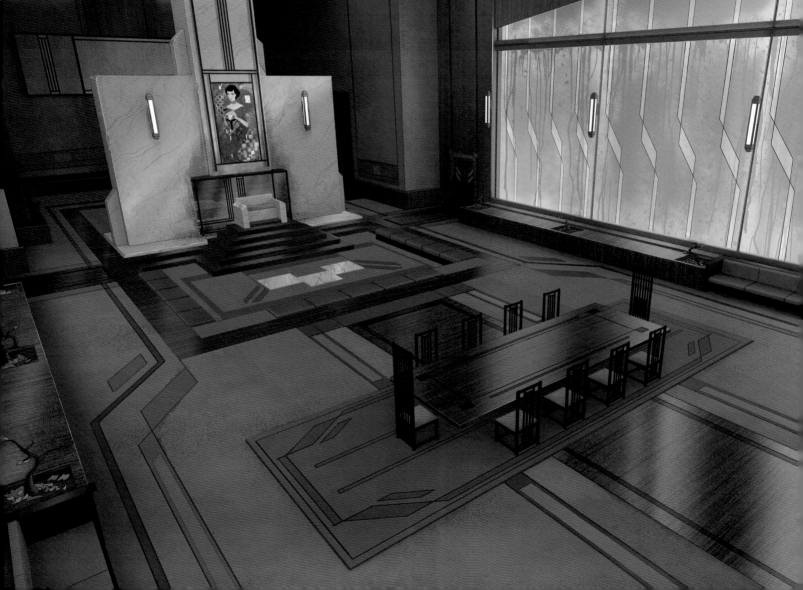

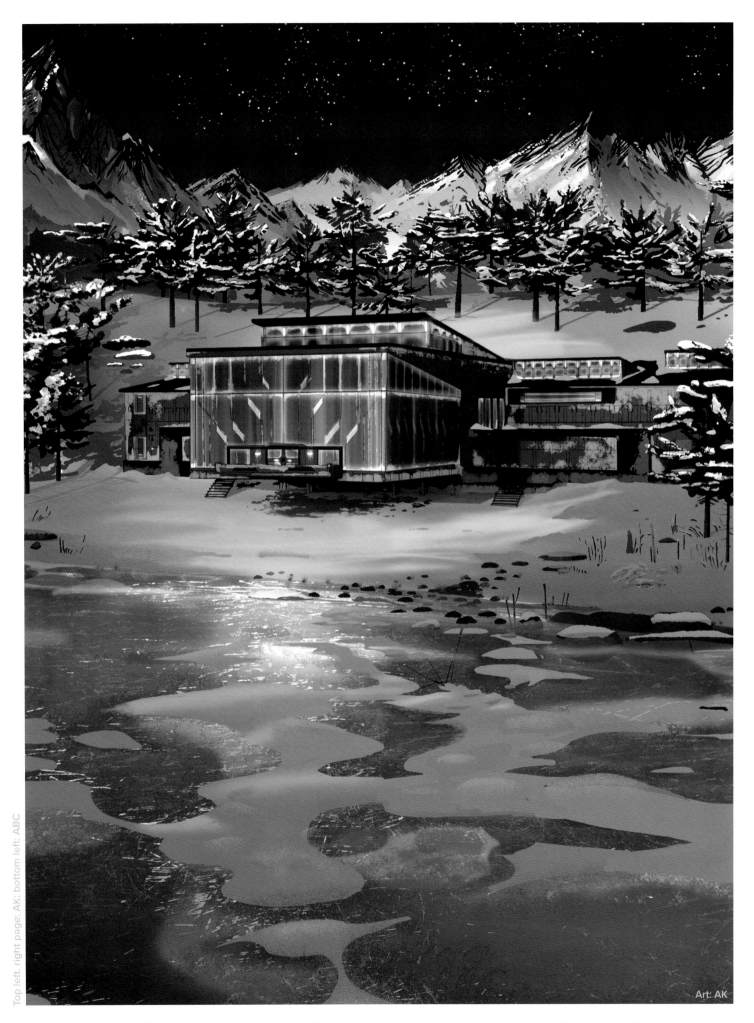

Art: AK

These views depict Clan Wren's stronghold on the icy world of Krownest. "It was an opportunity to elaborate on the Mandalorian aesthetic with snowy mountains," says Plunkett. "The throne room is modeled on the main meeting room at Lucasfilm's Big Rock Ranch."

PROPS

ꃎ�7ꎄꂔꆜ

The weapons of season three include those wielded by Mandalorian clan warriors and scavenged by desert nomads. The increased role of secondary factions in season three expanded the toolbox far beyond familiar Imperial and Rebel designs.

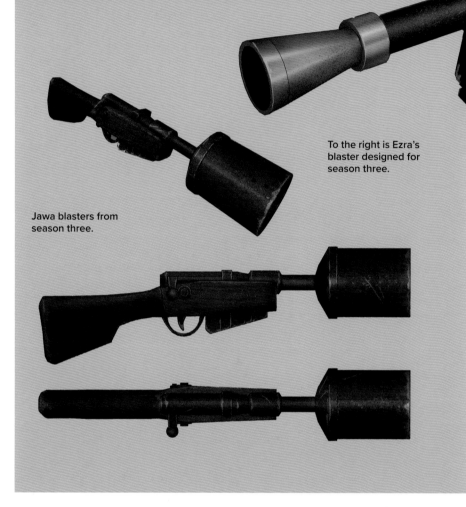

To the right is Ezra's blaster designed for season three.

Jawa blasters from season three.

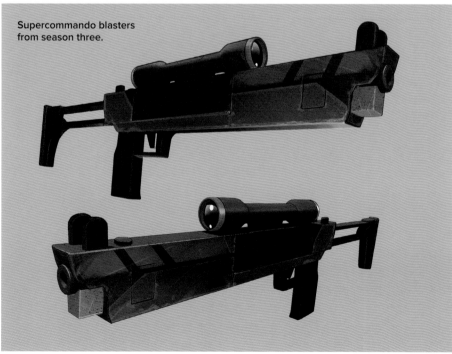

Supercommando blasters from season three.

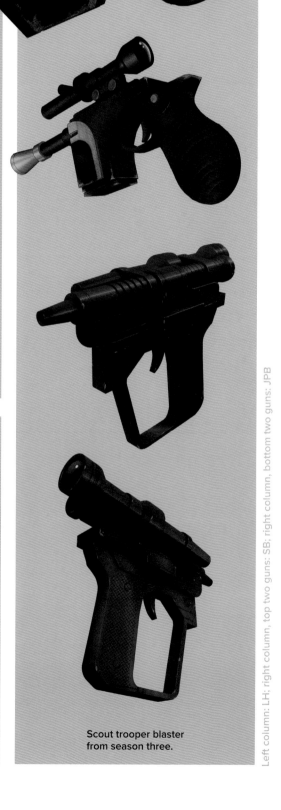

Scout trooper blaster from season three.

Left column: LH; right column, top two guns: SB; right column, bottom two guns: JPB

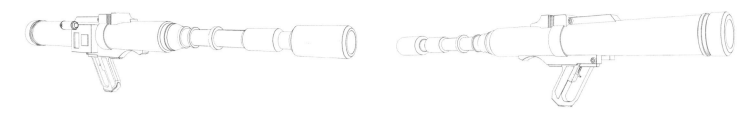

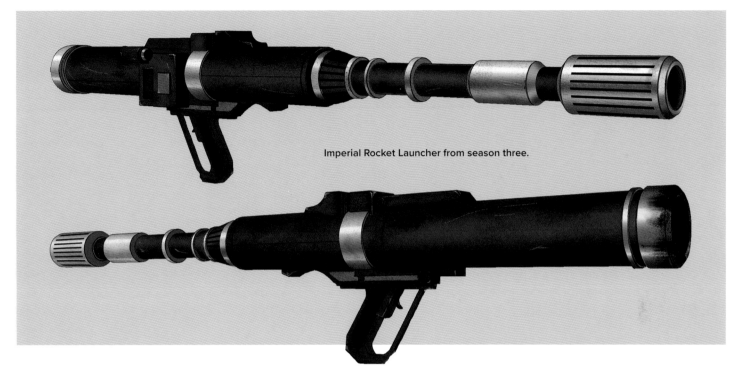

Imperial Rocket Launcher from season three.

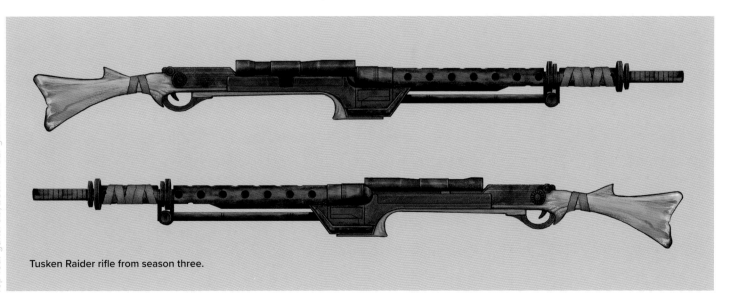

Tusken Raider rifle from season three.

LIGHTSABERS

These lightsaber treatments include several studies of Obi-Wan Kenobi's classic blade. Also seen is a three-bladed "crossguard saber," similar to Kylo Ren's weapon in *The Force Awakens*.

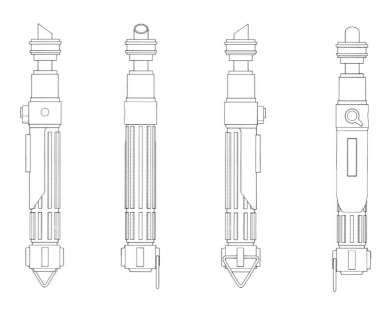

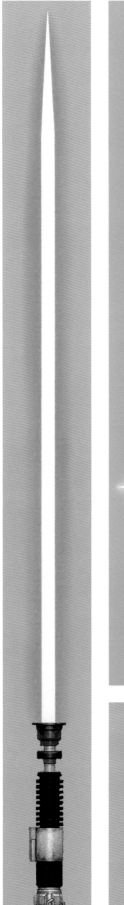

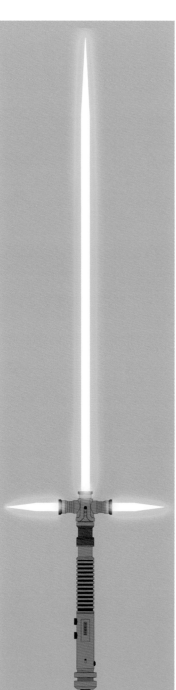

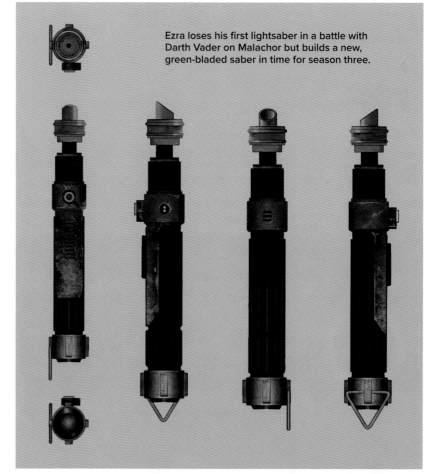

Ezra loses his first lightsaber in a battle with Darth Vader on Malachor but builds a new, green-bladed saber in time for season three.

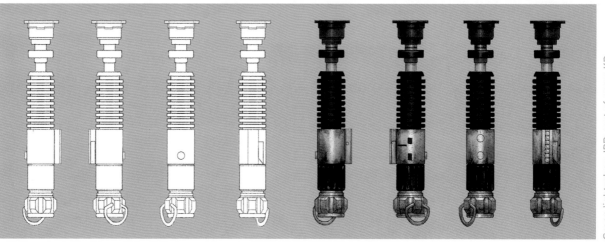

Green lightsaber: JPB; rest of page: KP

Top left section: AK; top right section: SB; bottom section: JPB

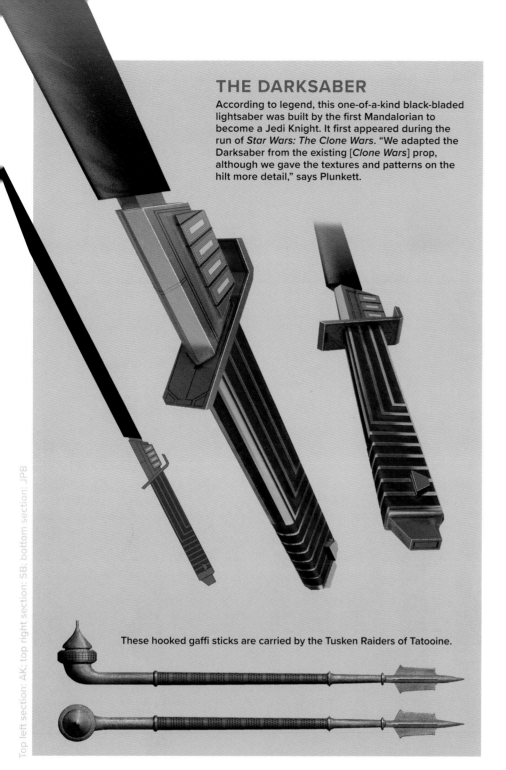

THE DARKSABER

According to legend, this one-of-a-kind black-bladed lightsaber was built by the first Mandalorian to become a Jedi Knight. It first appeared during the run of *Star Wars: The Clone Wars*. "We adapted the Darksaber from the existing [*Clone Wars*] prop, although we gave the textures and patterns on the hilt more detail," says Plunkett.

These hooked gaffi sticks are carried by the Tusken Raiders of Tatooine.

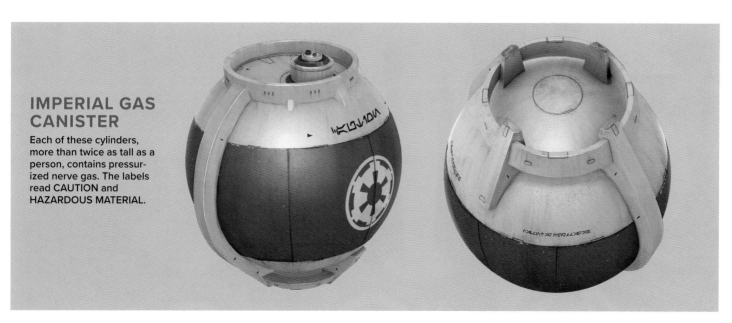

IMPERIAL GAS CANISTER

Each of these cylinders, more than twice as tall as a person, contains pressurized nerve gas. The labels read CAUTION and HAZARDOUS MATERIAL.

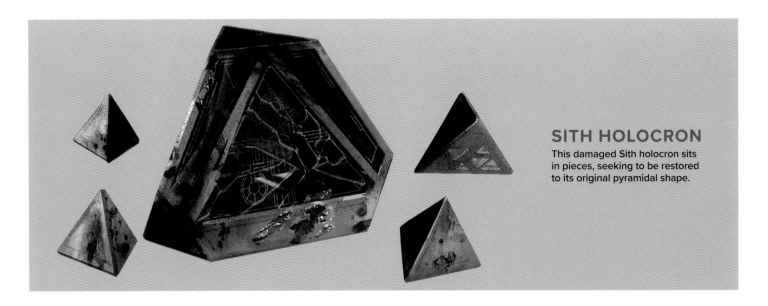

SITH HOLOCRON

This damaged Sith holocron sits in pieces, seeking to be restored to its original pyramidal shape.

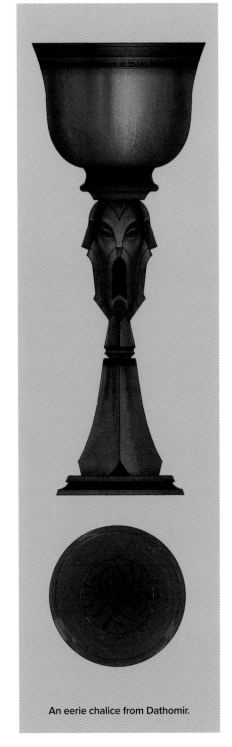

An eerie chalice from Dathomir.

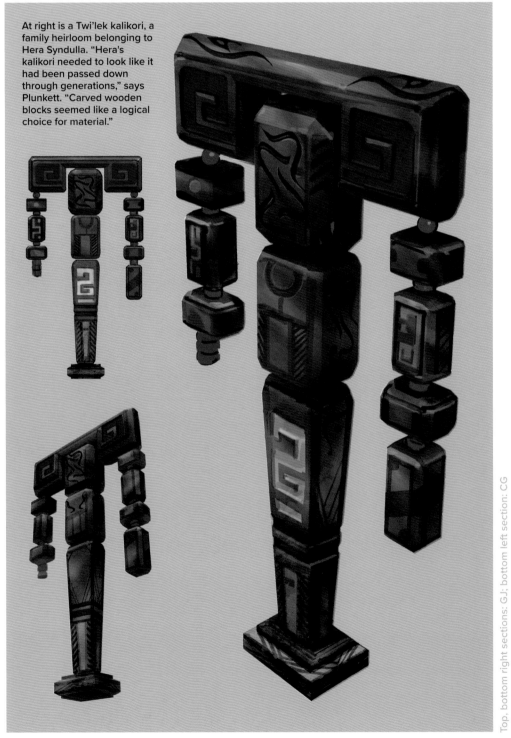

At right is a Twi'lek kalikori, a family heirloom belonging to Hera Syndulla. "Hera's kalikori needed to look like it had been passed down through generations," says Plunkett. "Carved wooden blocks seemed like a logical choice for material."

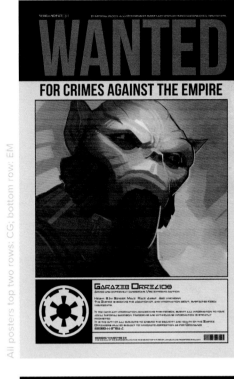

WANTED
FOR CRIMES AGAINST THE EMPIRE

Garazeb Orrelios

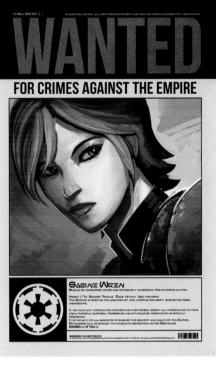

WANTED
FOR CRIMES AGAINST THE EMPIRE

Sabine Wren

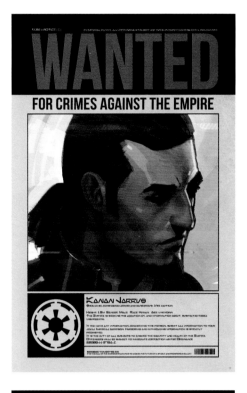

WANTED
FOR CRIMES AGAINST THE EMPIRE

Kanan Jarrus

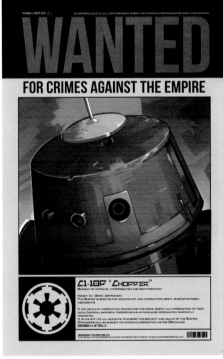

WANTED
FOR CRIMES AGAINST THE EMPIRE

C1-10P "Chopper"

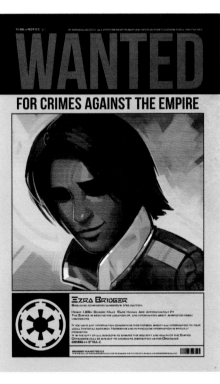

WANTED
FOR CRIMES AGAINST THE EMPIRE

Ezra Bridger

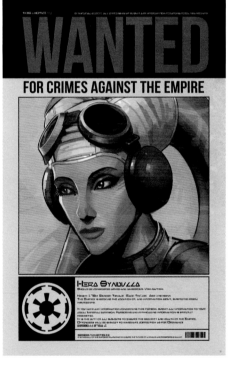

WANTED
FOR CRIMES AGAINST THE EMPIRE

Hera Syndulla

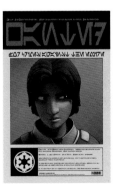
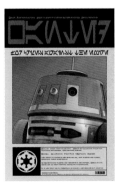
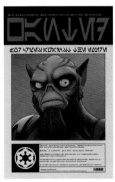
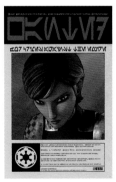

A series of "wanted" posters was created by Chris Glenn for promotional use. In season four our heroes return to Lothal to find that they have Imperial bounties on their heads. The existing "wanted" posters were recreated to work within the continuity of the show. This involved replacing the characters with images of the digital assets and translating all the english wording into aurebesh.

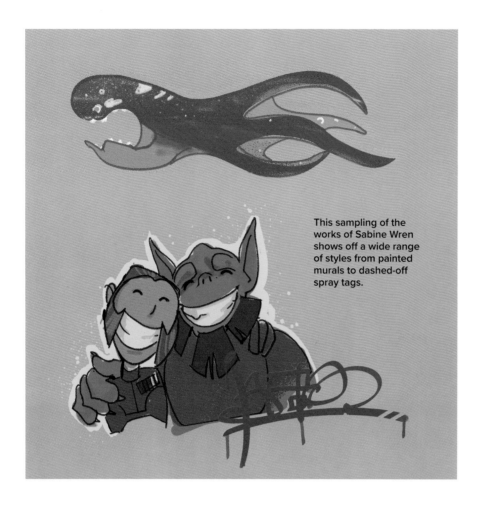

This sampling of the works of Sabine Wren shows off a wide range of styles from painted murals to dashed-off spray tags.

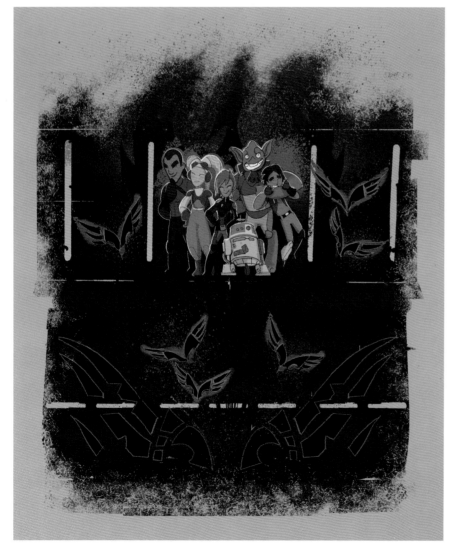

Right column top: AK; all others this page: ABC

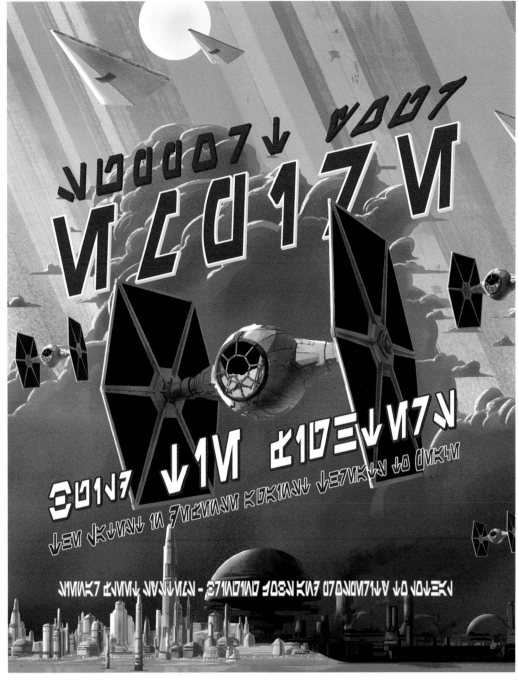

Imperial propaganda posters are plastered on buildings in Lothal City to encourage the normalization of the Empire's occupation. An entire book of similar imagery, *Star Wars Propaganda*, was published in 2016.

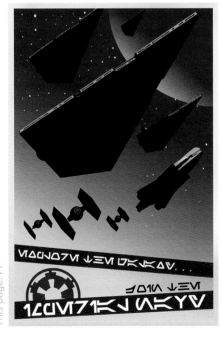

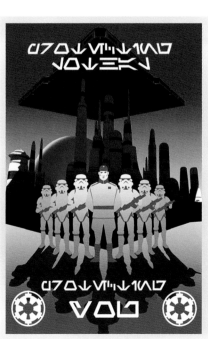

With the events occurring in *Star Wars Rebels* creeping ever closer to catching up to the original timeframe set in the classic *Star Wars* trilogy of films, it only made sense to pull in some of the more familiar designs from the films alongside all-new starships and aging rust-buckets from *Star Wars: The Clone Wars*. Ship designs like the Y-wing starfighter (*below*) feel recognizable to what was seen in *A New Hope*, yet different enough that it feels unique to the world of *Star Wars Rebels*.

Y-WING

The Y-wing starfighter is a tough ship with a reputation for soaking up punishment. It can function as a bomber, and its ion cannons are capable of disabling enemy cargo freighters.

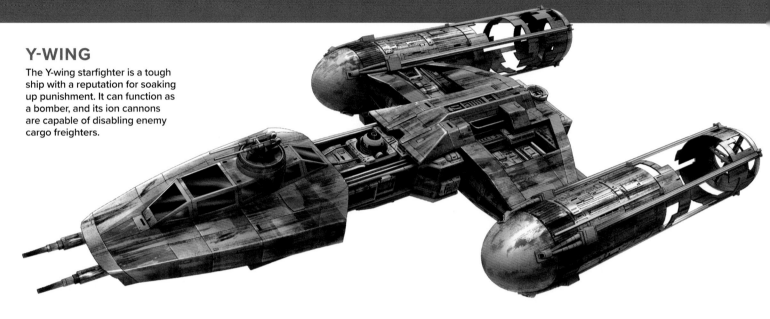

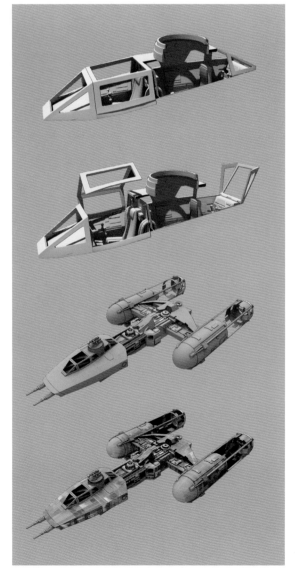

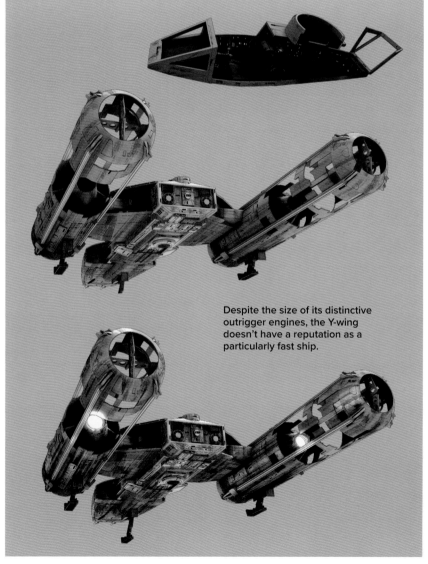

Despite the size of its distinctive outrigger engines, the Y-wing doesn't have a reputation as a particularly fast ship.

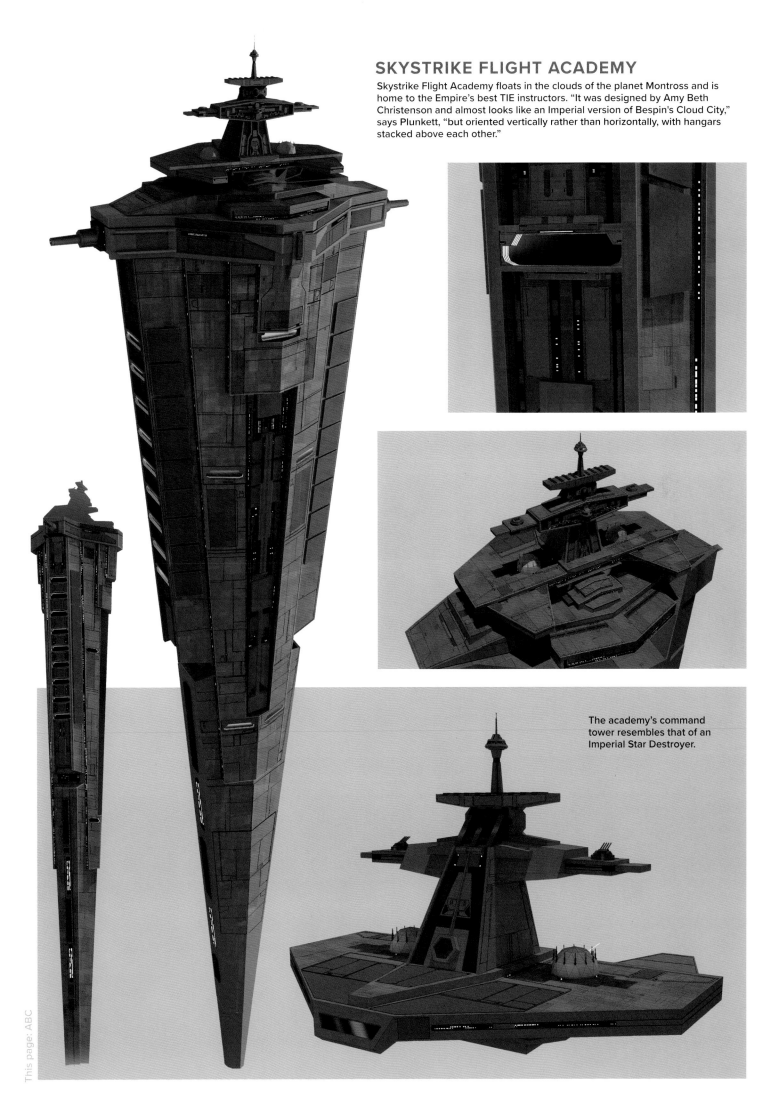

SKYSTRIKE FLIGHT ACADEMY

Skystrike Flight Academy floats in the clouds of the planet Montross and is home to the Empire's best TIE instructors. "It was designed by Amy Beth Christenson and almost looks like an Imperial version of Bespin's Cloud City," says Plunkett, "but oriented vertically rather than horizontally, with hangars stacked above each other."

The academy's command tower resembles that of an Imperial Star Destroyer.

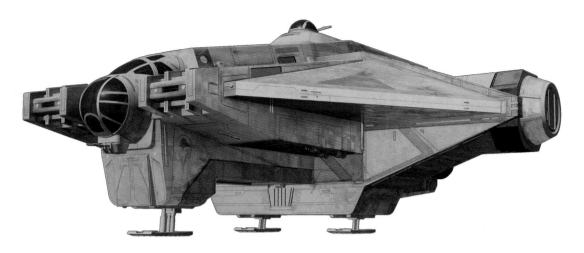

GHOST

The home to our rebel crew, the *Ghost* is almost as much of a character as any of our main heroes.

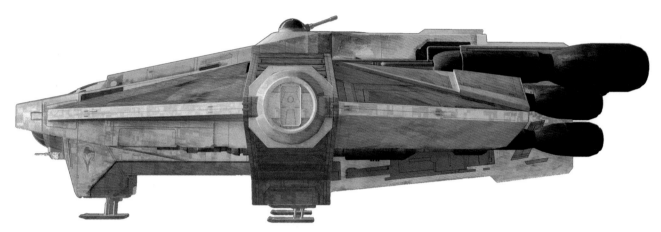

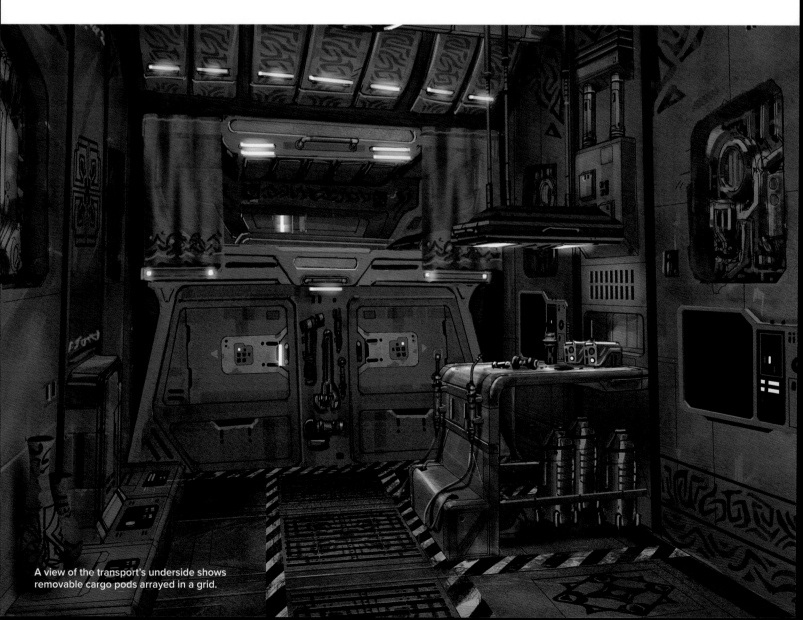

A view of the transport's underside shows removable cargo pods arrayed in a grid.

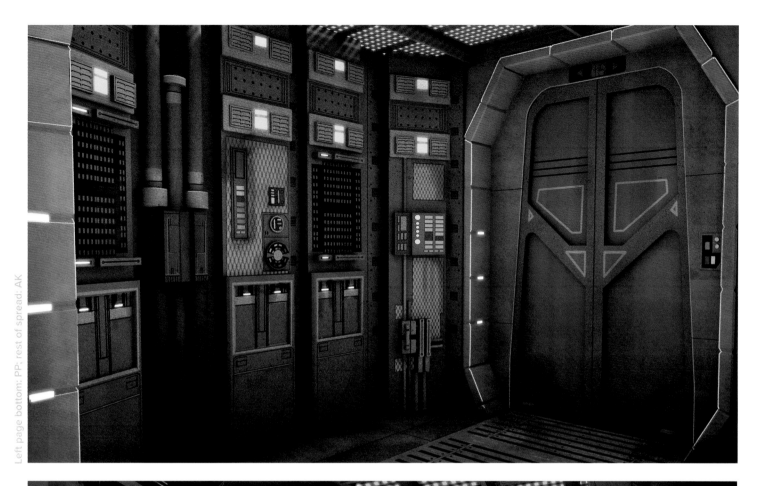

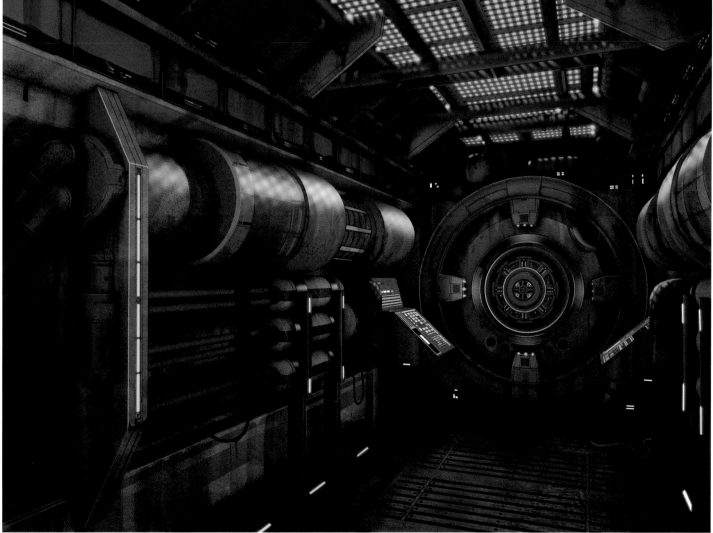

The engine room and hyperdrive for the *Ghost* were designed but not heavily featured in the series.

NEBULON-B FRIGATE

The midsection of this craft might look spindly, but TIE pilots know better than to get too close. The Nebulon-B frigate is packed with cannon batteries that lay down overlapping fields of laser fire.

The Rebel fleet uses Nebulon-B frigates for a variety of functions from escort duty to medical treatment.

This page: ABC

REBEL TRANSPORT

The Gallofree GR-75 medium transport is the unsung workhorse of the Rebel fleet. It can carry thousands of tons of cargo within its open hull but often has no lasers or other defensive weapons.

Even during the Clone Wars, these shuttles were rarely outfitted with anti-ship defenses.

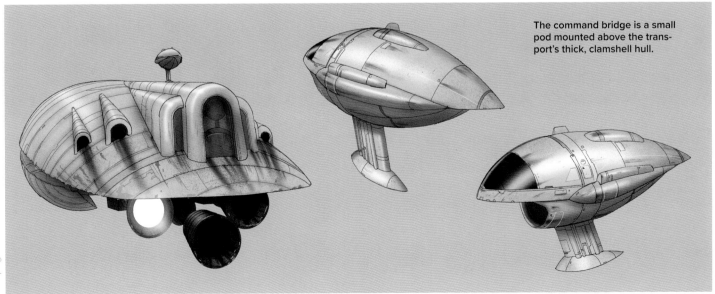

The command bridge is a small pod mounted above the transport's thick, clamshell hull.

This page: CG

SEPARATIST SHUTTLE

The *Sheathipede*-class shuttle was introduced in *The Phantom Menace* as a vessel of the Trade Federation. In season three, Captain Rex locates a number of these antiques and seeks to steal them for the Rebels.

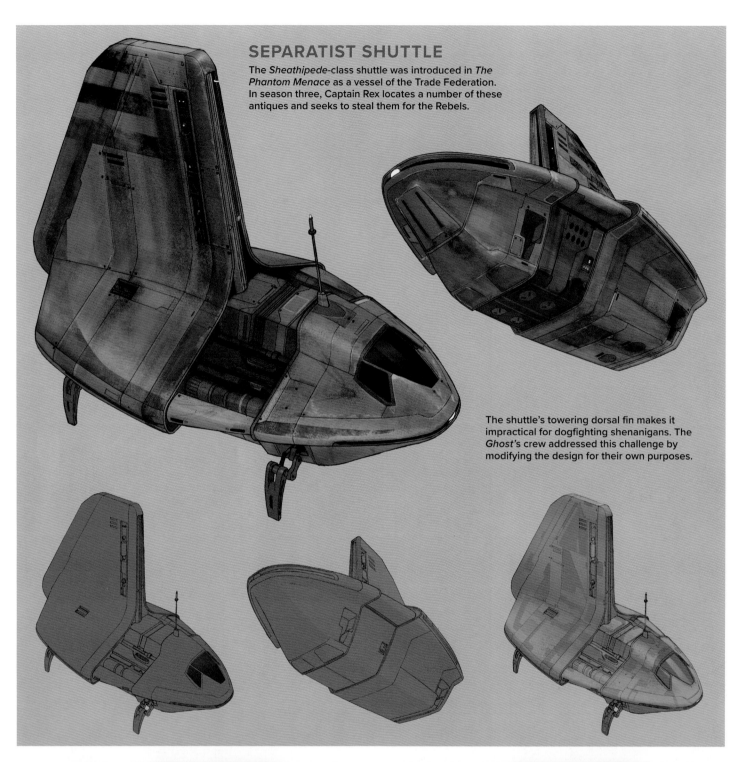

The shuttle's towering dorsal fin makes it impractical for dogfighting shenanigans. The *Ghost*'s crew addressed this challenge by modifying the design for their own purposes.

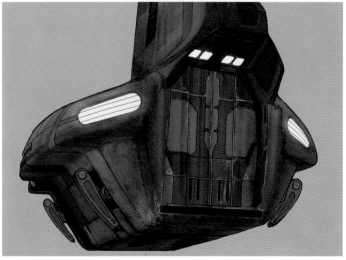

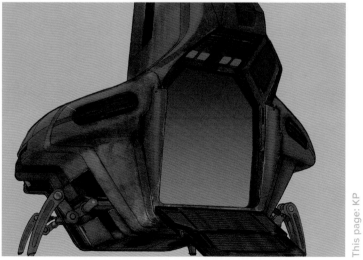

The primary hatchway of the Separatist shuttle is located at the rear.

This page: KP

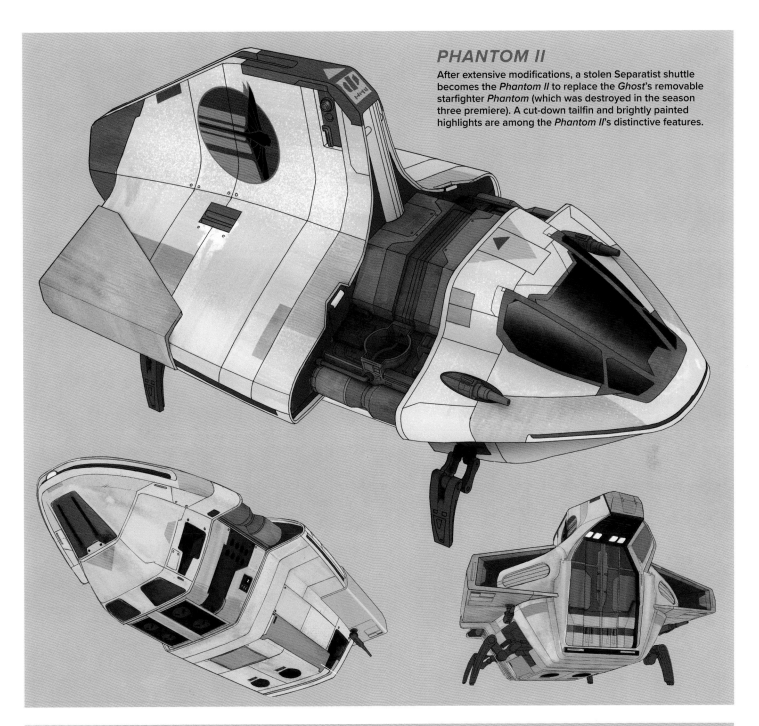

PHANTOM II

After extensive modifications, a stolen Separatist shuttle becomes the *Phantom II* to replace the *Ghost*'s removable starfighter *Phantom* (which was destroyed in the season three premiere). A cut-down tailfin and brightly painted highlights are among the *Phantom II*'s distinctive features.

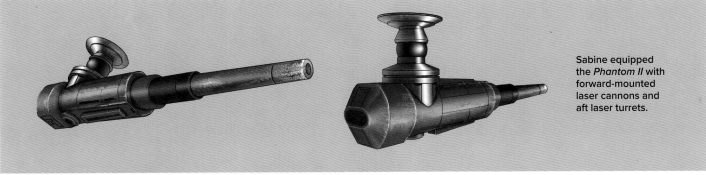

Sabine equipped the *Phantom II* with forward-mounted laser cannons and aft laser turrets.

Exterior hatch sliding open

Interior hatch sliding open

IMPERIAL LISTENER SHIP

The Empire uses IGV-55 surveillance vessels to eavesdrop on communications and root out Rebel traitors. Agents of Imperial Intelligence stationed aboard one such listener ship came dangerously close to uncovering Chopper Base on Atollon.

Says Plunkett, "The Empire is all about impersonal, mass-produced environments, so many Imperial bases and ships feel homogeneous. For the listening ship we reused an Imperial freighter from season one with an AWACS-style radar dish attached to it."

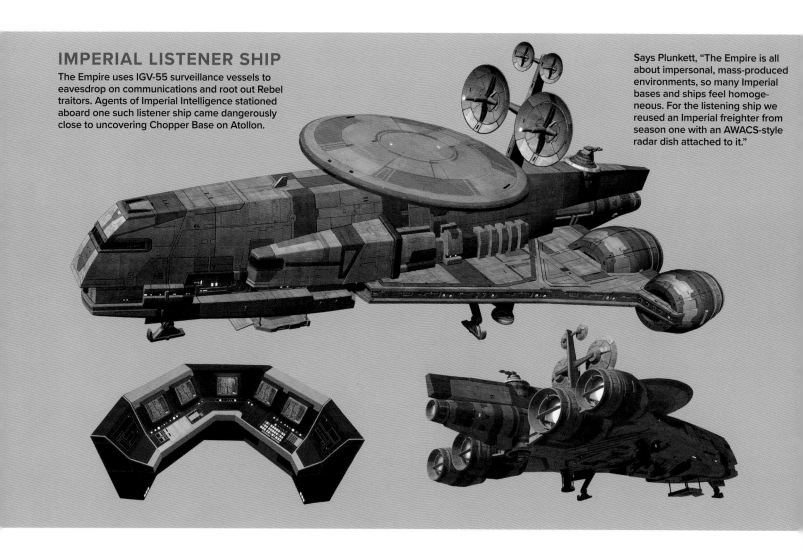

ARMED LANDSPEEDER

This landspeeder, outfitted with a rotating blaster turret, is used by the Lothal resistance for quick-strike raids against Imperial installations.

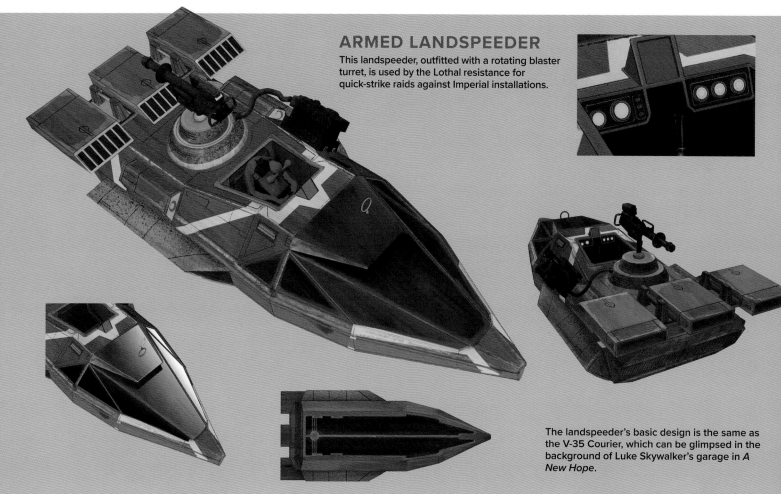

The landspeeder's basic design is the same as the V-35 Courier, which can be glimpsed in the background of Luke Skywalker's garage in *A New Hope*.

TIE INTERCEPTOR

The TIE interceptor is faster, more maneuverable, and better armed than the standard TIE fighter, but still lacks deflector shields for protecting its pilot. Its design resembles a multi-bladed dart.

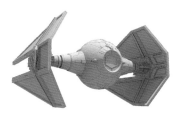

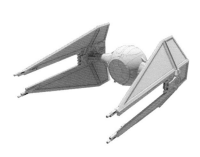

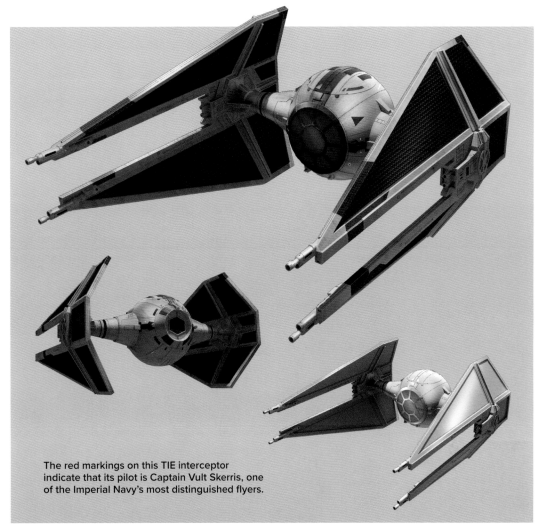

The red markings on this TIE interceptor indicate that its pilot is Captain Vult Skerris, one of the Imperial Navy's most distinguished flyers.

DORNEAN GUNSHIP

This class of ship, practically invisible in the background of *Return of the Jedi*'s space battle, received a second life in *Star Wars Rebels*. The Dornean gunship is armed with turbolasers and concussion missiles, and can carry several starfighters in its hangar.

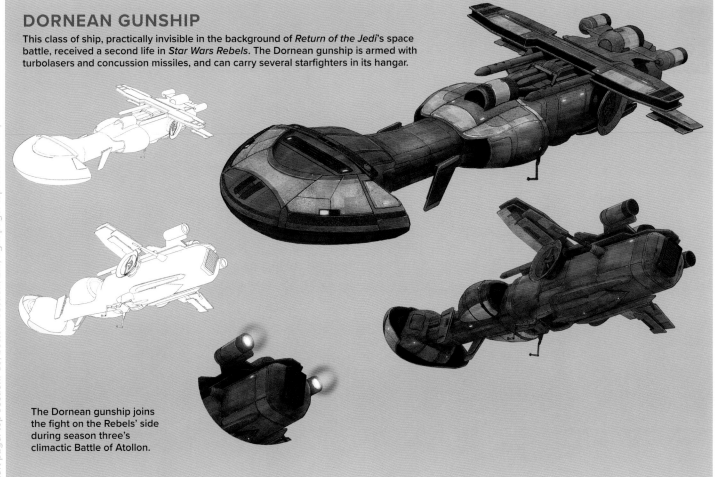

The Dornean gunship joins the fight on the Rebels' side during season three's climactic Battle of Atollon.

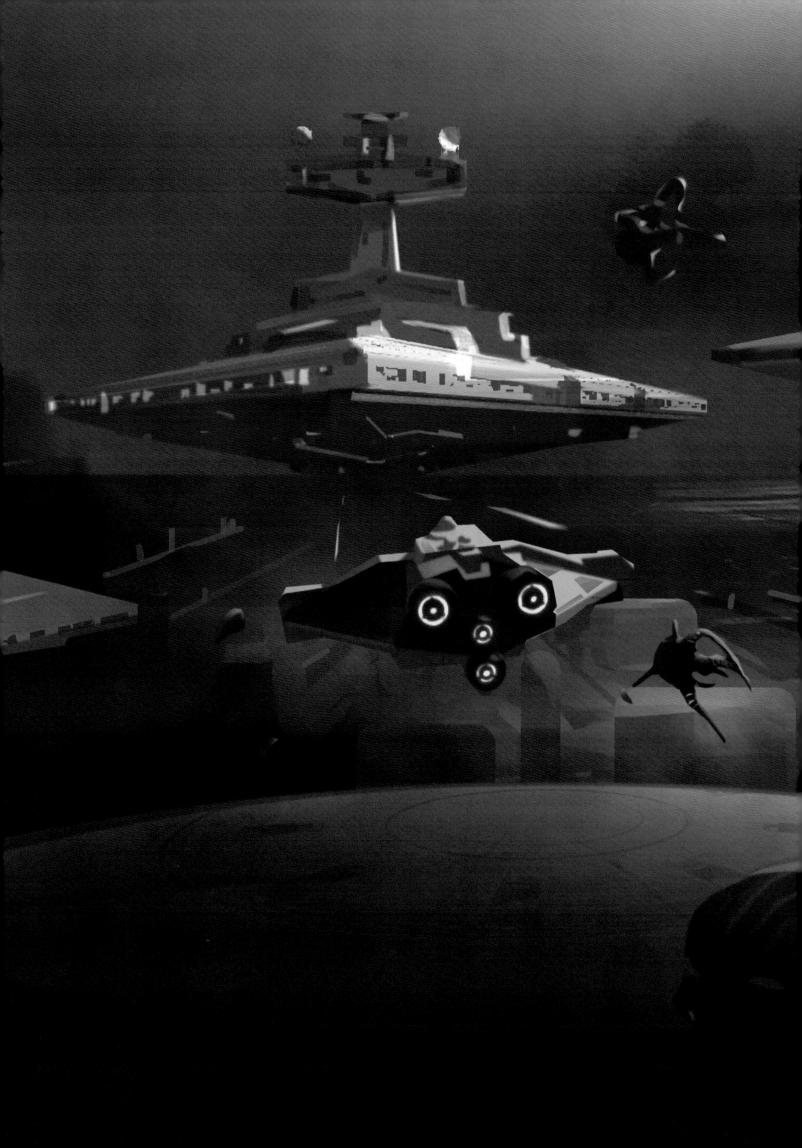

ONE GIANT STEP AHEAD

In season four, everything comes back to where it started. The final season of *Star Wars Rebels* cements the show's place as integral to the sweep of the galaxy-spanning *Star Wars* saga. What began as six rabble-rousers struggling to free an Outer Rim backwater grew to encompass an entire galactic movement, with events culminating in season four's epic Battle of Lothal. Along the way, the show leads viewers through the multipart journey to liberate Lothal and concludes vital narratives such as the fate of Mandalore, the future of the Rebel Alliance, and Ezra's decision to walk the path of the Force. What could be next for the Rebel heroes? The final episode of *Star Wars Rebels* offers some hints in a flash-forward sequence, but fans know there's more to the story. For heroes in *Star Wars* saga, there's always another battle worth fighting for.

New and returning Mandalorians assume prominent roles early on in season four, before the narrative shifts its focus to the planet Lothal, where our Rebel heroes began their journey four seasons prior. On Lothal, both Imperial and Rebel factions come head-to-head in an epic battle to determine the fate of the planet, once and for all. Will the Rebellion be able to save Ezra's homeworld in the end, or will it fall away to total destruction at the hands of the Empire?

BO-KATAN KRYZE

This armored Mandalorian first debuted in *Star Wars: The Clone Wars* among the violent warriors of the Death Watch. During *Rebels*, Bo-Katan accepts the Darksaber from Sabine and uses the ceremonial weapon to unite the Mandalorians. "As a returning *Clone Wars* character, we had to translate Bo-Katan into our *Rebels* design language," says Plunkett.

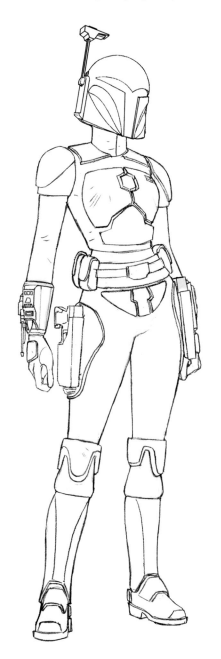

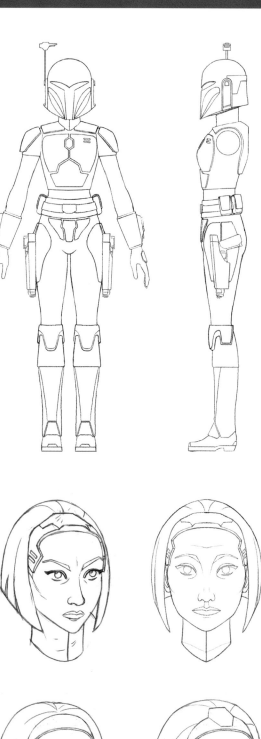

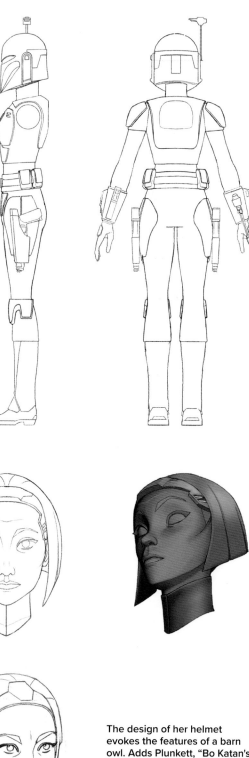

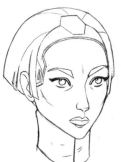

The design of her helmet evokes the features of a barn owl. Adds Plunkett, "Bo Katan's face was built using Hera as a base, and then adjusting the features from there."

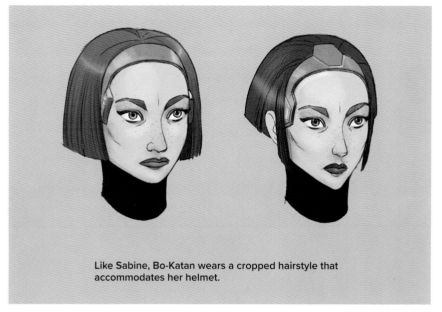

Like Sabine, Bo-Katan wears a cropped hairstyle that accommodates her helmet.

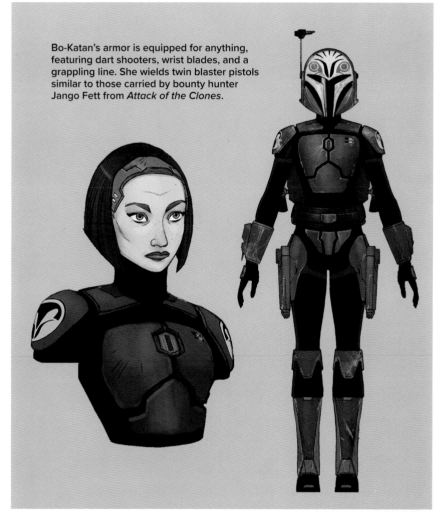

Bo-Katan's armor is equipped for anything, featuring dart shooters, wrist blades, and a grappling line. She wields twin blaster pistols similar to those carried by bounty hunter Jango Fett from *Attack of the Clones*.

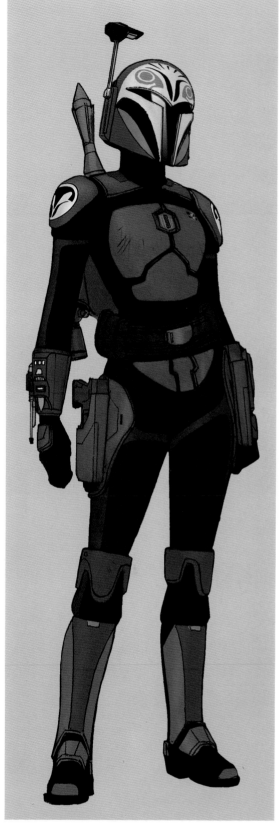

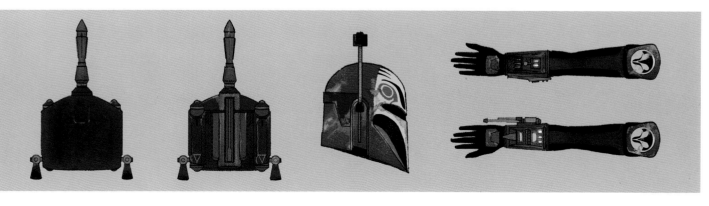

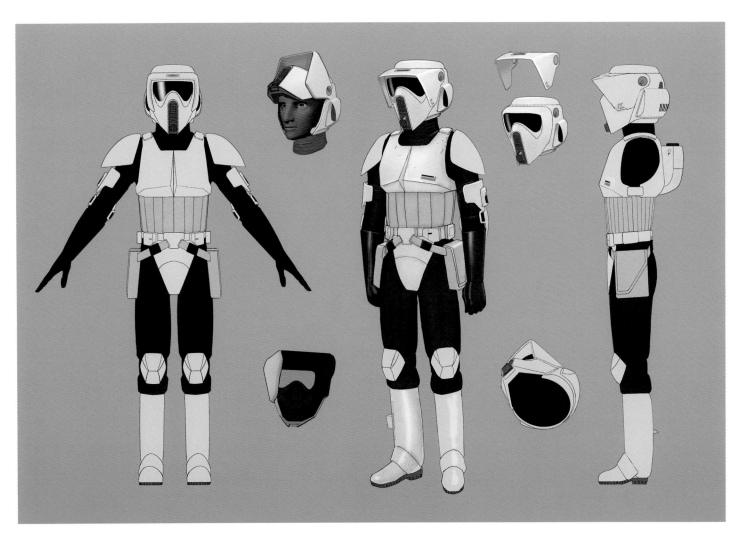

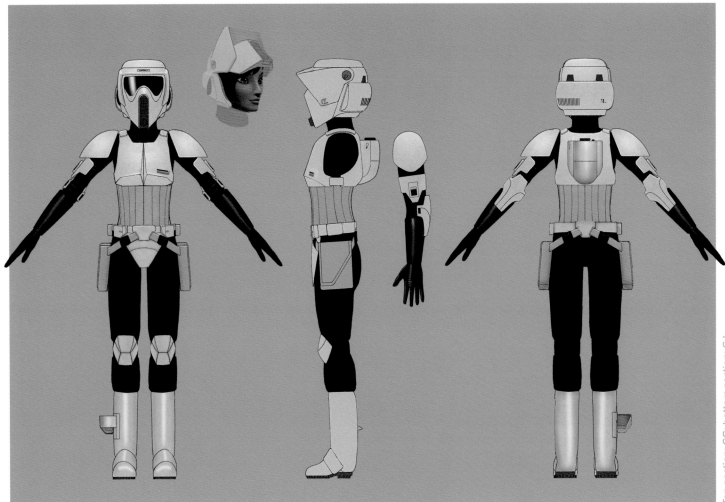

Top section: CG; bottom section: GJ

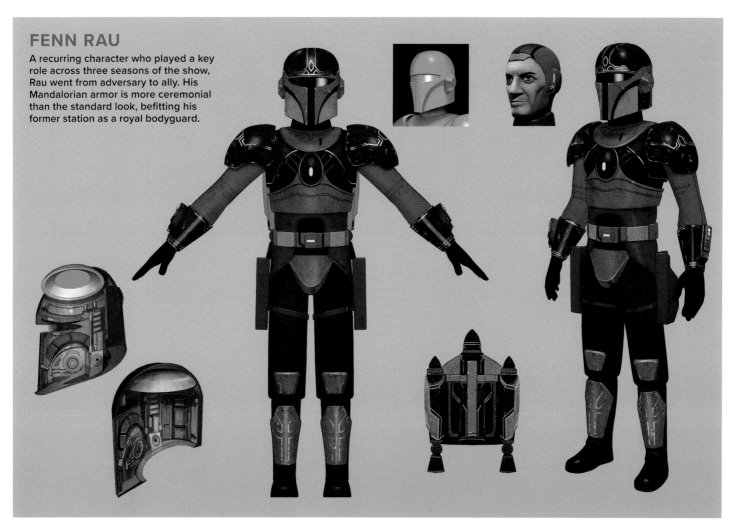

FENN RAU

A recurring character who played a key role across three seasons of the show, Rau went from adversary to ally. His Mandalorian armor is more ceremonial than the standard look, befitting his former station as a royal bodyguard.

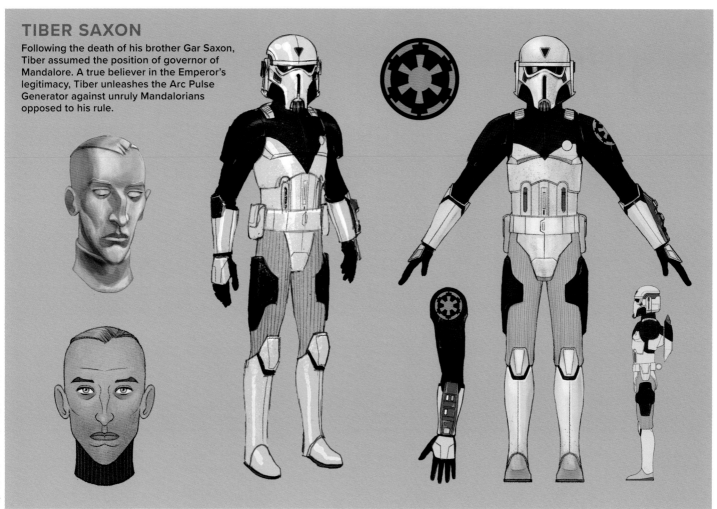

TIBER SAXON

Following the death of his brother Gar Saxon, Tiber assumed the position of governor of Mandalore. A true believer in the Emperor's legitimacy, Tiber unleashes the Arc Pulse Generator against unruly Mandalorians opposed to his rule.

EMPEROR PALPATINE

When the emperor of the galaxy turns his omnipotent eye towards Ezra, he deploys flattery and deception in the hopes of luring a new victim to the dark side of the Force. With the help of a holographic projection, Palpatine is able to assume his previous appearance of a simple, young senator during his initial conversations with Ezra.

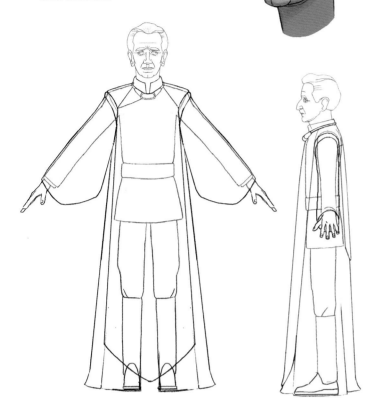

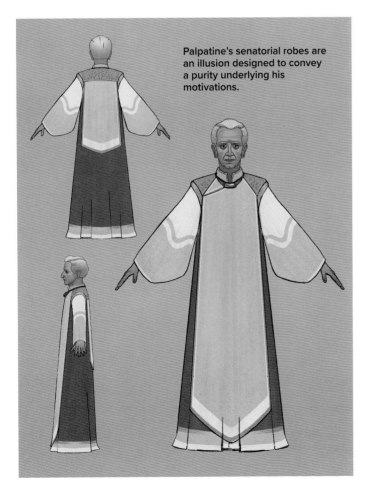

Palpatine's senatorial robes are an illusion designed to convey a purity underlying his motivations.

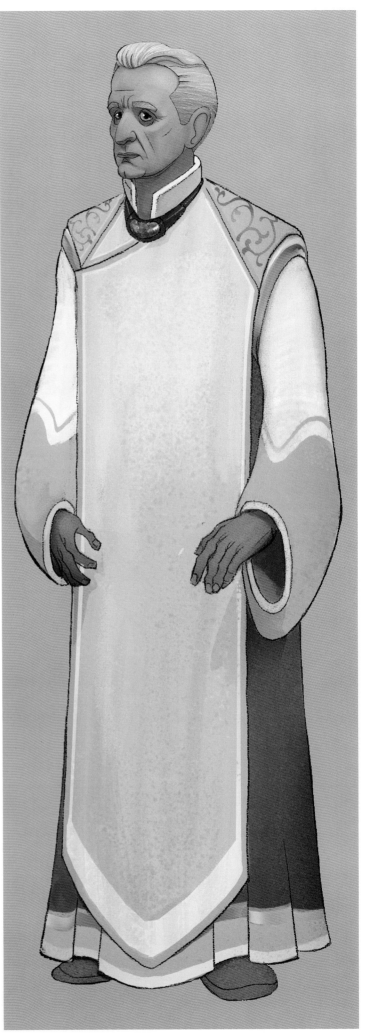

This page: LH

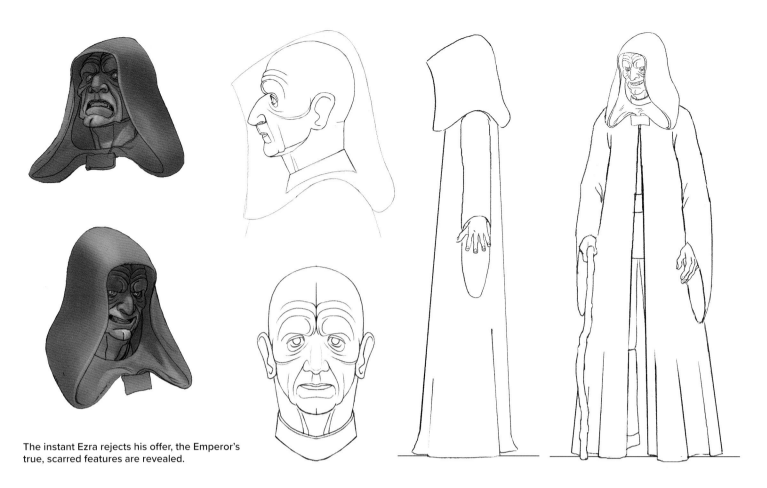

The instant Ezra rejects his offer, the Emperor's true, scarred features are revealed.

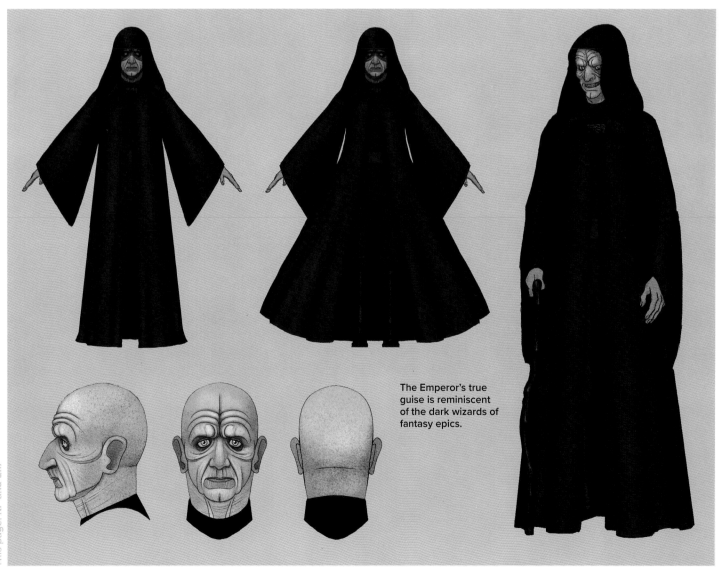

The Emperor's true guise is reminiscent of the dark wizards of fantasy epics.

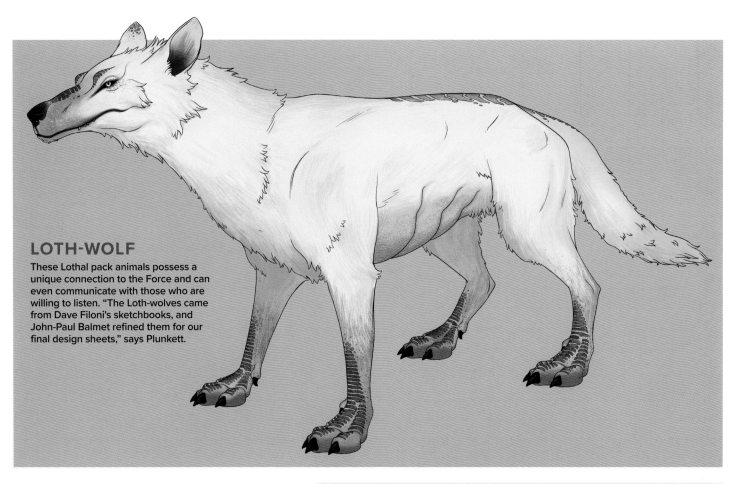

LOTH-WOLF

These Lothal pack animals possess a unique connection to the Force and can even communicate with those who are willing to listen. "The Loth-wolves came from Dave Filoni's sketchbooks, and John-Paul Balmet refined them for our final design sheets," says Plunkett.

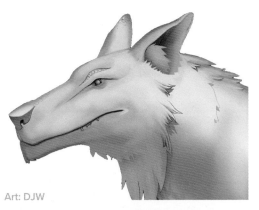

Art: DJW

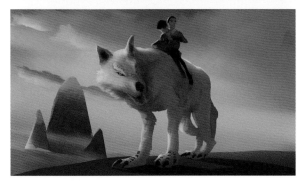

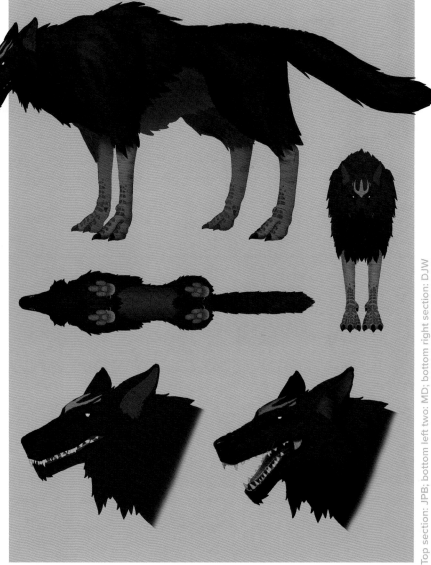

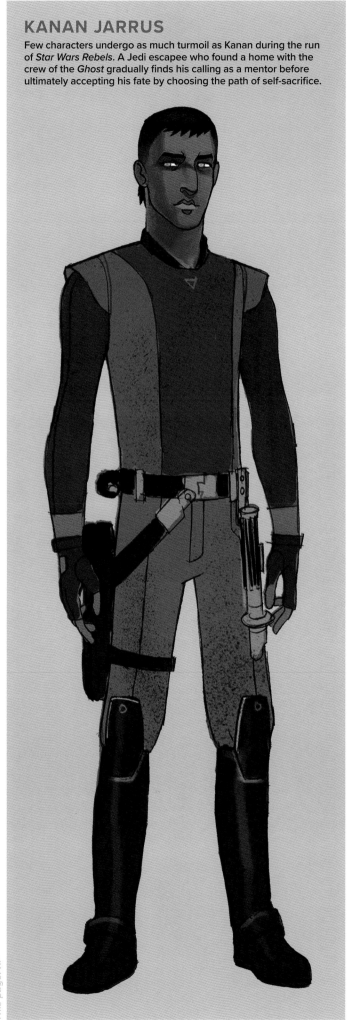

KANAN JARRUS

Few characters undergo as much turmoil as Kanan during the run of *Star Wars Rebels*. A Jedi escapee who found a home with the crew of the *Ghost* gradually finds his calling as a mentor before ultimately accepting his fate by choosing the path of self-sacrifice.

This long-haired look was explored for Kanan's civilian disguise when returning to Lothal in "The Occupation."

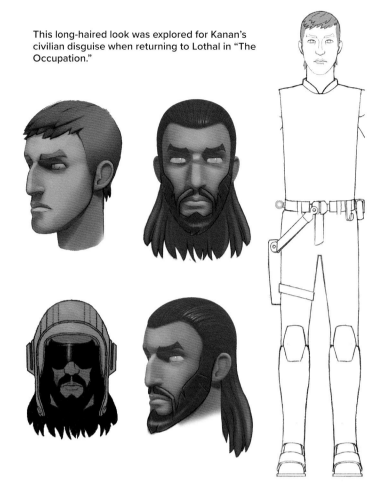

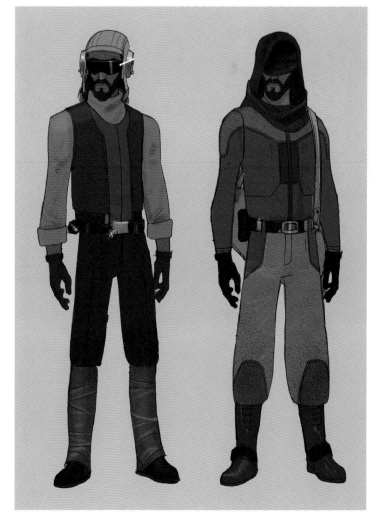

This page: KP

SABINE WREN

In the final season Sabine helps resolve the political futures of both Mandalore and Lothal. The studies below show how the crew explored long-haired and close-cropped styles as Sabine wrestles with the responsibilities of adulthood and the fate of a proud people.

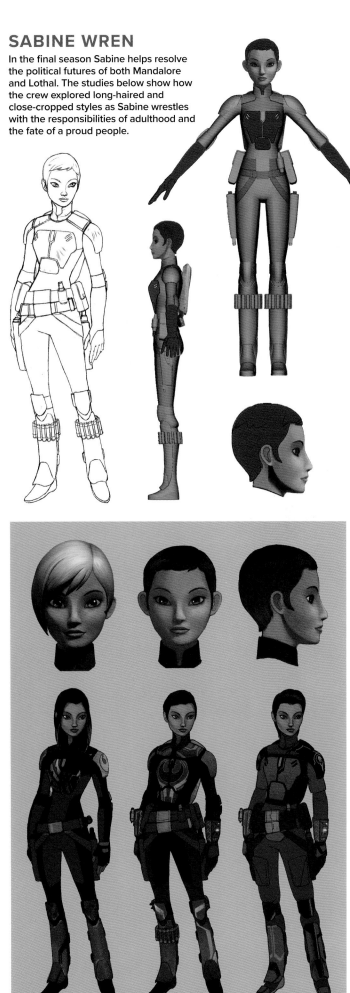

Because Mandalorians are known for customizing their armor, Sabine underwent a number of redesigns prior to season four.

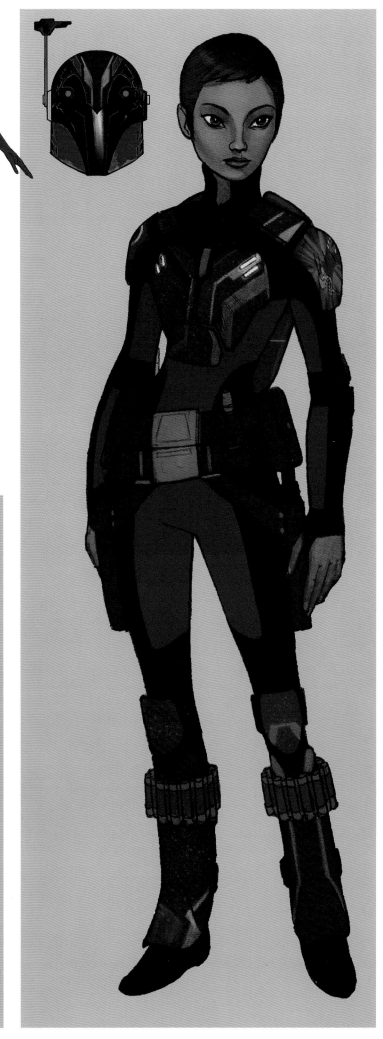

This page: KP

DEATH TROOPER COMMANDER

The Empire's elite Death Troopers first appeared in the film *Rogue One* before making their animated debut in *Rebels*. This particular trooper spoke with a a female voice, reminiscent of Captain Phasma from *The Force Awakens*.

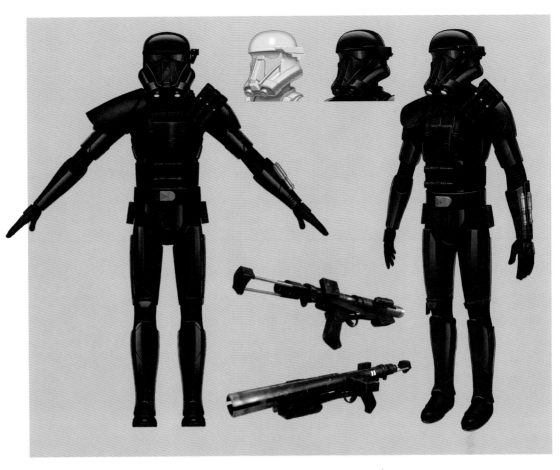

DIRECTOR ORSON KRENNIC

First seen in *Rogue One*, Krennic's flowing cape and all-white uniform are carried over from the film and lend the character a visual distinctiveness versus other Imperial officials. Though completely designed and mentioned by name, Krennic never actually appears in *Rebels*.

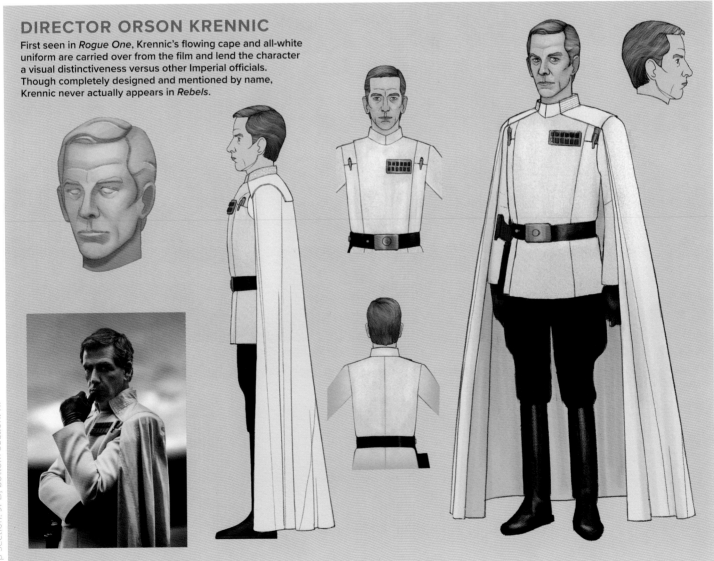

ALRICH WREN

Sabine's father, Alrich Wren, is an artist whose aesthetic obsessions helped inspire his daughter to pursue her own creative endeavors. After Sabine fled Mandalorian space, Alrich became a political prisoner.

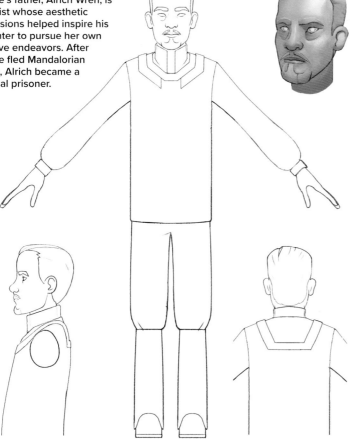

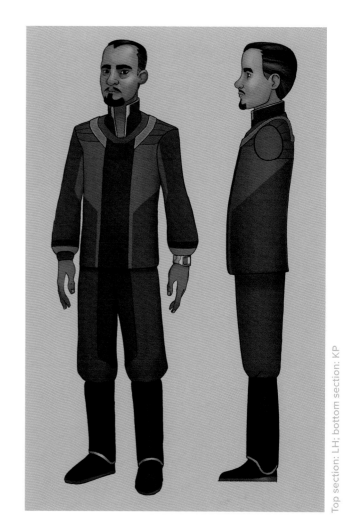

GOVERNOR ARIHNDA PRYCE

Arihnda Pryce oversees the sector containing Lothal and enjoys close ties with powerful Imperial figures, including Grand Moff Tarkin and Grand Admiral Thrawn. Doggedly focused on climbing the ranks, Pryce is acutely aware of any shifts in the balance of power.

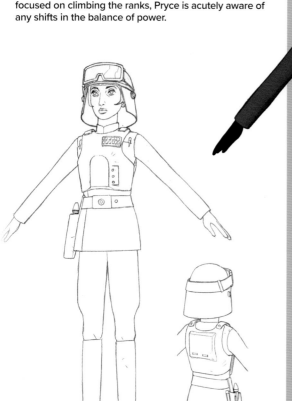

Pryce, depicted here wearing field armor, serves as Thrawn's agent during the lead-up to the liberation of Lothal.

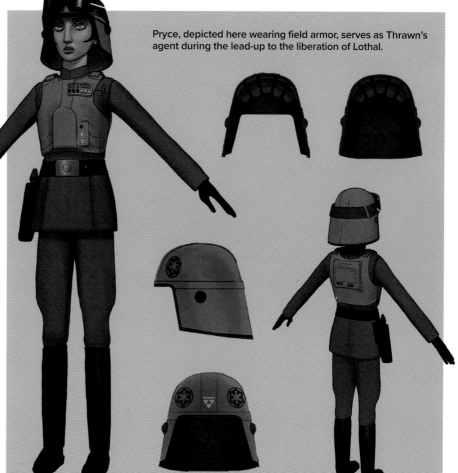

Top section: LH; bottom section: KP

RUKH

Thrawn's Noghri bodyguard is a relentless tracker and a silent assassin. "Dave Filoni had a specific quality he wanted to capture for Rukh, so our design went through a few iterations before it had the icy stare and sinewy strength to be credible as Thrawn's henchman," says Plunkett. The character originated in a 1990s novel by *Star Wars* author Timothy Zahn.

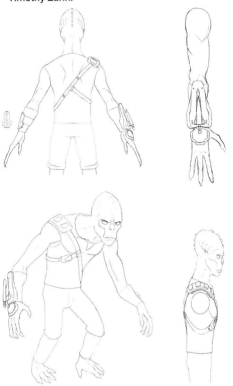

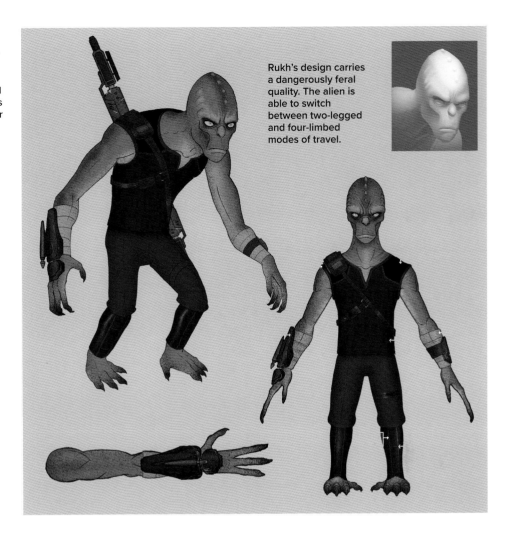

Rukh's design carries a dangerously feral quality. The alien is able to switch between two-legged and four-limbed modes of travel.

MICH MATT

Mich Matt, a scientist forced to work on weaponizing kyber crystals by the Empire. He appeared in "In the Name of the Rebellion Part 1."

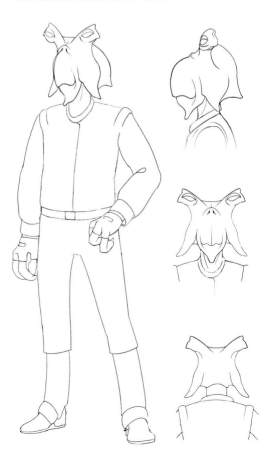

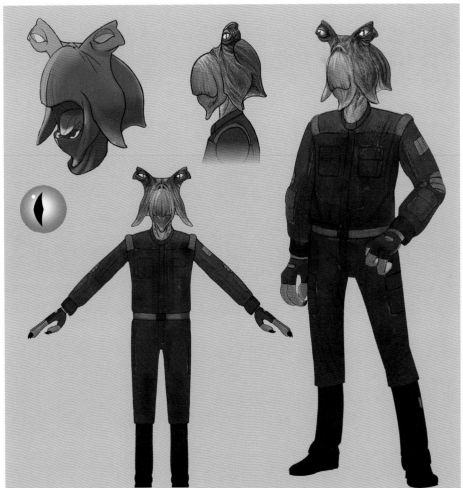

Top section: DJW; bottom section: GJ

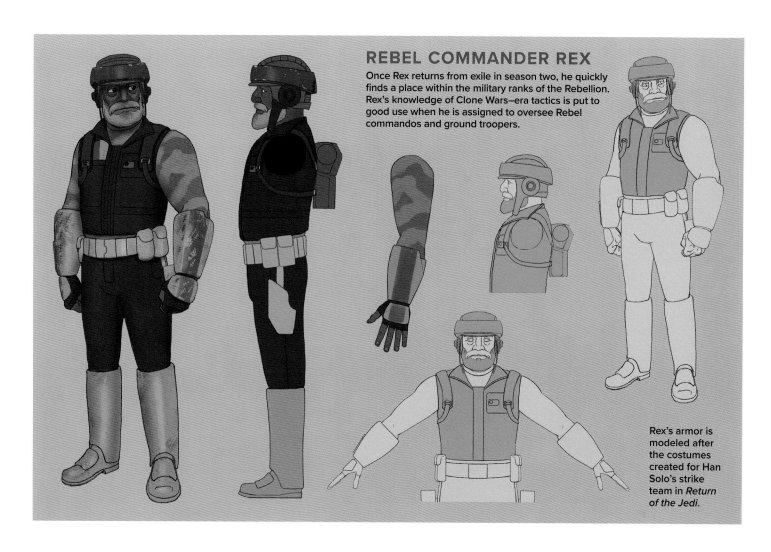

REBEL COMMANDER REX

Once Rex returns from exile in season two, he quickly finds a place within the military ranks of the Rebellion. Rex's knowledge of Clone Wars–era tactics is put to good use when he is assigned to oversee Rebel commandos and ground troopers.

Rex's armor is modeled after the costumes created for Han Solo's strike team in *Return of the Jedi*.

EDRIO "TWO TUBES"

This alien mercenary is a member of Saw Gerrera's Partisans and first appeared in the film *Rogue One*. Edrio is an expert at piloting a U-wing starfighter and demonstrates his mastery when rescuing the Rebel heroes from a crisis at the Jalindi Relay.

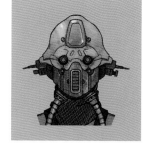

As a Tognath, Edrio must inhale standard atmospheres through an oxygen processer. This omnipresent apparatus is what inspired his nickname.

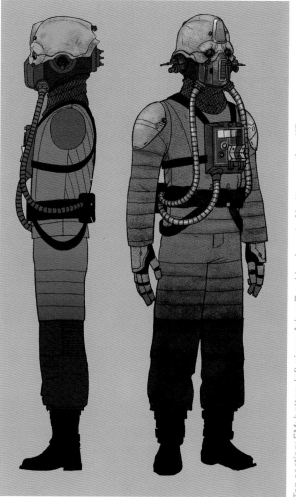

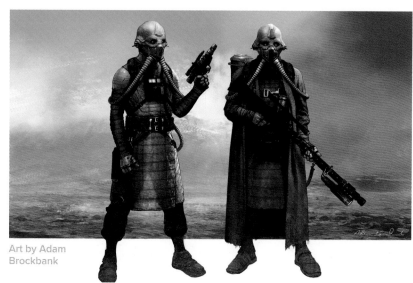

Art by Adam Brockbank

Top section: EM; bottom left piece: Adam Brockbank; rest of bottom section: KP

CAPTAIN SEEVOR

Unusually skinny for a member of his species, Seevor possesses a scrawny build that draws even more attention to the disproportionately long limbs of a typical Trandoshan. Captain Seevor works for the Mining Guild as the commander of Ore Crawler 413-24, stationed on Lothal.

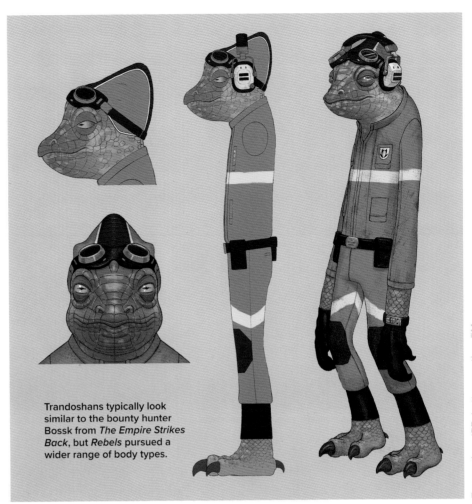

Trandoshans typically look similar to the bounty hunter Bossk from *The Empire Strikes Back*, but *Rebels* pursued a wider range of body types.

GUILD SLAVE MASTER PROACH

The beefy enforcer to Captain Seevor's weedy authoritarian, Proach is a muscular Trandoshan who works as a Mining Guild foreman. His duties include motivating the slave laborers aboard his ore crawler, and Proach carries an electro-whip for chastising the poor performers among his crew.

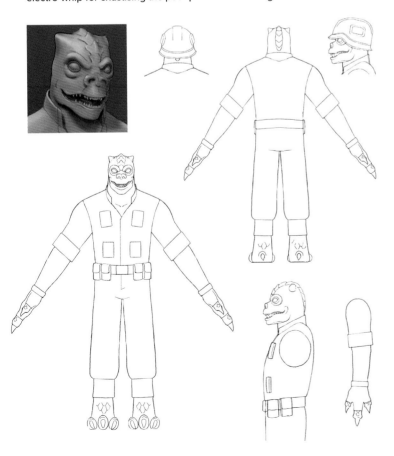

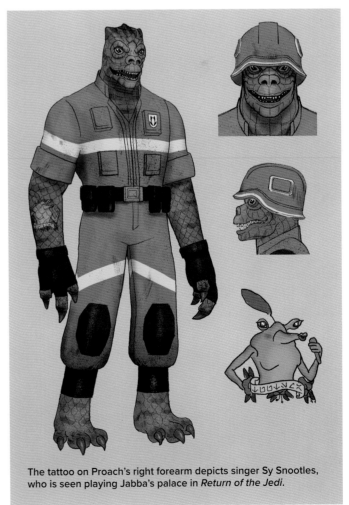

The tattoo on Proach's right forearm depicts singer Sy Snootles, who is seen playing Jabba's palace in *Return of the Jedi*.

Top section: JPB; bottom section: EM

ENVIRONMENTS

ᚢᛁᚷᚤᚫᚦᚦᚢᚷᛄᚦᚢᚷᛄᚤᚦ

Both Mandalore and Yavin 4 play prominent roles in season four, but it is the return of the heroes to Lothal that ultimately bookends the saga of *Star Wars Rebels*. "Now the rolling grasslands of Lothal are being burnt away to facilitate Imperial mining, on such a scale that the fires are visible from orbit," says Plunkett. "Lighting on Lothal is darker and in most night scenes the moonlit skies have been replaced by a thick orange smog."

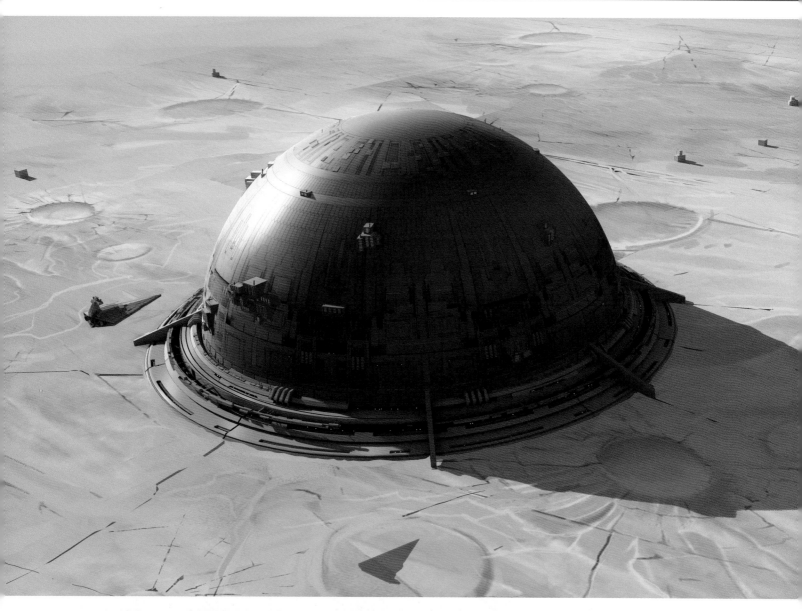

Top: ABC; bottom: JLD

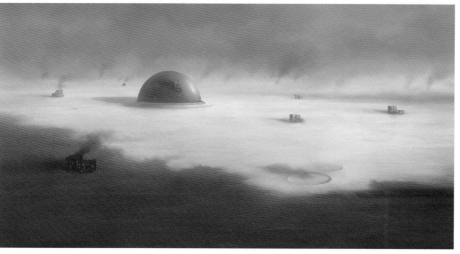

RETURN TO MANDALORE

Last seen in *The Clone Wars*, the design for the exterior of the domed capital city was reworked by Amy Beth Christenson. Extra detail was added around the base to give a greater sense of scale. More geometric outcroppings were added to the dome to suggest that the main spaceport, Sundari, was one of several entrances to the interior city. Small trenches not found on the ground in *The Close Wars* version allowed for a dynamic ground battle to take place on Mandalore's surface in the season four opener.

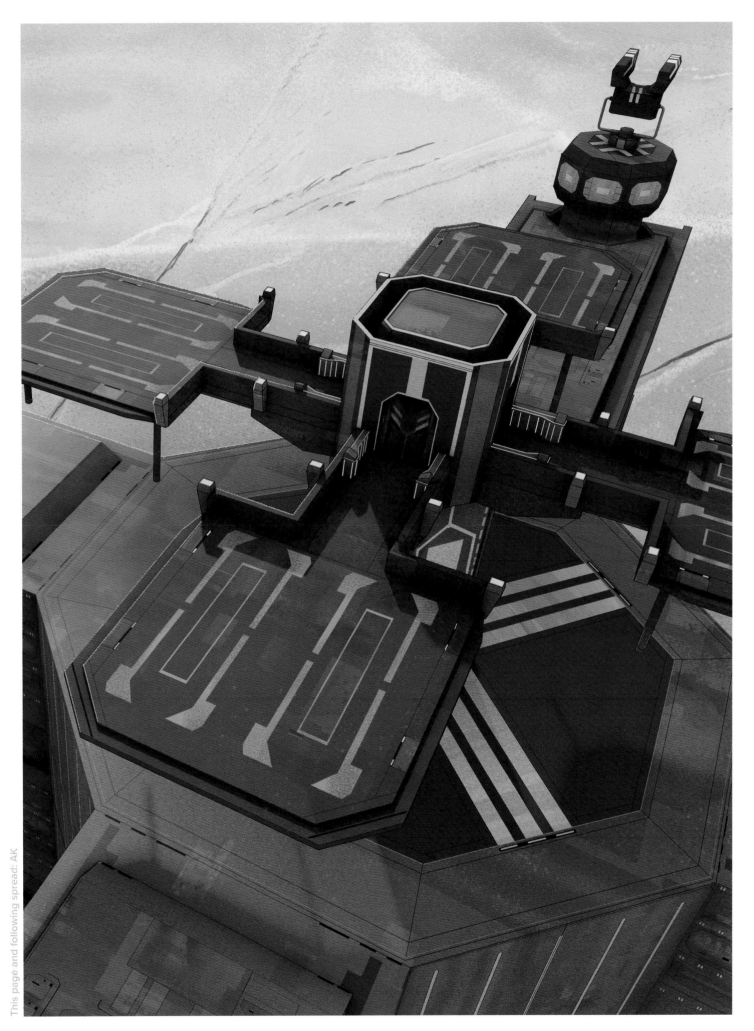

These images depict a stark landing platform attached to a Mandalorian prison outpost.

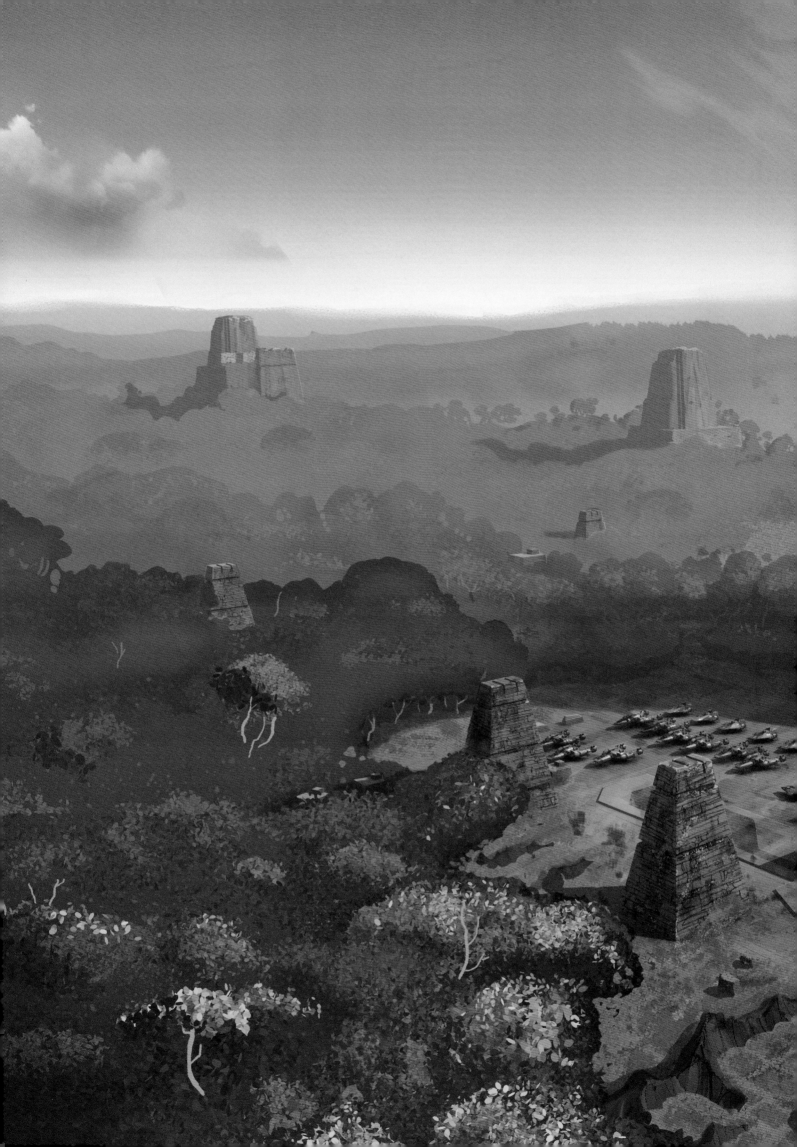

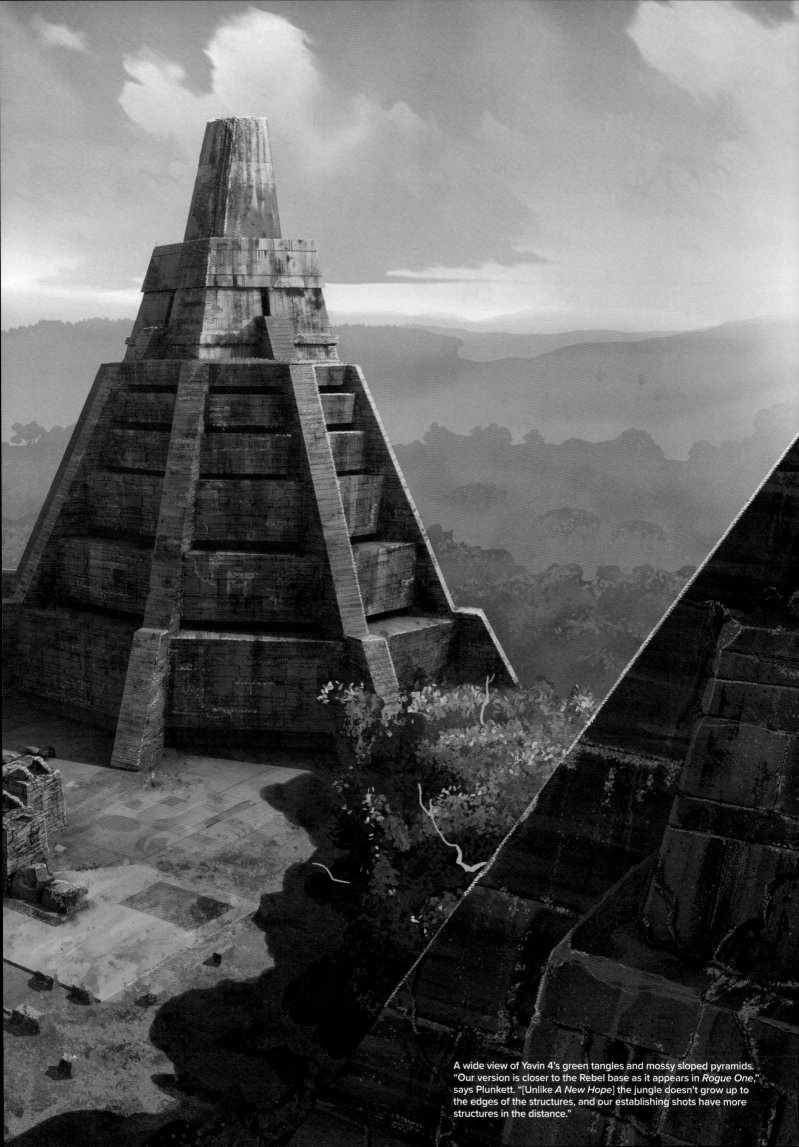

A wide view of Yavin 4's green tangles and mossy sloped pyramids. "Our version is closer to the Rebel base as it appears in *Rogue One*," says Plunkett. "[Unlike *A New Hope*] the jungle doesn't grow up to the edges of the structures, and our establishing shots have more structures in the distance."

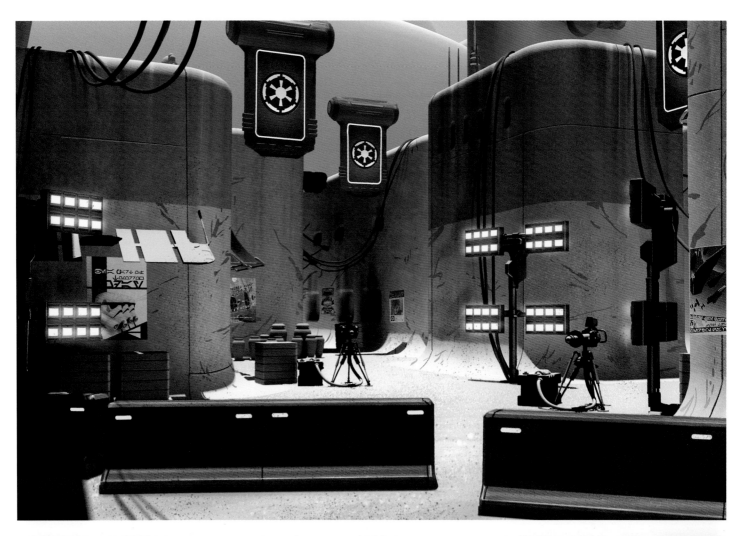

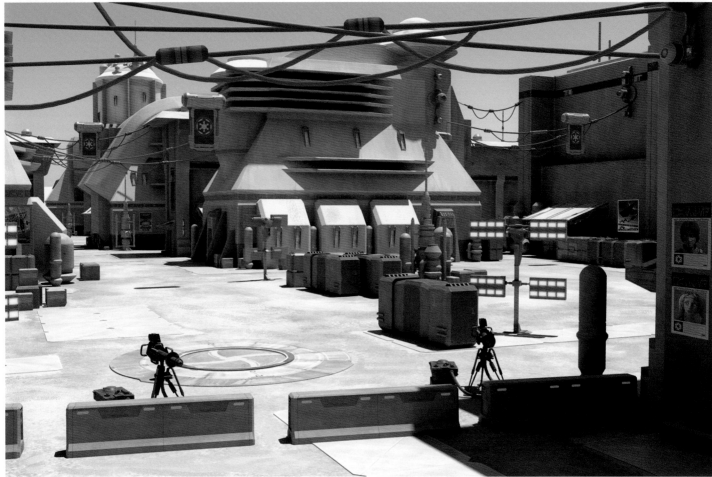

Daytime and nighttime views of Lothal show a world under occupation. Imperial warnings are everywhere as ordinary citizens hide inside their homes.

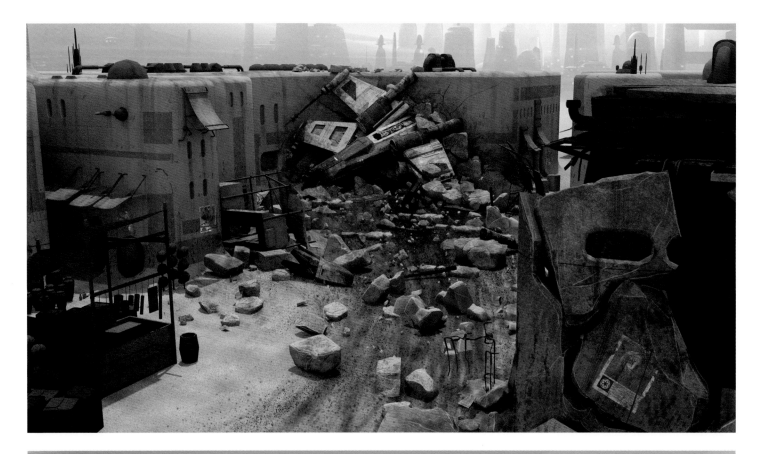

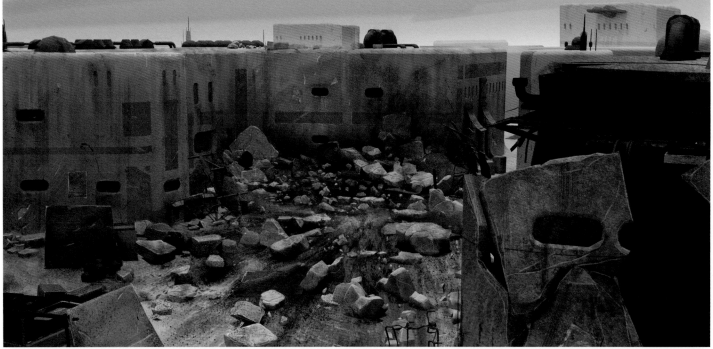

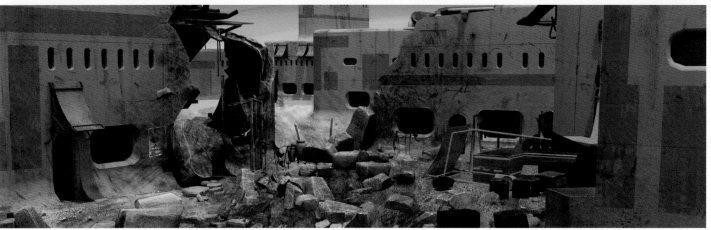

Top: JP; bottom two: GJ

Top two: Matte paintings; bottom: Goran Josic

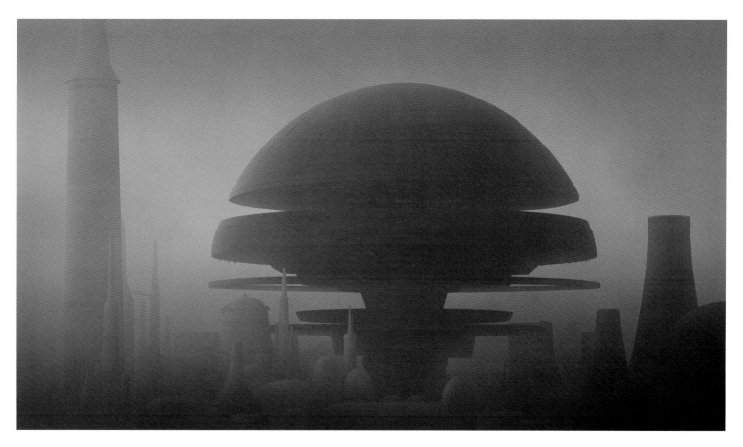

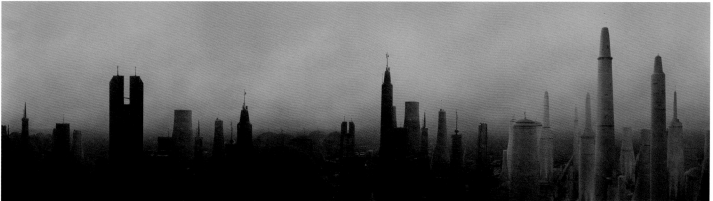

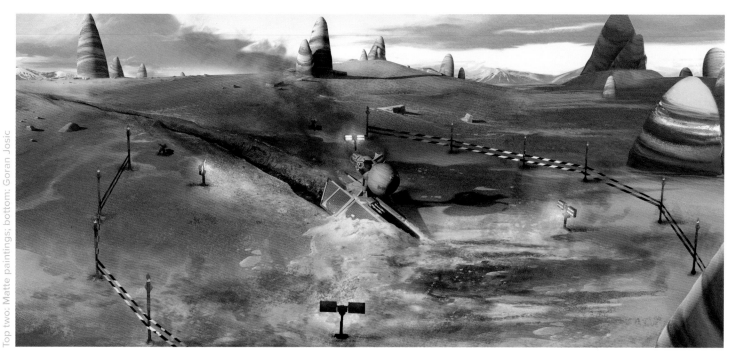

This cluttered alleyway was designed to accommodate a crashed X-wing. "There are more roadblocks on the streets and more Imperial propaganda signage," says Plunkett, of season four's Lothal.

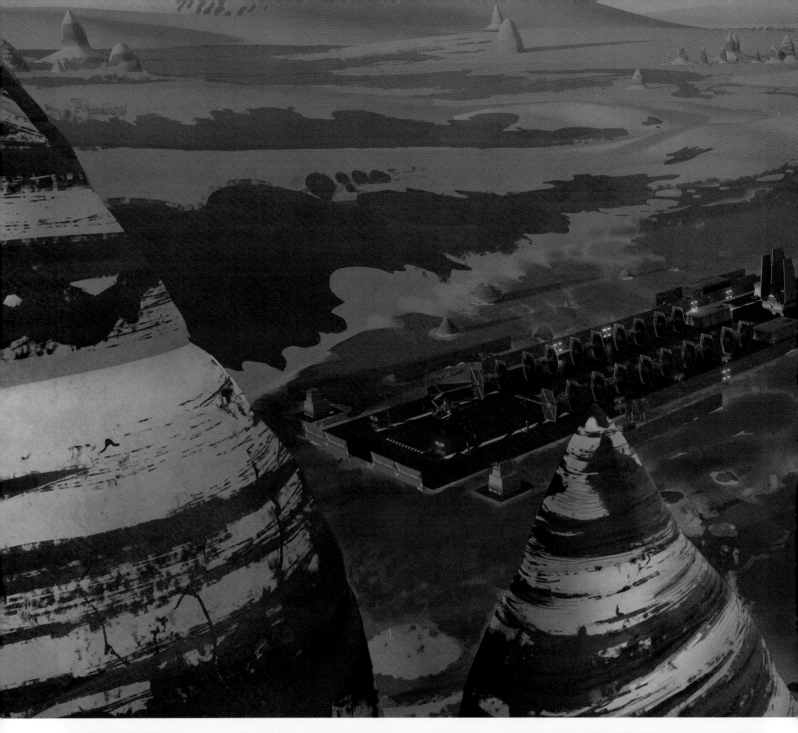

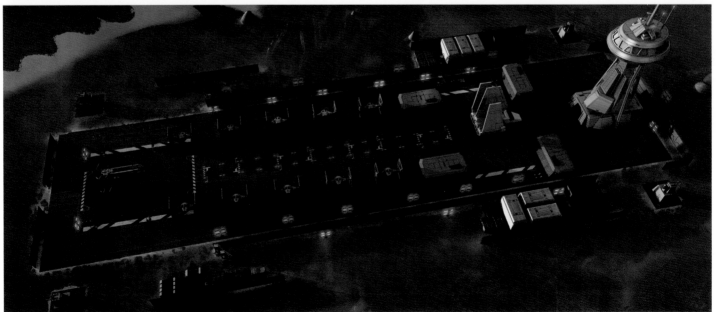

In this remote part of Lothal, wind-blown snowdrifts aren't uncommon. This Imperial airfield was chosen to stage test flights of the experimental TIE defender elite.

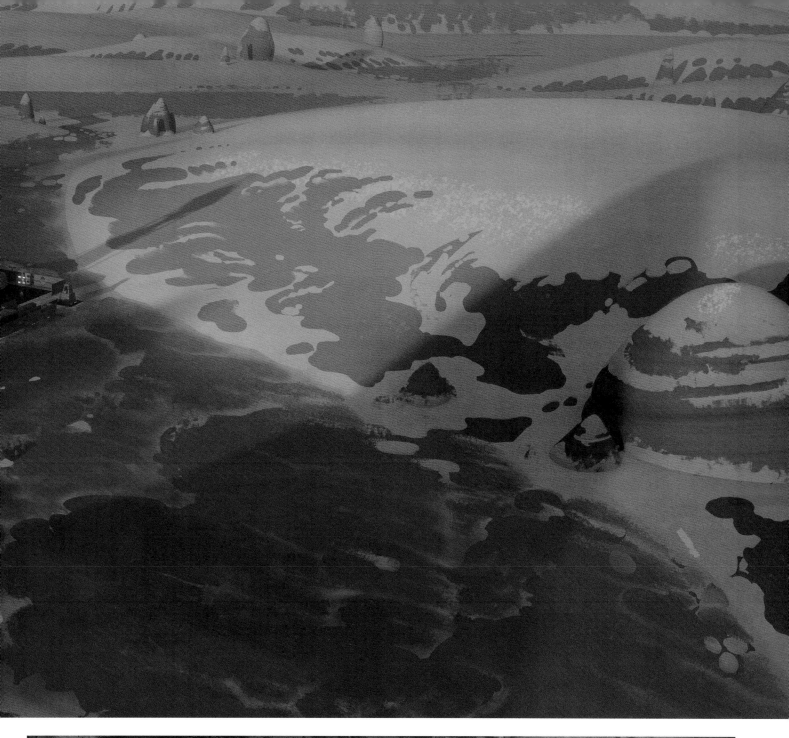

This spread: AK

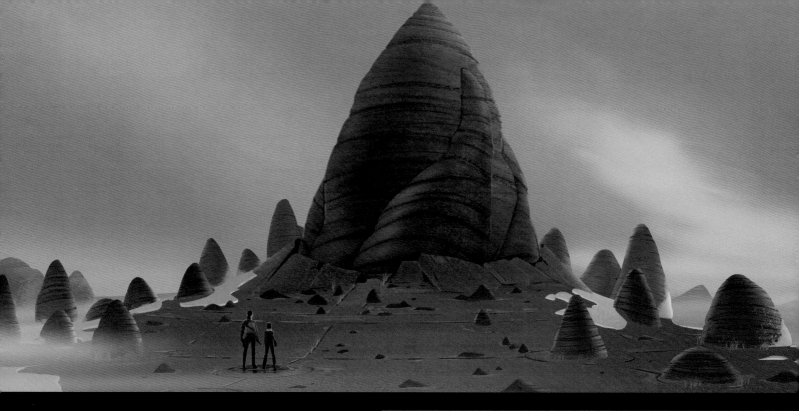

LOTHAL JEDI TEMPLE

A key location throughout the series, this mysterious structure holds the key to an ancient secret. The temple is hidden in plain sight, carved into a stone mound that can rise above the surrounding tundra.

Chris Glenn devised an alphabet derived from a Ralph McQuarrie concept for Yavin 4, which was used to decorate the various star maps seen inside the temple throughout all four seasons of *Rebels*.

These stylized figures represent the Father, the Son, and the Daughter, Force-strong beings from Mortis who debuted in *Star Wars: The Clone Wars*.

The "world between worlds" is a cryptic dimension that exists outside of time and space and is accessed through the Force.

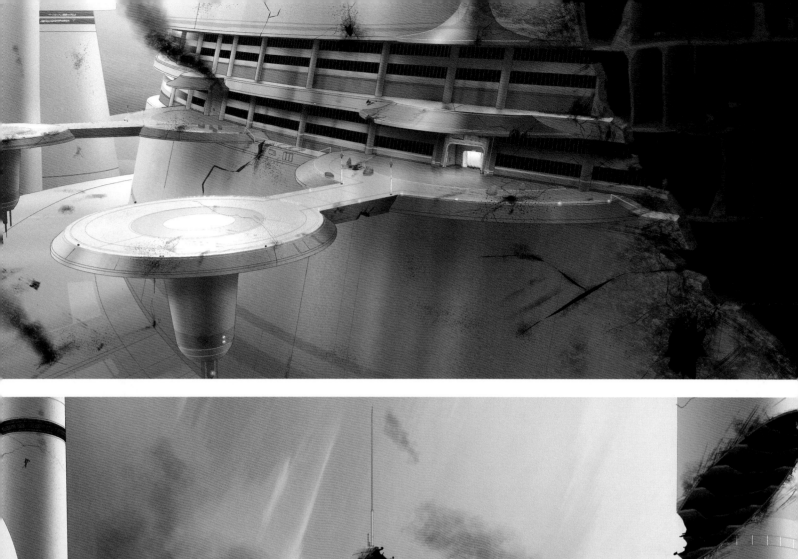
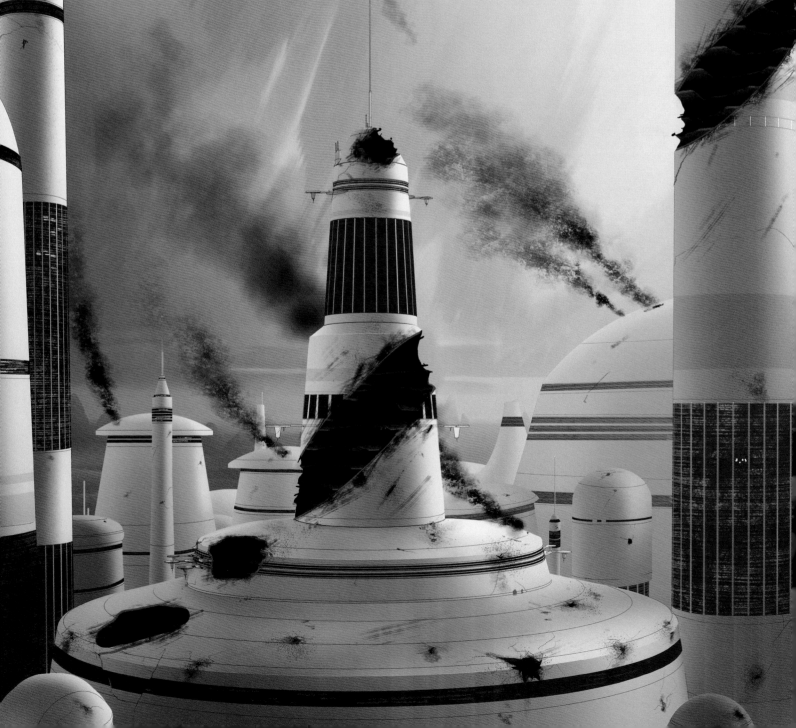

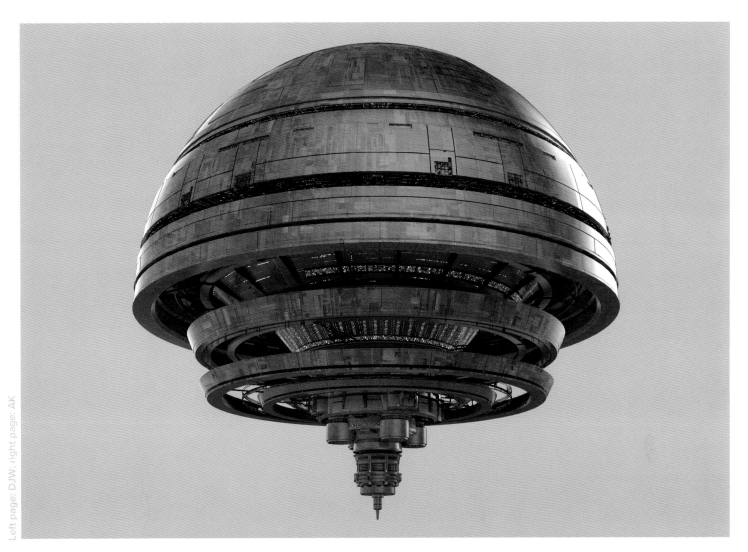

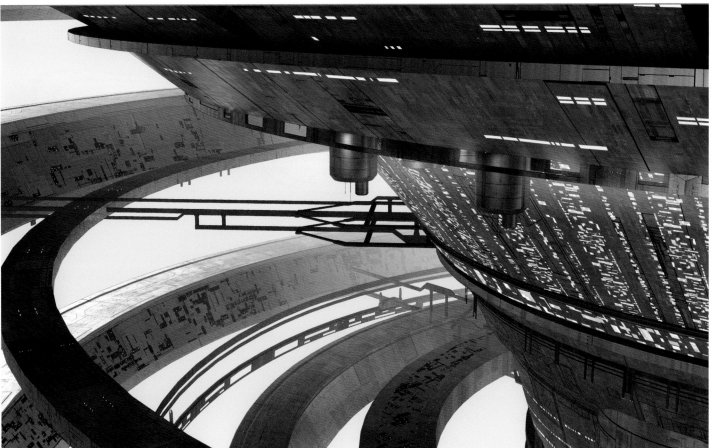

Damage sustained in a battle between Imperials and insurgents can be seen in these views of Lothal City. The capital's Imperial HQ is a self-contained structure with no visual ties to the surrounding architecture.

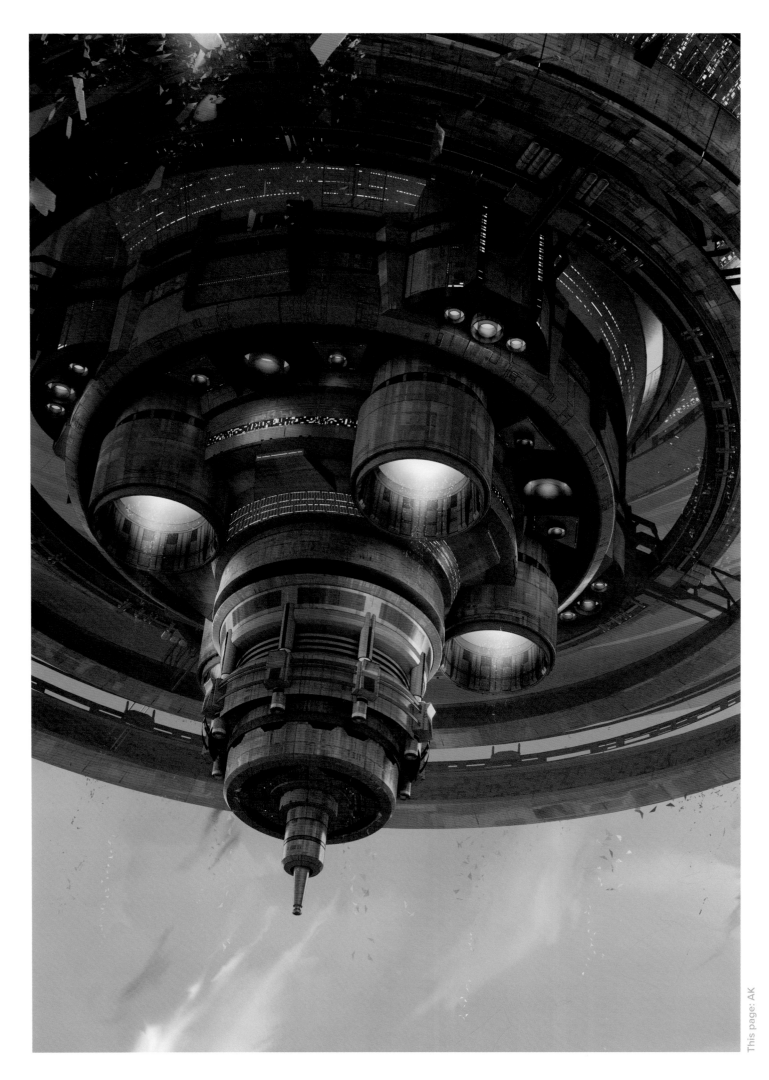

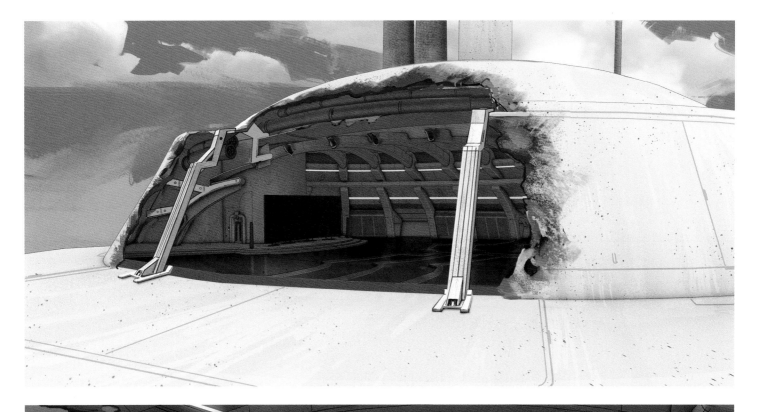

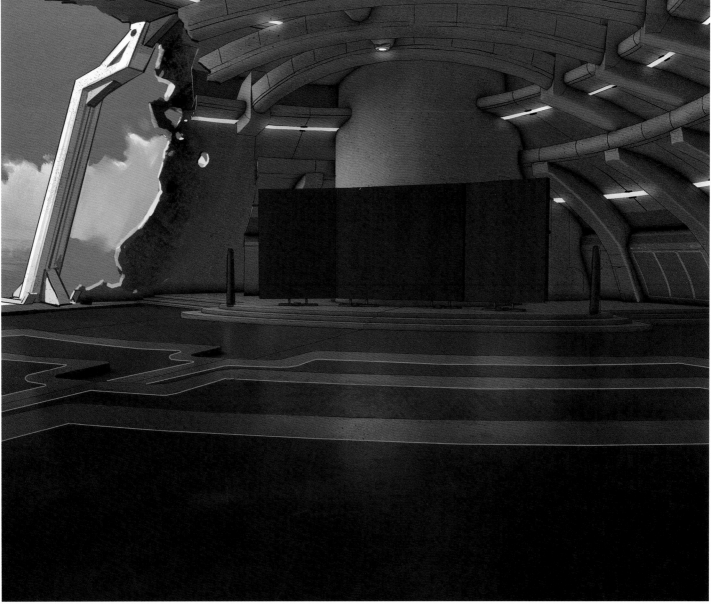

Lothal City's Imperial HQ, referred to as the "dome ship" by Rebels designers, ignites its engines and launches its multistory bulk into orbit.

PROPS
ᕹ⅂▱◠⅂∨

A return to Lothal sees the reappearance of similar designs while inviting a deeper look at the petroglyphs and ancient artifacts associated with the Jedi Temple. Mandalorian gear is prominent as well, with variations on helmets, armor, and jetpacks.

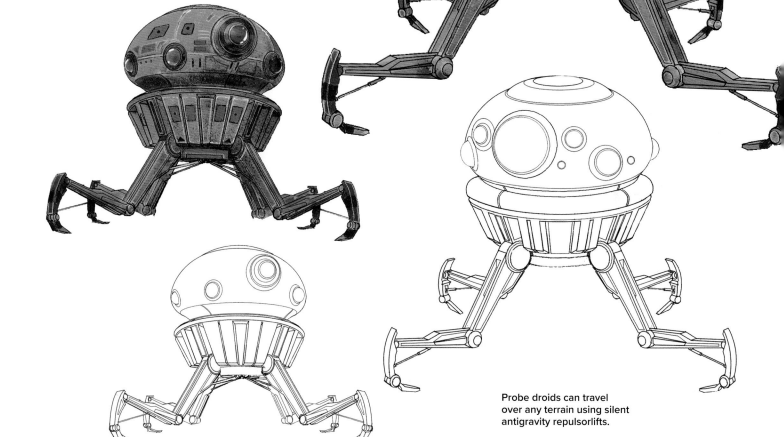

DWARF PROBE DROID
A smaller, more streamlined version of the Arakyd Viper probot, the dwarf probe droid has four robotic limbs and a pair of blaster cannons.

Probe droids can travel over any terrain using silent antigravity repulsorlifts.

MANDALORIAN JETPACK
Mandalorian clan jetpacks include variants based on the classic Boba Fett design and the rounded Jango Fett design introduced in the prequel era.

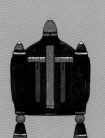
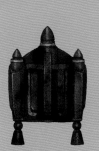
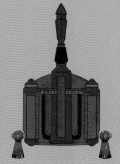
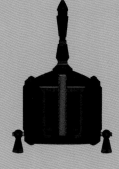

Top section: GJ; bottom section: various

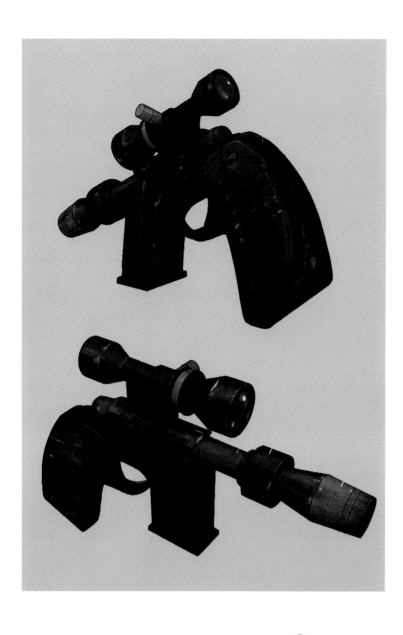

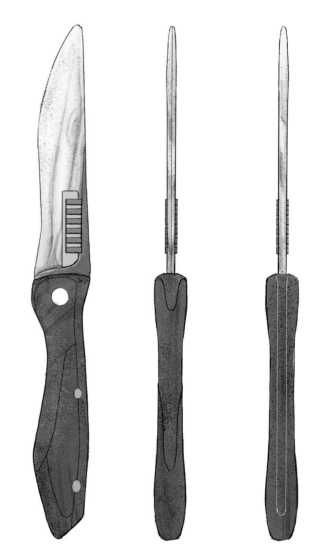

The knife featured in the episode, "Jedi Night," that Kanan uses to shave his beard and hair.

DROID HAULING EQUIPMENT

To complete his disguise as a common labor droid, Chopper wears a metal harness that allows him to carry stacked containers in the front and the rear.

Balancing such heavy cargo isn't a welcome assignment for such a droid as Chopper.

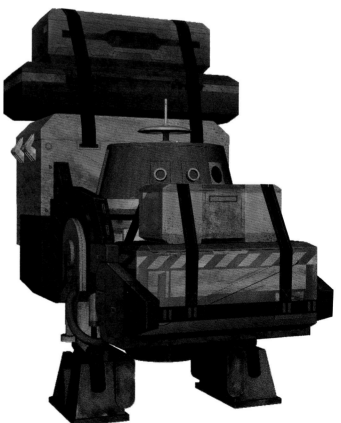

IMPERIAL MACROBINOCULARS

These Imperial-issue macrobinoculars exhibit the interchangeable qualities of machined uniformity. They are stamped with the Empire's cog-like insignia.

Built for field use, these macrobinoculars have a sturdy compactness to absorb impacts.

ARC PULSE GENERATOR

Before Sabine joined the Rebels, she designed this secret weapon for the Empire. The arc pulse generator zeroes in on the beskar metal used in Mandalorian armor and annihilates the person inside.

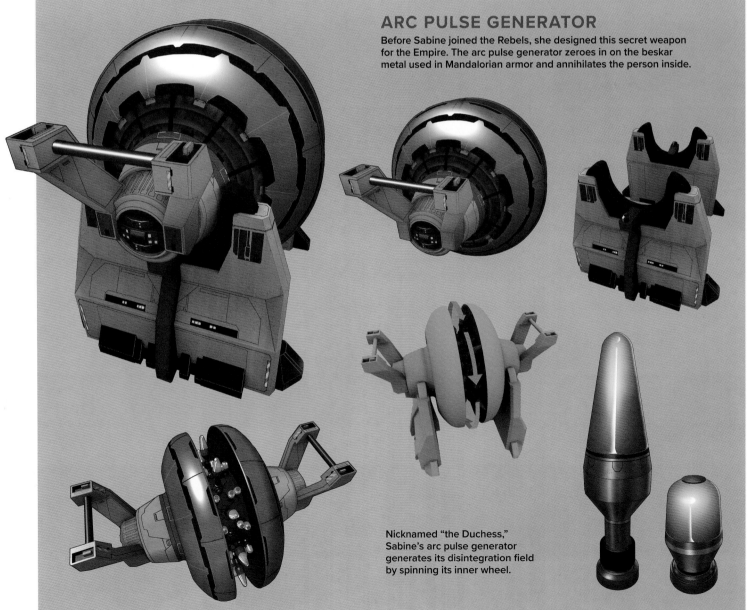

Nicknamed "the Duchess," Sabine's arc pulse generator generates its disintegration field by spinning its inner wheel.

Top section: LH; bottom section: AK

HELMETS

Many variations of the stock Mandalorian helmet were created for *Rebels*. "We used two female and two male geometries for the [nonstarring] Mandalorian characters," says Plunkett. "We picked a palette and a couple patterns or symbols, then applied those to all four variants to make each clan distinct."

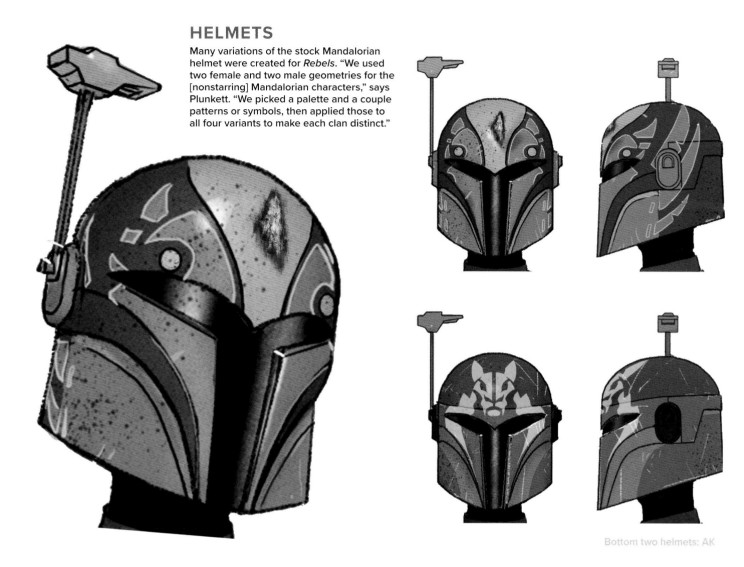

Bottom two helmets: AK

Large helmet and two helmets top right: EM

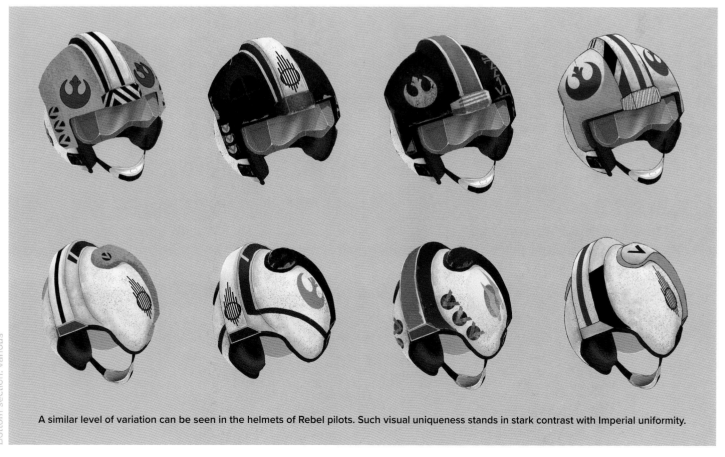

A similar level of variation can be seen in the helmets of Rebel pilots. Such visual uniqueness stands in stark contrast with Imperial uniformity.

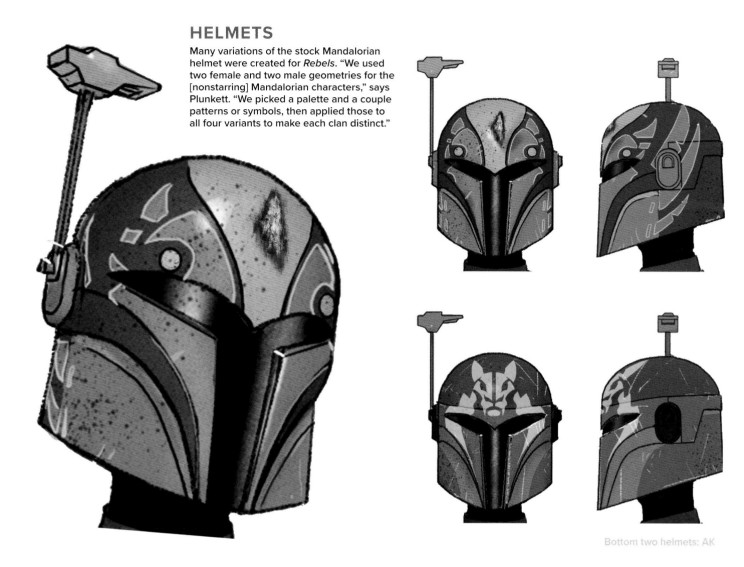Bottom section: various

GLIDER

As a native of Lothal, Ezra knows that mimicking the flight patterns of Loth-bats will allow his team to slip past the Empire's antiair defenses. The Rebels construct these lightweight gliders out of metal rods and fabric panels.

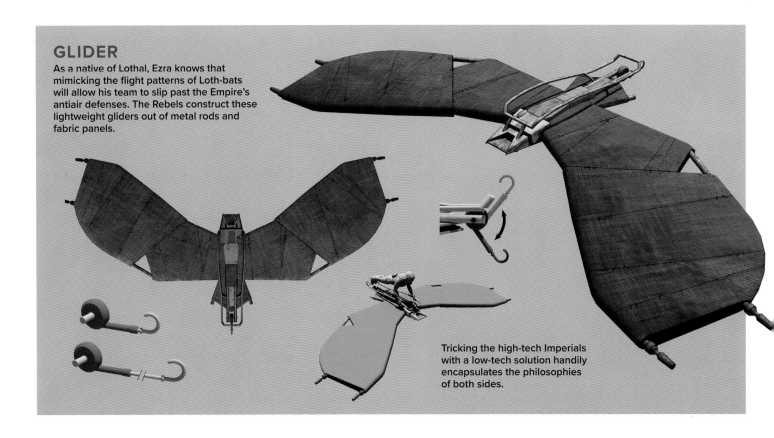

Tricking the high-tech Imperials with a low-tech solution handily encapsulates the philosophies of both sides.

CARBONITE BLOCK

Carbonite block from the episode "In the Name of the Rebellion Part Two."

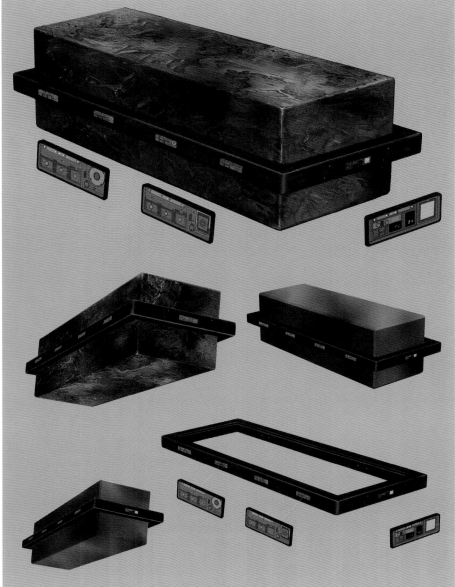

LOTHAL KEYSTONE

This artifact is etched with markings that depict Force priestesses and similar figures of legend. The Empire sought to decode its sacred geometry in order to unlock a door leading to the "world between worlds."

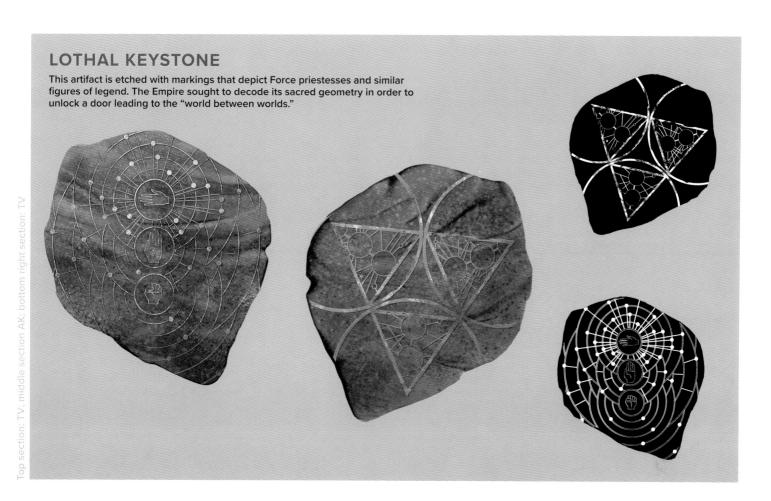

LOTHAL ANCIENT PAINTINGS

The cliffside dwellings on Lothal conceal primitive compositions showing humanoid figures interacting with Loth-wolves. The artworks hint at Lothal's long association with Force mysticism.

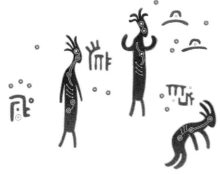

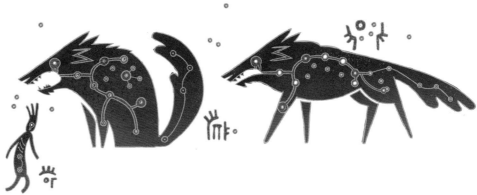

"The intent with the ancient iconography was to suggest a history stretching back to a distant past, though not necessarily created by that same culture," says Plunkett. "The paintings in the southern hemisphere are more aboriginal, while the ornate mural on the excavated Jedi Temple is from a different era."

The rock altar where Kanan shaves and cuts his hair from the episode "Dume."

To the left is the Loth Wolf symbol from the exterior of Wolffe's AT-AT from the episode "A Fool's Hope."

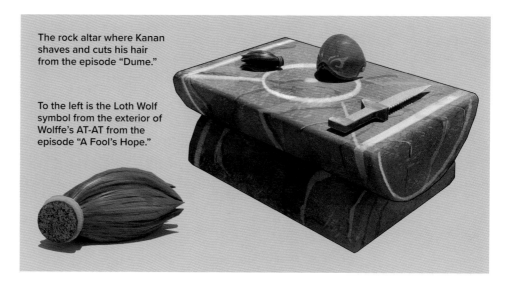

Art: DF

VEHICLES

War machines belonging to both sides of the Imperial/Rebel conflict are critical to the outcome of *Star Wars Rebels'* final season.

AT-DP ARC CANNON PROTOTYPE

The humble All Terrain Defense Pod is common among the Empire's forces in *Star Wars Rebels*, but in season four the AT-DP gets a massive upgrade. The Arc Cannon Prototype is a mobile platform to house the experimental arc pulse generator, a superweapon built to target armored Mandalorian warriors.

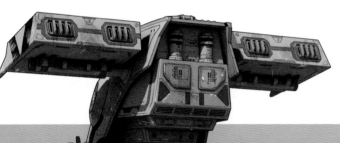

Because the Arc Pulse Generator emits a field effect when powered up, this AT-DP could theoretically wipe out an entire legion of armored Mandalorians with a single burst.

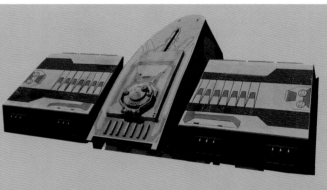

This page: EM

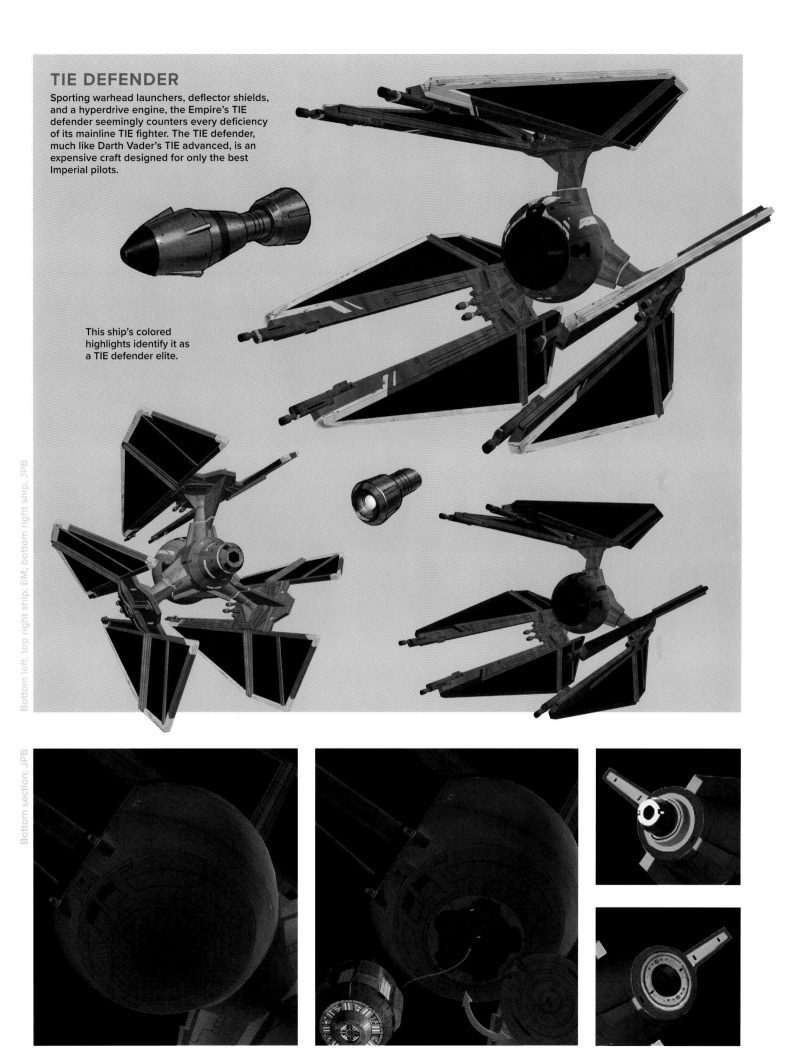

TIE DEFENDER

Sporting warhead launchers, deflector shields, and a hyperdrive engine, the Empire's TIE defender seemingly counters every deficiency of its mainline TIE fighter. The TIE defender, much like Darth Vader's TIE advanced, is an expensive craft designed for only the best Imperial pilots.

This ship's colored highlights identify it as a TIE defender elite.

Bottom left, top right ship: EM; bottom right ship: JPB

Bottom section: JPB

The hatch on the TIE defender socket where the where the hyperdrive unit is inserted.

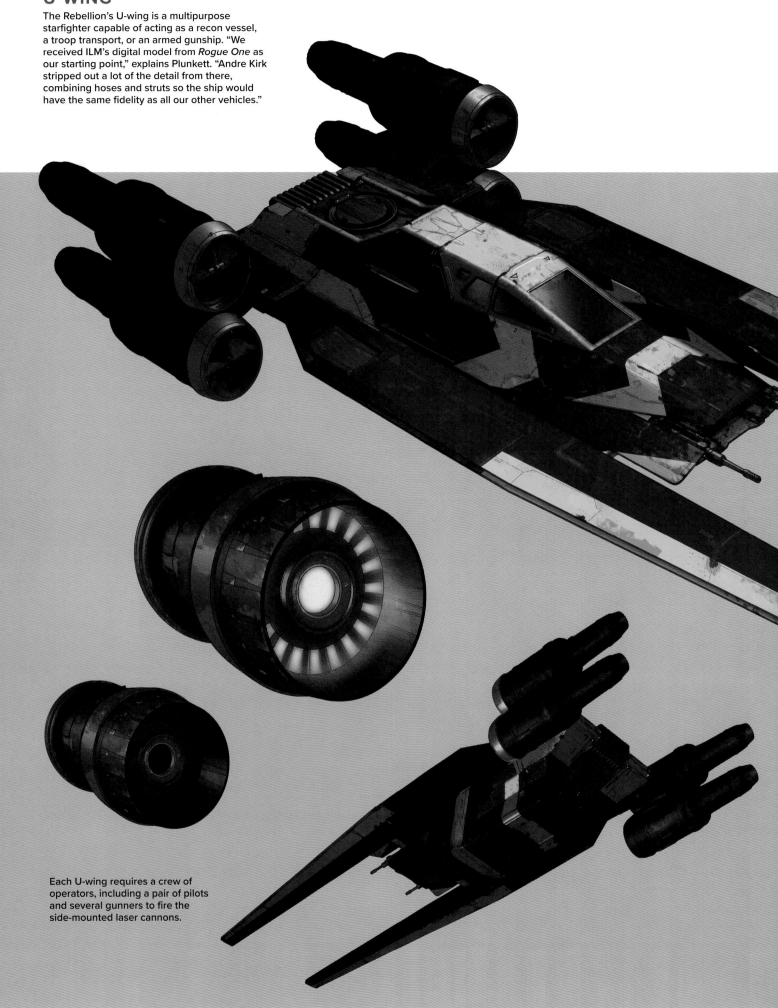

U-WING

The Rebellion's U-wing is a multipurpose starfighter capable of acting as a recon vessel, a troop transport, or an armed gunship. "We received ILM's digital model from *Rogue One* as our starting point," explains Plunkett. "Andre Kirk stripped out a lot of the detail from there, combining hoses and struts so the ship would have the same fidelity as all our other vehicles."

Each U-wing requires a crew of operators, including a pair of pilots and several gunners to fire the side-mounted laser cannons.

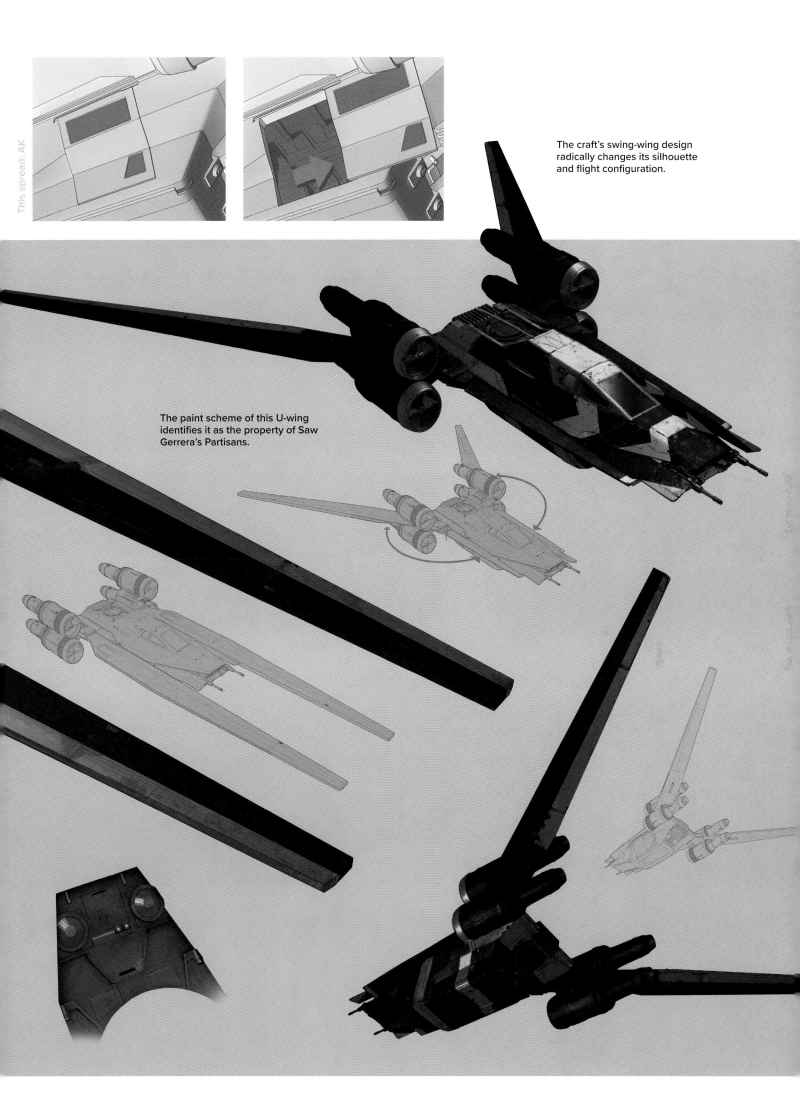

The craft's swing-wing design radically changes its silhouette and flight configuration.

The paint scheme of this U-wing identifies it as the property of Saw Gerrera's Partisans.

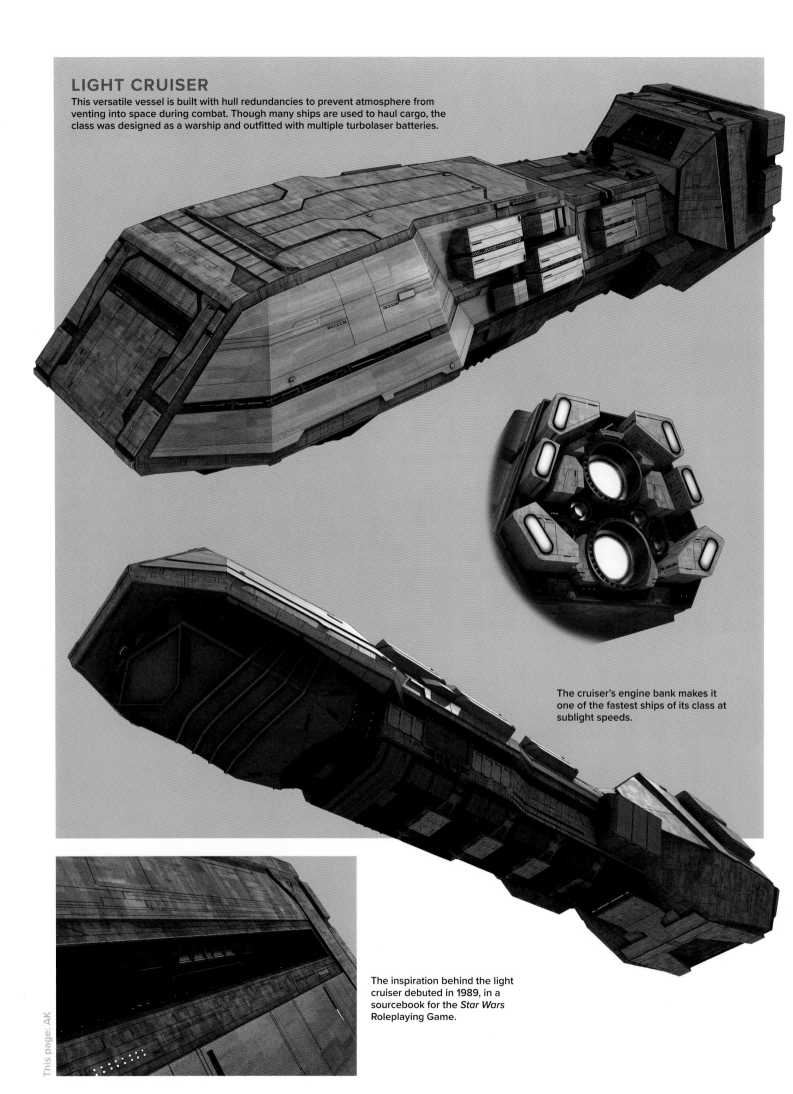

LIGHT CRUISER

This versatile vessel is built with hull redundancies to prevent atmosphere from venting into space during combat. Though many ships are used to haul cargo, the class was designed as a warship and outfitted with multiple turbolaser batteries.

The cruiser's engine bank makes it one of the fastest ships of its class at sublight speeds.

The inspiration behind the light cruiser debuted in 1989, in a sourcebook for the *Star Wars* Roleplaying Game.

This page: AK

IMPERIAL TROOP TRANSPORT

The Imperial Troop Transport, or ITT, is seen in *Star Wars Rebels* carrying Stormtroopers into battle or hauling prisoners away to detention centers. It is modeled after a popular *Star Wars* Kenner toy from 1978, which carried action figures in its side compartments.

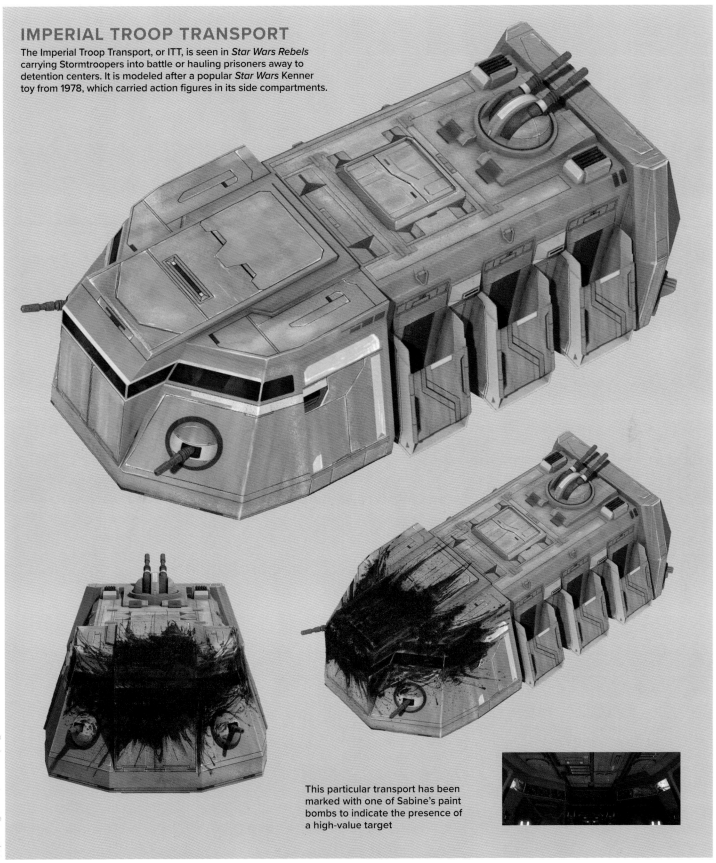

This particular transport has been marked with one of Sabine's paint bombs to indicate the presence of a high-value target

X-WING

The *Star Wars* saga's most famous starfighter gets a starring role in season four, as Hera Syndulla leaves the *Ghost* behind to command her own Rebel squadron during the efforts to liberate Lothal.

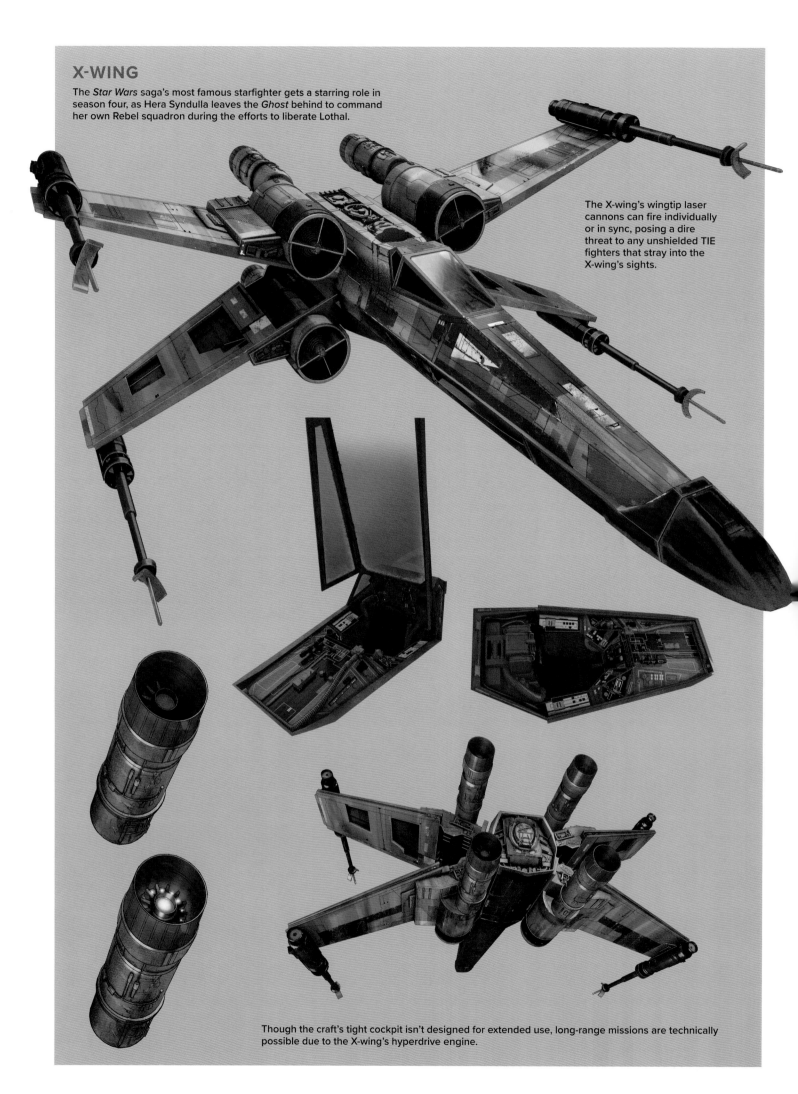

The X-wing's wingtip laser cannons can fire individually or in sync, posing a dire threat to any unshielded TIE fighters that stray into the X-wing's sights.

Though the craft's tight cockpit isn't designed for extended use, long-range missions are technically possible due to the X-wing's hyperdrive engine.

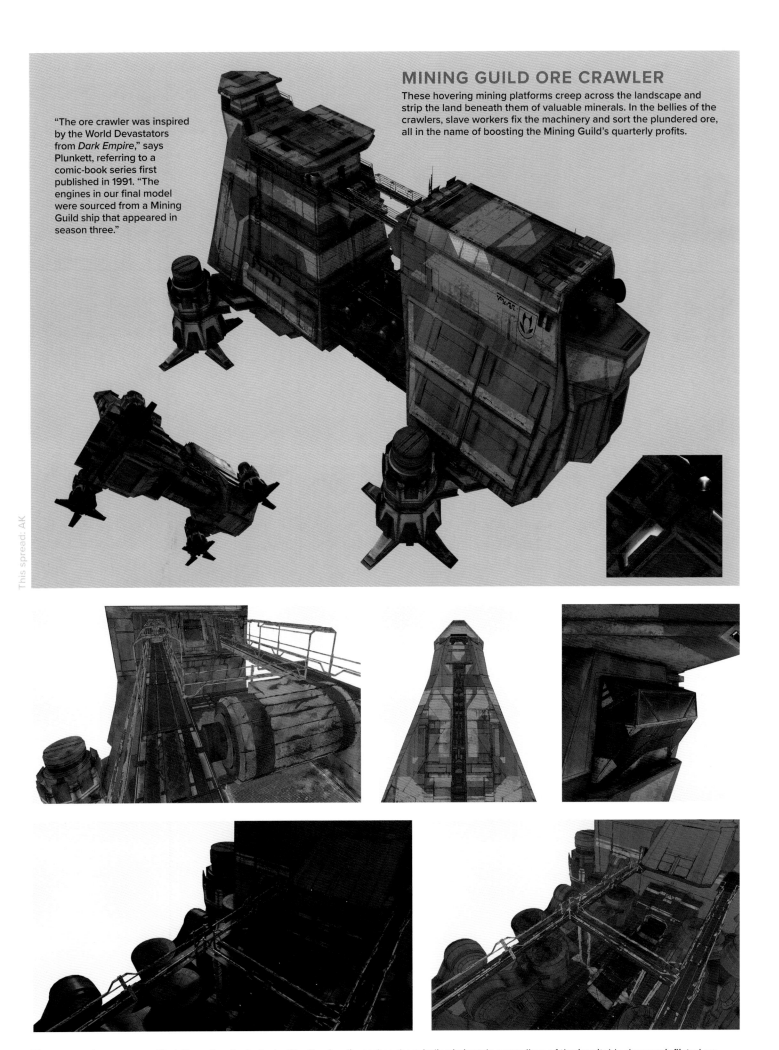

MINING GUILD ORE CRAWLER

These hovering mining platforms creep across the landscape and strip the land beneath them of valuable minerals. In the bellies of the crawlers, slave workers fix the machinery and sort the plundered ore, all in the name of boosting the Mining Guild's quarterly profits.

"The ore crawler was inspired by the World Devastators from *Dark Empire*," says Plunkett, referring to a comic-book series first published in 1991. "The engines in our final model were sourced from a Mining Guild ship that appeared in season three."

The ore crawlers are a manifestation of ecological ruin. The Empire dispatches them indiscriminately, regardless of the inevitable damage inflicted on living beings.

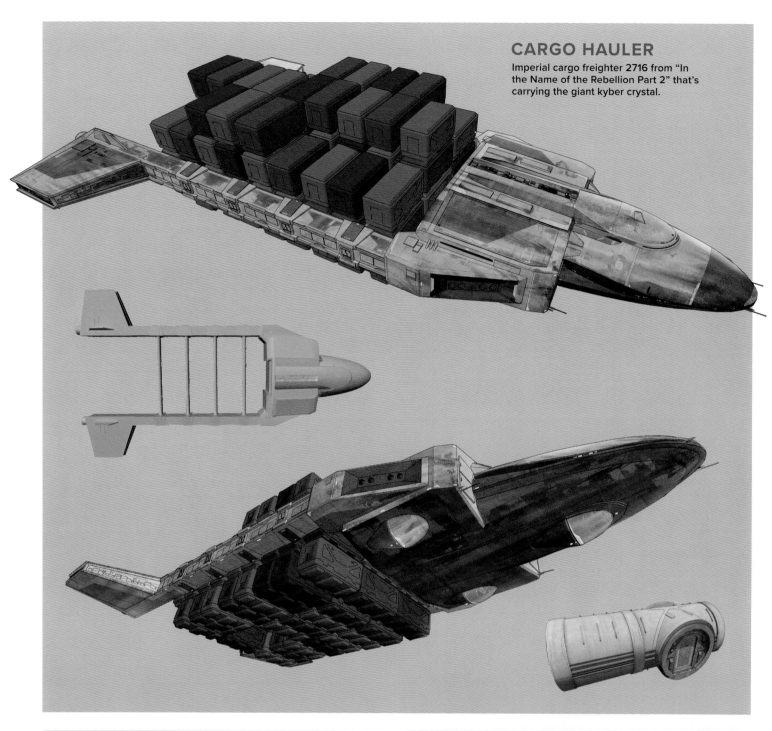

Imperial cargo freighter 2716 from "In the Name of the Rebellion Part 2" that's carrying the giant kyber crystal.

This page: LH

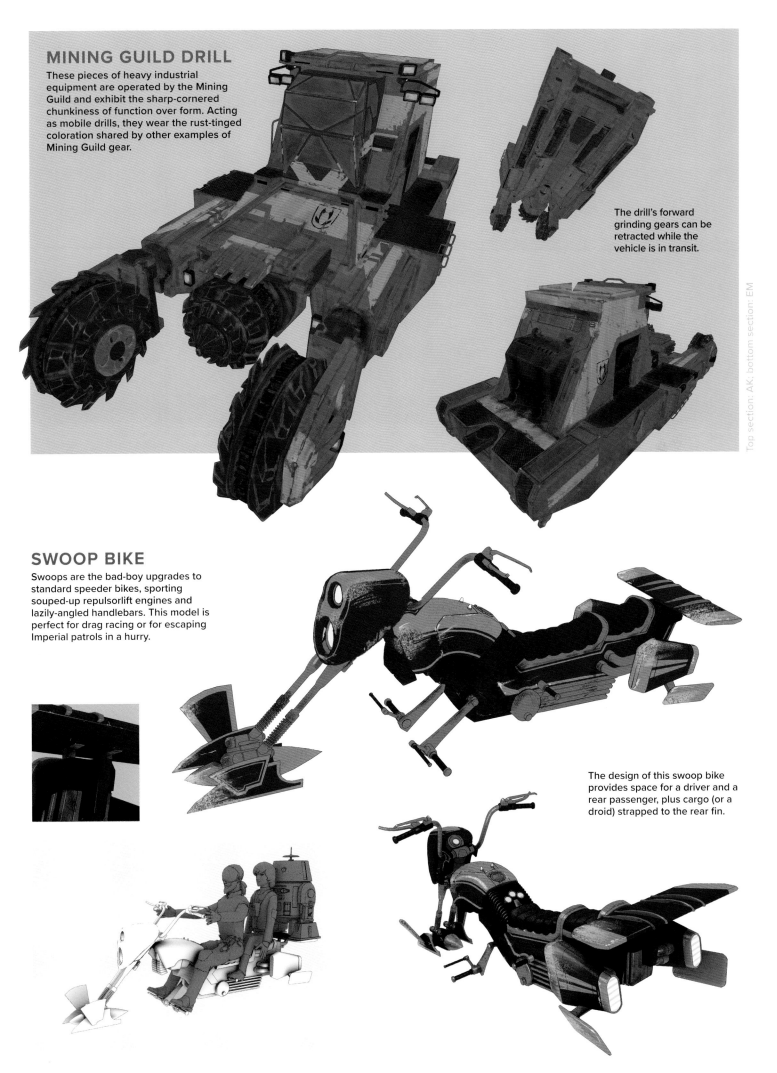

MINING GUILD DRILL

These pieces of heavy industrial equipment are operated by the Mining Guild and exhibit the sharp-cornered chunkiness of function over form. Acting as mobile drills, they wear the rust-tinged coloration shared by other examples of Mining Guild gear.

The drill's forward grinding gears can be retracted while the vehicle is in transit.

Top section: AK; bottom section: EM

SWOOP BIKE

Swoops are the bad-boy upgrades to standard speeder bikes, sporting souped-up repulsorlift engines and lazily-angled handlebars. This model is perfect for drag racing or for escaping Imperial patrols in a hurry.

The design of this swoop bike provides space for a driver and a rear passenger, plus cargo (or a droid) strapped to the rear fin.

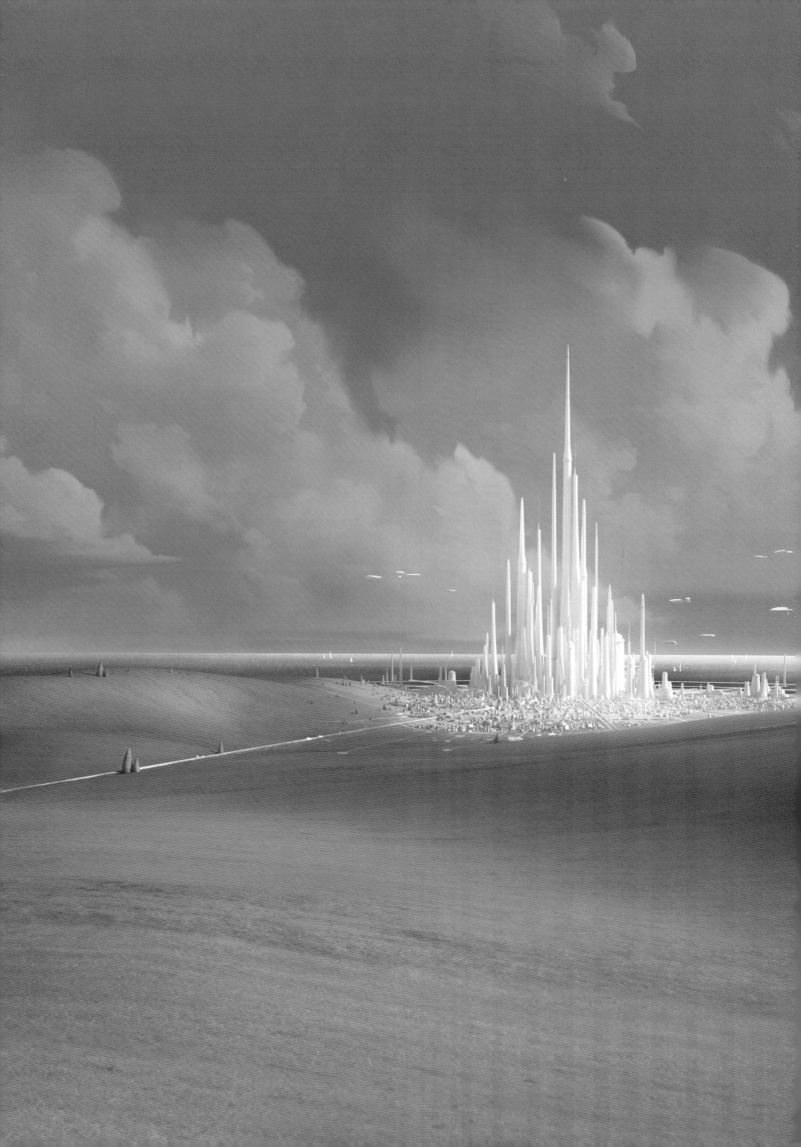

STAR WARS **REBELS**

Simon **Kinberg** Dave **Filoni** Carrie **Beck**
Based on **STAR WARS** by George **Lucas**

Greg **Weisman** Henry **Gilroy** Brent **Friedman** Kevin **Hopps** Steven **Melching** Matt **Michnovetz**
Charles **Murray** Christopher **Yost** Nicole **Dubuc** Gary **Whitta** Bill **Wolkoff**

Justin **Ridge**
Steven **Lee** Steward **Lee** Bosco **Ng** Sergio **Paez** Brad **Rau** Saul **Ruiz** Mel **Zwyer**

Kevin **Kiner** John **Williams**

Kiri **Hart**
Athena **Portillo** Jacqui **Lopez** Caroline Robinson **Kermel**

Kilian **Plunkett** Paul **Zinnes** Keith **Kellogg** Joel **Aron** Gianni **Aliotti** Nelson **Brown**
Joe **Elwood** Alexander **McDonnell** Nathan **Cormier** Christa **Di Falco** Alex **Rawlings**

John Paul **Balmet** Sean **Burke** Amy Beth **Christenson** Molly **Denmark** Christopher **Glenn** Luke **Harrington**
Goran **Josic** Andre **Kirk** Darren **Marshall** Eli **Maffei** Jim **Moore** Will **Nichols** Jason **Pichon**
Zak **Plucinski** Pat **Presley** DJ **Welch** Tuan **Vo** Christopher **Voy**

David **Au** Gordon **Clark** Zach **Ellsworth** Taylor **Hsieh** Douglas **Lovelace**
David **Maximo** F. David **Meyers** Shawna **Mills** Vaughn **Ross** Sterling **Sheehy**
Calvin **Tsang** Spyros **Tsiounis** Nathaniel **Villanueva**

Ed **Caspersen** Caitlin **Torsney** Christopher **Wasden**
Diane **Caliva** Aaron **Drown** Linsday **Halper** Julie **Kogura** Frank **La Monaca** Mike **Parkinson**
Gregory **Tremelling** Sean **Wells**

Claudia **Anahi Ramirez** Dario **Barrera** Jessica **Brunson** Carri **Diest** Kymberly **Dixon** Brandon **Eddington** Megan **Engle**
Darnell **Gooch** Rayna **Helgens** Christene Nicole **Liljedahl** Elizabeth **Marshall** Amanda Rose **Muñoz** DanAnh **Nguyen**
Drew **Patterson** Alia **Rezk** Jessica **Tsou** Caitlin **Satchell** Alexander **Spotswood** Vaughan **Weigert**
Danielle **Witz** Vicki **Wong**

Josh **Andrews** Darren **Cowan** Christa **Hulse** Josie **Huynh** Meghan **Mowery** Jeff **Ruggels** Shalonda **Ware**

Jason **McGatlin** Pippa **Anderson** Andrew **DeFrancis**
Steve **Blank** Leland **Chee** Pablo **Hidalgo** Matt **Martin** Nigel **McNulty** Josh **Rimes**
Rayne **Roberts** Diana **Williams**
Tracy **Cannobio** Jennifer **Zaccaro** Michael **Kohn**

Cameron **Davis** Tony **Diaz** Jared **Forman** Kevin **Fulleman** Sean **Kiner**
Dean **Kiner** Peter **Lam** Nolan **Markey** Jacob **Ortiz** David **Russell**

Dave **Acord** Jon **Borland** Ronni **Brown** Jason **Butler** Andrea **Gard** Luke **Dunn-Gielmuda** Jonathan **Gomez**
Richard **Gould** Mark **Evans** Ryan **Frias** Margie **O'Malley** Kim **Patrick** Frank **Rinella** David **Russell**
Matthew **St. Laurent** Matthew **Wood** Bonnie **Wild** Qianbaihui **Yang**

Cassandra **Barbour** Laura **Sevier**

With Thanks to
CGCG, Inc. **Virtous-Sparx** and **Ghostbot, Inc.**

Special Thanks to
George **Lucas** and Kathleen **Kennedy**

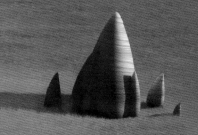

THE ART OF

STAR WARS REBELS™

A SPARK OF REBELLION IGNITES!

TAKE A STEP BEHIND-THE-SCENES TO WITNESS THE JOURNEY FROM
PAPER TO SCREEN WITH *THE ART OF STAR WARS REBELS*!

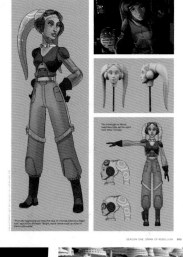

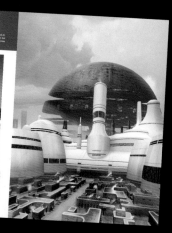

- Featuring never-before-seen concept art and process pieces
 from the production of the show!
- Includes exclusive commentary from the creative team behind
 Star Wars Rebels!
- The perfect addition to any *Star Wars* fan's collection!

$39.99 US
$53.99 CAN
DarkHorse.com
StarWars.com

ISBN 978-1-50671-091-4